THE VISUAL
EFFECTS PRODUCER

THE VISUAL EFFECTS PRODUCER

Understanding the Art and Business of VFX

CHARLES FINANCE
SUSAN ZWERMAN

AMSTERDAM • BOSTON • HEIDELBERG • LONDON • NEW YORK
OXFORD • PARIS • SAN DIEGO • SAN FRANCISCO
SINGAPORE • SYDNEY • TOKYO

Focal Press is an imprint of Elsevier

Focal Press is an imprint of Elsevier
30 Corporate Drive, Suite 400, Burlington, MA 01803, USA
Linacre House, Jordan Hill, Oxford OX2 8DP, UK

Library of Congress Cataloging-in-Publication Data
Zwerman, Susan.
 The visual effects producer : understanding the art and business of VFX/
Charles Finance, Susan Zwerman.
 p. cm.
 Includes bibliographical references and index.
 ISBN 978-0-240-81263-2 (pbk. : alk. paper) 1. Cinematography—Special effects.
2. Digital video. 3. Digital cinematography. I. Finance, Charles Zwerman, Susan
II. Title.
 TR858.Z84 2009
 778.5'349068—dc22
 2009023829

British Library Cataloguing-in-Publication Data
A catalogue record for this book is available from the British Library.

ISBN: 978-0-240-81263-2

For information on all Focal Press publications
visit our website at www.books.elsevier.com

09 10 11 5 4 3 2 1

Printed in the United States of America

CONTENTS

INTRODUCTION

We confess to having a certain Hollywood-centered bias. That's only natural, because both authors spent a span of 20 years working in the visual effects community. We were lucky to get our experience in Southern California which has the largest concentration of visual effects facilities in the world. Not only are several of the largest digital effects houses located here, but this region also is home to literally scores of prominent and not-so-prominent medium and smaller facilities that service the motion picture, TV, commercial, music video, and gaming industries.

Hollywood may have dominated the field for decades, but no longer. In the last few years the creation of visual effects has become an international growth industry. Technical genius and creative talent flourish on every continent. Software that once was so outrageously costly that only the largest facilities could afford it is now within easy reach of individual artists who work out of their homes. And when visual effects festivals are held from Germany to India, you know that "Hollywood" now extends to "Bollywood" and all points in between…at least when it comes to creating visual effects. The result of this trend has been a global blossoming of artistry that continues to astonish even professionals in the field.

What may not be widely recognized within our industry is that this extraordinary artistry comes at a price. Creating world-class visual effects is expensive, and to be consistently successful at it requires not only talented artists, but also effective producers (just ask the former owners of failed visual effects "boutiques" who created outstanding work but were clueless "businessmen"). And that is the purpose of this book: to help readers become more effective VFX Producers.

Our book looks mainly at producing visual effects from the studio's or production company's perspective. Studios and independent producers alike have learned the value of bringing their own VFX Producers and VFX Supervisors on board. And here we make an important distinction: We're dealing here with a ***freelance visual effects team*** that works for the ***production company***, not in-house staff producers like those who work at dozens of other visual and digital effects facilities all over the world.

We stress this point because the challenges of the digital producer or visual effects production manager working within a digital facility are quite different from the ones we face on the production end. The in-house facility producer's job is to see to it that his or her employer's work gets done on time and on budget.

This vendor may be only one of several companies creating visual effects for a project, each with its own interests at heart. The *producer's visual effects team,* on the other hand, is there to protect the production by seeing to it that the *overall* visual effects work will proceed smoothly and will have the unified vision that the director wishes to express.

In particular, we will be emphasizing the role of the **VFX Producer** in this book. It is not an exaggeration to say that visual effects have become the stars in many a film, and with the explosive growth of the visual effects industry in recent years, VFX Producers have found opportunities for an exciting and rewarding career have expanded exponentially. VFX Producers are playing an increasingly important role on most visual effects-heavy pictures, as well as major television specials and commercials. Additionally, the interactive games industry and many special venue films have also become heavy users of visual effects. They all need the guiding expertise of experienced VFX Producers.

Every film is unique. A group of people comes together for a time under the leadership of a producer and a director. They face a set of unique creative and logistical challenges and go about solving them to the best of their abilities, hoping that their efforts will result in a rewarding experience for the moviegoer. They will never face the exact same situations again. Instead, they will bring their accumulated experience to bear on the next project and the one after that, adapting as they go along.

We recognize this, and so what we present in this book are guidelines, not hard and fast rules. As you pursue your own career in visual effects, you will develop your own ways of working, adopting ideas that you find useful, ignoring those that are not. But our overall objective remains to provide information that will help you do your job more effectively, thus making you a better filmmaker. There will always be a demand for knowledgeable craftspeople to work in the industry, and we need more people who understand both the art and business of visual effects. It is a demanding field. Expectations keep rising, and the technology continues to change at a dizzying pace. But if you have the talent, drive, and desire to keep up with the changes, visual effects producing can provide a challenging and rewarding career.

Success Stories

All successful Visual Effects Producers began their careers in less prestigious jobs. We asked some of our colleagues to share their stories with us and to tell us their thoughts about being in this exciting field and about what producing visual effects entails. We have sprinkled their "Success Stories" throughout the book. We hope you will enjoy them—and perhaps derive some inspiration from them.

VISUAL EFFECTS IN REVIEW

THE "GOOD" OLD DAYS: VISUAL EFFECTS BEFORE COMPUTERS

Until fairly recently, the art and craft of visual effects went by the name *special photographic effects* because the work was accomplished photographically on film and relied heavily on special optical cameras called optical printers. Most of the serious visual effects work took place in postproduction. Nowadays we simply call it visual effects. But even defining a visual effect is far from straightforward. For one thing, some people include visual effects in the general category of special effects, while others may refer to them as special visual effects.

Visual effects have been a part of the filmmaker's creative toolbox almost from the first time a cinematographer cranked a handle on a wooden camera back in the 1890s.

The first known visual effect that seems to have survived was created in 1895 in a short film called *The Execution of Mary, Queen of Scots*. In that historic piece, an actress portraying the ill-fated queen puts her head on a chopping block. A hooded executioner raises his axe and brings it down on the neck of the victim, whose severed head rolls free onto the ground. The story goes that viewers were shocked by this unprecedented bit of cinema magic: the simple enough trick of stopping the camera at the appropriate moment and substituting a dummy for the actress, then resuming. Viewers of that era knew nothing about jump cuts or other visual trickery that even a 10-year-old youngster raised in today's media environment would recognize instantly.

Of course, that begs the question, what *is* a visual effect? Everyone seems to have a different definition, which only goes to show that the term's exact meaning is hard to pin down. Even the Visual Effects Society (which ought to know) hasn't come up with a satisfactory definition. Not too many years ago, it was

relatively easy to say what a visual effect was: If a shot required some sort of treatment in postproduction and rephotographing on an optical printer, it was called a "special photographic effect." John Dykstra, one of the top visual effects supervisors in the business today (and one of the main creative forces behind the visual effects for the seminal film *Star Wars* of 1977), once defined a visual effect as "two or more elements of film combined into a single image." That was a perfectly reasonable definition . . . until computers replaced optical printers and he modified that definition by saying that "with the advent of digital imaging, that could be considered two or more subjects captured in a separate media and made to *appear* (italics added) as if they were photographed together."[1] The key phrase here is "made to appear as if they were photographed together." Unless a visual effects shot maintains that illusion, no amount of technical wizardry is going to convince a viewer of the reality of the shot.

On one point most people in the industry would probably agree: Visual effects involve some form of image manipulation. That precept gives rise to the somewhat broader definition that we prefer: *A visual effect is the manipulation of moving images by photographic or digital means that creates a photo-realistic cinematic illusion that does not exist in the real world.* These effects invariably involve some sort of photographic or digital trickery. Let's face it: We're in the business of deceiving audiences.

We're quick to admit that this a somewhat broad definition (would that make slow-motion or timelapse photography a "visual effect"?), but it has the virtue that it allows us to include certain cinematic techniques under the heading of Visual Effects that don't *necessarily* require the combination of more than one visual element to make up the final shot (case in point: in-camera miniatures).

With that definition as a guide (and on the assumption that the reader already has a good understanding of film fundamentals), here follows a brief compilation of visual effects techniques that filmmakers have used over time, and that, either by themselves or in combination with digital techniques, are still useful today. Readers may notice that several techniques we describe here are accomplished all in-camera. As such, they don't necessarily qualify as true visual effects as we define the term. Nevertheless, we chose to include these techniques because they become the responsibility of the visual effects producer on many productions.

[1] (*Millimeter*, March 2002)

SUCCESS STORY
Lynda Thompson - (*Evan Almighty; Haunted Mansion*)

The first film I worked on was *Tron*…I was an assistant scene coordinator and I learned about animation, animation cameras, and the specifics of visual effects while working directly with a wonderful mentor… For the next 10 years I worked on numerous films as a VFX Coordinator and a VFX Production Supervisor. I also had the opportunity to work at several different companies and that added to my learning experience. In those days credits were still evolving and I received the title VFX Producer for the first time on *Dave* in 1993.

I have been working as a VFX Producer for over 15 years… My father and grandfather were both in visual effects but I graduated from the University of California, Irvine, with a B.A. in English and initially thought I would go a different route and become a journalist. Now I can't imagine that I almost made that choice.

The essential duties of the VFX Producer are breaking down the script, budgeting the VFX, overseeing the production of the VFX during prep/shoot/post and communicating well with the production and VFX teams. The responsibility of the VFX Producer is to facilitate delivery of final shots within the agreed-upon budget and time.

Keys to Success: Being able to see potential problems well in advance is one of the most important qualities for the job. A VFX Producer is responsible for keeping everything running smoothly. I believe the best VFX Producers steer the team away from pitfalls in a calm, decisive manner. The database keeps us informed on each shot's current status, an essential part in being able to meet the production schedule with final quality effects shots.

Stop-Motion Animation

Stop-motion animation is probably the oldest visual effects technique. It is based on the ability of a motion picture camera to shoot a series of frames one at a time instead of in a continuous burst of film, as is normally the case. As early as 1897, two American film pioneers produced a short film called *Humpty Dumpty Circus* in which they moved a child's toys by stop-motion, and in 1898 the French film pioneer Georges Méliès used stop-motion to animate wooden letters for what today we would call a commercial.

Stop-motion animation is a bit like traditional two-dimensional (2D) cartoon (or cel) animation in that an animator makes small changes in the subject's position from one frame to the next. In traditional animation, the animator creates the sense of movement by drawing a character on paper or a 2D sheet of acetate (called the cel) in a slightly different position in each frame. But in stop-motion, the animator moves a three-dimensional (3D) model in small increments from one frame to the next so that its movements will look smooth and continuous when the film is projected at the normal 24 frames per second. The technique is also called "dimensional animation." Undoubtedly the most famous practitioner of

this technique is the legendary Ray Harryhausen. He inspired a whole generation of animators and present-day visual effects artists with his classic stop-motion work in movies like the original *Mighty Joe Young* (1949), *Jason and the Argonauts* (1963), *Clash of the Titans* (1981), and many others.

The technique is still very much alive today, but today's stop-motion animators have a wide array of digital and electronic gadgetry at their disposal that enables them to create some truly wonderful animation. In fact, we would argue that it was the development of sophisticated electronic and digital tools that led to a revival in recent years of stop-motion films. Beginning with *The Nightmare before Christmas* (1993), followed in 2000 by the hit *Chicken Run* and later by such delightful stop-motion masterpieces as *Corpse Bride* (2005) and *Coraline* (2009), stop-motion artists could avail themselves of such technological innovations as motion control, digital image manipulation, and digital compositing that did not exist in precomputer times.

The technique does have its limitations, especially in today's filmmaking environment where many stories that might have been told with puppets in the past can now be presented more realistically through digitally created characters. But stop-motion has always worked best when it was in the service of fantasy and legends, rather than literal reality. It is this quality that gave

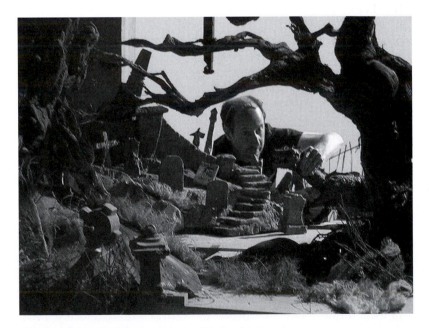

Figure 1.1 Stop-motion animator Stephen Chiodo on stop-motion set.
(Image courtesy of Chiodo Bros.)

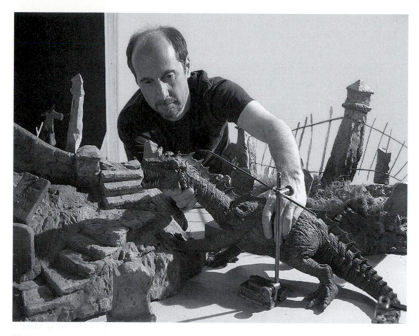

Figure 1.2 Animator Stephen Chiodo poses a dragon puppet.
(Image courtesy of Chiodo Bros.)

films like *James and the Giant Peach* (1996) their charm and lent an air of whimsy to the undersea creatures of *The Life Aquatic with Steve Zissou* (2004). The tradition continues with films like *Coraline* (2009) and *Mary and Max* (2009), made by creative filmmakers who devote their artistic energies to this oldest of visual effects techniques.

Puppets and Animatronics

Puppets are artificial creations that simulate a living creature, whether human or not. Puppets can be animated very simply by hand, wires, cables, rods, or—more likely these days—animatronics. Strictly speaking, animatronics is the control of motorized puppets through the use of electronics. But over time, the word animatronics has become kind of a catch-all term that covers electronic, mechanical, hydraulic, or radio-control devices. We just need to be clear that when we say that something is animatronic, we are merely talking about how a character is *animated*, or made to move. It does not mean that the entire character is artificial. In other words, a puppet is artificial by definition, but it is not necessarily animatronic.

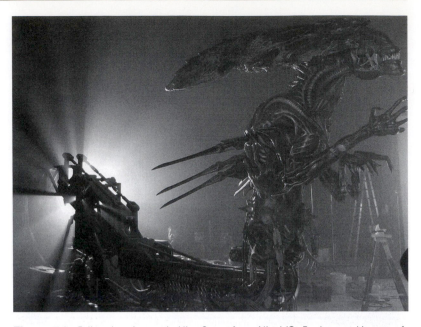

Figure 1.3 Full-scale animatronic Alien Queen from *Alien* VS. *Predator*, making use of a combination of electronics, hydraulics, and a computer-controlled performance system. (Image courtesy of Amalgamated Dynamics, Inc. *Alien* VS. *Predator* © 2004 Twentieth Century Fox. All rights reserved)

Matte Paintings

A matte painting is a painting that adds to or replaces part of a live action image. Matte paintings are used to create imaginary environments or to replace part of a scene to add complexity to a shot that would otherwise be too expensive or impossible to film. They have been called the invisible art, because when they are done well, viewers cannot tell that they are looking at a painting.

Matte paintings have their roots in what are called glass shots, a technique that predates motion pictures. Early still photographers would sometimes aim their cameras at a subject and find that the existing scene was not to their liking. Their solution lay in setting up a pane of glass between the camera and the subject, then painting a different scene directly on the glass so that the painting blended seamlessly with the subject they wanted to photograph.

It was just such a photographer, Norman Dawn, who was apparently the first cinematographer to apply the glass-shot technique to motion pictures, after having learned the trick while a still photographer. Unfortunately, glass shots had to be set up and completed at whatever location the action took place, be it city or desert, come rain or come shine. Glass shots enhanced many a

film for decades, but they were gradually replaced by true matte paintings after the invention of optical printers in the 1920s. With optical printers, a live action scene could be filmed on location, but the accompanying painting could be completed at a more leisurely pace in the studio.

Figure 1.4 Matte artist Syd Dutton of Illusion Arts at work on a digital matte painting. Today, virtually all matte paintings are created digitally.
(Image courtesy of Bill Taylor, ASC)

In the last decade, the art of matte painting has undergone yet another revolution. Thanks to digital technology, matte artists have almost completely abandoned their brushes and pigments and opted for the mouse or the digital graphics tablet instead. Virtually all matte "paintings" today are works of 3D computer-generated art. For the most part, artists embraced the change, because digital technology gives them the freedom to create matte shots of astonishing virtuosity that traditional matte painters could only dream about. There is even a new name that is being heard more frequently: created (or synthetic) 3D environments.

One area where digital matte paintings are being used very effectively is set extension. This simply means that the production builds a partial set, and the matte artists add on to it—extend it—where the physical set leaves off. Of course, in a sense that is what traditional, painted matte shots accomplished, too. The difference is that today, we can create *3D* matte paintings, which allow a virtual camera to move with relatively few restrictions through its environment. Such freedom of movement of the camera—panning, dollying, craning, flying—was unheard of a mere 10 or so years ago.

It's easy to recognize the value of set extensions as an excellent technique to enhance the illusion of nonexistent places and times both past and future. But they have also achieved renewed appeal among budget-conscious producers (and what producer isn't?) for another reason. With production costs soaring, many production companies are cutting back on distant location work, choosing instead to film closer to home and expanding the scope of their settings with digital set extensions or physical models that are skillfully lined up to full-scale set pieces to make them appear as one continuous environment.

Miniatures

The first miniature ever captured on film appears to have been the recreation in 1897 of a naval battle during the Greco-Turkish War by the French film pioneer Georges Méliès. It didn't look very convincing by our standards, but miniatures have been an invaluable adjunct to live-action photography ever since. We can use miniatures in various combinations with live action or digital elements, and like other visual effects, we use miniatures when it's impossible to use the real thing because it's too expensive to film, is inaccessible, or doesn't exist in the first place.

There's no limit to what a miniature might represent. It can be a city, a landscape (earthly or alien), cars, spaceships, an animal . . . you name it.

Getting miniatures to look convincing isn't just a matter of building smaller versions of bigger objects. In miniatures, the devil is in the details, and the art of the miniature builder lies in getting the details just right. Primarily among them are the scale, the mass (if the miniature has to move), the color and texture, and the final detailing. Human perception is very finely attuned to what looks real and what doesn't. If the miniature builder misses the mark even by a little, it takes only a fraction of a second on screen to spoil the illusion. But when miniatures are built right and skillfully photographed, the viewer will accept the illusion without a second thought.

Certain natural phenomena don't scale down very well, by which we mean that it is very difficult to pass them off as miniaturized versions of the full-scale event. These are water, fire, and explosions. Each of these obeys physical laws that make it impossible to miniaturize it. The closest we can come is to film it in slow motion, thereby giving it the *appearance* of miniaturization.[2]

[2]Readers who want to learn more about what camera speeds can be used successfully in these situations may wish to consult reference books such as the *American Cinematographer Manual* and other technical books on the art and science of visual effects.

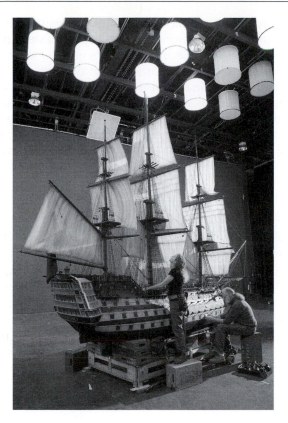

Figure 1.5 Model makers at Kerner Optical prepare a miniature for a bluescreen shot. (Courtesy of Kerner Optical and Industrial Light and Magic; © Disney Enterprises, Inc.)

In-Camera Miniatures

The "purest" form of using miniatures is in-camera. As the term implies, these are stand-alone miniatures that are filmed and can be cut into the film as is. In-camera miniatures often involve the destruction of the miniature, as when a building or a vehicle is blown to smithereens. But explosions, flowing water, and other natural phenomena have minds of their own. As often as not, something unpredictable will happen, the miniature will have to be restored, and the shot will have to be done over. VFX Producers need to be aware of this for budgeting and scheduling purposes. The common practice is to budget and schedule for three repetitions of these events . . . just in case the first two don't work out.

Hanging Miniatures with Live Action

Hanging miniatures are also called foreground miniatures. The terms are virtually interchangeable. This is an in-camera technique where a miniature is built close to the camera and lined

up and painted so that it blends perfectly with a live-action background. Hanging miniatures can be a very effective and relatively inexpensive means for a director to give a grander scale to a set or to create an imaginary environment that doesn't exist in the real world. It's the same basic idea as matte paintings, except that hanging miniatures have the advantage that they are 3D objects, which almost always look better than a 2D or even a 3D digital painting.

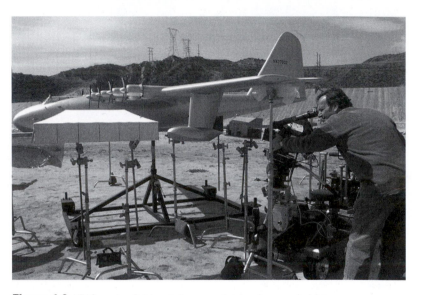

Figure 1.6 VFX Supervisor Rob Legato lines up a shot on a foreground miniature. (Image courtesy of New Deal Studios, Inc.)

Another nice thing about hanging miniatures is that you can easily change the lighting—for example, to shoot the same set-up in the daytime as well as at night—whereas a painting may have to be reworked extensively to change a daylight setting into nighttime. Because hanging miniatures are done in-camera, the director sees the finished shot in dailies the next day. There is no compositing involved, and therefore no reduction in quality of the original negative.

However, the director must be willing to accept a couple of limitations. For one, he or she must decide on the camera angle well in advance of shooting, because the miniature must be built so that it lines up perfectly with the background in terms of scale, perspective, and color. For another, camera moves on hanging miniatures are severely limited: dolly and crane shots are impossible, and even pans and tilts can only be done with the camera's lens on the nodal point.

Even in this digital age, foreground miniatures continue to be a useful tool in the VFX Supervisor's bag of tricks. For example, they

were used to great advantage in Martin Scorsese's film *The Aviator* (2004).

Miniatures with Composited Elements

This technique involves the compositing of a miniature either with a live-action plate, a matte painting, or some form of computer-generated background that will supplement the miniature photography. Compositing miniatures with other elements is probably the most common use of miniatures, and certainly one of the most widely used visual effects techniques. *The Lord of the Rings* and *Harry Potter* trilogies, for example, were full of such shots.

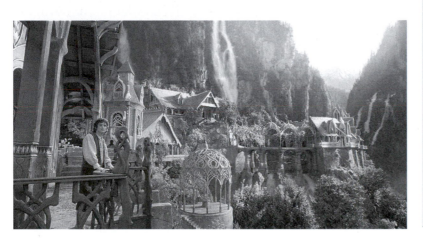

Figure 1.7 Actor Elijah Wood was filmed on a set piece in front of a blue screen and then composited with a miniature of the village of Rivendell and additional live-action elements of real waterfalls.
(*The Lord of the Rings: The Fellowship of the Ring* © New Line Productions, Inc.™ The Saul Zaentz Company d/b/a Tolkien Enterprises under license to New Line Productions, Inc. All rights reserved)

Front and Rear Projection

Front and rear projection are both *in-camera compositing* techniques. By this we mean that two (and rarely three) separate images are combined into one image in-camera at the time of filming. In front projection, an image is projected through a beam-splitter placed in front of the camera onto a highly reflective Scotchlite screen. The screen material is similar to the material that is used in highway signs. It has the virtue that it reflects more than 90% of the light that falls on it directly back at the light source.

Technical term

A beam splitter is simply a partially reflecting mirror. In other words, while it reflects some light like a normal mirror, it also allows a portion of the light to pass through it. It's a little bit like spray painting a piece of glass only lightly so that the paint doesn't form a solid layer. Beam splitters are usually 50-50, meaning that half the light is reflected and half is transmitted, but other combinations are also available.

Plates of the unbreakable kind

One technical term that you should be familiar with – and which we will use time again throughout this book – is "plates." It is one of the most commonly used terms in the lexicon of visual effects. Plates is simply the term we apply to filmed elements that are shot to be incorporated into a visual effect. We talk of live action plates, BG plates, miniature plates, greenscreen plates, and reference plates. It's a generic term for just about anything we shoot for the visual effects.

In rear projection (RP), the image that is to be combined with a live-action plate is projected from the rear onto a *translucent* screen, and the live action plays in front of it. As simple as this sounds, it is a technically challenging procedure. Projectors must have absolutely steady, pin-registered movements so that the projected image doesn't jiggle. The light beam must be even all across the screen, without a hot spot in the middle of the screen or fall-off at the edges. This usually requires a huge stage so that the projector can be as far in back of the screen as possible. Projector lamp houses must be very powerful to produce an adequate exposure on the screen. Additionally, the projected images must be in pristine condition (and remain so throughout the shoot). Dirt or scratches on the print are a dead giveaway that you're looking at a projected image.

The advantage of front and rear projection is that you see the completed shot in dailies the next day, instead of having to wait weeks or months for the final shot to be composited. Also, the director can more easily stage the foreground action to go with the action on the background plate, and the DP (Director of Photography) can more easily match the lighting of the foreground (FG) to the background (BG). This is a skill that only comes with experience.

One drawback to both techniques is that they require that the background plate be shot, selected, and prepared ahead of time. This isn't always possible, given the availability of locations and actors, weather conditions, and other challenges that have to be juggled. Also, there is almost always a slight loss of image quality of the background plate because it is, after all, a print made from the original negative, though with modern print stocks this is no longer the issue it once was.

Today, front projection has virtually disappeared. And while *film-based* rear projection is almost extinct as well, the process has made a significant comeback in digital production, in features as well as in television and commercials. For example, the movie *Get Smart* (2008) used digital rear projection for dozens of shots. The production team found that the technique offered several advantages: It was less expensive when compared with blue- or greenscreen compositing, it saved having to move actors and crew around on location for running vehicle shots, actors and crew were comfortable and safe on the set, and the director could immediately see the results after each take. Additionally, new background plates previously transferred to HD (High Definition)tape could be quickly queued up, and there were no concerns about blue or green reflections. RP is well suited to certain types of shots, such as actors in cars and plane cockpits. And although many producers prefer blue- or greenscreen compositing, if the script calls for many shots of this type, RP is well worth

considering, and the VFX Producer may be asked to budget the shots both as in-camera RP and conventional blue- or green-screen composites.

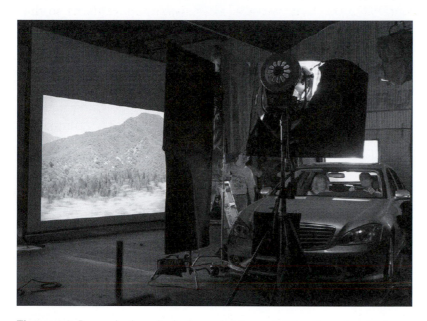

Figure 1.8 Rear projection using background plates on digital media, such as HD tape, give DPs unprecedented control over color, density, and contrast of the projected plate on set. Such quality controls were not available with film-based RP.
(Image courtesy of Illusion Arts, Inc.)

Forced Perspective with Live Action

Forced perspective is a technique that plays tricks with the spatial relationship between objects. It fools our brains into believing that objects are closer to or farther away from the camera than they really are or that they look bigger or smaller in relation to one another. The technique works because film is a 2D medium, meaning that the images are projected onto a flat screen, and so there is no real depth to them (the exception being, of course, stereoscopic or 3D photography, which creates the *illusion* of depth). Forced perspective can be done either in-camera or as a composite. In the right hands, the technique continues to be a useful tool and can be an effective money-saving technique for the VFX team.

Like most other visual effects techniques, forced perspective is not new. It has a long and honored history in scene design in the theater, and was used in film at least as early as 1915, when D. W. Griffith employed children instead of adults, ponies instead

Figure 1.9 In-camera forced perspective of actress Daryl Hannah appearing to be 50 feet tall in a scene from *Attack of the 50 Ft. Woman* (1993).
(Image courtesy of HBO Films)

of horses, and diminutive buildings to lend scope to some street scenes in his *Birth of a Nation* (1915).

Blue- or Greenscreen Composites

Collectively, blue- or greenscreen composites, along with older processes that relied on replacing a solid colored background with a scene, are referred to as traveling mattes. This is probably the most widely used visual effects technique in use today. Even most average laymen know something about it, just from watching various entertainment programs on TV and perusing the special features sections of DVDs. It is where we shoot a foreground element (which is usually either live action or a miniature) against a pure blue or green backing. Then, in postproduction, the blue or green color of the backing is digitally removed and replaced with a different background, which can be another piece of live action, a miniature, a matte painting, or a completely computer-generated environment. The FG element (with the blue or green backing now removed) and the new BG elements are then composited together.

With digital compositing, we can combine an almost unlimited number of layers or elements into one image. Shots with 20 or 30 layers are pretty routine these days, and shots with more than 200

layers are not unknown. Of course, the more layers you add, the more complex and expensive the shot becomes.

The VFX Producer must be able to explain to people not familiar with visual effects why one would choose either blue or green as the preferred background. The most fundamental reason has to do with subject matter: If objects in the frame are blue (such as an actor's wardrobe or a blue car), go with green, and vice versa. Beyond this, there are many fine points to be considered, and they are best left to the experts to sort out.[3]

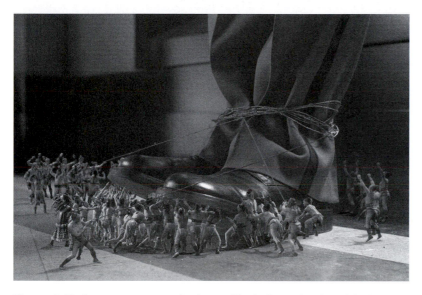

Figure 1.10 A greenscreen composite that combined a live-action plate of the legs and shoes with several greenscreen plates of live-action extras as well as digital extras. This is also a good application of forced perspective.
(Image courtesy of Rhythm & Hues Studios. *Night at the Museum* © 2006 Twentieth Century Fox. All rights reserved)

Motion Control

If there is one tool that almost single-handedly revolutionized contemporary visual effects, it is motion control. We use it when a camera move must be repeated exactly, or when a camera move calls for a degree of precision and smoothness that no human operator can consistently achieve. Motion control relies on a computer to send electrical pulses to a special type of electric motor called a stepper motor. Whereas a normal electric motor will run continuously as long as the power is on, a stepper

[3]A rarely used variant on blue- or greenscreen photography is black-screen photography in which the background is left black. In black-screen photography, mattes must be rotoscoped by hand.

motor will turn one tiny step at a time in response to each pulse it gets from the computer (sometimes taking more than a thousand steps for one revolution), and each step can be repeated precisely as many times as necessary.

The key to motion control is repeatability. It is what assures that different elements of a shot that were done at different times—and maybe even at different scales and camera speeds—will actually fit together when the shot is composited. Several excellent examples of this appear in the film *Babe: Pig in the City*, (1998) where there are numerous situations in which dozens of animals—cats, dogs, chimps, and orangutans—appear in the same shot. Many times the crew had to shoot literally dozens of motion control passes of the animals to make the shots work.

In-Camera Practical Effects

These are stand-alone effects that need no digital compositing help. In a strict interpretation of our definition of visual effects, you could reasonably argue that in-camera special effects are not really visual effects at all. We include them here just the same because we are not talking about the standard repertoire of special mechanical effects like explosions, rain, wind, running water, and the infinite variety of mechanical gadgets that are the purview of special effects artists. These types of special effects are shot in real time on the set and don't pretend to be anything other than what they are.

The kind of practical effects we have in mind are effects that alter reality, and so create a fantasy that does not exist in the real world. Even in this age of computer-generated effects, creative VFX Supervisors can still achieve totally believable results in-camera…and at very modest cost compared to costs often incurred in the digital realm. The key to success in this area is to understand not only the advantages, but also the limits of each technique.

Special (Mechanical) Effects and Visual Effects

Take a stroll sometime through the base camp of a moderately sized feature film production. Among the many trailers and trucks that such a production company hauls out on location you'll eventually spot a trailer filled with cabinets, workbenches, tanks of acetylene, wind machines, all sorts of tools, lengths of pipes and pieces of metal, buckets of fuller's earth, and what-have-you. You just found the special effects trailer.

You may hear this department referred to by various other names: mechanical effects, practical effects, floor effects. In the

paperwork it is usually abbreviated SFX or SPFX. Whatever its designation, its function is to create special effects *on set during principal photography in real time.* Among other things, the special effects crew conjures up weather effects (such as snow, rain, wind, and fog), fires, explosions, and bullet hits. They're the ones who hook up the plumbing in a shower so a hopeful starlet can bare all under a stream of artfully lit water, catapult a bus through the air, or build you a 2-ton pneumatic rig to move a fake dinosaur to scare the audience out of its wits. In other words, they will create pretty much everything mechanical on the set that does not, or cannot, happen naturally on its own.

SUCCESS STORY
Alison O'Brien - (*Vanilla Sky*; *Mission Impossible 2*)

I studied graphic design, software engineering, programming, and desktop publishing. I was lucky enough to become aware of the potential of putting graphics and computers together before visual effects were even heard of.

I took a job as a runner in a London-based company, which was pioneering in the world of computer effects for feature films… There were only around half a dozen places doing it around the globe at that time. I was able to get a broad knowledge of many aspects of the business because it was a pretty small company and there was room for overlap into many areas. My training with both software and visual analysis really helped me move ahead…I was visual effects producing within a couple of years.

Later, I was promoted to head of effects and director of production, before deciding I wanted to move to LA, out of post and into production. That was my first exposure to visual effects and I stayed at that company for 7 years. Now I work as a freelancer on the production side; I am hired by the studios as an independent entity.

Look ahead and anticipate the problems before they arise. Find solutions. Deliver on time and on budget.

Some key personality traits for succeeding in VFX work are: Intelligent. Calm. Organized. Good with numbers. A good eye. Must be prepared to work long hours. Patient.

The database is vital for tracking all shot-related data.

DIGITAL EFFECTS: THE 15-MINUTE VERSION

"A computer is just a very expensive pencil."
—Anonymous

Many people tend to think of computer-generated images (which we usually abbreviate CGI or simply CG) as a new technology that burst on the cinema scene already fully formed in films like *Jurassic Park* (1993). In actuality, the digital revolution in visual effects was decades in the making.

As far back as 1969, a company called MAGI was producing computer-generated TV commercials for IBM. 1973 saw the release of *Westworld,* which featured 2D computer-generated images simulating a robot's point of view (POV) of its environment, and its 1976 sequel, *Futureworld,* was the first feature to use 3D CG animation of a human head (Peter Fonda's). The relationship between computers and visual effects grew ever closer to the point where today, we can create images in the computer of just about anything we can imagine.

Creating the spectacular digital images we have become accustomed to seeing in contemporary visual effects extravaganzas takes enormous resources and the prodigious talents of thousands of artists working in the field. Anyone who has sat through seven minutes of credits rolling by at the end of one of those films is surely aware of that. Often the artists working on the digital effects outnumber the technicians of all the other crafts combined. The titles of their many specialties may have an unfamiliar ring to old-timers in the industry, titles like compositor, match mover, technical director, digital roto artist, and many others.

So what steps are actually involved in creating digital images? Before we answer that question, we want to make clear that we

will be limiting our discussion almost exclusively to *visual effects for feature films.* By choice, we are excluding special situations like 3D computer-generated animated films, although many of the same techniques apply to both. Think of it this way: In visual effects, we create objects, characters, environments, and sometimes entire scenes in the computer (what we call all-CG). But these digital effects serve to support a story that is basically told in live action and usually—though not always—are intended to look photorealistic, even when they depict fictitious situations. Mostly what we do in digital visual effects is create *elements* that are incorporated into live action shots.

Every shot must do two things: First, it must set the scene. That is, it must visually define the objects, environment, and characters in the frame. Secondly, every shot must tell a story. That is to say, objects or characters within the frame must move; they must *act* in furtherance of the story. Just as an actor delivers dialogue and expresses himself or herself through actions, so should a digital character have to act. If a shot fails in the first function, it may just look aesthetically bad but still serve its purpose. But if it fails in the second function, it will detract from the story and should be thrown out. It's the job of the VFX Supervisor and director to design each shot with those goals in mind.

Something to bear in mind is that when we create CG images we have to describe every last detail of the image to the computer. Live action photography—the real world—provides us with an incredible amount of detail for free: the change in expression on an Oscar-winning actress's face, the textures of a grungy city street, the unpredictable way an exploding car tumbles through the air and bounces on the pavement. In the computer—the virtual world—there is no such thing as "happy accidents," those unforeseen byproducts of nature that enrich our visual experience. If we want a digital shot to have those attributes, we have to specify them pixel by pixel.

Virtually all photorealistic objects, characters, and environments that we see in movies today are created with 3D software, and this software is very good indeed. Gone are the days when computer engineers ruled the artistic realm because they knew how the stuff worked. Though they are every bit as critical to the visual effects industry as ever, their roles have changed substantially. Software engineers now write the programs that solve really difficult visualization problems. Not so many years ago, creating realistic cloth was a major challenge. So were water, hair, smoke, skin, and many other natural phenomena, although every viewer instinctively knows what they should look like. All these challenges—and many others—have been largely solved. But remember: The programs crunch the numbers. The *artists* do the creating.

Two-Dimensional (2D) vs. Three-Dimensional (3D) CGI

Two-dimensionality—the lack of depth of objects—is a short-coming that has challenged practitioners of the visual arts for millennia, from the pre-historic artists who left their handprints in the caves of Lascaux to the unfathomable paintings of avant-garde painters of the 21st century. About the only artists who escaped its constraints were sculptors.

The artistic imperative to simulate three-dimensionality on a two-dimensional canvas is even stronger today as we strive to create convincing virtual worlds in the computer to entertain moviegoers all over the globe. The gift that computer technology has bestowed on artists is that they now have the choice of working in either two dimensions (2D) or three dimensions (3D). In visual effects, we usually deal with both, even in the same shot. There are important differences between 2D and 3D; each is best suited for certain tasks.

2D CGI

If you have ever strolled through a movie theater lobby and walked past one of those life-sized standup cardboard cutout displays of an action hero promoting an upcoming feature, you understand the concept of two-dimensionality. Look from the side or from behind the cutouts, and there's nothing there (talk about a two-dimensional character!).

That's a rough analogy of computer images created in 2D. They exist in only one plane and have only two dimensions, width and height. Like paintings, 2D images have no depth, and there is no shift in parallax when you look at the image from slightly different positions. Think of it this way: If you were an artist creating a 2D image, as far as the computer is concerned, it's as if you were drawing the image on the surface of the monitor.

To clarify this a bit, let's say you drew a picture of a cube in 2D, as shown in Figure 2.1.

Figure 2.1 Drawing of a 2D cube simulating 3D.

Axes of movement

The screen basically has two directions, up-down and left-right. We call these direction axes. Left-right is the X-axis and up-down is the Y-axis (or East-West and North-South, as they are referred to in animation). We can specify the movement of an object on the screen by stating where the object is in any given frame relative to its X-, Y-, and Z-axes.

To be sure, you can move this image around on the screen; slide it up, down, and sideways in frame; zoom in and out on it to make it get bigger or smaller; or twirl it clockwise or counterclockwise like a pinwheel spinning in the eyes of a hypnotized cartoon rabbit. But if you wanted to show the cube rotating on its vertical axis to reveal the hidden sides, you would have to draw the visible faces of the cube in a slightly different shape and position for each successive frame. The changes in shape and dimension of the faces of the cube as it rotates do not carry over from frame to frame because the computer program has no knowledge or memory of any hidden parts of the cube; it "sees" only what's in that one frame.

Even though 2D CG has its limitations, it is very useful for creating shapes and objects that only need to move in the plane of a surface such as a screen, a monitor, or a sketchpad. We use 2D to create many different types of visual effects elements: things that glow (think Luke Skywalker's light saber), pixie dust, lightning bolts, and some matte paintings. We can also perform numerous routine operations in 2D, such as wire removals, rotoscoping, and digital paint work. Many powerful computer programs (including Adobe Photoshop) are designed to work in two dimensions. As a rule, 2D CG computer programs are relatively economical, and creating images in 2D is usually much simpler and faster than doing them in 3D, and therefore considerably cheaper.

In addition to generating actual visual effects elements, certain other computer operations vital to creating visual effects are strictly 2D functions; they do not need to see the virtual world in three dimensions. Among these are such functions as color corrections, contrast adjustments, and—most important of all—*compositing*.

In fact, compositing is possibly the single most important application of 2D computer technology in contemporary visual effects. Without exception, all compositing is done in 2D. A compositor may have dozens or hundreds of 3D CG elements at his disposal, but when he or she composites the final shot, all these 3D CG elements are figuratively pasted—frame by frame—into the two-dimensional world of a flat screen. You see objects on the screen in three dimensions only because a powerful 3D CG program was able to construct the objects by looking at them from all sides *in successive frames*.

3D CGI

Now you may well ask, why do we need expensive 3D CG programs anyway? Well, there are two intertwined fundamental reasons. First, when we create objects, characters, or environments with a 3D CG program, we can create *the entire object* in one fell swoop. It may take six months, but every detail of the object—size, shape, color, texture—as it would appear from all sides can be described to the computer, which then "remembers" everything about the object that the digital artist built into it. Once the object

exists in 3D, we can then change our point of view—our angle—as much as we want without having to completely redraw the object for each new angle, as would be the case in 2D. What's more, the information about the objects carries over from frame to frame.

Secondly (and this is the real reason for using 3D CG), 3D allows us to freely *move* objects and/or the camera during a shot and have the computer automatically adjust the perspective and parallax of everything in the scene from frame to frame. Using all the information about the contents of the scene that's stored in its memory, the computer recalculates where objects and the camera are located at each point in time.

This is made possible because 3D CG adds volume to objects and the space they exist in. In technical jargon, it is the addition of a third axis, the Z axis, to the X and Y axes. The Z axis lies perpendicular to the screen's surface, and this allows us to add *depth* and three-dimensionality to our images. To put it another way, you are describing the *whole* cube to the computer, not just the two or three sides you are limited to when you work in two dimensions. And when you are finished, the computer will remember all the details you drew. In effect, 3D CG allows you to conquer space, albeit only *virtual* space.

3D CG is where the glamour—and the big money—are. It is what every digital artist ultimately wants to excel in. Almost all CG images you see in movies today that look photorealistic were done three-dimensionally using one of a number of incredibly powerful and versatile computer programs. In practical terms, 3D CG programs typically cost more than 2D programs and are vastly more complex, and it takes longer to create the images. Not surprisingly, therefore, 3D CG visual effects are expensive.

Moviegoers are justifiably awed by the extraordinary digital artistry on display in contemporary movies: the fantastical creatures, photorealistic environments, and epic space battles. But let us not lose sight of the fact that CG is an extremely useful tool to perform a vast array of relatively mundane touch-up and repair functions that go unseen—and unappreciated—by viewers: wire and rig removals, painting out a mole on an actress's face, sky replacements, dust and dirt removal, and a thousand other tasks. The glamour may be in 3D CG character animation, but the bulk of CG work is accomplished at thousands of anonymous workstations scattered throughout our industry.

Creating a Digital Image

To create an image in 3D CG you basically have to accomplish five things:
- Build a model
- Texture and paint the model
- Animate the model

Elements

In the context of visual effects, 3D CG objects are used almost exclusively as *elements* to be composited into shots consisting of live action and other elements.

- Render the model
- Composite the model with other elements

Building Digital Models

In the digital world, the word model is the general term we use for any object—from the simplest to the most exquisitely complex—that exists only in the computer's memory. Assuming you have a design to work with, building a model is first on the list of tasks. Modeling is where you build your digital sets, define the environment, and determine the size and shape of objects and characters.

An artist can use several methods to build a CG model. The most common method is to build a model from scratch, employing one of several 3D computer programs. Even with the help of such programs this is not a fast process; it can take weeks or months to build a complex model, say, of a city or a photorealistic digital character. Another approach is to buy a ready-made 3D digital model from a company that created it and put it into their stock library, and adapt it to your own use. Thousands of such models of almost anything imaginable, from aardvarks to zombies, are commercially available. Yet another possible source for a CG model is a maquette (i.e., a detailed sculpture) of an object or character that has been designed specifically for the project.

One term that's being heard more and more often is "digital back lot."[1] The term generally refers to the now-common practice of filming foreground action on blue or green screens on a stage and then combining it with a digitally created environment, the digital (or virtual) backlot. In effect the digital backlot takes the place of a real studio backlot, with the added benefit that once a digital environment exists in the computer, it can be easily modified for other projects with different lighting, new "set dressing," different weather conditions, etc. By archiving the files of digital sets and environments it created, a digital facility can build up its own virtual backlot and tap these files for future projects, much as a studio reuses its existing sets from earlier pictures.

To build a model, the artist may first do a sort of digital sketch, drawing a three-dimensional wireframe (see Figure 2.2) to delineate the object's shapes. Wireframe models may also be referred to as vector models. A wireframe model may include all significant structures of the object being modeled, including not only the structures that viewers will eventually see in the completed image, but also often some of the internal ones that give the object its overall shape but aren't necessarily revealed in the shot.

[1] The term was coined in 1998 by matte artist Robert Stromberg, who realized that in the near future the idea of digital sets would become common.

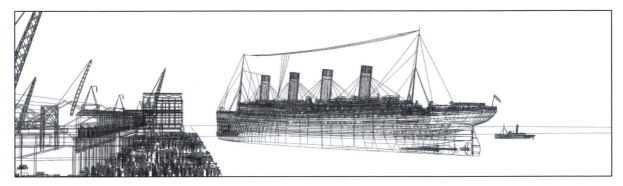

Figure 2.2 Wireframe model of a ship and dock.
(Image courtesy of Emil Besirevic and Gnomon School of Visual Effects)

Another type of 3D CG model is what is called a shaded model (Figure 2.3). They are also called raster models. An artist may generate a wireframe model first and then convert it into a shaded form, or may start modeling the object in its shaded, or raster, form from the start. Shaded models are fully three-dimensional and appear solid. They show the outer skin of the object, but have no color or texture at this point. All contemporary CG modeling programs are capable of producing both wire frame and shaded models.

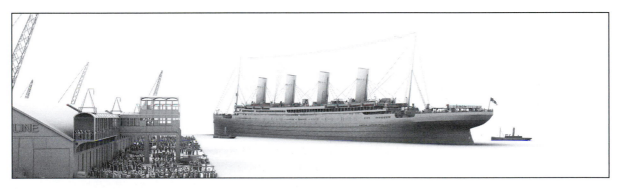

Figure 2.3 The shaded models matching the wire frame models above.
(Image courtesy of Emil Besirevic and Gnomon School of Visual Effects)

Texturing, Painting, and Lighting

As you see in Figure 2.3, shaded models are a far cry from being finished works of art of the kind that bring viewers into theaters. Models must be textured and painted. This is the step where objects start to look real, where the artist gives surface characteristics to environments, characters, and objects. Artists have various means to texture an object. One is to laboriously draw or paint the texture onto an object, wrinkle by wrinkle or hair by hair.

Figure 2.4 The completed composite of the fully painted and textured ship model with CG smoke and water.
(Image courtesy of Emil Besirevic and Gnomon School of Visual Effects)

Another technique, one that is much more efficient, is to digitally project or map a texture onto a three-dimensional shape that matches the finished model. This technique is also referred to as 2-1/2D. In this approach, the texture of a *real* object is digitally "projected" or mapped onto the unfinished digital model. A good example of this approach is the scenes of Spider-Man soaring through the canyons of Manhattan. The skyscrapers were created digitally as three-dimensional but unfinished shapes. The visual effects crew also took thousands of photographs of real buildings in New York. Later, to complete the illusion of flying through New York City streets, the appropriate textures and colors of the real buildings were "projected" onto the unfinished shapes. And voila! A make-believe Gothic cathedral door without having to build one.

Figure 2.5 All CG models, whether of living creatures or inanimate objects, must be textured and painted to give them the look of real objects.
(*The Lord of the Rings: The Two Towers* © New Line Productions, Inc. ™ The Saul Zaentz Company d/b/a Tolkien Enterprises under license to New Line Productions, Inc. All rights reserved)

Texturing goes hand in hand with *painting* a model. Now, when digital artists talk of painting a model, they really have a somewhat more technical concept in mind than what most laypeople would think of when you mention "painting." To a digital artist, painting encompasses everything that has to do with light falling on, being affected by, and reflecting from the model. In other words, painting is associated with *lighting* and everything the word implies: color, shadows, brightness, contrast, the direction of the light, and other pictorial qualities.

Lighting a computer model is a highly intricate, delicate process, essential to integrating a digital model into a live action scene and making it look like the two were photographed together. Humans become lifelong experts at knowing instinctively how things should look in the real world. We rarely give a thought to how light bounces around from object to object with thousands of reflections and shadings that cast subtle hues of color everywhere. This is one of the reasons why few things will ruin an otherwise perfectly good digital model quicker than if it is improperly lit and therefore does not blend in with live-action elements in the shot.

As far as the computer is concerned, a light is simply another object to keep track of. Computer programs have innumerable ways of describing the characteristics of a light—whether it's a small lightbulb, a large spotlight, or a diffuse sky—and an artist can place the lights anywhere he or she wants, even within the frame or in places it would be physically impossible to place a light, if necessary, because this light is virtual, not real.

CG Characters

CG characters and creatures are merely a special type of model. Modeling a 3D CG character has much in common with sculpting. In fact, quite often a producer will commission a sculptor to sculpt a *maquette* of a character for the director's approval. This can be an invaluable procedure when a character will be seen in the film both as an animatronic puppet that will be shot as a live-action element and as a CG creation. The two versions of the character must obviously match each other, and so the maquette becomes a common visual reference for everyone whose work has to look consistent throughout the film.

A fairly recent technique uses lasers in conjunction with computers to *digitize* an actor, and the digital data then becomes the basis for modeling the character. In this procedure, a digital version of the actor is created for such purposes as head replacement or creating a digital stunt double for situations where it would be too dangerous or otherwise impossible for the real actor to perform. Actors may be scanned from head to foot or head only, and with or without their wardrobe.

Creating 3D CG characters or environments is not a neat, linear process. It's somewhat similar to nonlinear editing, in that you can work on several aspects of the CG image at the same time. For example, you might be doing animation tests even before a character has been textured. Or one of your artists may be playing with different textures or lighting while the character or environment is still being modeled.

Animation

Animation is about *motion*. It is where the artist defines the movement of objects and characters in the shot and how they change over time. In dramatic terms, animation is where the artist deals with *expression and performance*, that is to say, he or she makes the objects and characters *act* (although some people might argue whether making an inanimate object like *Herbie* go through its motions should be called acting). Even lights can be animated if the scene calls for the light to change.

Animators distinguish between primary and secondary animation. Primary animation deals with the overall movements of a character, how the character or object moves through its environment, and how it moves its body and extremities. An example of primary animation would be a dinosaur galloping across a grassy plain. Secondary animation addresses more subtle, smaller movements that are added on top of the primary movements. Secondary animation often gives a character its individuality and adds realism. An example of secondary animation would be the ripple of flesh beneath the skin as the dinosaur's feet pound the ground.

Rendering

Up to now, the 3D image the artist has been working on has existed in the computer's memory only as sort of a cloud of imaginary points floating in virtual space. The "cloud" has the shape of the image the artist is working on. If you were to look over the artist's shoulder, you would see a single two-dimensional image of whatever he or she is working on. But you would not be able to see the shot in motion. In order to be able to play the image in its final form on a monitor screen or output it to a recording media (e.g., tape, disk, or film), every frame of every element has to be *rendered* at every step along the way. To oversimplify the process, the computer pulls together all the information about an image (such as lighting, texture, color, density, etc.) and performs millions of calculations to produce a *viewable* two-dimensional image on a screen.

Rendering[2] can be very time-consuming, depending on the amount of detail in a frame and the resolution at which an image is rendered. The more detail a frame contains, the longer it takes to render it. In the early stages of a project, when elements are fewer in number, relatively simple, and low in resolution, render times are usually fairly short. They get progressively longer as elements take on greater detail and more layers are added that subsequently have to be composited with one another. Elements such as smoke, water, mist, and fire are notorious for being "render hogs" because they basically consist of individual particles, each of which must be individually addressed by the renderer.

Point of interest

Consider that each frame of the 35-mm Academy film format is made up of almost 21/2 million pixels, and that each pixel is assigned its own numeric value to describe its position, density, and color, and you begin to get an appreciation of the amount of computing power needed to calculate, say, a three-second shot consisting of 100 layers or elements.

Compositing

Compositing is the final step in creating visual effects shots. This is where the dozens or even hundreds of layers that the artists have been working on come together in one final image. The challenge in compositing is to combine all these layers so that they look *as though they had all been photographed together*, becoming a finished, beautiful work of art. And compositing *is* an art; the best compositors are true artists who not only know computer technology, but also have what we often call a "great eye," that mysterious talent that enables them to make us believe that what we're looking at is real.

The staggering complexity of many of today's visual effects shots often require render times that stretch over many hours and even days per frame. For this reason, digital facilities may *precomposite* groups of visual effects elements. For example, they might take several elements of a stormy sea and composite them into one image, making all necessary adjustments in composition, color, and contrast in the precomposite. This "precomp," with most of its technical problems already solved, can later be integrated during final compositing, thus saving rendering time at that stage of production.

And the culmination of all this hard work? It's the final recording of the finished visual effects shots onto film, tape, or other digital media, to become part of a presentation that the producer and studio hope will bring us, the viewing public, into movie theaters around the world.

[2]Just to help avoid some possible confusion: Rendering is not the same as either compositing or recording. It's simply taking the digital file and converting it so it is visible on a 2D screen. It's roughly like the ink and paint process in cel animation where each cel is painted individually and then stacked with one or more other cels to be photographed on the animation stand.

Miniatures vs. Digital Models

In recent years, miniatures have run into stiff competition from computer-generated environments and objects. The trend began mainly in television and gradually spread into feature films as software became more sophisticated, allowing digital artists to model, texture, and paint their creations in the computer faster and cheaper than their colleagues who were building physical models. That trend appears to have stabilized as filmmakers found that each technique has its merits, depending on the requirements of a particular project.

A good example of this is the 2004 film *The Aviator,* a film starring Leonardo DiCaprio in the role of famed aviation pioneer Howard Hughes. That film seamlessly blended both physical and CG models. The re-creation of an aerial dogfight near the beginning of the film was realized almost entirely with CG models, while later sequences—including a spectacular sequence of Hughes crashing an experimental aircraft into a Beverly Hills neighborhood—were accomplished entirely with physical models.

Figure 2.6 Model makers prepare a miniature for an in-camera plane crash. (Image courtesy of New Deal Studios, Inc.)

Leaving the question of cost aside for the moment, physical models (the words miniature and model are interchangeable in this context) appeal to many directors and VFX Supervisors because they are true three-dimensional objects. You can touch them, walk around them, put a camera up to them, and do all the other things with and to them that a real object permits. They are subject to the same subconsciously perceived flaws that full-size objects are, such as a slight ripple in a metal fuselage here, a slightly off-kilter wall there, and other imperfections in the real

world. When a model maker works on a miniature, he or she will inevitably introduce an artist's human touch that sometimes results in what is called the happy accident, the little imperfections or unexpected flourishes that help miniatures look so convincing on screen.

Among their disadvantages are that miniatures often require a large crew to build. It is a slow and labor-intensive process that may take months to complete. Once they are built, you have to transport them to where they will be filmed, reassemble them, detail them to camera, hire the crew and equipment to maintain them during filming, then strike and move them to storage until the production is sure that it is done with them.

CG models, on the other hand, can generally be built in the computer relatively quickly and by fewer people. Shapes, dimensions, and textures can be easily changed. Since CG models exist in the computer's memory as three-dimensional objects, a virtual camera can look at them from any angle and perform any move that the director calls for. In fact, one of the liberating things about CG models is that a virtual camera can accomplish any camera move the director desires. It is free of the physical constraints of a real camera. Another factor that works in favor of digital models is that once a 3D CG model has been built and detailed, it can be worked on by several artists at the same time working on different shots or sequences. That is not possible to do with physical miniatures, which must be filmed one setup at a time.

One of the drawbacks of digital models is that every detail must be described to the computer. In other words, the digital artist has to imagine all these details and build, texture, or paint them onto the CG model. There is no provision for happy accidents, although admittedly, contemporary software has given digital artists some powerful tools to help them create highly photorealistic models.

For the producer the issue of miniatures vs. digital models often comes down to cost. There are so many variables that it's impossible to try to come up with any widely applicable rules as to which approach is better. Assuming that the director and VFX Supervisor would be content with either approach, it will be up to the VFX Producer to get bids and prepare a budget that fairly compares one to the other. In today's digital environment, it is often less expensive to build CG models than to build and shoot miniatures.

However, that statement needs some qualification. There are times when miniatures are the only solution to a problem. This happens every so often late in postproduction when the director finds that the film needs a few more visual effects shots to clarify the story line. Because 3D CG typically is a lengthy process, it may be possible to build and shoot a miniature in a much shorter time. Ultimately, the specific circumstances will dictate the choice of physical versus digital models.

SUCCESS STORY

Amy Jupiter - (*T2-3D: Battle Across Time; Open Season 2*)

I was an intern at the Walt Disney Studios while I attended college in Southern California. I didn't go to film school but rather majored in liberal arts. That first summer at Disney, I spent a lot of time building vintage bicycles for *Dead Poets Society* in a warehouse on the lot…When I grew tired of the bikes, I would go and hide in both the camera and matte departments. I learned from some of the greatest camera mechanics, visual effects camera people and matte painters how this amazing process worked and how the cameras went together, came apart and how to handle and maintain all this delicate equipment. I have carried these lessons and this experience with me for many years before I was able to put them to good use. When I finally had the opportunity, years later, to take a job in an upstart VFX House called Digital Domain, I found that I felt as if I had finally come home.

Being passionate about the work and being a skilled story-teller are some of the keys to success in the VFX Industry. Other, equally important traits include: having a thorough understanding of the techniques which we use to achieve the work; having a thorough understanding of budgeting and scheduling to achieve the work; being a good listener, a good interpreter and a good generalist.

Part **2**

PREPRODUCTION AND PREP

WHO YOU GONNA CALL? THE VFX TEAM

*"Teamwork means a lot of people running
around doing what I tell them to."*
—Anonymous director

What is the purpose of the visual effects team, its reason for being? Fundamentally, the visual effects team exists for the sole purpose of supporting the director's vision of the film through the creative use of visual effects and getting his vision to the screen. Everything that we do derives from that, and in that respect the visual effects department is no different from any other department. If you were to draw up an organization chart of a film production, the visual effects department would be only one of many departments that answer to the producer. Even though it often happens that the visual effects department stands alone, having under its wing one or more smaller production units of its own (such as a plate unit or a miniature unit), it is ultimately responsible directly to the production.

The core of a typical visual effects team often consists of only three or four people. This small group grows and shrinks as a project passes through its various phases, from development to preproduction, production, and eventually postproduction. Under the best of circumstances, a producer will bring the core visual effects team on his or her show as early as possible. This will allow the visual effects team to interact with other departments, lending advice about how the effects can be accomplished, collaborating with other departments on alternative approaches to the effects challenges, and alerting the producer and director to the ramifications their decisions may have in postproduction. Often, the early involvement of the VFX Supervisor and VFX Producer can save the production substantial sums of money, for example by suggesting how a digital set extension

could eliminate the need for building a huge set, or by foreseeing how using a specific technique could prevent a costly calamity in postproduction.

Let's assume that you are a producer, production manager, or director about to embark on a film that will include a substantial number of visual effects. You're still in prep, or maybe your script is still being worked on. Still, you know that you're going to need to plan for the visual effects, and your instincts tell you that you should start assembling a visual effects team. In the words of the Ghostbusters, "who you gonna call?"

At the top of the list will be…

The Visual Effects Supervisor

In a sense, the VFX Supervisor is to the visual effects what the director is to the film: he or she is the *creative* head of the visual effects department. The VFX Supervisor is first and foremost a visual storyteller and the director's creative partner.[1] As the number of visual effects in features has increased dramatically in recent years, the VFX Supervisor has become all the more important because so much more is riding on the success of the effects. The supervisor's role involves him or her in countless creative and operational matters. Instead of actors, the supervisor uses other tools to tell the story visually: models, animation, and digital characters and environments.

By the way, we want to distinguish here between a supervisor who is hired by the production company to supervise the effects for the entire film and an in-house supervisor who is on the staff of a digital facility. They serve different masters, even though their mutual goal is to make the visual effects look as good as possible. Not to put too fine a point on it, facility supervisors' main role is to protect the company's interests and to keep their employers out of trouble. Their focus is on finishing the company's work on time and on budget. If they make a mistake (say, by not noticing that an actor's action carried him partly beyond the blue screen behind him), the company they work for will have to absorb the cost of fixing it.

On the creative side, the VFX Supervisor
- Brings creative and visual coherence to the visual effects.
- Is ultimately responsible to the director for the visual quality of the completed shots and the telling of the story through visual effects.
- Collaborates with the director in generating storyboards and previs (Please see Chapter 8 for definition and explanation of previs) for the effects.

[1] Usually, the VFX Supervisor is a man, but recently more and more women are achieving that position, generally after having learned their craft and made their creative contributions in digital production facilities.

- Helps design the shots and decides on the techniques to be used and how each shot is to be accomplished.
- Often acts as a 2nd Unit director when no principal actors are involved in the shoot (e.g., while filming stunts on blue or green screens, or when directing miniature photography). In those situations, his or her own team of production staff and technicians will support the VFX Supervisor. On some occasions the supervisor, acting as 2nd Unit director, may be entrusted with directing principal actors.
- Supervises the work of digital artists in postproduction to keep them on track and assure creative continuity.

On the operational side, the VFX Supervisor

- Organizes the visual effects unit with the help of the VFX Producer.
- During preproduction, advises the director on what visual effects shots are needed, works with storyboard artists, designs the effects, and oversees the making of previs and animatics.
- Once production starts, supervises shooting of all elements and plates; he or she should be on set whenever visual effects elements are being shot.
- Designs additional shots that may be needed.
- Supports the editor and his staff in making sure that the visual effects are properly integrated into the film in a timely manner.

The Visual Effects Producer

The VFX Producer is the business and administrative head of the visual effects department. As such the VFX Producer should look on the department as a business enterprise in which the principal goal is bringing the visual effects in on budget and on schedule. In that sense, the VFX Producer is analogous in the visual effects department to the producer or UPM (Unit Production Manager) of the movie. Where the VFX Supervisor is responsible to the director for the *creative* aspects of visual effects, the VFX Producer is responsible to the producer for the *visual effects budget and schedule*. The VFX Producer is essential to assembling the pieces that are required to get the visual effects to the screen.

In addition—and depending on the individual's experience—she may actively collaborate with and support the VFX Supervisor on the choice of visual effects techniques and help to make sure that the supervisor's (and hence the director's) vision can be accomplished within the schedule and budget allowed.

The relationship between VFX Producer and VFX Supervisor needs to be one of trust. On the one hand, the VFX Supervisor is

Getting acquainted

Get to know your VFX Supervisor even before you start on a project, ask others about him, find out what he's done and how he works. You'll be spending many months working with that person, sometimes under very difficult circumstances, so it's important to develop a good relationship. You need to be in sync with him, and he needs to understand your budget and schedule and be in agreement with them. The two of you need to have confidence in each other's ability and judgment.

in charge of the visual effects, and the role of the VFX Producer is to support the supervisor by making sure that she gets what he needs to fulfill both the supervisor's and the director's vision. On the other hand, the VFX Producer is ultimately responsible for the budget and schedule. As the producer, she may occasionally have to assert authority and say no to a request when it seems unnecessary or unreasonable. It is a delicate balance where first one, then the other person's influence is felt most strongly.

The VFX Producer needs to keep up with—and even stay ahead of—the VFX Supervisor. Things get very hectic during production on an effects-heavy feature. Along with the film's director, the supervisor will be juggling a multitude of tasks: supervising the day's plate photography, reviewing shots in the effects editing room, viewing dailies at night with the director, perhaps working with a previs team to design future shots, and planning the next day's (or next week's) shooting…the list goes on. The VFX Producer is indispensable to this process.

First In—Last Out

Sometimes a studio or production company may hire a VFX Producer even before a supervisor is brought on board. This happens most often when a script is just being considered for production and the production company is still trying to assess how much the visual effects are going to cost. The benefit to bringing in the VFX Producer early during a project is that this allows him or her to play a more effective role in helping the producer, director, and VFX Supervisor achieve their goals.

In another fairly common procedure among independent film production companies, or in instances where the film calls for relatively few visual effects, the producer may skip hiring a VFX Supervisor altogether and will rely instead on a savvy VFX Producer to wear both hats. In other words, the VFX Producer acts as a "surrogate" supervisor, advising the director on creative decisions and techniques. The VFX Producer may—with the producer's and director's consent—take on the responsibility of supervising the shooting of visual effects plates by making a deal with a digital facility to send its in-house VFX Supervisor to the set when needed. This way the digital facility has a degree of control over how the elements for the visual effects are shot, and it also gives the producer a bit of additional insurance against things going wrong in postproduction.

It also happens at times that the supervisor may act as his or her own producer. Again, this is mostly a money-saving method for the production company when the visual effects load is modest. Under this scenario, the VFX Supervisor usually counts on support from other members of the production team to help with

the organizational and administrative duties. He or she makes sure that all the elements needed to produce the visual effects are shot correctly by either the 1st or 2nd Units, and then collaborates with one or more digital facilities to complete the shots in postproduction.

It is also fairly common for the VFX Supervisor and producer to stay on the picture from preproduction through the end of postproduction (or at least until the visual effects are completed), long after other members of the crew have gone on to their next blockbuster. After all, it is these two individuals who form the core of the director's visual effects team, providing continuity of function and vision from start to finish.

What Does the VFX Producer Do?

The VFX Producer operates mainly in two domains, budgeting and scheduling. These two functions go hand in hand. They perform an interdependent dance that spins on throughout the course of the project. The VFX Producer's expertise in choreographing this dance helps the producer and production manager achieve their goal of bringing the movie in on time and on budget. In pursuing that goal, the VFX Producer is a manager of assets and of artists. It is not always a glamorous job, but when she does the job well, the VFX Producer gets the visual effects artists the tools, personnel, and facilities they need when they need them. When the producer accomplishes that, it shows organizational skills at their best.

As a producer you will constantly be making judgments about what is urgent versus what is important. You will be dealing with the gamut of personalities, many of them egocentric, demanding, and not agreeing with those around them. You will often be called on to decide what's possible to do and what is not from the budgetary or scheduling standpoint. You'll be conducting countless negotiations, ranging from the trivial to deal breakers. Throughout this process, those around you will look to you for steadfastness, wisdom, and good judgment. You are the person everyone in your department will look to for answers concerning the business aspects of the visual effects. There is tremendous satisfaction in that. The downside is that, if things go wrong, you might start to feel the wrath of a number of highly placed individuals who do not quite understand why a vendor could not make up for lost time when he did not get the plates from the editor in a timely fashion.

On the budgeting front, the VFX Producer

- Estimates the cost of the visual effects at the outset.
- Prepares a detailed budget based on the script, storyboards, previs (sometimes called animatics) and production schedule.

- Monitors the budget throughout the course of the production and postproduction.
- Amends the budget on a continuing basis to adjust to changes in the number and complexity of visual effects shots that invariably occur over the course of a project.

On the scheduling front, the VFX Producer

- Analyzes the script and storyboards to determine when and where visual effects elements need to be filmed.
- Collaborates with the 1st AD (Assistant Director) in generating the shooting schedule both for Principal Photography (when principal actors are involved) and 2nd Unit or visual effects shooting units.
- Works with digital facilities in establishing their deadlines for the delivery of visual effects shots.
- Keeps track of the progress of all visual effects.
- During preproduction, oversees all aspects of script breakdown, works with the VFX Supervisor on storyboards, analyses the needs of each shot, and budgets and schedules the visual effects work (which includes preparation of strip boards).
- During production, hires the support staff, negotiates prices and rates for crew, facilities, equipment and services, and works closely with the 1st Unit AD on scheduling the visual effects elements that are shot during principal photography, making sure that nothing gets left out accidentally.
- Schedules the elements that are filmed by separate effects units, such as miniatures, blue- or greenscreen shoots, motion control shots, aerial photography, and plate elements (e.g., fire, smoke, explosions, and water splashes).

The VFX Producer also oversees the postproduction of visual effects, including CGI, digital compositing, motion control shooting, blue- or greenscreen shoots, miniature photography, aerial photography (when part of a visual effects shot), visual effects elements and plates, creature effects, and other special elements.

VFX Producer's Abilities and Personal Qualities

It should be clear from the description of the tasks the VFX Producer has to juggle that this is not a job for the faint of heart. A good visual effects producer should have many talents and personal attributes to be effective. It's not that any one attribute is more important than any other. Rather, a good VFX Producer embodies them all in varying degrees.

If there is one generality that we can point to, it's that a VFX Producer has to have the qualities of a good leader. It is beyond the scope of this book to discuss how to be or become a good leader. There are many excellent sources for that kind of information and training. But here are a few points that are worth stating.

The VFX Producer has to be able to juggle many balls at the same time. The popular term for this is multitasking. The VFX Producer needs to be a proactive problem solver; she can't just sit back and wait for things to happen. The VFX Producer is a "the buck stops here" type, in part because she often has to be the one to say, "We can't do this, we don't have the money." Another way to put it is that VFX Producers must be people who are willing to accept responsibility and who will speak up when they see that certain limits are being exceeded.

The VFX Producer should bring a good sense of humor to the job, respect the abilities of coworkers, and be even-handed in how she treats the crew. The VFX Producer should have a knack for cultivating and maintaining personal relationships. Good diplomatic skills are a definite plus, because there will be times when she will have to apply pressure on colleagues to get the job done.

To be an effective VFX Producer takes the energy of an Olympic decathlete. The hours can be—and often are—brutally long. 12 to 14-hour days are the norm during production. During postproduction, it's 10 hours. When you're on location, you work six days straight, and even on the seventh day you may have to attend a production meeting, sit in with the editor and director on editing sessions because the director is busy shooting during the week, or take a few quiet hours to catch up on record keeping that there was no time for during a busy week of shooting.

While it is true that the VFX Producer is, first and foremost, the business manager of the visual effects department, she shouldn't just be a budget and scheduling fanatic. Ideally, the producer also brings his or her own artistic sensibilities to a project. Filmmaking is a collaborative art, and although the VFX Producer's primary job is to ride herd on the visual effects, an experienced producer with a good artistic sense can make a valuable—although supplemental—artistic contribution throughout the course of a project. There may well be times when questions come up and the VFX Supervisor is not immediately at hand to answer a question. Often, the VFX Producer can provide the answer or can offer an opinion as to the design or look of a shot regarding an element that others may not have seen or thought of.

For this reason it is very helpful for the VFX Producer also to have a solid basis in such technical aspects of film—and increasingly digital—production as film stocks, cameras and lenses, and special equipment. Having a command of these technical details will allow you to play a strong advisory role when it comes to discussing visual effects techniques with the VFX Supervisor, DP, and other key people on the production.

The key, however, is always to understand and respect the artists you are working with. It will inevitably happen that an artist will get bogged down in the details of his or her work and lose

sight of the ultimate goal, which is to complete the assigned work with the highest artistic standards, but within the time and budget allotted. It is the proverbial quandary of not being able to see the forest for the trees (that is, missing an overview of the whole process). Visual effects being an artistic undertaking, the VFX Producer has to find that delicate balance between encouraging the effects artists to do their very best and knowing when it is time to move on.

This even applies occasionally to the relationship between the VFX Supervisor and the VFX Producer. The supervisor will continually strive to make the shots better, and sometimes this may cause him or her to keep "noodling" shots endlessly. When that happens, it is the VFX Producer's job to bring some perspective to the work and encourage the supervisor to move on. It is a delicate task that must be handled with great sensitivity and judgment.

As the business head of the VFX Department, the producer is the "point person" not only for everyone in the department, but also for others whose responsibilities bring them in contact with the visual effects team. The 2nd AD may want to know what actor or stunt person will be needed for a greenscreen shoot tomorrow. The assistant cameraperson wants to know when he or she will need, say, the high-speed camera and for how long. The editor asks how soon he will get a certain series of shots, while the vendor is concerned about the hang-up of his most recent payment. The VFX Producer is everyone's go-to person, and as such, she must be able to communicate clearly. The producer must keep a myriad details in his or her head and be able to answer questions from seemingly inconsequential inquiries from a Set PA (Production Assistant) to probing financial questions from the studio's head of production.

Along with the ability to communicate clearly, the VFX Producer must also be decisive and clear thinking. There are no worse enemies of the VFX Producer than indecision and confusion: indecision on the part of the director on what he wants, confusion on the part of production staff or vendors as to what is expected of them.

It is surprising how often indecision on the part of a director causes havoc with your schedule or budget. This is by no means intended to belittle directors. Rather, it's an acknowledgment of the fact that directors come in all shades of experience and visual sensibility. Some top-notch directors are not only visually gifted artists, but are also technologically savvy. They know what they want, understand the technology of visual effects, and can articulate their wishes to their colleagues. Other directors may have a less well-developed visual sense. Their talents may lie in guiding actors to outstanding performances but they may be "technologically challenged." Such individuals may not be comfortable with visual effects and, in fact, may cringe at the idea of having

a visual effects crew hovering near them. To them, visual effects may be little more than a necessary evil they have to tolerate to get their story told. Guess which type of director will be easier to work with.

Oh, and by the way, the VFX Producer should be a superbly organized individual, have confidence in himself or herself, and have the ability to infuse others with that sense of confidence. Ideally she should be an island of calm amidst a turbulent sea and help create as peaceful an environment for his or her colleagues to work in as possible. If this means that the VFX Producer has to absorb some arrows in shielding his or her crew from unpleasantness…so be it.

VFX Producers and Guild Membership

As is well known, the film industry is heavily unionized. So-called "above-the-line" talent, which generally refers to the high-priced artists who are hired by flat contracts for the entire picture (mainly writers, directors, and actors) are represented by their own guilds. "Below-the-line" people, who comprise the rest of the crew that is hired by the day or week, are represented by various unions that—in the United States—fall under the umbrella protection of IATSE or NABET.[2]

Very few VFX Producers are members either of a guild or a union. There are numerous reasons why this is so, not the least of which is that the position of visual effects producer is a relatively new one and rigorous qualifications for the job have not been developed. A handful of VFX Producers are members of the Directors Guild of America (DGA), the guild that production managers and 1st and 2nd assistant directors belong to. But the few who are DGA members gained their guild membership through having worked as UPMs or ADs and advancing to the post of VFX Producer. There has been an ongoing effort to enroll VFX Producers in the Producers Guild of America (PGA). But securing guild representation for VFX Producers presents many obstacles that must be overcome. Perhaps this will change in time as the role of VFX Producers becomes more clearly defined and their importance to the production better appreciated.

The VFX Producer and Marketing

An increasingly valuable function the VFX Producer can perform is working with a studio or production company's marketing department. These are the people whose job it is to sell the film

[2]IATSE: International Association of Theatrical and Stage Employees. NABET: National Association of Broadcast Employees and Technicians.

to the movie-going public. The stakes can be huge, and a visual effects-driven film will need to show off some of its visual razzle-dazzle with teasers, promos, and trailers as soon as the marketing campaign gets underway months before the film's release. The VFX Producer can help marketing in promoting the movie by giving them some visual effects shots as early as possible.

Marketing representatives will ask what shots they can get, and they may even ask for certain specific shots to help them in their campaign. The VFX Producer is in a great position to prioritize shots with the help of the digital facilities working on the show. With his or her intimate knowledge of how the work is proceeding, the producer can arrange to have temporary—but high quality—composites made for the trailer long before the effects are finaled. By planning ahead for this, the VFX Producer can ease the job of the marketing department, avoiding panic at the last moment and having to incur overtime at a facility to get one or more shots out for a trailer.

Having stated this, we should also point out that the marketing staff may not always give the visual effects department sufficient advance notice of when they might want to start putting effects shots into the trailers. If the VFX Producer anticipates this possibility, she should ask the postproduction supervisor for the post schedule as soon as possible and discuss the matter with the VFX Supervisor. Perhaps, as a service to Marketing, a few effects shots can be put on a fast track to completion.

Visual Effects Production Coordinator

The VFX Coordinator is the producer's right arm in keeping the visual effects department running on an even keel.

- The coordinator should be a self-starter, meticulous, and a stickler for detail.
- He or she should have at least a rudimentary background in production and be familiar with the basics of feature film production. It helps for him or her to have been a production assistant, assistant editor, or similar entry-level employee.
- With so much emphasis on record keeping and detail work, the VFX Coordinator must be computer literate and have a command of two or three of the most useful computer programs, such as Microsoft Word, Excel, and FileMaker Pro.
- He or she updates the visual effects bible (which we will discuss in more detail later) and keeps track of changes to the shot list. This is an enormous task on films containing several hundred visual effects shots, where changes often happen on a daily basis. Shots may get dropped or added, or they may get modified substantially.

- At the direction and under the supervision of the VFX Producer, he or she communicates with other departments so that everyone is up-to-date on what's going on. He or she advises them of changes, sends memos, prepares updated storyboards, takes notes during viewing shots with the director and supervisor, and makes an unending series of telephone calls.
- He or she helps line up the effects crew, equipment, and facilities, and does a myriad of other tasks that the VFX Producer needs help with.

In sum, a good coordinator is worth every penny of his or her salary.

Visual Effects Data Coordinator

The VFX Data Coordinator, also called a VFX Plate Coordinator, may be thought of as the visual effects crew's script supervisor. Not every production needs a plate data coordinator. On light shooting days (meaning days when the effects team only needs to get a couple of simple elements shot) or on projects with only a small number of fairly simple effects, keeping track of the technical data concerning the elements can often be done by the VFX Producer or VFX Supervisor, one or both of whom will be on the set anyway. But on shows involving hundreds of complex effects shots, neither the VFX Producer nor the VFX Supervisor will have time to gather the mountain of technical data that digital facilities will need to complete the shots. At those times, a data coordinator is essential. This individual's sole job is to note down all relevant technical data for every element that is shot on any given day. Such data may include—but is by no means limited to—camera and lens information, positioning of set pieces, lighting conditions, special effects used in the shot, and any observations that the VFX Supervisor may want to make a note of concerning various takes.

The VFX Data Coordinator must be a very detail-oriented person. With data sheets in hand, he or she will be in the midst of the action the entire time that effects filming is underway. As you may well imagine, this individual needs also to have persistence (to make sure he or she gets all important details and doesn't overlook anything) and stamina (to last through the usual 12- to 14-hour work days of a movie shoot).

Visual Effects PA, Runner, and Similar Support Positions

All productions will have one or more PAs (short for Production Assistants) on their crew. These are the unsung, usually woefully

underpaid assistants who are assigned all the unglamorous but necessary tasks that can be delegated to a relatively inexperienced but trustworthy person: handling the phones, running errands, copying scripts and distributing them, logging artwork or videotapes in and out, and other tasks.

Whether the visual effects department rates having its own PA is usually a matter of the budget and size of the production. Frequently, the visual effects team has to draw on the production's PAs for help. Generally only the larger, higher-budget productions can afford to hire a PA for exclusive assignment to the effects team.

During postproduction, the visual effects department often shares a PA with the editorial department. The duties of the PA and runner are usually combined in one person. Lest you think that this is an unimportant position, keep in mind that a runner is frequently entrusted with delivering or picking up extremely valuable materials, such as dailies, original negatives, various digital data, etc. Imagine the consequences of losing such materials or getting them late to a screening.

Freelance Visual Effects Crew

Creating the filmed elements for visual effects often calls for special skills on the part of crew members. The main reason is that the effects crew often includes specialists who are not found on 1st Units, such as miniature DPs, motion control operators and technicians, pyrotechnicians, wire specialists, and other talents who are brought in from time to time.

Here are some of the specialists who may be needed on a visual effects project:

First Assistant Director (AD)

Full-fledged 1st Assistant Directors who are dedicated full-time to the visual effects unit are relatively rare. We encounter them mainly on high-budget productions that may have several visual effects units going at the same time, or when actors or stunt players are involved apart from principal photography. The 1st AD is the person who runs the set, which can become a fairly complex operation in a visual effects unit. Examples of such situations are bluescreen shoots, large-scale miniature shoots, and stunts such as wire work. When there is a VFX AD on board, he or she will often schedule and strip out all effects shots and help the 1st AD of the main unit incorporate plates (often live-action elements) and blue- or greenscreen photography into the shooting schedule. He or she should also schedule the shooting of effects elements and set up a separate schedule for the miniature photography, if any.

Visual Effects DP

Few who have seen the visual effects artistry of films like the *Lord of the Rings* trilogy would contest that the VFX Director of Photography plays a major role in the art of visual storytelling. It is the VFX DP's job to make all visual effects elements—be they background plates, miniatures, stunt doubles on a blue screen, aerial photography, or what-have-you—match the look of the 1st Unit DP's photography so that all the elements will ultimately look like they have been photographed together.

To do this job well requires an extraordinarily good creative eye, a thorough understanding of cinematic techniques, and more than a dollop of technical ingenuity. The nature of visual effects usually requires the VFX DP to photograph places, objects, and events under vastly different conditions from those of principal photography. For instance, he may need to film five or six plates at different locations, all for just one finished shot. Or he may have to light a miniature to match the style of a live-action plate that was filmed months ago, or film a stuntman in a wire harness leaping from a 30-foot-high platform, an explosion against a blackened ceiling, or a fake lava flow in a trough. The challenges are endless.

Blue or Green Screen DP

This employee is a specialist in seeing to it that blue and green screens are set up and shot properly, either for principal, 2nd Unit, or miniature photography. At first, you might think that it would hardly be worth it to hire a specialist for this phase of photography. "Let the 1st Unit DP do this," you might say. And often he will, particularly on smaller shows.

But there are many situations where it is to the production's advantage to hire a specialist to do the job. For one thing, the 1st Unit DP may not have time to take on the added task of setting up and lighting the blue- or greenscreen elements. It's one thing to shoot a couple of actors standing in front of a 20- by 30-foot blue screen. However, it is much more difficult to supervise weeks of shooting in front of a 30- by 120-foot blue screen.

More importantly, exposing blue or green screens properly so that the resulting negative will yield good, clean mattes is a tricky business. The tendency nowadays is for many producers to underestimate the importance of properly shot matte elements, with the result that untold tens of thousands of dollars have been spent in postproduction "fixing" badly exposed blue- or greenscreen elements. On the other hand, hiring a DP experienced in this specialty is cheap insurance for the producer, because he knows what type of lighting is needed, how to place the screen the right distance from the foreground to minimize blue or green

spill on the subject, whether shadows can be tolerated on the screen, and what the lighting ratio should be between screen and foreground. The payoff is in faster, better, and less expensive digital compositing in postproduction.

Motion Control Technician

Motion control, as most everyone in the film industry now knows, is the technique of repeating the same motion of a camera or other objects over and over in exactly the same way. The technique calls for the use of highly specialized, computer-driven motion control equipment.

Operating motion control equipment is a relatively rare skill. Motion control technicians must have an intimate understanding of the computer programs (the most popular of which is the Kuper Controls system) that run the equipment so that they can quickly preprogram a specific set of moves and tweak them to take account of the actual situation on the set. They must be able to work under pressure (think of having 50 people standing around waiting for you to type in a bunch of instructions on a keyboard), yet have great patience. Most of them have the ability to visualize in their mind's eye roughly how a camera move will play out just from looking at a set of curves displayed on a monitor. This skill comes only with experience, and the best among this small group of people quickly develop a reputation for their exceptional talent.

The motion control technician will also look after such mundane tasks as making sure the production's electrical department supplies the correct electrical power (preferably a dedicated circuit just for his or her system) and seeing to it that the dolly tracks are level and free of bumps. Depending on the situation, the motion control technician may require an assistant who will tend such tasks as picking up the equipment and setting it up, hooking up cables, and keeping records.

Miniature Pyrotechnicians

These are the wizards who blow up miniatures and make them look real. They have given us some of the most spectacular and memorable images in effects films. Who can forget the shot of the White House blowing up in *Independence Day* (1996) or the special effects work of the hospital being obliterated in *The Dark*

Knight (2008)? Whenever word goes out on a production that such-and-such a miniature is going to get blown up, the event always seems to attract a larger-than-normal group of spectators: We all like to see things go "Boom!"

But making an exploding miniature look real on screen is not just a matter of blowing it to smithereens with an overdose of C-4 explosive. Rather, it takes a surprisingly delicate touch and a thorough knowledge of different types of explosives. The pyro-technician must know how different exploding materials will look on film (for example, does the scene call for a large fireball, or a smokeless disintegration of a structure?) and the rates at which different explosives burn. He has to advise the DP, director, and VFX Supervisor on what frame rate to use to shoot the event, and must know how many milliseconds apart to trigger several explosions so that they don't all look like they're going off together... and so one explosion doesn't unintentionally extinguish another if it's triggered at the wrong time. These are only a few of the details that come into consideration.

Other Special VFX Crew

In addition to the specialists just mentioned, there are several other crafts that may be hired specifically to serve the visual effects department. These are not necessarily effects specialists. Rather, they become part of the effects crew for as long as their skills are needed, and for this reason the VFX Producer has to budget and schedule them. They may or may not have extensive experience on effects shoots. Among them are

- A grip crew to rig blue or green screens, to put tracking markers on screens or walls, or to set up platforms that are often needed to place actors on.
- An electrical crew to rig and set up the BS/GS lights.
- A wire (special effects) crew to install such items as descenders and other wire rigs needed to suspend and fly actors and stunt players on set.
- VFX Data Coordinators to take measurements on the set to document distances among and placement of cameras, set pieces, and props, measurements that will later be used by digital artists to integrate computer-generated objects and characters in the scene.

SUCCESS STORY

Janet Muswell Hamilton - (*Dragonball; Snakes on a Plane*)

Before I became a VFX Producer I was working as a VFX Supervisor, mainly for TV. There was no life before VFX!

I studied classical music in London, UK. I have been a full-time feature VFX Producer for only four years; before that I was a VFX Producer/Supervisor on features, TV and commercials. The more producing I did, the more I liked it, and so the more I pursued it…I love to be able to build and lead a team that can work together to get the job done smoothly, efficiently, and with a sense of fun.

The producer is not only the support for the VFX Supervisor, he or she is their right hand, their buffer, their partner, and their constant collaborator…It's a high-pressure job; you need dedication, fearlessness, and most of all, a working knowledge of all aspects of visual effects. With that I mean an understanding of how shots go together, how to shoot plates and elements, what equipment is best for the shooting and which facilities will serve the project artistically, budgetarily and with enthusiasm…

Without a database you are at a complete loss (or completely crazy!). I find the database to be a constantly evolving project in its own right and enjoy every aspect of its creation and upkeep. It is also necessary to have a coordinator who is proficient in the database program you are using and understands the importance of its upkeep. In my office, the database is "sacred"!

4

BASIC VFX TECHNOLOGIES AND EQUIPMENT

On one point everyone in our business agrees: The astonishing images that continue to dazzle viewers in film after film, year after year, would not be possible without equally astonishing advances in the technology that empowers the art. Over time, artists and engineers invented or adapted tools that are unique to visual effects, and we now explore some of these tools. Whether your aim is to work as a VFX Producer or in some other capacity in visual effects, we urge you to familiarize yourself with these tools. Sooner or later you will be using them.

Blue and Green Screens

Blue- and greenscreen photography (collectively called traveling matte photography) is now commonplace. It seems there are hardly any productions these days that don't call for at least one blue- or greenscreen composite. Effects-heavy productions use blue or green screens routinely, in sizes from just a few feet across to monstrous expanses of digital cloth measuring 240 feet wide by 40 feet high to cover entire stages.

Both blue and green screen cloths come in several shades and the choice depends on how they are going to be used. The best ones are known as Digital Blue, Digital Green, and (for television) Digital Video Blue.[1] The aforementioned materials are specially made for visual effects filming. The leading company that supplies these screens worldwide is Composite Components Company of Los Angeles. Other types of cloth can be (and have been) used successfully, though they take greater care to light properly and are not usually worth the extra trouble. In the long

[1] There is also a Digital Red material, but red screens are relatively rare and are used mostly for model work.

When in a *real* pinch

If you are shooting where you just can't get specially formulated digital blue or green paints (like on a foreign location), or your budget is so tight that you really, *really* can't afford them, you may be able to use a commercial paint that closely approximates the color of digital paints. Most likely you would also have to use blue or green filters over your lights to help boost the color of the paint. You will have to shoot tests first to see if a digital facility is able to produce workable mattes. The technique is known to work in a pinch, but don't use it as a reason for saving a few dollars.

run you are much better off budgeting for the correct material to begin with.

Augmenting the standard cloth screens are several other types of materials:

- Specially formulated blue or green paint, to paint floors or walls. It's sometimes easier to paint an expanse of wall and floor than to rent the cloth screens for weeks at a time. These paints are expensive, so be sure to budget carefully
- Mirrorplex, a tough, silvery, highly reflective plastic material that acts like a mirror. It can be placed on floors or hung as a ceiling piece to reflect the normal blue or green screen. Mirrorplex is useful when actors are shown full length walking on the floor because it reflects the purity of the color of the background, whereas a painted floor is never as pure in color because the normal stage lighting contaminates the blue or green, thus making it more difficult to pull clean mattes. Mirrorplex comes in several thicknesses, all of them costly
- Similar to Mirrorplex are materials called Roscoflex M (#3801) and LEE Mirror Silver (#271). They come in 4-foot by 25-foot rolls and can be adhered to a smooth surface with a clear adhesive
- Blue or green leotards, gloves, and hoods to cover puppeteers or other people who must be in frame but eventually have to be matted out of the shot. It is a lot less expensive to eliminate a green-suited puppeteer from a scene than to rotoscope out a normally clothed person.

Lighting for Blue- or Greenscreen Photography

Blue or green screens must be lit properly so that clean mattes can be pulled successfully. You need two things for that: an experienced DP who understands the complexities of traveling matte photography, and the proper lights.

It is best to use fluorescent light fixtures specially designed for visual effects photography. These fluorescent tubes emit narrow bands (or spikes) of blue or green light to maximize the saturation of the blue or green color of the screen. The objective in both cases is to minimize the amount of red light falling on the screen, as red contaminates the screen and makes it more difficult to pull a matte. Your eye may not see the red, but the film and the compositing software will.

When you must use other light sources or have to resort to less-than-ideal materials for your blue or green screens, your choices narrow dramatically. The best alternative with blue screens is to use HMI lights, as they are fairly rich in blue light. Even then, they should be augmented with blue gel filters in front of the lights to boost the amount of blue, though the filters cause a substantial loss of light.

If things get really desperate, you can use incandescent lights such as sky pans, have the DP do his or her best to light the screen as evenly as possible, and hope that your visual effects facility's compositing software (with a lot of expensive help from a digital artist) will be able to work its magic and pull a decent matte. In any case, incandescent lights must absolutely be augmented with either deep blue or deep green filtration. Avoid this situation if at all possible!

One thing we are no longer overly concerned about is blue- and greenscreen photography outdoors. Sunlight consists of all colors, but it is sufficiently rich in blue and green that, given color film's built-in sensitivity to blue and green, clean mattes can be pulled relatively easily. And the nice thing about sunlight is that it is free. Sometimes even Mother Nature can come to our aid. In some regions of the world, the grass is so lush and green that it can serve as a perfectly acceptable—or at least workable—green screen.

Motion Control

If ever there were two words to strike terror into the hearts of producers, directors, and assistant directors, they are…*motion control*. Few production tools are more despised by 1st Unit people, yet few have made a greater contribution to the success of contemporary visual effects than motion control.

The reason for this attitude is simple: Motion control (moco for short) causes a disruption of the normal filming routine. Even under the best of circumstances, having a motion control system on stage slows things down, and to a certain extent the normal flow of filming becomes a captive of the demands of the motion control system. As a result, the visual effects team may encounter resistance to the use of motion control on live-action sets.

Motion control systems basically consist of a camera, a motorized head, a dolly or crane and a track to run on, and a computer to drive them. What sets a true motion control system apart from normal camera systems is that any part of the system (including the camera's shutter and focus ring) that can move is driven by a stepper motor which, in turn, is controlled by a computer program specially written for this purpose.

The classic motion control shoots of the past occurred on dark stages during the photography of miniatures and models where several passes of the camera had to match one another precisely. These situations are almost nonexistent today thanks to computer graphics, which have replaced physical models in many situations

Today, motion control is used mostly to shoot *real-time* events on live-action sets. Motion control systems have become lighter

and can be set up much more quickly, and experienced motion control operators using contemporary software are able to program moves quite efficiently.

Motion control systems come in different levels of complexity. At one end of the scale is a simple encoded head for the camera, which is very similar to a normal geared or fluid head except that it is equipped with special sensors, called encoders, which convert the physical pan and tilt motions of the camera head into electronic pulses. These pulses are recorded by a computer.

Systems like this take little time to set up and cause minimal disruption. We use this type of head when we need to repeat a camera move to shoot moving plates of the empty set for such purposes as digital wire and rig removals in postproduction or to make an actor fade out in the scene. The camera operator follows the live action using the same geared wheels to operate the camera that he or she is accustomed to as each take is being recorded. Once the director has a take that he or she is happy with, the move that's just been recorded can be automatically repeated to film another take with the identical camera move across the background. More importantly, the data from some of these encoding systems can be used by a digital facility to create *virtual* camera moves in the computer that match the original live-action take. An encoded head can be easily mounted on a Techno Crane to record the camera movement, and needs to be budgeted in your visual effects budget.

You need to be aware, however, that this type of motorized playback head is not *true* motion control; it is "motion control lite." The two camera moves will be very close to each other but will not line up *perfectly*. Nevertheless they will serve the purposes we just mentioned.[2]

More sophisticated systems are capable of encoding dolly moves in addition to pans and tilts of the camera head (see discussion of EncodaCam system, below). This is still a step short of full-blown motion control dollies in that the encoding system merely senses, records, and plays back the physical actions of a dolly as the grips were manipulating it during a take. It is not, in other words, preprogrammed to perform a specific set of movements and is generally not as precise.

At the other end of this spectrum are the true moco systems that involve dollies or cranes whose moves have to be *preprogrammed* for one reason or another and can be repeated perfectly. Depending on the situation, programming could take two to three hours and most likely will require some support from the 1st Unit to physically set up the machinery. When this is the case, it is best to arrange with the 1st AD for the motion control crew to

[2]The reasons for the discrepancy are rather technical and don't need to concern us here.

be able to work apart from the 1st Unit until the programming is done and has been tested to the extent the situation allows.

When you need to bring a motion control system on the set, you must be very scrupulous about preparing for the shoot. Well before the shoot, get all the details from the director and VFX Supervisor and let the motion control company know what the requirements are so that they can prepare and check out the equipment. Give them as much information as possible about the shots, the location, the type of support you can provide…all the things that you would normally bring to any other type of shoot.

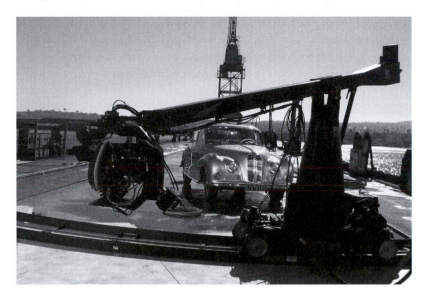

Figure 4.1 This is a real-time Motion Control System on location with curved track, motion control head, crane and camera. All components of this system are stepper motor-driven.
(Image courtesy of Joe Lewis, General Lift)

A variation on this theme has been made possible by the increasing sophistication of previsualization (previs). More and more directors and VFX Supervisors are using previs to design complex visual effects shots before going into production. Data from a virtual camera move from an approved previs can be transferred to a motion control system on stage and used to drive the camera dolly or crane so that it performs the virtual camera move in the real world that the director approved in the previs.[3] This approach has many advantages, not the least of which is that it cuts down on the setup time on set.

On the budget level, full-blown motion control systems with dollies, cranes, and tracks (usually also requiring a specially modified camera with a complete set of lenses and accessories) are costly items. The VFX Producer should analyze the breakdown to decide how many days' rental to provide for. On the other hand, a simple pan–tilt encoder package may not be a heavy budgetary burden, and the producer may be able to make a deal with a rental house

[3] For more on this topic, see Chapter 8.

to keep such a package throughout the show at a favorable rate. It is likely to come in handy.

Motion control systems are relatively rare and can be rented from only a small number of companies in the United States and abroad in the UK, Australia, New Zealand, Eastern Europe, and other parts of the world. Moco systems vary in size from relatively small to enormous, and rental costs vary accordingly. Be sure you understand the needs of your shoot clearly and start your inquiries early.

One point to consider when you have to rent a motion control system is sound. Moco systems, especially if a dolly or crane is involved, are noisy because of the constant hum and buzz of electric motors and gears that must remain turned on all the time. So you need to find out whether the motion control scenes involve sync sound. If they do, you need to rent a silent system, or, if one is not available for your shoot, you must make the producer aware that he or she may need to schedule an ADR (Automated Dialogue Replacement) session at additional cost.

When to Use Motion Control

Some of the situations where motion control plays a pivotal role:

- In twin shots, when an actor has to appear twice (or more) in the same scene and the camera is moving.
- For choreography of camera motion of an otherwise difficult shot, such as in a car commercial where exact camera placement and timing are critical.
- Hazardous scenes with dangerous elements or location. Examples include a shot of an actor having to interact with a dangerous animal, or actors being engulfed by an explosion.
- Match shots of live action with miniatures and models; scaled shots. Not as common as they once were because miniatures are less commonly used. Also useful when a shot calls for scaling either very small people or giants to normal-sized humans while the camera is moving.
- Removal of wires, special rigs, or an actor. Used primarily to shoot clean plates when extensive wire and rig removals are called for.
- Table Top Photography. Mostly used for commercials where a product and the camera must move in precise relation to each other and the moves must be repeated in successive passes.
- Crowd Enhancement. Less common than in times past because of the great strides made in creating CG people, it can be used to multiply a relatively small group of real people into a huge crowd.

- Multiple Animals. To achieve the appearance that multiple animals of different species "acted" together in the same shot (think *Babe: Pig in the City* [1998]).
- Stop Motion Animation. This oldest of all visual effects techniques is still one of the most active areas that uses motion control to make puppets in sets take on a life of their own, and to automate the motions of the camera.
- When large portions of a background have to be replaced. An extreme example occurred on the film *Hollow Man* (2000), in which every scene with the invisible man had to have a background pass to allow the compositors to fill in the background.

EncodaCam

The EncodaCam Visualization System is a production tool that makes it possible to record actors in real time on a blue or green screen set and combine their live performance with a pre-existing background. The background can be a set extension, a 3D CG character, or 3D CG animation. The system employs the same standard production cranes, dollies, and camera heads that crews are used to working with. While it is not a motion control system, EncodaCam does employ encoders on the head, crane, or dolly that send a signal into a compositing system which, in turn, displays the virtual (i.e., CG) background in real time in sync with the live action camera move. The image from the camera's video tap is composited with the virtual background during filming, and the combined signal is sent to the "video village," where everyone can see it and where it can be recorded.

This previsualization system has several benefits. It helps the director, VFX Supervisor, and actors judge how well the action and a digitally created background are working together. The camera operator can see how his or her camera moves work in relation to the background. The editor can immediately incorporate a take that the director likes into the cut of the film as a placeholder till the final shot is completed. Finally, the recorded camera data can be given to the visual effects facility so that its digital artists will know exactly what the camera move was.

VistaVision Cameras

VistaVision is a 35 mm film format developed by Paramount Pictures in the early 1950s to compete with Cinemascope and other wide-screen processes then gaining popularity. VistaVision produces an image that is approximately double the size of a normal 35 mm negative and looks very much like that of a 35 mm still camera.

VistaVision never really caught on as a theatrical film format, but many visual effects facilities recognized the value of the large VistaVision frame for doing their optical work[4] and used VistaVision for filming their visual effects plates for many years.

Today, only a few VFX Supervisors and effects facilities still use VistaVision cameras when they think they will need a larger frame to work with than what a full-aperture 35 mm frame provides. The larger frame allows a certain amount of panning, tilting, or zooming on the original plate, and some digital facilities use VistaVision in the creation of matte paintings, particularly when the shot calls for a long tilt-down or a sweeping pan.

High-Speed Photography

High-speed photography is quite common in the visual effects business, mainly when we want to film certain natural phenomena in connection with miniatures. It is relatively easy to make a *static* miniature look like the real thing (e.g., a miniature of a castle perched on a craggy hill), but it becomes a major challenge to make *moving* miniatures look convincing. This is because natural events filmed on a miniature scale simply happen too fast to look natural. When filmed at the normal 24 frames per second, they are over in the blink of an eye. They lack the appearance of size and mass that we associate instinctively with natural events. Prime examples of this are water, fire, explosions, the collapse of structures, and the speed of vehicles, among many others.

We can overcome many of these limitations with slow-motion or high-speed photography. This encompasses anything from a slight overcranking of the production camera (say, at 36 frames per second) to filming with specially built cameras capable of frame rates up to 360 frames per second. On rare occasions cameras capable of even higher frame rates are called into service. Which type of high-speed camera to rent will naturally depend on the subject that's to be filmed.

Ultra-high-speed film cameras (cameras capable of running as high as 1,000 fps) unfortunately do not deliver a steady image, which greatly limits their usefulness for visual effects work where we rely on reasonably steady images as a starting point. On the other hand, there now are high-definition video cameras that are capable of shooting at 1,000 fps and higher and deliver perfectly steady images. Given the right circumstances it may be worth looking into shooting an event with an HD video camera and using the resulting plate in your visual effects work.

[4]Opticals involve duplicating the original film, which inevitably caused a loss of quality through a build-up of grain and contrast. But when they are made from an oversized original, opticals using VistaVision originals look very good when they are cut in with the 35 mm production footage.

Digital Video Assist with Compositing Capability

What would a contemporary movie set be without its "video village," that magnet that attracts not only the director, but also any number of other onlookers? It is the place that has a direct line—visual and auditory—to the camera and microphone that is recording the action on the set.

Video assist, as it's commonly known, is now taken for granted. Not so long ago video assist packages were basically limited to a VCR recorder and a monitor. Today, with a piece of equipment not much bigger than a portable computer, a digital video assist technician can record every take on disk and, once recorded, play them back at random: instant dailies, in effect. He can also call up and play any take from the entire production at random, make simple edits, and perform a number of other functions that a few years ago were mere dreams.

While digital video assist has become a convenience for directors during the normal course of filming, it is almost a necessity when complex visual effects shots are being planned. Why? The right type of digital video assist system can help the director and VFX Supervisor plan and preview how the elements of many visual effects shots will actually fit together while on the set. This takes much of the guesswork out of staging and framing the effects shots.

This could be as simple as laying out the position of a split screen when an actor is playing multiple roles opposite himself or deciding how to frame a live action greenscreen plate that will be composited with a matte painting. More common in contemporary filmmaking is when a director, production designer, and VFX Supervisor previs a sequence in a computer prior to production in which they map out the layout of the stage; select the correct sizes and shapes of set pieces, cranes, dollies and other equipment; and plot camera angles on their virtual set. Everything in the computer is built to actual scale. The previs with the animation of the planned action is recorded and then brought to the set. There, not only can prerecorded camera moves be viewed on a monitor, but the camera data can also be fed to the live-action camera so that it will faithfully duplicate the moves of the virtual camera.

Another extremely useful application of video assist on set is that 3D CG elements that were created prior to filming can be displayed on the video technician's workstation. Having the 3D CG data available on set and combining it with the video feed from the production camera then enables the director and VFX Supervisor to make sure that all elements will line up as planned. This removes much of the uncertainty of staging the action for complex visual effects shots: Everyone involved—director, DP, VFX

Supervisor, actors—can see exactly what they are creating on the set. The result: better shots, less chance of mistakes, and lower costs (at least in theory).

The versatility of digital video assist systems has grown considerably as some companies specializing in playback technologies have built *scalable* systems, meaning that they can record inputs from more than one camera, each camera requiring its own record deck. It is now fairly common to have three or more cameras shooting difficult visual effects set-ups simultaneously. The newer video assist systems are basically modular, and you can rent as many record decks, software packages, accompanying monitors, and accessories as you need, subject to their availability…and your production's pocketbook.

Figure 4.2 This scalable digital video assist system from Ocean Video can handle input from two cameras. The monitor screen on top shows a real-time greenscreen composite. The boxes at bottom are Raptor disc recorders (one for each camera). The monitor at right displays a list of all shots currently on the disc.
(Image courtesy of Jeb Johenning, Ocean Video)

For critical visual effects-heavy sequences it may also be advisable to budget for and have on set a simple editing system with software such as Media Composer 100 or Final Cut Pro with which a video technician can perform simple edits and temporary composites of the visual effects shots for the director and VFX Supervisor. With a few keystrokes the video assist operator can call up and play any take from any camera at random. The technician can also burn a DVD disk of the footage shot that day and of any temporary composites he made and hand the disk to the editorial department, which can then ingest the material into its Avid system for the editor to start working with.

Motion Capture

Motion capture—often referred to simply as mocap—is a rapidly evolving technology that has become almost indispensable to visual effects. It is a tool that allows us to record—to capture—the movements of a performer's body, limbs, and facial expressions not on film or tape, but digitally in the form of data points that get recorded by a computer. The movements are captured by a number of special cameras that detect the movements of special markers attached to the performer. The change in position of the markers is recorded by powerful computers.

The data points (of which there may be millions from a single performance) are then used to animate a computer-generated character that mimics the movements of the live performer quite closely. The technique has become a virtually indispensable tool in the creation of photorealistic digital characters in feature film, broadcast, and video game production, especially as a substitute for human actors when it would be impossible or too dangerous to perform the action for real (such as Harry Potter and friends whizzing through the air in the Quidditch matches in the *Harry Potter* movies), or to create imaginary characters that have to be animated in a more or less realistic fashion.

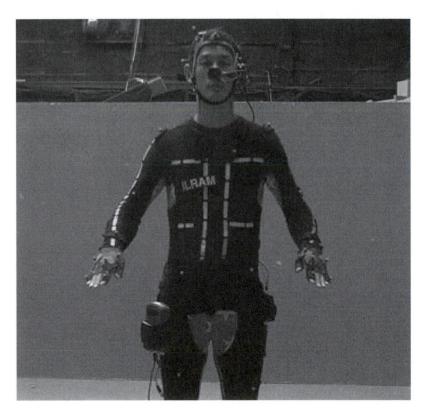

Figure 4.3 Solo Motion Capture Performer in a motion capture suit with special reflective markers.
(Image courtesy of Giant Studios, Inc.)

Figure 4.4 These images summarize the motion capture process. In the top image, two performers are captured in action on a motion capture stage. The bottom image shows 3D CG models based on data captured from their performance. (Images courtesy of Giant Studios, Inc.)

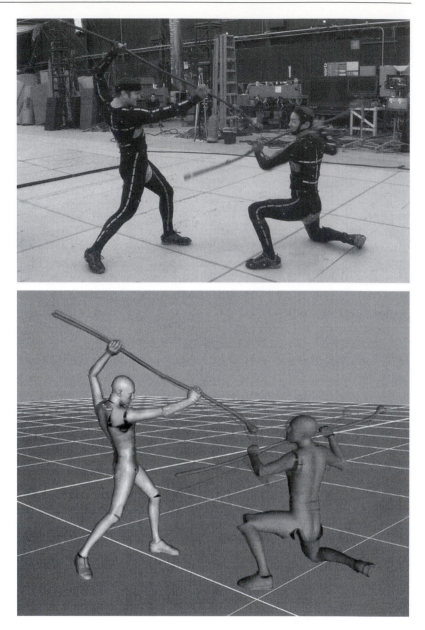

An animator can use the captured performance as a ready-made template for animating three-dimensional CG characters. In essence the *animation* of the character emerges from the motion capture data, at least in its broad outlines. Imagine how many days or even weeks of an animator's time can be saved using motion capture, particularly when many 3D CG characters (think "digital extras") have to populate a scene.

Motion capture is not the answer to all CG animation challenges. It has its limitations, one of which is that the captured data has to be extensively processed and the animation still has to be refined when the CG character actually takes shape and now has to act in a scene. As in the case of other visual effects techniques, the VFX Supervisor and director have to evaluate whether motion capture suits their project's, or even a particular character's, needs. Quite often, key-frame animation may still turn out to be the technique of choice.

SpaceCam, Wescam, Flying-Cam

All three of these systems are variations on the theme of helicopter-based aerial photography. Two of these systems (SpaceCam and Wescam) operate from full-sized aircraft and can be adapted to ground-operated camera positions. Flying-Cam is a small, light-weight (30 lbs/15 kg), remote-controlled helicopter able to operate indoors and close to actors. A principal feature of SpaceCam and Wescam is that these systems stabilize cameras that are mounted on basically *un*stable platforms—helicopters, cranes, trucks, etc. Under normal shooting conditions, it would be quite difficult to composite visual effects plates filmed from such moving vehicles with digital backgrounds. Both SpaceCam and Wescam, however, can record various camera data (primarily roll, pitch, and yaw positions of the camera and focal length of the lens) during shooting to make it easier to composite digital elements with live-action plate photography. All three systems accommodate a variety of film and HD cameras.

Figure 4.5 This helicopter is equipped for aerial photography with Wescam camera attached. The camera is controlled from inside the aircraft.

Cyberscanning and Structured Light Scanning

Suppose your visual effects call for creating a photorealistic double of one of your actors for a dangerous action sequence. You want to clearly see that it's the actor on the screen, not a photo double. How will you go about achieving this?

One way to create your digital "superactor" would be to ask a really talented artist to digitally sculpt the actor's likeness in the computer, wrinkle by wrinkle, hair by hair. In time—and at great expense—the artist might succeed in creating a reasonable facsimile of the actor, but whether today's sophisticated audiences would find this digital double believable is questionable.

A far better way would be to *cyberscan* the actor. 3D cyberscanning is a process by which an extremely thin, low-energy laser beam is used to scan an actor's face or body. Full-body scans are generally accomplished by having the actor remain stationary as a laser scans progressively down the subject's body on all four sides. For head and shoulder scans the actor sits in a chair and either the actor is rotated on a turntable as the laser remains stationary, or the laser rotates around the actor. Both full-body and head-and-shoulder systems work on basically the same principle: An extremely thin beam of laser light bounces off the subject, and a sensor records the *precise* distance of any given point on the subject's face or body from the sensor. Because each point (and here we are talking about points the width of a few wavelengths of light) on the actor's face or body is just slightly closer or farther from the originating beam, the cyberscan machine basically draws a three-dimensional digital map consisting of thousands or millions of individual points of the subject.

After the data are processed to clean up various artifacts, you will be handed a digital file that an artist can use to create an astonishing likeness of your actor. This likeness will be more accurate than even the most accomplished artist can conjure up by hand. It will be three-dimensional, eerily realistic, and ready for an animator to throw into any situation the script calls for.

A point to consider here is how dense the digital scan should be. This is important because an excessively dense scan may contain much more information than the digital model requires and would translate into higher processing costs for your budget.

Another approach to creating a photorealistic digital double is through a technique called structured light scanning. It uses a series of high-resolution 2D images to create a 3D model. Each of these has different light shapes or grids projected on the talent. The actor is rotated into different positions while high-resolution digital still photographs are taken to obtain an extremely detailed record of the subject's face and body. The digital images are then

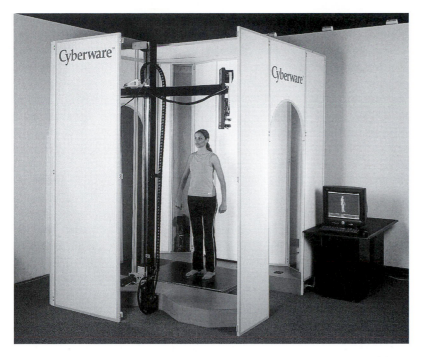

Figure 4.6 A model stands in position in a full body scanner, ready to be scanned. In this system, the laser beam scans horizontally across the subject as the laser is lowered from top to bottom.
(Image courtesy of Cyberware, Inc.)

"stitched" together and a 3D model of the actor's head is constructed in the computer. Figure 4.7 illustrates different stages in this process.

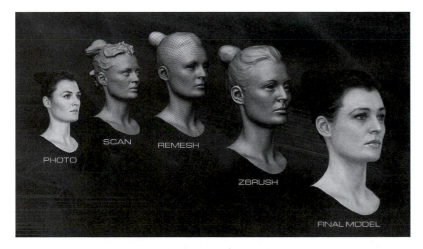

Figure 4.7 The result of a head scan using a structured light scanning technique.
(Image courtesy of Nick Tesi, Eyetronics, Inc.)

It has become quite common to cyberscan actors because of the relative ease with which the scans enable digital artists to create photorealistic digital doubles. In fact, we recommend doing a cyberscan of the principal actors as a back-up in case you need to generate unexpected visual effects shots with the actor in post-production long after the actor has gone on to another project and may no longer be available or would cost the production a substantial fee for an additional day's work.

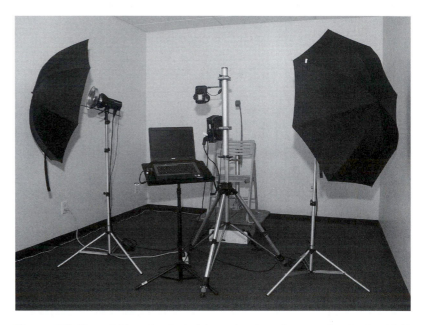

Figure 4.8 The portable system for facial scanning shown here uses the structured light scanning technique. This system can be converted to do a full-body scan in a short time. (Image courtesy of Nick Tesi, Eyetronics, Inc.)

Scanning systems can be brought to and set up on location in a short time and at reasonable cost. As in the case of other budget items, the VFX Producer should ask several companies to submit estimates. But be sure you know what type of scan your digital artists will need, whether it's full length or head only, and how highly detailed the scan needs to be.

In practice, actors are often scanned or digitized while in their wardrobe so that digital artists are spared the task of creating an actor's wardrobe in the computer. Actors may also be scanned wearing special visual effects makeup if their roles call for it, or they may be scanned while making certain facial expressions that can later be morphed together to produce a range of expressions on the digital double.

Scanning should not be done until after the wardrobe, hairstyle, and special makeup (if any) have been approved by the director. It's a total waste of time and money to scan an actor before the director has signed off on these items. Since you're hiring the scanning equipment and crew by the day it doesn't cost any more to do 10 poses than to do 1. However, you *will* incur additional charges for cleaning up the extra data and modeling the 3D actors, so you need to exercise good judgment in how many finished models you ask the scanning facility to provide.

Because actors are usually pretty tightly scheduled it will probably be more efficient to have the scanning vendor bring his system to where the production is filming. This will allow you take the actor aside during a break in the day's filming and capture the scan at a convenient time. Depending on the system being used, scans may take only a few minutes and the actor can be released again.

Not only actors, but also extras, props, cars, maquettes of alien creatures, and almost any other type of object can be cyberscanned. Extras, in particular, are good candidates for scanning because it is a widespread practice to create digital extras for crowd scenes. No more hiring 10,000 extras for a day! Instead, 10 or 15 extras can be scanned in several changes of wardrobe, thereby building up a library of digital extras that can be multiplied and animated for a crowd scene. One thing to be aware of is that, depending on the scanning system to be used, props may have to be painted white in order to be cyberscanned. This adds to the cost, and you need to take this into consideration when you construct your budget. As always: ask lots of questions, and make the final question to the vendor, "what are we leaving out that I *should* be including to make my budget complete?"

In general, scanning facilities are more common in and around Hollywood and are almost nonexistent in most other cities and foreign countries. In that case, you have no choice but to bring the cyberscan company's crew and equipment to your filming location. Some visual effects facilities also have their own scanning capabilities.

Although they are by no means common, cyberscan and image-based modeling systems are now available in many parts of the world. This is something to be taken into consideration when you prepare your budget. If the scans have to be done on distant location you would have to budget their travel, hotel, and *per diem* in your visual effects budget.

Set Surveys

We do set surveys when we need to provide a digital facility with detailed information about the topography, layout, and

dimensions of a live-action set. The ultimate purpose of a set survey is to give a computer a three-dimensional digital description of the environment so that a digital facility can build a precise 3D CG replica of the set. We frequently need this type of information when a 3D CG character needs to look like it is moving through and interacting with the live-action set and when we need to build a complete 3D CG environment to match the live action set.

Set surveys can be as simple as taking a tape measure and paper pad, making a diagram of the set, and accurately measuring (down to the inch) all the important dimensions. Measurements should include furniture or other potential obstacles on the set that a digital character will either have to avoid or physically interact with. You can delegate the job to just about anyone on your team. Along with the measurements, your colleague should also take a number of pictures.

A somewhat more elaborate way of doing a set survey is through laser-based, hand-held distance finders. They offer an easy and very precise way to make measurements when distances are larger than a standard steel tape measure reaches, or when a high vertical dimension, say to the top of a building, has to be measured. Such digital point finders may be purchased for as little as $300, and may be worth the price if you have a lot of set measuring to do.

It should be obvious that you can only do a set survey when the company is not actually shooting. Frequently, the effects team ends up doing its survey after the company has wrapped for the day (getting to stay late is one of the dubious honors of working in this field). From the time that the 1st Unit moves on until after the visual effects team has done its survey, the set should be closed and labeled a "hot set." Nothing should be moved on the set that is likely to interact in any way with a CG character.

Lighting References and HDRI (High Dynamic Range Imaging)

To build a 3D CG environment or to place a digital character within it so it is believable, a digital artist also needs to know how to light the scene in the computer so that it matches the lighting of the live-action set. The artist gets that information from the VFX Supervisor, who has several techniques to use for this purpose.

The systems currently being used have the ability to record—with great accuracy and realism—the exact lighting conditions that exist on a set or location. One such system (pictured in Figure 4.9) uses two high-resolution digital cameras mounted next to each other, equipped with fisheye lenses pointing in opposite directions

to capture both front and back 180° fields of view simultaneously. The purpose is to capture 360° of imagery of the set. If only one camera is used, the camera must be rotated, either to capture two sets of images 180° apart, or to capture images from three positions 120° apart, which provides more overlap and makes it easier to stitch the images together digitally to complete the 360° view.

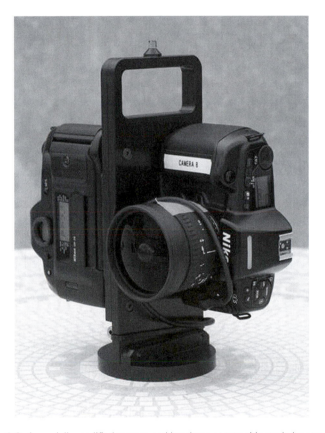

Figure 4.9 A specially modified camera and head use a very wide-angle lens to record the lighting and environment on the set.
(Image courtesy of Derek Spears, Rhythm & Hues Studios)

A series of images of the set is taken through a full range of *f*-stops so that every detail of the set and its lighting, from the very brightest to the very darkest, is recorded. These images need to be taken from the best spot on the set from which the lighting can be properly documented. Often the procedure is repeated from two or three different positions on the set.

Another type of system relies on a high-resolution digital camera that has been fitted with a special lens and a mirrored

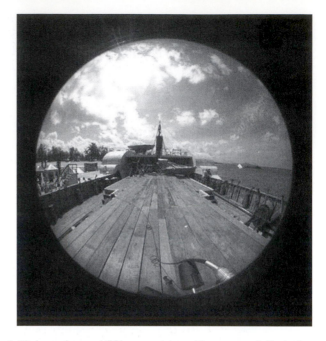

Figure 4.10 Image from an HDRI camera taken with a camera similar to the one shown in Figure 4.9. The round image is what the HDRI camera sees through its fisheye lens. (Image courtesy of Derek Spears, Rhythm & Hues Studios)

inverted cone (Figure 4.11). While cameras with fisheye lenses must be rotated to capture a 360° view of the set, this system takes in the entire set in one view. These systems are simple to use, and recording the data takes up very little time on the set. With either method, artists can then use the captured data to digitally recreate the lighting that existed on the live-action set. In a manner of speaking, they can "paint" their computer-generated characters or objects with the lighting derived from the set so that the objects will look like they belong in that set.

We should note that not every set requires such detailed documentation. Depending on the complexity of the digital work that lies ahead, a VFX Supervisor may simply take a large number of stills from different angles to deliver to a digital facility. For budgeting purposes, a system like the one described in Figure 4.11 below can be purchased for approximately $1,100. It may be worth the cost if you have many sets to document.

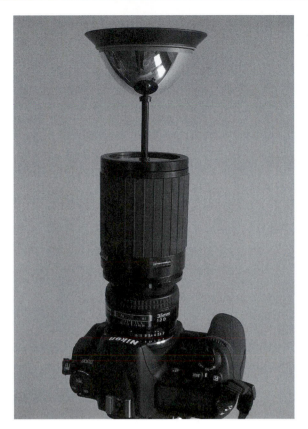

Figure 4.11 This camera has been fitted with a special lens and an inverted mirrored half-sphere to document the lighting and layout of a set in one image, 360° circle horizontally and approximately 110° vertically.
(Image courtesy of Jeffrey A. Okun)

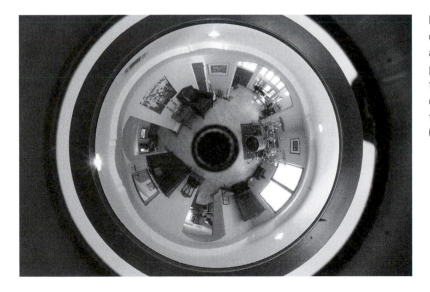

Figure 4.12 This image is the result of a 360° record taken by the camera and lens setup shown in Figure 4.11. In practice the VFX Supervisor would record the scene at several different *f*-stops to capture the full range of illumination on the set, from darkest to brightest.
(Image courtesy of Jeffrey A. Okun)

Figure 4.13 When the digital data is processed it not only documents the lighting within a set but it can also be used by a digital facility to reconstruct the entire set in 3D space.
(Image courtesy of Jeffrey A. Okun)

The most recent advance in obtaining detailed set and location lighting references comes through a system called HDR-Cam. This system records a 360° panorama of high-dynamic range images through a brightness range of 20 *f*/stops in about 30 seconds. The camera is linked to a powerful computer program that analyzes, blends and integrates all the images so as to provide VFX Supervisors and digital effects facilities a complete set of data about lighting conditions on the set. Among numerous other benefits, this system greatly reduces the time needed to match the virtual lighting of a digital environment to the real lighting encountered on a set, thereby not only helping to improve the quality of the images, but also reducing costs for both vendor and producer alike.

LIDAR (Light Detection and Ranging)

Many set surveys today are accomplished with a tool called LIDAR. LIDAR (an acronym for Light Detection and Ranging) is a powerful tool that allows us to obtain high-resolution 3D scans of real locations: buildings, cities, parks, mountains, etc. LIDAR is based on the same principle as radar, except instead of sending out radio waves, the LIDAR apparatus sends out a laser beam. That beam is scanned back and forth over an object (which can literally be as large as several city blocks), and laser light bouncing back from the object is recorded and analyzed. This may be done from one stationary position, which yields a laser image that looks a bit like an abstract still photograph. The process can be repeated from different angles of the object being scanned. This allows the eventual user to build up an amazingly detailed three-dimensional view of the desired object from many angles. Digital artists can now use this view (basically nothing more than a digital file) to create a 3D CG model of the location.

Figure 4.14 A LIDAR scan of New York City.
(Image courtesy of LIDAR VFX)

If you know that you have to create extensive CG environments of streets and buildings, let's say for a period film, LIDAR is the best method to scan a large expanse of contemporary buildings. The digitally processed LIDAR scan results in a 3D model that is given to a digital facility which, in turn, uses the LIDAR model to create the digital city buildings. In the 2008 film *Changeling*, for example, all of the period backgrounds of 1920s Los Angeles had to be recreated in the computer.

LIDAR is an extremely cost-effective means for capturing the dimensions and textures of real locations that have to be built as 3D CG images, saving a digital facility untold hours in having to build and texture the desired computer model from scratch. LIDAR and HDRI equipment can be rented and crews hired just like any other piece of equipment. The VFX Producer just needs to make sure that the budget provides for them, including the almost inevitable travel, accommodation, and *per diem* costs.

Renting Equipment

One of the constants in the film business is that the equipment we use is evolving all the time. Anyone who attends one of the various show business conventions or equipment exhibitions regularly, or who pays attention to the advertising in trade magazines, can't help but observe this phenomenon first hand. This—along with the fleeting nature that characterizes film production—is one of the main reasons why equipment is almost always rented.

The equipment rental business is intensely competitive in major production centers such as Hollywood. Producers generally have great leverage, especially during economic downturns, when

it comes to negotiating deals and putting together equipment packages for the standard items every production company needs: cameras, lenses, lighting and grip equipment, trucks and trailers, and a variety of other equipment.

The competitive pressure on rental prices is somewhat different in visual effects because we often need specialized equipment that is not normally used in 1st Unit photography, such as blue or green screens and their accompanying specialized lighting fixtures, motion control dollies/cranes, and high-speed or timelapse cameras. Whereas it's usually a simple task to put together a 35 mm camera package for a two-day plate shoot, it's quite another to lock in a VistaVision camera for two months: there aren't that many of them around.

For this reason the VFX Producer needs to be aware of the visual effects unit's equipment needs and plan well ahead if certain specialized equipment will be needed down the road. It could happen that several effects-driven films may be in production at the same time, creating a tight market for certain pieces of rare equipment that may suddenly be in demand. Under these conditions it may be a bit challenging to negotiate a bargain price for what you need.

Equipment can be rented by the day, the week, the month, the run of the show, or almost any combination of the above, depending on what the needs are. Daily rates—obviously the least profitable for a rental house because they entail the greatest amount of work to check the equipment before and after it leaves the facility—are at best only modestly negotiable.

Weekly rates, on the other hand, are open to a wide range of discounts. The most common discounts (and here we reflect a Hollywood bias) are what are called a 3-day or 2-day week, meaning that the rental cost for a week—indeed, for any rental period greater than 2 or 3 days, respectively—is charged at two or three times the daily rate. Weekends tend to be charged as 1 day, though this may vary from rental house to rental house and should be clearly stated in the company's rate sheet.

It should go without saying that whoever is given the task of negotiating should always strive to make the best deal possible. "Is that the best you can do for me?" is a legitimate question. Give and take between producer and rental house is expected, and there is no shame in pressing the rental house for a better deal or for shopping around.

It's one thing to drive a hard bargain in Hollywood, where rental houses abound, and quite another when you find yourself on a distant location where equipment is either scarce or not available at all. As we mentioned earlier, visual effects often requires specialized equipment that doesn't exist in many parts of the world. In those situations, you may have to fly the equipment in from the United States or find a supplier, say, in England or Germany, who can meet your needs. As a producer, it is your challenge to plan for these situations and assure the availability of the equipment well in advance.

Under certain circumstances it may make sense to buy the equipment instead of renting it and then resell it at the conclusion of production. This approach is best when you need a particular item for a long time, the price is reasonable, and there is a reasonably steady demand for the item on the open market, such as for blue or green screens.

The decision to buy should be influenced by both budget and convenience. If renting a given equipment package is significantly cheaper than buying it, it's a "no-brainer": you rent it. The time to weigh the pros and cons of buying vs. renting comes when rental costs approach or even exceed the cost of purchase. Items such as cameras and lenses, for example, tend to retain their value. Provided the equipment isn't abused during production, it's entirely possible that you may be able to sell it for close to what you paid for it. There is also a certain convenience factor in knowing that the equipment is yours to use for as long as you need it. This needs to be balanced, however, against the possibility of an equipment breakdown while you're on location, which may have you scrambling to bring in a replacement while your equipment is gone for repair.

When renting equipment, you need to be careful about having every piece of equipment that leaves the rental facility checked by whoever is delegated to pick it up. Every piece of equipment needs to be itemized (even the "freebies") and verified to be in working order. Few things are as aggravating as returning equipment to a rental house and being told that something is missing or damaged.

SUCCESS STORY
Tom Boland - (*Blood Diamond*; *The Last Samurai*)

I moved to Los Angeles…with the hope of getting into the film or television industry. My brother told me he worked for a production company and that he needed a driver to pick things up for the company… I didn't really want to do it…but he kept badgering me through the evening until he finally said that I'd be doing him a real favor if I would do it. I showed up for work at Apogee Productions, which at the time was one of four full-service visual effects companies in the world, headed up by Academy Award winner John Dykstra. I had never seen such a place….I was in awe….I ended up working there on staff for 5 years and worked my way up to production assistant, then became the purchasing agent… After that stint, I became a production coordinator and then a VFX Producer. It was 5 years of Visual Effects College, working with the best in the business and I loved going to work there every single day. I have now worked as VFX Producer since about 1991.

I think the most important duties of a VFX Producer are to enable the "creatives," the VFX Supervisor, director, etc., to do their best work possible within the restraints of a budget. This means you have…to be prepared to come up with solutions to problems that arise throughout the production so that you never have to say as a producer "no", unless you absolutely have to. I think trying to keep reality afloat in the midst of craziness is also a huge duty of the VFX Producer.

Key personality traits for success include honesty and integrity first and foremost. Then thinking ahead, being prepared, having a plan B and C, rolling with the changes, having a sense of humor, and being able to be firm when you have to—all vital. In any business you also have to have the ability to suffer fools gladly because you will run into many in your career.

BREAKDOWNS

It is one of the peculiarities of making movies that a VFX Producer may be hired at any one of several stages of a project. Unlike the director (who is on the project from beginning to end), a DP (whose role is confined largely to the production phase), or a composer (who usually doesn't start work until postproduction gets underway), a VFX Producer may be brought on board as early as script development to as late as postproduction or anywhere in between. The actual function of the VFX Producer may, in fact, be performed by someone who is not a specialist in this field at all, but who is drafted to "wrangle" the visual effects because there's no one else on the production staff to do it.

Of all the functions that a VFX Producer performs, getting the effects done on budget and on time are by far the most critical. But how a budget and a schedule are arrived at varies a lot from show to show, and depends a great deal on just where in the overall process of making the film the VFX Producer is hired, and how much advance work has already been done by the producer in terms of determining what the film's visual effects needs are going to be. Thus, the VFX Producer who is hired while the script is still in development (and therefore subject to extensive changes) faces a slightly different task than if she were hired during preproduction (when the extent of the visual effects needs are, presumably, fairly clear).

What we are getting at is that the visual effects budget and schedule will evolve right along with the script and the movie itself. The two are interdependent: As one changes, the other one does as well. Not only that, but the VFX Producer of a relatively effects-heavy film must really deal with two types of budgets and schedules that run along on parallel tracks, so to speak. One is the cost and scheduling of the digital part of the work (i.e., all the manipulation of the effects that will be done by computer). The other is the cost and scheduling of all the production support (i.e., the personnel, facilities, equipment, visual effects crew, and other items relating to producing the visual effects). For ease

of distinguishing between the two types, we'll refer to the one as digital shot costs, the other as production support.

Production Breakdowns

Let us begin our discussion of budgeting and scheduling, then, at a point in a project's history where there exists a script but little else. This is by no means an unusual situation. Studios and independent production companies will often commission a VFX Producer to prepare a breakdown and budget of the effects as a sort of proof of concept. Many a feature project has been canceled or severely trimmed back because the visual effects were simply too ambitious, and wise is the head of production who turns to an experienced VFX Producer to assess the project before millions of dollars are spent on it.

One of the very first things every production needs is a breakdown. Now what, exactly, is a breakdown? Well, a breakdown is the systematic dissecting of a script into its constituent parts and listing of all the essential physical items that will be needed for each scene, everything from actors and extras to props, wardrobe, and special equipment. A breakdown basically answers the question, "What will we need to turn this script into a movie?"

Breakdowns come in all manner of shapes and sizes and serve a variety of purposes depending on the person or department who needs that specific information. On most films, the initial script breakdown is usually done by the line producer, an experienced production manager, or an assistant director. The goal at this point is to get a general view of all of the production's physical requirements. Visual effects are only one part of an overall production breakdown. In fact, unless it is an effects-driven film, visual effects may not loom large on the production's radar screen at all, perhaps meriting little more than a casual entry "Visual FX" in the Optical FX category of the breakdown sheet.

Once the initial breakdown sheets are completed, each department will then analyze the script and the breakdown in detail to determine its own specific needs so it can provide what's expected of it. This is where the visual effects breakdown comes in.

On visual effects-driven films a visual effects breakdown should be prepared as soon as a script is available. This will give the VFX Producer a chance to start assessing the production's needs, prepare a digital cost estimate and give the producer and director some guidance about how the visual effects might be accomplished and an educated guess of their cost.

This breakdown is likely to change several times before shooting starts. Quite often a studio will commission a producer or UPM to prepare a complete budget and perhaps even storyboards, and then decide whether to proceed. Visual effects budgets of effects-driven films can easily run into millions of dollars

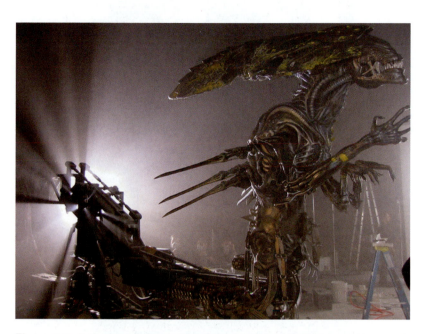

Figure 1.3 Full-scale animatronic Alien Queen from *Alien* VS. *Predator*, making use of a combination of electronics, hydraulics, and a computer-controlled performance system. (Image courtesy of Amalgamated Dynamics, Inc. *Alien* VS. *Predator* © 2004 Twentieth Century Fox.

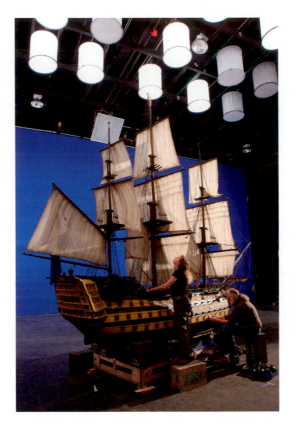

Figure 1.5 Model makers at Kerner Optical prepare a miniature for a bluescreen shot.
(Courtesy of Kerner Optical and Industrial Light and Magic; © Disney Enterprises, Inc.)

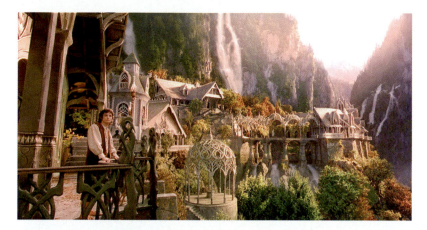

Figure 1.7 Actor Elijah Wood was filmed on a set piece in front of a blue screen and then composited with a miniature of the village of Rivendell and additional live-action elements of real waterfalls.

(*The Lord of the Rings: The Fellowship of the Ring* © New Line Productions, Inc.™ The Saul Zaentz Company d/b/a Tolkien Enterprises under license to New Line Productions, Inc. All rights reserved)

Figure 1.10 A greenscreen composite that combined a live-action plate of the legs and shoes with several greenscreen plates of live-action extras as well as digital extras. This is also a good application of forced perspective.

(Image courtesy of Rhythm & Hues Studios. *Night at the Museum* © 2006 Twentieth Century Fox. All rights reserved)

Figure 2.5 All CG models, whether of living creatures or inanimate objects, must be textured and painted to give them the look of real objects.
(*The Lord of the Rings: The Two Towers* © New Line Productions, Inc. ™ The Saul Zaentz Company d/b/a Tolkien Enterprises under license to New Line Productions, Inc. All rights reserved)

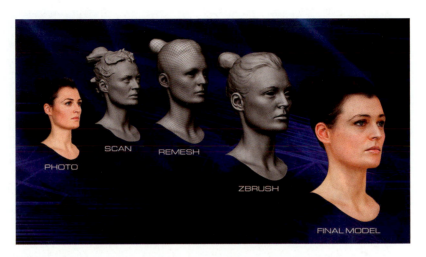

Figure 4.7 The result of a head scan using a structured light scanning technique.
(Image courtesy of Nick Tesi, Eyetronics, Inc.)

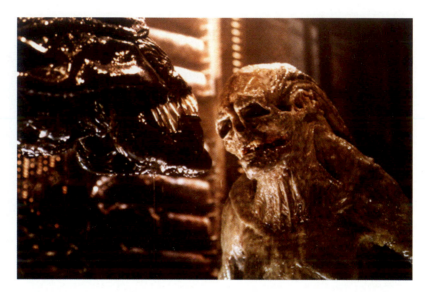

Figure 11.1 Alien Queen and Newborn—Animatronic Puppets.
(Image courtesy of Amalgamated Dynamics, Inc. *Alien Resurrection* © 1997 Twentieth Century Fox.
All rights reserved)

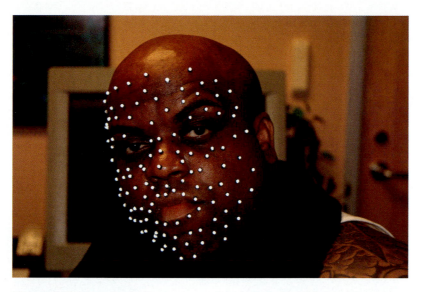

Figure 11.3 Singer Cee-Lo Green wears markers for capturing his facial performance for the animation in the music video *Who's Gonna Save My Soul* (2008).
(Image courtesy of Monopoly Management)

Figure 11.4 CG Character based on Cee-Lo Green's performance for the music video *Who's Gonna Save My Soul* (2008).
(Image courtesy of Gradient Effects)

Figure 12.1 In-camera miniature of a giant radio antenna built at 1/24th scale. The landscape behind it is a scenic painting that matches an actual location. By definition, in-camera miniatures can be cut into a film "as is".
(Image courtesy of David B. Sharp Productions)

in a contemporary "tent pole" feature. Given the growing power of computer graphics to bring virtually any type of visual to the screen, writers have become accustomed to letting their imaginations run free. This freedom, however, can exact a price that even a major studio may not be willing to pay. A number of high-profile effects-laden features of recent years had to undergo extensive script and budget revisions before they were green-lit. In this environment a well-prepared visual effects breakdown could play a significant role in helping a producer or studio decide where simplifications or cuts can be made before greenlighting the project.

The First Go-Around: Generating a VFX Breakdown

Getting Started

Let's assume now that you have been hired to be the VFX Producer on a show that is still in development or in preparation. Perhaps the studio hasn't decided yet whether to greenlight the picture and the executives want to get an idea of how much it will cost to produce. Or maybe the picture is a "go," but the budget hasn't been quite finalized. Whatever the case may be, if the project involves a lot of visual effects, a producer is likely to call on someone with your expertise to analyze the script and advise how much the visual effects are going to cost.

The amount of information you'll be given to go on at this point will vary quite a bit from project to project. Sometimes you will get a preliminary list of visual and special effects the producer foresees needing for the film. If a director has been engaged, he or she may have been working with a storyboard artist to generate storyboards, which will give you an idea of what the director is thinking. But sometimes you'll get nothing more than a script and a "See you in a week" as you're ushered out the door.

Marking Up the Script

Excited at the prospect of working on this feature, you first, of course, read the script. Your first reading should be aimed merely at getting an overview of the plot, setting, characters, and action. If you're lucky, it will be a good script, and you'll look forward to working on this project. But good script or not, keep in mind that your job is to produce the visual effects, not be a critic. It's the director's film, not yours, and if you are going to stay on the project you owe it your support and best effort.

This would also be a good time to ask to meet with the director and VFX Supervisor (if he has already been hired) to discuss the

visual effects, ask questions, and consider alternatives. Directors are notoriously busy people, so you're not likely to get more than an hour or two with the director at any one sitting. But any amount of information you can extract from him or her will make the job of breaking down the visual effects easier. The VFX Supervisor, on the other hand, should be readily available (after all, the effects are the supervisor's baby), and the two of you should analyze the script together.

Once you have a sense of what the script is all about, you are ready to break out the visual effects. There are numerous ways of going about that, and you can consider the procedures we discuss here as starting points for developing your own methods.

We recommend that you get yourself some different colored highlighters. You can use these to highlight different types of visual effects in the script if you so desire. (For example, you can highlight in blue the visual effects part in a sentence so it stands out and is clearer to find). You can devise your own color code, as long as it is consistent and not overly diversified. At a minimum, you'll probably want to highlight every sentence or paragraph in the script that looks like it calls for one or more visual effects shots. It helps to think a little like a director or editor when you do this. Whereas writers can convey complex action in just a few words, the director has to bring the words alive on the screen. (Think of it this way: What does the line "They fight" mean?) So ask yourself "What would I do if I were shooting this sequence? Can I tell the story here in one shot (say, an establishing matte painting of old Boston harbor), or will I need several cuts (as in a furious martial arts fight requiring lots of wire removals)?"

Numbering Visual Effects Shots

You will also want to start assigning numbers to the effects shots, if possible. How you do this depends on whether you were handed a numbered script (i.e., a script with scene numbers) or not. If there are no scene numbers yet, your best bet is to hold off on assigning numbers to the effects and merely refer to the script page numbers in the breakdown you are about to prepare.

If you are working from a numbered script, assigning numbers to the visual effects shots is fairly straightforward. Many visual effects practitioners favor preceding all visual effects shots with the letter "V" followed by the scene number, then a period followed by an ascending number for each successive effects shot in that scene, such as shot V8.1, V8.2, etc. Thus, V8.1 means scene 8 and visual effects shot number 1. This way you can count how many visual effects shots are in that scene. This system also has the virtue that everybody knows immediately what scene the shot belongs to. Other people may use "X" or "VFX" instead of "V" as a prefix.

Script Numbering

Script numbering is a vital step in organizing a production because every detail of the film's physical production is keyed to scene numbers. As simple as it sounds, assigning scene numbers can be surprisingly intricate and must be done with care. It is usually done by an AD or UPM (rarely by a VFX Producer) after a script is deemed to be in good enough shape that the producer feels that future script changes can be accommodated without too much disruption in the numbers.

Another common method for numbering visual effects shots is to give each sequence a name, then use a two- or three-letter abbreviation of that name followed by a number. For example, a sequence might have been dubbed "Fishing Boat." The effects could then be consecutively numbered FB-1, FB-2, and FB-3. Some people prefer this system because it helps them remember what sequence a shot belongs to. For others, knowing the scene number is good enough. There's no hard-and-fast rule. Do not be concerned if people get confused at first by so many shot numbers. Before long, you and everyone else closely connected with the visual effects will instantly know a shot by its number, much as you instantly recognize the face of a friend.

If the project you are working on is still in its early stages, it's very likely that you will have to revise your first breakdown several times as the script is rewritten. Scenes get added or dropped, sequences may get moved around, visual effects requirements may get simpler or more complex. At this point it is likely that you will have to renumber the effects. This is a bit more work for you, but changing the numbers now is not a big deal, because the breakdowns you generate are still somewhat preliminary.

One rule that should be rigorously observed, however, is that once a project has advanced to the point where the script is approved for production and scene numbers are set, *visual effects numbers should not be changed, duplicated, or used again after a shot has been omitted*. Consistency in your paperwork is important, and you must use the same numbers throughout the course of the project. Although it's inevitable that the film (and some of the effects shots with it) will undergo changes as it progresses, you should keep in mind that by the time production gets underway, many departments will have received visual effects shot breakdowns, storyboards, budgets, and other communications that refer to the shot numbers you created early on. Confusion will reign if a shot is eliminated and its number is used again for a different one, or if a shot number is duplicated by accident.

Keep a pad and pen handy as you mark up the script to note down questions you will want to ask the director or the producer. At this stage of the game, many decisions are still up in the air. Neither practical production choices nor creative ones will have been made yet, anything from where the film is to be shot to whether a given piece of action can be accomplished live on set or needs the help of visual effects. Because you may not know what the director has in mind, your first breakdown should include every effects shot that reasonably suggests itself to you.

Your breakdown may, in fact, help the producer or director formulate their creative approach once they get an idea of what the shots will cost and are presented with possible alternatives that they may not have thought of.

Categorizing effects shots as low, moderate, and high cost can be a useful tactic when a producer only wants a rough idea what his project is likely to cost. The VFX Producer merely needs to (somewhat arbitrarily) assign a level of complexity to shots with a corresponding cost estimate and count up the shots. This is also a quick and informal way for a potential vendor to come up with a cost estimate for the visual effects. As you might imagine, it takes a bit of experience to do this with a fair degree of accuracy.

Constructing a Digital Cost Breakdown Spreadsheet

Very well, then. You have read the script and marked and numbered the visual effects shots in it, and the director has discussed his or her ideas for the effects with you and the VFX Supervisor. Or maybe you're on your own for the moment. Either way, you should now be ready to start on the visual effects shot breakdown. You may use any method for this task that you are comfortable with. We would urge you, however, to be as systematic about it as possible so that others can quickly grasp the data you are presenting. The information should be clear, it should be specific in its references to script scenes, and it should give others a concise picture of the type of work each shot entails.

Several computer programs can help you in this task. We favor the use of Microsoft Excel, a spreadsheet program, because it is so widely used and because of its relative ease of use and capability for dealing with mathematical formulas.

Figure 5.1, below, is an example of a simple Excel breakdown. It serves several purposes. It lists all effects shots, gives an overview of the live-action plates that will have to be filmed, names the digital elements that will need to be created, and indicates the methodologies to be used in compositing the shots. We will deal with the next step, estimating digital shot costs, shortly.

The first four columns of the breakdown are routine information: scene number, script page number, visual effects number (which you assigned when you marked up the script), and a shot description. The shot description is an almost verbatim copy of how the writer described the scene in the script. The reason for this is that everyone else who reads your breakdown will know right away which bit of action in the script you are referring to. You don't necessarily have to be this literal in your description; we just think it helps.

Column 5 states the number of filmed plates that will have to be scanned and that will later be turned over to one or more digital facilities to work with. We emphasize "filmed" here to distinguish the live-action elements from the digitally created ones.

The number of scan layers is derived from the next column (column 6), which states the production plates that need to be

Sc. #	PAGE #	VFX #	Description	# of Scan Layers	Plates/Production Elements	Digital Elements: CGI-Matte Painting	Methodology
8	8	V8.1	EXT. GERMAN SUBMARINE-MID OCENA - DAY - The Captain and his number Two and a Spotter are on the bridge. They peer out across the Atlantic with their binoculars. The waves are so big, they look as if they threaten to break the boat apart.	1	GS Plate of Captain, Number Two, and Spotter on bridge set piece (Note: SPFX to rig water spray)	3D CG Ocean 3D CG Strom Waves 3D CG Spray Digital Matte Painting of Sky	Digital Comp w/CGI
39	21	V39.1	EXT BRIDGE - U.S. DESTROYER - DAY - The Captain of the destroyer stands next to a Spotter, who looks through his field glass at the German U-Boat.	1	GS Plate of Captain and Spotter on set piece of Destroyer	3D CG Ocean 3D CG Strom Waves Digital Matte Painting of Sky	Digital Comp w/CGI
70	41	V70.1	EXT. PARADISE SPRINGS INTERNMENT CAMP - DAY- The truckload of new prisoners pulls up to the gates of the camp.	1	Plate of Internment Camp (Note: Requires Set Survey and 3D tracking in Post)	3D CG Set Extension of Internment Camp 3D Digital Matte Painting of mountains and desert	Digital Comp w/CGI
152	92	V152.1	EXT. DESERT - NIGHT - The Captain is galloping the horse through the desert. There is more thunder and lightning.	1	Plate of the Captain galloping	CG Lightning Possible Sky Replacement w/rotosocoping around the captain	Digital Comp w/CGI
179	118	V179.1	EXT. GULF OF CALIFORNIA - SUNSET - We are coming down a trail, then they pass by camera, and we see the patrolman is leading a second horse with the dead body across it. Camera pans to reveal that the trail leads out onto a beach on the Gulf a California.	2	Plate of patrolman on horseback leading the horse with the dead body Plate of Expanse of Gulf of California (Note: Possible use of Encoded Crane for Plate Shoot) (Note: Requires Set Survey and 3D tracking in Post)	3D CG Set Extension of Cliff 3D Digital Matte Painting	Digital Comp s/CGI

Figure 5.1 Example of a shot breakdown generated using Microsoft Excel.

filmed. This column lists all live-action and stock footage elements that have to be provided. You should describe the live-action plates briefly, naming the principal characters, what they do, and where they are. Just enough information so a reader can quickly get the idea. This is also where you may wish to indicate anything special about the plates, such as whether the action is to be shot against a blue or green screen, from a helicopter, in a water tank, or from another visual effects unit.

One of the things to watch out for when listing the live-action plates is shots that either begin in one set and end up in another or that include other images within them. An example of the former might be a shot that begins as an exterior and ends as an interior in a different place. (A classic example occurs in the film *Contact* (1997), where Jody Foster's character runs through a parking lot—shot on location in New Mexico—and the camera follows her as she charges through a doorway into the control room of a radio observatory—shot on a set at SONY Studios). In both cases, your breakdown must list all elements that have to be shot.

In addition, you should list in this column any reference plates that need to be shot. Reference plates are shots that will not appear in the film, but will be used by digital artists as a reference in their work. Common types of reference plates are shots of the fully lit but empty set, actors going through actions that will later be replicated by CG creatures, shots of the set in which the VFX Supervisor has placed a shiny, chromed sphere as well as a white sphere to show digital artists how the set was lit, and similar plates (see Chapter 10, On-Set References, for more information on this topic).

If you plan to use a lot of miniatures or animatronics in your film, you may wish to add a column to list them separately. The important thing is to be flexible when it comes to designing the layout of your breakdown.

In the next column (column 7) you list the digital elements that need to be created in the computer. Digital elements may include rotoscoped effects, matte paintings, creatures, vehicles, and 3D CG environments. It's a good idea to note whether an element is 2D or 3D CG, as it helps others to quickly evaluate the digital workload.

The last column indicates the compositing methodology for each shot. In brief, this answers the question, "How is the shot put together?" In contemporary visual effects production, virtually all compositing is done digitally, opticals having gone the way of the horse and buggy. The methodology allows us to indicate whether the shot is a simple digital composite, whether it includes one or more CG elements, and whether it involves any other kind of digital manipulation. In the sample breakdown sheet below, for

example, the methodology for all shots is "Digital Comp w/CGI," meaning that the composite also involves a CG element.

Other shots might call for a digital composite with wire removals, an unusually demanding amount of rotoscoping, or a combination of these. If you prefer to be more explicit, you may want to indicate whether the composite includes a blue or green screen, for example, "Digital Comp w/BS, Wire Removal, and CGI."

Keyboard Shortcuts and Tricks

When you do your initial shot breakdown you will often end up having to type the same entry into your breakdown over and over: for example, the term "Digital Comp w/CGI." This poses no inconvenience if your project only has a relatively small number of shots. But repeat entries get very time-consuming if you are doing a show with dozens or even hundreds of shots. Fortunately there is an efficient way around this problem, and that is taking advantage of the "find and replace" capability that many computer programs, including Microsoft Word and Excel, offer.

The way this works is that you make up a short three- or four-letter code to represent the technical term you want to avoid entering repeatedly. When you are all done with the breakdown, you use the "Find" mode in your program to identify the code, and then use "Replace" or "Replace All" to replace the code with the full technical term. For example, you could use the code "dcc" to stand for "Digital Comp w/CGI." It takes only a few moments, and could save you much tedious work. But a word of caution: Be sure to choose a letter combination that does not occur in normal words or you could end up with your technical term in the middle of a legitimate word. For example, you don't want to abbreviate GreenScreen as "GS," in a search and replace operation, or *any* word with those two letters (like the word legs) will have Green-Screen stuck in the middle.

Another good habit to get into when you do your breakdown is to be consistent in how you label things throughout your breakdown. This will help you perform some useful operations. Primarily it will enable you to identify and separate specific groups of shots that all have the same requirement in common, all greenscreen shots, for example, or all matte paintings. Let's say that your script calls for a significant number of greenscreen shots. Part of your job as VFX Producer will be to budget and schedule these shots. To do this effectively you will not only need to know how many there are in total, you will also want to group them according to location, cast members, and special effects needs.

If you are working with Microsoft Excel or a program with similar capabilities, you can find these shots quite easily with the help of the Data > Filter function of the program. Focus your search by

using a label that is common only to the elements you are looking for. The Search command will then isolate the target records in your breakdown, and from there you can simply copy them into another sheet or file. Placing these "birds of a feather" in a separate worksheet or file will make the task of budgeting, scheduling, and bidding them much easier not only for you, but also for the AD and anyone else who may need that information. You can do this for any group of shots with a common label.

The trick here is to be totally *consistent* in how you name your elements. If, for example, you label a matte painting as "MP" in some places, and "MPtg" in others and then try to extract the data for all matte paintings, you may end up with a jumbled and incomplete list of elements.

The Data > Filter function also comes in handy when you want to make sure that you have not overlooked companion elements that get entered in one column but are always paired with a related item in a different column. Assume, for example, that you have a bunch of wire removals in your show, and you know you have to shoot a clean background plate of the set for all those shots. If you use Data > Filter to select all shots where you have entered Wire Removal in the appropriate column, it now becomes a snap to review these shots and make sure that you have filmed a clean plate from any shots that need it. The example below will help make this clear. The filter was set to find all shots that contain Wire Removal in column 6. We now want to make sure that we shoot a clean plate for each of those shots. It takes only a quick look for us to notice that we forgot the clean plate in shot V1.11. You can apply this technique to any type of shots that share specific characteristics.

Incidentally, although we favor using Microsoft Excel to do these early shot breakdowns because of its relative ease of use, you could also employ a program such as FileMaker Pro and achieve essentially the same result. Each program has its own strengths and weaknesses for our purposes. While Excel is a spreadsheet program best suited for business applications where "crunching numbers" is paramount, FileMaker Pro is a relational *database* program, designed for handling huge amounts of data and finding relationships among them. We also make extensive use of FileMaker Pro in other areas of visual effects producing.

Generating an effects breakdown in Excel is fairly straightforward in terms of setting up the fields, cells, columns, and rows. However, it is not well suited to extracting large amounts of data and instantly presenting it in many different forms. FileMaker Pro, on the other hand, is considerably more cumbersome to work with when you initially set up a visual effects breakdown or its many derivations. But once you learn the ins and outs of the program, you will find it to be a powerful tool for reconfiguring the same data into a virtually unlimited number of layouts.

Sc #	VFX #	Description	No. of Scan Layers	Plates/Production Elements	Digital Elements: CGI/Matte Painting	Methodology
1	V1.3	EXT. MOUNTAINTOP - DAY - He wheels, leaps, lands bird-light on his bare feet	2	Plate of young man leaping, landing on his feet Clean Plate of set	CG Enhancement of Mist 3D CG Ribbons of Mist Wire Removal	Digital Comp w/Wire Removal
1	V1.10	EXT. MOUNTAIN PEAK - DAY - In a comedic/beautiful, bizarre display of Monkey Style Kung-Fu he shimmies up the staff and perches at the top...	2	Plate of Sun Wukong shimmying up pole Clean Plate of set (Note: Keep wire behind actor)	Wire Removal	Digital Comp w/Wire Removal
1	V1.11	EXT. MOUNTAIN PEAK - DAY - ...before sliding back down...	1	Plate of Sun Wukong sliding down pole amid attackers	Wire Removal	Digital Comp w/Wire Removal
41	V41.22	EXT. MARSHY RIVER BANK - DAY - He falls from the saddle, dead in the rocks.	2	Plate of White Horse falling from horse Clean Plate of set (Note: Have blue or green stunt pad standing by on set)	3D CG Spear 3D CG Spear Debris Wire Removal	Digital Comp w/CGI and Wire Removal

Figure 5.2 Result of using the Data > Filter function in an Excel spreadsheet in conjunction with Text Filter to find all shots requiring wire removal.

Estimating Digital Shot Costs

Even before you start on the breakdown, one of the first questions from the producer's lips will be, "How much are the effects gonna cost?" Having completed the breakdown, you are now ready to tackle this question. How you proceed depends a bit on how far along the production is.

As we said earlier, the VFX Producer really has to prepare two different types of budgets, one for the digital shot costs, and one for the production support required. When we talk about digital shot costs, we are talking only about the costs directly associated with creating the digital work, up to and including the final film-out. In effect, the digital shot costs are kind of a budget within a budget.

We treat them as a second type mainly because it's fairly easy to deal with the digital shot costs as one lump sum that can be embedded in the overall visual effects budget with a few keystrokes at any time the digital shot costs have been worked out. Also, by dealing with the digital shot costs as a separate category, the VFX Producer can work on the production support budget and schedule independently. This can be a great advantage given the erratic nature of film projects with their fits and starts.

Let us then continue along these lines, ignore production support for now, and press on with developing the digital shot costs only. The objective here is to put a tentative price tag on each shot and to estimate as closely as possible all the other costs associated directly with creating the digital work. Depending on how knowledgeable the VFX Producer is about the cost of digital services, she may make an initial guesstimate as to the cost of the shots and enter them in the appropriate column of the breakdown. If possible, the VFX Producer should consult with the VFX Supervisor on this matter, assuming that a supervisor is already on the show at this point.

Though estimating digital shot costs is a bit of a guessing game, you can be confident about one general rule: it is, on average, considerably more costly to create shots with 3D digital characters than it is to produce more conventional visual effects. That really isn't surprising. When you think about the steps involved in creating digital characters—design, animation setup, modeling, texturing, animating, integrating with the body of the film, and so forth—you know intuitively that a great many more resources go into this type of work than go into, say, an equal number of shots requiring wire removals, flying spaceships, or greenscreen composites. Because of these differences, it's not unusual to encounter a price range from as low as $2,500 for a simple composite up to $100,000 or even more for a shot involving complex 3D digital characters.

Estimating the costs of 3D CG animation can be particularly challenging because so much depends on the complexity of the animation. We're not talking here about fully animated digital feature films (they fall into a class all to themselves), but only about digital animation that is part of a live action picture.

Many considerations affect the cost of 3D CG animation. Some of them apply to all 3D CG objects, living or not: modeling, texturing and shading, rigging the object's parts so they are capable of moving. In the case of an animated character, the cost will also be affected by such additional factors as the articulation of the face and the rigging of the body. These will determine how believable an "actor" the character becomes. For example, think of the difference in the range of facial expressions between a relatively stoic dinosaur and a digital Benjamin Button with his extraordinary range of human emotions.

The models that a project requires generally fall under the heading of digital assets. Depending on their number and intricacy, the digital assets by themselves can represent a huge investment on the part of a vendor. You will need to budget them whether a particular model appears in only one scene or one hundred. For this reason, it is a good idea to list the models that a project requires as a separate item on your digital cost estimate.

There is also considerable variation in cost among facilities and among facilities in different countries. So when you find yourself preparing a preliminary budget estimate involving 3D CG animation, you would be well advised to get some ballpark figures from several digital facilities that you may want to work with.

Continuing to use your favorite spreadsheet program, you can now add a new column to the breakdown, enter the shot cost according to your best initial judgment, and so arrive at a first approximation of the digital shot costs (see Figure 5.3). Obviously, this is a bit of a guessing game until you can gather more reliable figures from potential vendors. Be aware that the costs in this column are for *compositing only*. As you will see shortly, other costs associated with the digital work appear elsewhere on the breakdown in what we here call ancillary costs.

VFX BREAKDOWN WITH DIGITAL COSTS

Shot #	Sc. #	PAGE #	VFX #	Description	# of Scan Layers	Plates/Production Elements	Digital Elements: CGI/Matte Painting	Methodology	Digital Shot Cost
1	8	8	V8.1	EXT. GERMAN SUBMARINE-MID-OCEAN-DAY-The Captian and his Number Two and a Spotter are on the bridge. They peer out. across the Atlantic with their binoculars. The waves are so big, they look as if they threaten to break the boat apart.	1	GS Plate of Captain, Number Two, and Spotter on bridge set piece (Note: SPFX to rig water spray)	3D CG Ocean 3D CG Storm Waves 3D CG Spray Digital Matte Painting of Sky	Digital Comp w/CGI	$35,000
2	39	21	V39.1	EXT. BRIDE-U.S. DESTROYER-DAY - The Captain of the destroyer stands next to a Spotter, who looks throught his field glasses at the German U-Boat	1	GS Plate of Captain and Spotter on set piece of Destroyer	3D CG Ocean 3D CG Storm Waves Digital Matte Painting of Sky	Digital Comp w/CGI	$35,000
3	70	41	V70.1	EXT. PARADISE SPRINGS INTERNMENT CAMP -DAY-The truckload of new prisoners pulls up to the gates of the camp.	1	Plate of InterNment Camp (Note: Possible use of Vista Vision for Plate Shoot) (Note: Requries Set Survey and 3D tracking in Post)	3D CG Set Extension of Internment Camp 3D Digital Matte Painting of mountains and desert	Digital Comp w/CGI	$25,000
4	152	92	V152.1	EXT. DESERT-NIGHT-The Captain is galloping the horse through the desert. There is more thunder and lightning.	1	Plate of the Captain galloping	CG Lighting Possible Sky Replacement w/rotosocoping around the captain	Digital Comp w/CGI	$5,500
33	179	118	V179.1	EXT. GULF OF CALIFORNIA-SUNSET-We are coming down a trail, then they pass by camera, and we see the patrolman is leading a second horse with the dead body across it. Camera pans to reveal that the trail leads out onto a beach on the Gulf of California.	2	Plate of patrolman on horseback leading the Captain and horse with the dead body Plate of Expanse of Gulf of California (Note: Possible use of Vista Vision Camera and Encoded Crane for Plate Shoot) (Note: Requires Set Survey and 3D tracking in Post)	3D CG Set Extension of Cliff 3D Digital Matte Painting	Digital Comp w/CGI	$25,500

Figure 5.3 In this shot breakdown, a column has been added to show the VFX Producer's initial digital shot cost estimate.

A Sampling of Ancillary Digital Costs

In addition to the compositing costs, the VFX Producer must also estimate a variety of ancillary costs that are part of the overall digital work. These can add a substantial amount to the digital budget. Here are some of the more common items that need to be taken into account.

Negative Scanning Costs

You'll remember that the visual effects breakdown contains a column listing the number of layers (meaning filmed elements) to be scanned. Scanning costs are charged by the frame, so the question now is how many frames long each layer is? Obviously, there is no way to know this with any precision at this juncture. To get around this dilemma, VFX Producers use an industry-wide rule of thumb that assumes that a shot runs 5 seconds, or 120 frames. (This is based on 24 frames per second).

To that we add what is called a handle, which is an extra bit of footage at the head and tail of each shot "for safety." Generally, the handle is a minimum of 8 frames at the head and tail for a total of 16 frames (handles may also be longer). Thus, when we estimate scanning costs, we assume that each filmed element is 136 frames long. If the VFX Producer used a spreadsheet program like Excel for the breakdown, it is now a simple matter to write a formula that totals the number of scan layers, multiplies that by 136 and then multiplies the result by the cost per frame (see Figure 5.4 for an example). As with all services, scanning costs vary and are negotiable, so the VFX Producer doesn't have to be shy about asking for the most favorable rate possible. At the time of this writing, scanning services ranged from $0.50 to $0.55 per frame, and they may well continue to drift lower as the technology improves.

To give you an appreciation of how rapidly these costs can escalate, assume you have 200 live-action plates (the scan layers in our example) to be scanned, and they run an average of 5 seconds each, plus 16 frames of handle, for a total of 136 frames per layer. At $0.50 per frame, that comes to $13,600 in scanning costs.

A question that sometimes comes up is, "What if the editor wants to use pieces of the same take several times? Do I budget a separate shot for every time the editor cuts back to it?" That depends. A general rule of thumb is that if there are more than 2 feet of film between cuts you budget each of them as a separate shot. The reasoning behind this is that we normally use eight frames of handles at the head and tail of each take when a shot gets scanned. If the cut back occurs with less than 2 feet between cuts, it's generally considered one shot. So if you have a greenscreen composite of a shot that runs a minute (90 feet) and the editor uses 10 seconds (15 feet) from the head of the shot and another 5 seconds (7.5 feet) from the middle or the tail, you would count that as two shots. But if the editor uses a piece from two different camera takes, this automatically becomes two shots.

On shows with many visual effects shots, you should also assume that a few elements will have to be rescanned. This can happen because the first scan did not turn out well, because the director or editor changed his or her mind and decided to use a different take, or for a number of other reasons. Sometimes, a 10 percent rescan rate is not unreasonable to add to your budget.

Lastly, most scanning facilities will charge a setup fee. This basically pays for someone (the line-up person) to take the negative supplied by production and prepare it for scanning. There is a certain amount of labor involved, and it is a delicate task since the line-up person must handle the original negative. As a general rule, the editorial department (negative cutter) will group the negatives of several shots together and send them in for scanning in batches. The number of setups, therefore, will be a fraction of the number of scan layers. A good estimate would be to assume that shots will be sent for scanning five at a time, so a formula for setups might be something like the number of effects shots divided by five times the cost per setup.

Figure 5.4 Example of ancillary digital shot costs. This section would normally follow at the end of the shot breakdown.

Example of scanning and recording costs

Total layers to scan	200		
Total VFX shots	100		
Total Digital Costs (Total from Excel budget)			
Scanning costs (based on $.50 per frame on 5 sec. per shot)			$ 13,600
Scanning setup costs (5 layers per setup)			$ 2,500
Re-Scans			$ -
Recording costs (based on $.75 per frame) (1 Temp/2 Finals)			$ 27,000
Film Lab charges/reprints			$ -
Grand Total of Above			$ 43,100

Recording of Final Shots

Recording is the last step in getting a computer-generated visual effects shot back out to film so it can be cut into the final negative. As with scanning, recording is charged by the frame. On average, record-out costs tend to be slightly higher than scanning, but they

can also be negotiated to $0.65 to $0.75 or less, especially if you have a high volume of work that you can guarantee a facility.

To continue with the example from above, let's assume that the number of visual effects shots that actually ends up in your movie is 100, each averaging 5 seconds for a total of 12,000 frames to be recorded out to film. An important point to be aware of in budgeting recording is that there are *no handles* when shots are recorded. That's because these are now final shots that are exactly the length they are supposed to be in the film. When we estimate recording costs, therefore, we do this on the basis of 120 frames only (again applying the 5-second-average rule) per shot. A simple formula (number of shots × 120 frames × cost per frame) will do the trick for coming up with a total for recording.

But the story doesn't end there. Whereas scanning is usually acceptable on the first try, that's not the case with recording. Visual effects shots typically have to be recorded two or three times before they are deemed acceptable (and that's not ounting the tests a vendor may record for his or her own purposes). In large part this is because digital artists view their images on monitors, and no matter how good a monitor is it is extremely difficult even for a discerning eye to see tiny flaws that only reveal themselves when the shot is projected on a theater screen. What's more, a shot may not "cut in" well with the surrounding scenes in terms of its color, density, contrast, graininess, and other qualities. So the first record-out may serve more as an opportunity to tweak the shot than as a final. Bottom line? By the time the 100 shots are approved, you will have added another $43,100 to your shot costs for scanning and recording. And that doesn't include additional items such as possible rescans and lab costs.

Most facilities that perform this service will also have a setup charge. As with scanning, finished effects shots are sent to the recording facility in batches whenever possible. But because final composites can sometimes dribble out of a visual effects facility one at a time, it's difficult to guess at a consistent average for the number of shots per batch. Three is probably as good a number as any.

In sum, taken together the costs of scanning and recording are not exactly pocket change, and because of this we recommend including scanning and recording in Excel breakdowns from the very beginning. (Normally they are listed as a separate line item and not part of the shot cost.) It's a simple step to insert a row at the bottom of the shot list and create a formula that adds up the total number of plates to be scanned and calculates the scanning and recording cost according to the figures you define. This way, these costs become part of the initial digital cost estimates.

Additional Workprints

Most features these days are edited on Avid, Final Cut Pro, Adobe Premier, or similar digital nonlinear editing systems. As a result, to see actual 35 mm film in editorial suites is less common

than it once was. But sooner or later the director and his creative team have to evaluate the effects shots on a big screen and decide whether they are acceptable. This means having to record the shots to film in order to get screening approvals for finals or outputting the digital files to 2K and reviewing them on a digital projector.

When working in film you should order two workprints. One workprint goes to the VFX Editor who sets up a reel with the day's shots for screening. The second print should go to the digital facility so that they will have an exact copy of what the production has. This allows the director or VFX Supervisor to discuss any given shot on the telephone with the vendor's artists and be assured that they are both looking at the same images. The cost of these extra workprints should be included in the initial digital shot cost budget.

In the case of shooting digital, workprints are not needed, but color-corrected digital files are sent as references to the visual effects facility. These color-corrected digital files may be given to you directly by the DP who may use his own color correction system on the set, or he may rely on the lab's colorist to give you color corrected files for approval.

Research and Development

Research and Development (R&D) is common not only in industry, but also in visual effects. Filmmakers are always hoping to create new, different, and exciting visuals, and so almost every project—from modestly budgeted independent films to major studio blockbusters—will need to do a certain amount of R&D for its visual effects. Whether it's highly sophisticated computer code or nothing more than a series of sketches developed in Photoshop, the VFX Producer needs to be aware of the potential need for R&D and put an allowance appropriate to the project in the budget.

Modeling and Texturing

We must remember that, in CG, an artist must build every object that's in a shot in the computer. In this respect, the digital artist is not unlike a model maker. But where the model maker uses wood, metals, plastics, and other physical materials, the digital artist uses computer code to build digital models that exist only in the computer's memory.

Once the object has been modeled, it must be textured and painted. Say, for example, that a shot calls for a medieval castle. An artist builds the castle in the computer, but at first the castle's stones and wooden beams will be nothing but smooth, monochromatic, geometric shapes. Recognizable, to be sure, but about as real as a Lego toy looks in comparison to the real thing. The bare geometric shapes will not look like stone or wood until they are textured and painted.

These items should also be included in your digital shot costs. The greater the number of digital models that have to be built, textured, and painted, the higher the budget will be.

SUCCESS STORY
Jenny Fulle - (*Apollo 13*; *Spider-Man 1, 2, & 3*)

My career in visual effects began in 1980, working as a janitor for George Lucas. I worked for Lucasfilm for over 8 years, moving from janitorial, to the mailroom, production assistant, and eventually VFX Coordinator. In those early days, the role of VFX Producer didn't really exist; VFX Coordinator was it. I continued to work my way through the ranks while working at such facilities as Boss Film, 4-Ward Productions, Digital Domain, Warner Digital, and Sony Imageworks. My first opportunity to work as a VFX Producer was given to me by 4-Ward Productions in 1992.

It was in the early 80's, working at ILM right out of high school, that I knew I wanted to work in VFX, and production in particular. It was impossible to resist the energy, passion, and personalities of those modern-day pioneers who were creating fantastic images for films that would entertain and touch the lives of so many.

The role of the VFX Producer is to create a synergy between the visual artistry and budgetary limitations so that vision of the film is given as much room as possible to be explored and brought to life within the context of a finite amount of resources. The traits that I have found most valuable in being effective as a VFX Producer are common sense, open-mindedness in finding common ground to work with a dizzying array of personalities, and ability to constantly multitask and look ahead. A good VFX Producer must be willing to help steer the direction of a project and take an active role in ensuring its success.

Facility Visual Effects Supervision and Management

It's common procedure for a digital facility (the vendor) to have its own VFX Supervisor present on the set to help supervise the shooting of live action plates for shots that the vendor will be creating. This works to the advantage of both the production and the digital facility. The producer is assured that a knowledgeable person will help guide the shooting of the plates (not to mention, there will be someone to hold responsible if things don't work out right), and the vendor feels more comfortable for having had a chance to make sure plates got shot correctly. A facility VFX Supervisor is usually charged on a daily basis. The fee tends to be in the $1,000–1,500 per day range, but can go higher when an "A" list VFX Supervisor is hired for the job.

Visual effects management cost represents the vendor's overhead, usually calculated on a weekly basis, which pays for the vendor's in-house production personnel who supervise and manage the project. Some vendors will amortize this cost across all shots, while others will show it as a separate item in their bids. Since a project may consume many weeks or even months of a digital facility's resources, visual effects production management may add up to a tidy sum. Each project is different in this regard, so a VFX Producer may have to make a reasonable allowance of about 15–25% for facility production management until she gets specific figures from a vendor. In lower budget productions this percentage will be less.

Preliminary Bids: Getting a Handle on the Digital Shot Costs

This brings us to the next topic, moving beyond the initial estimate and firming up the digital budget.

Once again, the VFX Producer may be at a minor crossroads. The producer's visual effects breakdown and digital cost estimate is complete, ready to be presented to the producer. If the project is still in its infant stages, the information may be enough for the producer and the studio to go on. More likely, however, the producer will want to explore how different vendors would approach the project and what they would charge.

As you move on to this phase, you will want to know where the producer is planning to do the postproduction for the film. Will it be in Hollywood (or wherever postproduction is based), another city, perhaps even abroad? Though geographic separation between postproduction facilities and the director's home base is no longer as much as a hindrance as it once was when it came to evaluating the visual effects work, it is still more convenient—and usually less costly—for them to be close to one another.

Budget Guidelines for Digital Work

Costs for digital services are in constant—and unpredictable—flux. One month they may go up because every facility is busy. The next month they're down because business is slow. One shop is desperate and will undercut everyone else, while another one is in Fat City and will quote you a high price just to make you go away or make you pay through the nose if you really want this facility to do your work. We therefore recommend that you shop around carefully before committing yourself to a specific facility.

Meanwhile, if you just need to put an initial budget together so that a producer will have a realistic idea of what the visual effects are likely to cost, here are a few guidelines.

• Matte paintings	$7,500–10,000 for a simple, locked-off camera matte shot, to a mid-range of $15,000–20,000 up to $25,000–35,000 or higher for complex, moving camera 3D CG created environments
• GS/BS composites	$3,500–7,500 depending on the complexity of the shot and the number of layers
• Simple 2-layer composites	$3,500–5,500
• Wire removals	$2,500 for one wire

- Additional wires $4,500 for two wires; more by quotation
- Simple split screens $2,500
- Scanning (Input) Approximately $0.50–0.55/frame
- Recording (Output) Approximately $0.65–0.75/frame

Incidentally, vendors usually include the cost of scanning and recording in their prices. However, the studios like you to show these as separate line items.

Casting and Evaluating Potential Vendors

At this point, the VFX Producer opens a dialogue with several digital facilities that are likely candidates to do the digital work. Whom to approach is a matter of individual preference and judgment. Over time, VFX Producers and supervisors become familiar with many digital facilities and learn their strengths and weaknesses. Drawing on their experience, they can quickly whittle down the field of potential vendors. Producers and directors, too, may have specific preferences, perhaps from having seen a company's work in the theater, having worked with a given company in the past, having been impressed by a demo reel, or having heard good things about a company from colleagues.

Facilities should be "cast" on the basis of who is right for the job, not just who turns in the lowest bid. Facilities get a reputation for being good at certain types of work. Some excel in compositing, some in matte paintings, some in 3D CG character animation or some other creative specialty. Casting for the right digital facility to do your visual effects is every bit as challenging as selecting the right DP for the show. Ultimately, the VFX Producer and Supervisor have to match the vendor(s) to the project—and perhaps more importantly, to the director's personality—and answer the question: Who is best for what part of the operation?

Quite often the choice of a digital facility is made by the studio and neither the VFX Supervisor nor producer has the influence to change that. Truth be told, studios often prefer to hire a large facility over a smaller one. The reasoning is that a large facility is more likely to be able to deliver the work, whereas they may wonder whether a smaller company will be in business long enough to finish the work. But there's another factor at work that few studio executives will admit: If things go wrong, a large facility may be worth suing for damages, while a small company wouldn't be worth the trouble.

You need to consider four main issues as you ponder that question:

- Does the vendor have the personnel and demonstrated capability to meet the *artistic* challenges of your project? Facilities differ substantially in their artistic and technical capabilities. This is not to suggest that Company

A does inferior work (we have to assume that you would only consider companies with good reputations to begin with) while Company B soars to artistic heights. Rather, it is to acknowledge that different companies are good at doing different things and you need to be aware of that. Additionally, a large company with many artists on its staff can more easily shift personnel to your project than a small one can when a tight deadline looms and the work isn't as far along as it needs to be.

- Does the vendor have the *physical* resources to cope with the workload? By this we refer to the number and type of workstations and software licenses. Does the facility have its own render farm, and if so, how many CPUs are dedicated to this function? Some shots on your project may be so dense with data that each frame can take hours or even days to render. If their render farm is a bit on the small side, does the vendor have ready access to an outside render farm that can take up the slack?

- Is the in-house supervisor personally a good fit with both your VFX Supervisor and the director? Keep in mind that these individuals will be working together for many months in a creative pressure cooker. It may be advisable for the VFX Producer to get these key people together for a few casual sessions so they can share their ideas about how they envision the effects and also to discuss the facility's workflow. You need to find out *before* you are committed to a vendor whether there is a sense of mutual understanding and respect between the director and your VFX Supervisor on the one hand, and the facility's creative leader on the other.

- Does the vendor have the *business and financial* resources to complete the job? This is no small matter when hundreds of thousands or even millions of dollars are at stake. Studios often prefer to work with large effects facilities because they have confidence in the team that runs the business side of the operation. With smaller vendors there's often the question in the back of the mind: Will they be in business long enough to finish the work? It doesn't happen every day, but it is not unheard of that companies go out of business in the middle of a project.

If you are not already acquainted with the vendor, you will want to check out their facility. This serves a purpose beyond simply seeing how many workstations there are or whether there's a fancy client lounge. A personal visit may give you an invaluable "feel" for the place. Almost everyone has had the experience of walking into a place of business and quickly sensing that it is a "cool" place to work. You may not be able to put your finger on why this is so, but you are more likely to get good work from—and enjoy a better relationship with—a company that maintains

a positive work atmosphere than from one where everyone looks grim as they go about their tasks.

Practical Steps in Checking Out a Vendor

Some steps in checking out a vendor are pretty obvious, such as what are the company's credits? Or how long has it been in business?

Ask for and review a demo reel. Be sure it is a recent one and shows work that was done mostly by artists currently employed by the company. No use looking at great effects if the artists are now applying their talents elsewhere.

Check out the company's website. Almost all companies in the visual effects business nowadays have one. Its design can give you a hint of the company's artistic capabilities.

Other, more specific, questions you may want to ask are

- How many staff artists does the company have, and what are their specific skills?
- To what extent will the vendor have to hire freelance people to do your work, either for the length of the project or for specific skills like modeling or animating?
- How many workstations are there, and what software programs does the vendor expect to use for specific tasks?
- If your project involves a great deal of digital animation or other tasks that are best done by a specific program (such as Maya), how many licenses does the vendor have for that software?
- What support services will the company have to farm out?

The Importance of Artists

There is a line in the movie *Jerry Maguire* (1996) that was oft repeated by the character played by Cuba Gooding, Jr.: "Show me the money!" Let us paraphrase this here and say "Show us the artists!" By this we mean that the artists are the driving force in any digital facility. But the workforce in our industry is highly fluid. Artists follow the work from facility to facility, from project to project. You should not rely on your experience at a given facility from a few months ago and assume things are still the same.

So when it comes to evaluating a vendor, even one that you worked with before, it pays to ask for a demo reel of his *current* artists. It is not uncommon that a company may want to coast along on work that was done by artists no longer in its employ. You can't entirely blame the vendor: He wants your work, and so he is going to show you the company's best stuff. But you want to be assured that examples shown on the demo reel were actually created by artists who will work on your project.

You should also find out whether they did the work featured on the demo reel at that facility or at a previous employer. It can make a difference in how the artist will perform at a new place. And if there's an artist that you've worked with before and you admire his or her work, be sure that he or she will be assigned to your show. You may even want to make that a condition in the contract with this facility. It is your prerogative, even your duty, to press that issue.

In part, your choice of potential bidders will be determined by the type and number of visual effects the project calls for. Is Facility "A" especially good at creating 3D CG environments? Is Facility "B" particularly adept at 2D compositing? What are the potential vendors' strengths and weaknesses? The talent to create and animate a photorealistic furry creature acting alongside humans (think *The Chronicles of Narnia*) is different from what's needed to do competent wire removal (think almost any martial arts movie). A vendor shop may be capable of handling 30 shots, but not 100, in the time allotted for postproduction.

The budget range of the project will also be a factor. Every director wants the best-looking effects of all time for his picture, but he or she needs to face the fact that a low-to-medium budget film may not be able to afford the top tier of digital effects facilities. And even though the technical and creative proficiency of most digital effects companies has risen to a very high level, there still will be some differences that are due to budget constraints. "You get what you pay for" applies in this business, too. Even so, resist the temptation—and pressure from others—to settle for a low-cost bidder if gut instinct tells you that company is not right for the job. If the director isn't going to like the work, it doesn't matter if it's cheap.

After you have decided on who should be invited to bid on the work, you will now want to contact potential bidders to go over the project with them and find out whether they would be interested in bidding on it. Assuming the answer is yes (as it usually is) it is now time to send out the bid guidelines.

Bidding Guidelines: Comparing Apples to Apples

If there is one general rule that applies to inviting bids it is that all bidders should be treated equally. They should all receive the same visual effects breakdown (without the VFX Producer's cost estimates, of course) to work from, the same storyboards (if any exist), and the same specifications, and should be permitted the same access to the director or other key personnel to ask questions. Without even-handed treatment it will be difficult for the VFX Producer to discern who is offering the best value.

"Best value," incidentally, does not mean "lowest bidder." You should not assume that a vendor who comes in with a low bid would be the best choice for the job. Many factors besides money enter

into judging what constitutes best value: the quality of the artists, the company's track record, financial stability, location, trust and confidence, and other factors. Deciding among more or less equally qualified bidders is a delicate task, made all the more so because we are dealing not with a standardized product rolling off an assembly line, but with aesthetics. Recommending and sometimes deciding on a digital facility for a major visual effects project is one of the most critical decisions facing a VFX Supervisor and VFX Producer.

What usually happens during this bidding phase is that vendors come back to the VFX Producer with questions. Fair enough. A breakdown, storyboards—even conversations with a director— won't necessarily clear up all the uncertainties concerning the body of work being bid on. The VFX Producer must do her best to answer the questions fairly for all.

It will also quickly become evident when certain vendors take themselves out of the running for certain shots. Unlike a mega-visual effects facility that employs dozens or even hundreds of highly skilled artists of every stripe, smaller vendors with equally skilled artists may decide that the overall number of shots is greater than what they can take on or that their company is not suited to do a certain type of digital work. Consider, for example, the difference in skills required to create set extensions and matte paintings versus those required to create 3D digital character animation.

To deal with bids from several vendors the VFX Producer needs merely to add additional columns—one for each vendor—to the breakdown sheet that went out to the various bidders (assuming you used a spreadsheet format similar to what we described earlier). Ideally, the VFX Producer and Vendor would both use the same software in their work, thus making the exchange of information via computer disk or e-mail a snap. If they use incompatible programs, there may be no alternative but for the VFX Producer to manually enter the vendor's prices in the right place.

In Figure 5.5, one column seen in the shot breakdown in Figure 5.2 was omitted for convenience, and three new columns showing prices bid by three vendors were added. Note that Vendor 3 has chosen not to bid on two shots that require expertise in 3D CG water and storms, but bid the lowest price on shots requiring matte paintings.

For this reason the VFX Producer should insist that the bidder use the same visual effects breakdown that was provided to bid on, even if the vendor decides not to bid on certain shots. Instead of a price, the vendor should simply enter "0" in that slot, but not omit the shot from the breakdown. This is important because that way every vendor's shots and budget figures will line up on the breakdown sheet. Just imagine the hodge-podge the VFX Producer would end up with if a few lines were missing here and there in the breakdowns that are returned by different vendors (see Figure 5.5).

Sc.#	VFX #	Description	# of Scan Layers	Plates/Production Elements	Digital Elements: CGI/Matte Painting	Methodology	Vendor 1	Vendor 2	Vendor 3
8	V8.1	EXT. GERMAN SUBMARINE-MID-OCEAN-DAY-The Captain and his Number Two and a Spotter are on the bridge. They peer out across the Atlantic with their binoculars. The waves are so big, they look as if they threaten to break the boat apart.	1	GS Plate of Captain, Number Two, and Spotter on bridge set piece (Note: SPFX to rig water spray)	3D CG Ocean 3D CG Strom Waves 3D CG Spray Digital Matte Painting of sky	Digital Comp w/CGI	$35,000	$23,500	$0
39	V39.1	EXT BRIDGE-U.S. DESTROYER-DAY-The Captain of the destroyer stands next to a Spotter, who looks through his field glasses at the German U-Boat.	1	GS Plate of Captain and Spotter on set piece of Destroyer	3D CG Ocean 3D CG Strom Waves Digital Matte Painting of sky	Digital Comp w/CGI	$35,000	$23,500	$0
70	V70.1	EXT PARADISE SPRINGS INTERNMENT CAMP-DAY-The truckload of new prisoners pulls up to the gates of the camp.	1	Plate of Internment Camp (Note: Requires Set Survey and 3D tracking in Post)	3D CG Set Extension of Internment Camp 3D Digital Matte Painting of mountains and desert	Digital Comp w/CGI	$25,000	$26,700	$21,250
152	V152.1	EXT.DESERT-NIGHT-The Captain is galloping the horse through the desert. There is no more thunder and lightning.	1	Plate of the Captain galloping	CG Lighting Possible Sky Replacement w/rotoscoping around the captain	Digital Comp w/CGI	$5,500	$6,500	$4,625
179	V179.1	EXT. GULF OF CALIFORNIA-SUNSET-We are coming down a trail, then they pass by camera, we see the patrolman is leading a second horse with the dead body across it. Camera pans to reveal that the trail leads out on to a beach on the Gulf of California.	2	Plate of patrolman on horseback leading the Captain and horse with the dead body Plate of Expanse of Gulf of California (Note: Possible use of Enclosed Crane for Plate Shoot) (Note: Requires Set Survey and 3D tracking in Post)	3D CG Set Extension of Cliff 3D Digital Matte Painting	Digital Comp w/CGI	$25,500	$27,800	$22,000

Figure 5.5 VFX breakdown with bids from multiple vendors.

In the best of worlds, your bid package will include storyboards of the shots vendors will be bidding on. But since ours is an imperfect world, there will be times when potential vendors will have only a written description of the shots to go on. Under this scenario, vendors will sometimes group shots according to their estimated degree of complexity (e.g., low, medium, high). They will then assign a dollar value to each group of shots and submit a preliminary bid based on those values.

As imprecise as this estimate may be, it can serve a very useful function when a script is still in development. Using the "complexity scale" the producer can go to the writer and ask him or her to modify the script's next draft to reduce the number of highly complex—and therefore expensive—shots, thereby lowering the overall budget and increasing the chances that the film will get made.

Following Up

After receiving the bids from the vendors, the VFX Producer should review the bids carefully, compare them with one another, and then question vendors on items that catch his or her eye. Why, for example, might one shot cost X dollars when another, essentially identical, shot is bid at Y dollars? Do any costs appear greatly out of line from what the VFX Producer expected? If so, she must not only question the vendor but must also examine his or her own assumptions to see if they were correct in the first place.

The answers may be perfectly reasonable and the discrepancies quite innocent. Nevertheless, the VFX Producer should discuss them frankly with the vendor and give the company an opportunity to revise—or defend—its figures as it deems appropriate. Bidding is as much art as it is science, and fairness to all should carry the day. Then, at the end of the process, the VFX Producer can be confident that she and the VFX Supervisor can make an informed judgment on which company is offering the best value.

Sometimes a potential vendor will come back with a wildly different bid than the others. At such times, you have to ask yourself, did the bidder miss something critical in the way he interpreted the shots? Or is it a sign that the vendor is truly seeing ways of doing your shots that neither you nor the VFX Supervisor thought of? If the bid is exorbitantly high, is the vendor simply charging too much or does he truly think that the shots justify the high price? If the bid is too low, is the vendor trying to "buy" the work in the hope of getting more work from you later when he plans to charge a much higher rate because you are already committed to that vendor (a common occurrence in any business)? In all bids, the VFX Supervisor and VFX Producer must make the scope of the project clear to all vendors. If they don't understand what you want, the bids you get back will not be reliable.

If the vendor simply missed something, and you are aware of the oversight, it is perfectly OK to draw the vendor's attention to it. You're not giving away a competitor's data, simply correcting a potentially material oversight. For example, if you're soliciting bids to composite a number of greenscreen shots that put a lot of responsibility on the vendor who will do the compositing, and the other bidders built in the cost of their on-set supervisor but this vendor did not, he should be alerted to that. Otherwise the vendor may be held to a contract that he unwittingly underbid. Or worse, you may accept his bid only to be informed after the job is awarded and the day of the shoot draws close that the cost of an on-set supervisor was not included.

Other sources of discrepancies may be as simple as a typographical error. It's pretty easy to omit a zero in a column of numbers… or to put in an extra one. Either way, that item will be off by one order of magnitude. If you spot that error (and you or someone on your staff should check all the numbers carefully), you are bound by good business ethics to give the vendor a chance to correct the error. (As an aside, you may find that some contracts include a clause that contains words to the effect that "vendor shall not be responsible for typographical errors.")

One or more visits to a potential vendor's facility are almost a must when you are casting for vendors; it's not enough just to interact with your counterpart at a facility via telephone, e-mail, or demo reel. There's nothing like going out there to "kick the tires," so to speak. A visit to a vendor will give you and the VFX Supervisor (who should be part of this expedition) a sense of the vendor's working environment. What does the place look like? How many workstations are there? Do you get the feeling that it is a decent place to work, or does it feel like a digital salt mine? Granted, catching these impressions is a bit tricky, but humans have a built-in antenna that often gives us a valid impression of another person or company. Just be aware of one factor: When the vendor knows you are coming, he will put his best foot forward to impress you. It may take some judicious questioning and prodding—and possibly more than one visit—to get past that veneer.

Another factor to consider when you plan to spread your visual effects work among several facilities is whether their software programs can talk to one another. By this we mean, can some of your potential vendors share data and move it back and forth between them? Not so many years ago that would have been nearly impossible as every facility ran on a different computer code and actively tried to protect its secrets. This has changed. Today, commercial software packages like Maya, RenderMan, Boujou, and so forth are ubiquitous; digital artists all over the world are experienced using them. And even proprietary code that was first written specifically for a facility's project may, if it was successful, be offered for sale to all comers.

Clearly there are some advantages in interfacility compatibility. It opens the door to taking advantage of the strengths of different facilities and can also be a useful safety valve in case a vendor falls behind schedule and you feel that shifting some of the work to another vendor will relieve the bottleneck.

Budgeting Miniatures

When you are called upon to budget the miniatures for a project, you are best off soliciting bids from reliable vendors with a strong track record. If you try to "guesstimate," your chances of getting it right are pretty slim unless you have had experience working with miniatures. It's a lot like asking how much it costs to build a house; the variables are simply too great. For example, if you expect to film a miniature city street that has some cars parked in the deep background, your vendor can buy toy car models for a few dollars each, have them repainted, and put them on the miniature set.

But if he had to build a one-eighth scale photorealistic model of a specific car—even one that remains parked or is seen only in long shot—it is likely to cost about $25,000. For that you might not get much more than an existing "kit" car artfully modified with the required customized details. And if you need that model built at a quarter scale or larger with functional headlights, a puppet driver capable of moving his head, and a working wheelbase so that the model can interact realistically with the road, you may be looking at a $50,000 to $75,000 cost just for the car.

Therefore, before you start soliciting bids you should have a clear understanding of what miniatures the production will need so that you can communicate that to a potential vendor. There are a number of pieces of information the vendor will need:

- How many different miniatures are to be built?
- What is the scale of the various pieces?
- What kinds of actions must the miniatures be capable of performing?
- How many sides of each miniature have to be fully detailed?
- Will you need mounting points for the model for motion control shots, and if so, how many?
- Will you need miniatures of the same object for both beauty and stunt shots?
- If you plan to blow up any of the miniatures, how many spares will you want?
- How soon do they have to be ready?
- Where will you shoot them?

You can provide this information only after the director, the VFX Supervisor, you, and possibly the production designer have analyzed the shots. Accurate storyboards are essential in this process, and production illustrations are highly desirable because they tell a vendor what the miniatures should look like. The storyboards will

help define camera angles, scale, and level of detailing and answer other questions about the miniatures. If your budget permits, have a previs made that shows the action the miniatures are to perform and how they might relate to live-action or CG elements. This will be invaluable to a vendor as he prepares the bid and a great asset to you because a bid based on a previs is apt to be much more reliable than a bid based only on storyboards.

Another factor that you will have to consider is the scale at which your miniatures should be built. This often becomes a compromise between cost and size because larger usually means more expensive. As a general rule the VFX Supervisors will want the miniatures to be as large as possible. If the miniature is of a moving vehicle, one-quarter to one-fifth scale is usually acceptable, whereas a miniature for a wide shot of a city might work quite nicely at one-twenty-fourth or even smaller scale. All these considerations will impact your budget.

On rare occasions you may be able to rent existing miniatures from a miniature builder, studio, or even a private collector and adapt them to your needs. Sometimes a miniature company stores generic-looking miniatures and brings them out again for another project. This applies primarily to miniatures of relatively common objects, such as air- or spacecraft, ships, vehicles, and buildings. If your project calls for miniatures of that type, it would pay to ask your vendor about repurposing previously existing miniatures as this could reduce your costs significantly, even when you factor in the cost of repainting the miniature to suit your needs.

One of the decisions the VFX Producer and VFX Supervisor will have to make is whether shooting the miniatures should be outsourced to the miniature construction company (a service that many of these companies offer), or whether it would be better to assemble your own miniature shooting unit. There is no clear-cut better way; it depends on the situation. You will probably have to prepare several comparative budgets before the preferred path becomes clear.

Because the costs of building and filming miniatures encompass such a wide range it is virtually impossible to give any meaningful budget guidelines. Suffice to say that the cost of a mid-range miniature shoot on a stage may cost roughly $25,000–35,000/day for prep and set-up, and can range between $40,000–45,000/day for the shoot, about $20,000 for the strike. A pyrotechnic effects shoot on stage can cost up to $10,000 more per day. And if your miniature effect is so large that it requires a water tank, hangar, warehouse, or very large exterior space with clear horizons, then all those day-cost estimates can easily double. If that seems like a lot, keep in mind that shooting miniatures often is not all that different from a normal 1st Unit shoot. Much of the time, you'll need the same type of crew and equipment as the 1st Unit, with specialized technicians for high-speed or motion-control effects. Model makers take the place of set dressers, and you rarely will need departments such as sound,

script, or transportation and usually none of the talent "vanities" such as make-up, hair, and wardrobe, so your overall unit will be smaller and will therefore require less logistical support. So where a 1st Unit may consist of more than 100 crew members, a miniature crew is not likely to exceed 50.

SUCCESS STORY

Lori Nelson - (*Fast and Furious; Men in Black II*)

Right after graduating from high school, I started going to college and looking for work to make ends meet. I applied at a temporary employment agency....One day the agency...asked if I would be interested in being the receptionist at ILM. I started off answering phones, writing response letters to potential employees....and giving tours of the facility. Working at ILM in those days was great training for my future as they had very high standards. One day they asked me a question about how to do something which was a bit of a test to see if I would be a good candidate to be promoted into the newly created Optical Coordinator position. I passed and was moved into that position. I loved that job.

Through the years I had made connections with people in Los Angeles and went to work at Boss Films. I did three movies at Boss....It was a great time in the business but optical work was dying out and digital work was becoming the new medium.... In 1993 I was hired to be the editorial coordinator on *Last Action Hero*...and I was beyond thrilled.

The most important duties of the VFX Producer: Anticipating issues and resolving them before they become problems are key to successful producing...but I like to avoid problems as much as possible. Organization is key, knowledge of how films are made, how studios function....I feel that being fair and honest are very important.

I can't imagine doing a film without my database. At this point in the movie business and with budgets so tight, a database can save a lot of money.

SCHEDULING AND BUDGETING PRODUCTION SUPPORT

To be sure, digital shot costs are an important part of an effects-heavy picture's budget. It has been convenient for us to deal with them first because they are so directly linked to the visual effects breakdown. But as we alluded to in the section on "Getting Started," they're only part of the story. The other—and actually much more complex—part is the scheduling and budgeting of all the production support—meaning the whole gamut of items pertaining to crews, personnel, equipment, facilities, purchases, rentals, and what-have-you that is needed to bring the visual effects to the screen. This is the thread we now follow.

The Production Support Breakdown Sheet

Just as the main production unit prepares a complete production breakdown sheet, so the visual effects department should prepare its own breakdown that focuses on its own specific needs. You may say, "But we already did a visual effects breakdown! What do we need another one for?" The reason is that although the first one *does* list all the visual effects shots, it deals only with items related to their digital shot costs. This second breakdown sheet lists the *production* needs (*labor and equipment*)—that is, items that you will actually need on set while shooting the plates or that other departments must be aware of relating to the visual effects.

Using Movie Magic Scheduling

Virtually all production breakdowns nowadays are prepared with the help of computer programs designed for this purpose. Probably the most popular and versatile of these is *Movie Magic Scheduling*. The program allows the user not only to schedule all the shooting, but also to prepare any number of different reports and breakdowns suitable for different purposes. We can take full

advantage of the program's capabilities and turn them to good use in visual effects production.

The visual effects production support breakdown sheet should mirror the main production breakdown in most respects, except for two things:

1. It contains only those scenes for which a visual effects element must be filmed, and
2. It lists only production items needed for each visual effects shot.

In other words, we won't bother with scenes that our department is not involved in (such as a dialogue-only scene), nor will we list items on our sheets that aren't visual-effects related (such as picture cars or hand props).

This is where the help and cooperation of the 1st AD is essential. Chances are that the 1st AD will have prepared the production breakdown sheets by the time the VFX Producer is ready to prepare his or hers. The producer should ask the AD for that production breakdown in order to integrate the visual effects with it.

The simplest way to do this would be to work with the 1st AD's existing breakdown sheets. You get a copy of his or her computer file and add the visual effects department's requirements on the same breakdown sheets that the 1st AD has prepared. When finished, you give the completed file back to the 1st AD. This has the virtue that everyone can work off the same breakdown sheet for everything, and therefore no extra breakdown sheets are created to add confusion.

This approach, however, is subject to some *caveats:*

- The VFX Producer must get the 1st AD's approval ahead of time, because no AD wants his or her breakdown sheets changed in any way without prior knowledge.
- The approach works only if the visual effects needs are relatively modest and there is an appropriate category on the breakdown sheet to enter the items.

Because of script and other changes, the 1st AD has to repeatedly update his or her breakdown sheets. In the process, visual effects elements may get overlooked.

Therefore, you will almost certainly be better off creating your own breakdown sheets even though it will take some extra effort. You can still use the 1st AD's production breakdown sheets—which already contain a lot of information you will need anyway—as a template. This will make it easier for you to address only the visual-effects-related sheets and pass revisions on to the AD as you make changes.

VFX Breakdown Sheets

Let's now look in some detail at how we can adapt Movie Magic Scheduling Breakdown functions to generate a visual effects breakdown.

Delegating

 If a show calls for a sufficiently large number of visual effects to justify hiring an AD just for the VFX Department, the task of doing the breakdown could be delegated to that individual. However, the VFX Producer should go over the completed breakdown sheets before passing the breakdown on to the 1st Unit AD to make sure nothing important was overlooked.

When the VFX Producer gets a completed production breakdown sheet from the 1st AD it will probably be missing most, if not all, information pertaining to visual effects. It is now up to the VFX Producer to supply the details.

As the first step we suggest that you duplicate the breakdown sheets that involve visual effects. One of the first things you will notice on the duplicate sheets is that a letter has been added to the original Breakdown Page number, while the rest of the information remained the same.

You are now ready to add the pertinent effects information. But here we encounter another level of complexity. First of all, one *scene* may contain several effects *shots*, and each shot may need several *elements*. A simple option for handling this in the breakdown is to list *all* visual effects plates for a shot in the Visual Effects breakdown box. This results in only one visual effects strip for that shot. 1st ADs usually prefer this option because they have to deal with only one visual effects strip per shot.

For the VFX Producer, however, that may not be enough. Ideally, you want each element to have its own breakdown sheet. The reason is that each *sheet* also represents one *strip* on the strip board. This is crucial for the VFX Producer in scheduling the shooting of the elements. Because different elements are usually filmed at different times and places, if you forget or omit a breakdown sheet, you may forget to shoot this element.

Preparing the VFX Breakdown

Now let's see how this might work in practice. Figure 6.1 is an example of a breakdown sheet. Instead of just the simple entry "Visual Effects," the VFX Producer has added a number of items to reflect what she and/or the VFX Supervisor decided are necessary: plates—including clean plates, if any—that need to be shot, green or blue screens to be used, whether motion control will come into play, and whether the shot will need wire removal in postproduction.

This breakdown sheet covers visual effects shot number 1 for Scene 15. The *breakdown page* is now 1A, the "A" having been attached automatically when the AD's breakdown sheet #1 was duplicated. Also, the page count is left at zero for all visual effects breakdown pages so as not to alter the overall page count in the production breakdown. In visual effects we are not concerned with the script page count.

Additionally, the VFX Producer modified the *scene description* to reflect the action that is occurring in this particular plate. Whereas the original production breakdown described the *overall* action of the whole scene, the visual effects breakdown states what is to happen in this particular plate. Two principal characters were needed for this plate shot, Captain Jock McFarley and Ensign Holly Rogers. To complete the information for this shot, the

An assumption

We assume that the reader is already familiar with Movie Magic Scheduling or a similar program and knows how to access various menu functions. We will, therefore, focus our discussion on features and tricks that apply mainly to visual effects and show you how to apply them to scheduling your effects shooting.

Scene # V15.1	**FALSE HORIZON**	Date:
		Bkdown Page# **1A**
Script Page 5		Int/Ext: INT
Page Count	Breakdown Sheet	Day/Night: Day

Scene Description: McFarley and Rogers in cockpit looking out GS window

Setting: Space Freighter-Cockpit - (Greenscreen)

Location: Freighter Hull Set (Stage 2)

Sequence: Spotting Comet Script Day:

Cast	Extras	Props
1. Capt. Jock McFarley 2. Ens. Holly Rogers	Deck Crew (4)	3D Digital Map Display Computers and Monitors (4)

Special VFX Equipment	Costumes	Makeup
20' X 80' Greenscreen Digital Video Assist Encoder Head High-Speed Camera Motion Control Equipment	McFarley's Uniform	Scar on Face
	Set Dressing	**Special Effects**
	Flat-Screen Display Monitors	Rig Motion Base for Cockpit

Visual Effects
3D CG Matte Painting of Planet Surface
CG Comet
CG Engine Exhaust
CG Sky Replacement
CG Space
GS Plate Captain and Co-Pilot in Cockpit
Tracking Markers

Miniatures
1/32 Scale Ophichus Terrain
1/4 Scale Shuttle Craft

Notes

12 Flat-Screen Video Displays	Display graphics needed 5 days before shoot
24-frame Playback	Tracking Markers

Figure 6.1 Customized breakdown categories: The Miniatures, Visual Effects, and Special VFX Equipment categories were created from unused categories available within the Design > Categories function of Movie Magic Scheduling.[1]

VFX Producer also listed the other visual-effects-related elements that will be required.

If the shot requires other visual effects elements, we simply duplicate the sheet again and modify the additional sheets to reflect what is needed for that particular plate, but keep all the basic information.

[1] Screen shot created using Movie Magic Scheduling software owned by DISC Intellectual Properties, LLC. For more information, see http://www.entertainmentpartners.com/products_and_services/products/mm_scheduling/support/.

Later, when it comes to working with the strip board for the project, you can display some of the information in the breakdown sheets in abbreviated form, depending on how you want to modify your strip board design. This will make the visual effects items specified in your strip board layout easier to see when you do your schedule.

Depending on the complexity of the project, the VFX Producer may choose to add one or more special boxes to further break down the visual effects elements, using one of the "Unused Categories" from Movie Magic Scheduling. You might, for example, want a special box to list miniatures, animatronics, or special visual effects equipment as shown in the above example. This latter category may be especially useful because of the variety of specialized gear used in visual effects photography. Much of this equipment may not be familiar even to experienced 1st Unit ADs and crews, and listing such equipment in the breakdown will serve to alert other crewmembers.

Among the most commonly used special visual effects equipment are green or blue screens; set survey equipment; motion control dollies or cranes; VistaVision, timelapse, or high-speed cameras; digital video assist with mixing and frame storage capability. Listing these special items can be of enormous help to the 1st AD because he or she can take note of them when preparing the call sheets and make sure the items will appear on the shooting schedules right along with other production requirements.

> **Sharing the breakdown**
>
> If only people in the Visual Effects Department will use the breakdown sheets, it is perfectly OK to list digital elements along with live-action elements. But if you expect to share your breakdown sheets with other departments, you may want to omit the CG elements. That way, only visual effect plates that must be filmed by the 1st Unit will show up on reports like a Day-out-of-Days.

Stand-Alone VFX Elements

So far we have assumed that you are adding visual effects breakdown sheets to an existing 1st Unit production breakdown that give the information you and other departments need to make sure the required visual effects plates get shot during principal or 2nd Unit photography. The breakdown sheets you created for this purpose can, for the most part, simply be added to the existing sheets.

In visual effects, though, we often have to shoot plates independently of the 1st or 2nd Units. These situations arise when, for example, a project has numerous stand-alone miniatures (i.e., in-camera miniatures that don't need any live-action elements to augment them), or when a separate crew is sent out to shoot aerial plates, background plates for matte paintings, or any kind of plate that might later be integrated with computer graphics, but no live action.

In situations like these, the VFX Producer generates a separate breakdown sheet that lists only elements needed for these stand-alone plates. It is no different from any other visual-effects-related breakdown sheet, but it is important to take this

step to make sure that no element gets overlooked. Also, by creating these breakdown sheets, the VFX Producer can readily use the strip board mode in Movie Magic Scheduling to schedule the shooting of stand-alone plates.

Scheduling the Shooting of Your Effects

Now that the information has been entered into the breakdown sheets, the VFX Producer can proceed to scheduling. This is done via the strip board function in Movie Magic Scheduling or another scheduling program you may be using.

Scheduling is as much art as it is science. It involves both guesswork and shrewd calculation, and sometimes you have to depend on other parties to advise you about how long it may take to "shoot out" a given setup. There are no hard-and-fast rules here, except to say that scheduling needs to be approached with common sense and an analytical mind so that the work can be accomplished in the most efficient way.

When it comes to the shooting of visual effects plates, we need to distinguish between two types of schedules. One is the scheduling of elements that are to be filmed by the 1st or 2nd Units (i.e., all the plates that involve principal actors and other live-action elements that are part of principal photography). The other type is the scheduling of plates and elements that are to be shot by a separate visual effects unit working independently of the 1st Unit. This might involve miniatures, background plates, aerial plates, and elements for compositing. There are some significant differences between how the two types of schedules are handled.

Collaborating with the 1st Unit

It is one of the thinly disguised truths of film production that there frequently is some resistance to the visual effects department and its needs. Keep in mind that ADs are always under enormous pressure to keep the production on schedule (to "make their day"), and many ADs may not be—and shouldn't be expected to be—familiar with all the special needs of the VFX Department. Yet visual effects often *do* take extra time to set up, and often *do* have special requirements. As a result, visual effects people are sometimes perceived as the guys who always hold up the shooting.

It is also a fact that the visual effects department has to rely heavily on the 1st Unit for much of its production support. This applies not only to certain types of equipment, but also to the occasional "borrowing" of members of the crew. An independent or low-budget production, for example, may not have the luxury of carrying a separate camera package with its attendant crew dedicated to shooting visual effects plates. The result is that the

Numbering breakdown sheets

When you are numbering the visual effects breakdown sheets, you might want to ask the 1st AD or UPM what the highest number is on his or her breakdown, then start the VFX sheet numbers slightly above that (say, at the next 10, or the next higher hundred break point). This is a simple way of easily distinguishing between production and visual effects production support sheets.

1st Unit may occasionally have to divert some of its resources to the visual effects department.

At such times, you must rely on your diplomatic and negotiating skills to get what you need. For this to happen successfully, you should work diligently to obtain and keep the crew's cooperation, from set PA on up to the director, and especially with the ADs. Just as in any other business endeavor, you should not—you cannot—ignore the importance of maintaining good human relations. There are a number of practical steps you can take to make the system work more smoothly.

Communication—Key to Smooth Sailing

Of foremost importance when working with the 1st Unit is communication. You must communicate freely, often, and clearly. Keep everyone in the loop, particularly the ADs who frequently are swamped and may know little about visual effects needs unless you tell them. Advise the ADs and other departments *in writing* of what they will need to provide for a visual effects shoot. Will they need to hire additional grips or electricians to set up and light a green screen? Will the camera department need to rent special cameras and lenses? What about Special Effects? What kind of mechanical effects might need some digital enhancement?

All these needs must be addressed, and the sooner you let people know what you will need, the better. Send memos to every department that will be affected, with courtesy copies to the producer and UPM. The other departments will appreciate getting the information because it avoids last-minute surprises, makes their jobs easier, and helps make everybody look good. And quite frankly, it is also good self-defense, because by putting the information in writing, the VFX Producer makes sure that the information will get on the call sheet.

Think ahead! How far in advance should you let another department know that you will have a certain requirement coming up, be it tomorrow or in 3 days or 3 weeks? Some things take a long time to get ready, or equipment must be reserved way in advance. Whatever the situation may be, it's up to the VFX Producer to keep a close watch on the timeline so that nothing gets overlooked. Write yourself notes, use Post-Its, or use a program like Outlook to help you manage the tasks.

Earlier we alluded to the fact that effects often take a bit of extra time on the set. With the help of the VFX Supervisor, the VFX Producer should assess each plate shoot and estimate how much extra time it may take to acquire the various elements. We are talking here not so much about how long it may take to shoot a dialogue scene that also happens to be a live action element for, let's say, a matte shot. Rather, we are talking about visual effects

elements that the 1st Unit may not know about unless you tell them in advance. Among these elements are empty background plates that may be needed for wire or rig removals, reference plates that may capture a given bit of action to show to digital artists so they can match digital animation to it, lighting references of chromed or white spheres for matching the lighting in the computer, and cubes made of plastic pipes of a known length to show scale.

Other special visual effects activities that aren't part of a normal live-action shoot are motion control setups, traveling matte shots (i.e., blue- or greenscreen shots), and set surveys. A lot of progress has been made in recent years to make these procedures faster with the help of new technology. But even so, it is essential to let the 1st AD or UPM know well in advance what adjustments the 1st Unit will need to make.

Scheduling 1st Unit Shooting

The 1st Unit's schedule is almost exclusively the AD's responsibility. Shooting schedules are notorious for being in constant flux. There is little the VFX Producer can do about this except to adjust to them. The 1st Unit's schedule takes precedence because the live action must get shot according to the production company's needs. On every well-run production, there will be a high level of collaboration between the 1st Unit—primarily involving the 1st AD and DP—and the visual effects department—mainly represented by the VFX Supervisor and VFX Producer—to assure that no visual elements will be overlooked.

But there *is* one important area where the VFX Producer can do his or her best to influence the 1st Unit's schedule: she can lobby for visual-effects-related scenes to be scheduled as early as possible. The advantage of this should be obvious: It may take weeks, or even months, to generate the digital effects for a feature, so the sooner the live-action shots can be turned over to a vendor to begin his CG work, the less panic there will be later on when both money and time run short in postproduction, as they often do.

Working with a Strip Board

Figure 6.2 shows an excerpt from a simple and greatly abbreviated horizontal strip board. What you see here is extracted from the breakdown sheets that the AD, using Movie Magic Scheduling, prepared for the first four scenes of the shooting schedule. This is as much information as a 1st AD might put on his or her strips. If you were to look at the matching breakdown sheets, you would see the same information, just in a more elaborate form. Here, the information is quite straightforward: breakdown sheet and scene numbers, summation of what the scene is about and where

	**Begin Production - March 16, 2009**						
	**Calvert Studios - Stage 2**						
1	15	INT	Space Freighter Cockpit McFarley spots tail of comet in distance	Day	1 1/8	pgs.	1, 2
13	21	INT	Freight Deck (Breakaway Set) The space freighter's hull breaks open	Day	1 7/8	pgs.	3, 4, 5, 6, 7
14	23	INT	Freight Deck - (Greenscreen) Aftermath - ship has crashed on Planet	Day		pgs.	
	**--- END OF DAY 1 -- Mon, Mar 16, 2009 -- 3 pgs.**						
	**--- END OF DAY 2 -- Tue, Mar 17, 2009 -- pgs.**						
47	89	EXT	Wrecked Fuselage - Shelter Survivors argue; McFarley is angry at Misha	Day	2 3/8	pgs.	1, 1A, 2, 4, 4A
	**--- END OF DAY 3 -- Wed, Mar 18, 2009 -- 2 3/8 pgs.**						
	**--- END OF DAY 4 -- Thu, Mar 19, 2009 -- pgs.**						

Figure 6.2 This excerpt from a standard horizontal stripboard shows how the AD has scheduled three scenes for the first 4 days of shooting.

it is set, how many script pages it runs, and who is in it. There is no hint here that the scenes might involve visual effects.

Let's assume now that the VFX Producer has prepared the visual effects breakdown sheets listing the production support that will be needed on set for every visual effects shot. At this point, she is ready to work with her own strip board.

Where the AD only needed three strips for the scenes scheduled for the first 4 days of shooting, the VFX Producer needed four additional strips, each corresponding to its own breakdown sheet, to represent the visual effects elements for the same scenes. This is what we see in Figure 6.3 below. Here, the VFX Producer has inserted his or her strips in the appropriate place in the schedule prepared by the 1st AD. Note that the AD's strips are still there in the same order and on the same day, but they are now followed by several new strips to cover the visual effects plates that need to be shot.

What's important to note is that there is one strip for every visual effects element that will have to be filmed. Refer for a moment to Scenes 15, 21, and 23 in the preceding example. The first strip, #1, #13, and #14, are the strips that the 1st AD prepared, while strip #1A, 13A, and 14A were prepared by the VFX Producer. They show that we need additional filmed elements to complete the scene. Strip #47A (V89.6) calls for a plate of the actor sent flying. The same logic applies to the other scenes in our example. The above strip board only deals with 1st Unit and visual effects filming. All miniature and element plates have been moved to a miniature shooting schedule (see Figure 6.4).

Begin Production - March 16, 2009						
Calvert Studios - Stage 2						
1	15	INT	Space Freighter - Cockpit - (Greenscreen) McFarley spots tail of comet in distance	Day	1 1/8 pgs.	1, 2
1A	V15.1	INT	Space Freighter - Cockpit - (Greenscreen) McFarley and Rogers in cockpit looking out GS window	Day	pgs.	1, 2
13	21	INT	Freight Deck (Breakaway Set) The space freighter crashes into planet	Day	1 7/8 pgs.	3, 4, 5, 6, 7
13A	V21.3	INT	Freight Deck - (Greenscreen) Alondra slides past GS hull opening of ship	Day	pgs.	5
14	23	INT	Freight Deck - (Greenscreen) Aftermath - ship has crashed on Planet	Day	pgs.	
14A	V23.1	INT	Freight Deck - (Greenscreen) A gaping hole has been ripped into side of ship	Day	pgs.	
--- END OF DAY 1 -- Mon, Mar 16, 2009 -- 3 pgs.						
--- END OF DAY 2 -- Tue, Mar 17, 2009 -- pgs.						
47	89	EXT	Wrecked Fuselage - Shelter Survivors argue; McFarley is angry at Misha	Day	2 3/8 pgs.	1, 1A, 2, 4, 4A
47A	V89.6	EXT	Wrecked Fuselage - Shelter McFarlane sends Misha flying	Day	pgs.	1, 1A, 2, 4, 4A
--- END OF DAY 3 -- Wed, Mar 18, 2009 -- 2 3/8 pgs.						
--- END OF DAY 4 -- Thu, Mar 19, 2009 -- pgs.						

Figure 6.3 This is a sample 1st Unit and VFX shooting schedule stripboard. This is how a highly simplified set of horizontal strips might look after the VFX Producer has inserted the visual-effects-related strips immediately following their respective 1st Unit live action strips that were prepared by the AD. Note the "V" designation of each element.

Separating 1st Unit and VFX Unit Shooting

Now, since the purpose of a strip board is mainly to schedule the shooting of principal photography, it makes no sense to leave strips dealing with miniatures, visual effects stage elements, and the like mixed in with the 1st Unit schedule. The AD is not concerned with these elements, so it would create massive confusion on his or her strip board to leave them there (for our purposes we can ignore the fact that the 2nd Unit, too, might have its own AD and strip board; the basic idea is the same). So the VFX Producer now moves all strips that aren't concerned with principal photography to the very end of the schedule so she can later schedule those elements separately.

While shooting miniatures, try to take advantage of the availability of your crew, equipment, and stage to shoot other elements (fire, smoke, bullet hits, dust, etc.) against black on the miniature stage or outside at night.

-- Being Work on VFX Miniature Stage --						
1B	V22.1	EXT	Space Freighter - Miniature Hull Moco plate of miniature hull crashing into planet	Day	pgs.	_____
--- END OF DAY 1 -- Mon, Jun 01, 2009 -- pgs.						
1C	V22.2	EXT	Planet - Ophiuchus Miniature Moco plate of Ophiuchus Terrain Miniature	Day	pgs.	_____
--- END OF DAY 3 -- Tue, Jun 02, 2009 -- pgs.						
13B	V24.1	EXT	1/32 Scale Ophiuchus Terrain Moco plate of Ophiuchus Terrain Miniature	Day	pgs.	_____
--- END OF DAY 3 -- Wed, Jun 03, 2009 -- pgs.						
13C	V21.3, V23.1	INT	VFX Stage - (Black) Elements - Smoke on Black	Day	pgs.	_____
13D	V22.1, V22.2	INT	VFX Stage - (Black) Elements - Flame/Sparks/Smoke on Black	Day	pgs.	_____
--- END OF DAY 4 -- Thu, Jun 04, 2009 -- pgs.						

Figure 6.4 This is a miniature & effects elements stripboard. This is how a shooting schedule might appear after the VFX Producer has begun scheduling shooting the miniatures and other stand-alone VFX elements. Note that the relevant strips have been moved to the end of the 1st Unit schedule. Strip 1B calls for a miniature hull. Strip 1C calls for a miniature of an alien planet's terrain.

Designating Different Types of VFX Plates

At this point it may be useful to digress for a moment and discuss how various types of visual effects plates might be labeled and slated. This could be important when you are dealing with complex visual effects shots that require several different types of elements: live action, blue- or greenscreens, perhaps a miniature and/or a plate for a matte painting, reference plates, and the like. It's essential to keep all these elements straight to avoid confusion in postproduction when editors, negative cutters, and digital facilities must be able to access the correct elements efficiently.

Over time, people in the industry have used different numbering systems to deal with the need to accomplish this. Everyone may have his or her own preferences; there are no industry-wide standards. What we offer here are some suggestions that you may wish to consider should you be called on to come up with a numbering system.

Whatever system you devise, try to keep it simple. Remember that you will most likely have to rely on a camera assistant on set to slate each element. When things get hectic during a shoot, you will want the camera assistant to feel comfortable with your system so that he or she will not be confused when you tell the script supervisor what visual effects number to use on the slate.

One of the first things you will notice in our sample visual effects strip board in Figure 6.3 is that each new strip carries the prefix "V," denoting that it is a visual effects plate. This is the most commonly used designation for visual effects plates. There is nothing sacred about this symbol. You might just as easily choose the letter X, or Y, or Z to mark your visual effects plates. Be aware, though, that people doing breakdowns as well as camera crews are apt to use the letter X for other purposes, such as pick-up shots, a 2nd Unit shot, or even in an emergency when someone needs to make up a shot number on the spot. So we recommend you stick with V as the universal prefix.

Modifying the Strip Board Design

Earlier we discussed adding to or modifying categories in the breakdown sheets to better reflect the VFX Department's requirements. Similarly, we can modify the design of our strips (vertical or horizontal) to help the 1st AD and the VFX Producer spot specific visual effects items at a glance.

Figure 6.5 shows a typical vertical strip board layout. Typical, that is, except for one important aspect: Look towards the lower half of the strips, and you will see three rows of entries that pertain specifically to visual effects. On the header at left they are called Visual FX (VFX), Blue/Green Screens (BS/GS), and Motion Control (MC) respectively.

The amount of information we can stuff into such a small space on the strip board is very limited, no more than two to three letters. But it calls attention on the strip board to the fact that these shots have certain visual effects requirements. Just as the AD needs to know what cast members have to be called on a given day, it's useful for us to know which days we will need either a blue or green screen. This can be immensely helpful when we are dealing with a strip board with a couple of hundred strips.

Additionally, you may wish to color code the visual effects strips using a color that is available from the Movie Magic Scheduling color palette and that is not being used by the 1st AD for his or her strip board. For example, you might want to select orange to designate the blue- or greenscreen strips, especially if you intend to share your strip boards with the AD. Just check with him or her that your color for the visual effects strips isn't going to confuse the AD's strip board. After all, the main purpose of a strip board is to make the schedule easy to read at a glance.

Keeping Up with Changes

Now that all this thorough preparatory work has been done comes the hard part: keeping the strip board current. You may be assured that neither the 1st nor 2nd AD will have time to

Color-coding breakdown strips

When you are designing nonvisual-effects-related strips you should follow the industrywide color-coding conventions:

White – Day Interior
Yellow – Day Exterior
Green – Night Interior
Blue – Night Exterior

FALSE HORIZON

Director: _____

Producer: _____

Asst. Director: _____

Script Dated: _____

Prepared by: _____

Begin Production – March 16, 2009 — Calvert Studios - Stage 2

Sheet Number:	1	1A	13	13A	14	14A	47	47A
Page Count	1 1/8		1 7/8				2 3/8	
Shoot Day:	1	1	1	1	1	1	3	3
Scene	INT - Space Freighter - Cockpit - (Greenscreen) - Scs. 15	INT - Space Freighter - Cockpit - (Greenscreen) - Scs. V15.1	INT - Freight Deck (Breakaway Set) - Day - Scs. 21	INT - Freight Deck - (Greenscreen) - Day - Scs. V21.3	INT - Freight Deck - (Greenscreen) - Day - Scs. 23	INT - Freight Deck - (Greenscreen) - Day - Scs. V23.1	EXT - Wrecked Fuselage - Shelter - Day - Scs. 89	EXT - Wrecked Fuselage - Shelter - Day - Scs. V89.6

Character	No.	1	1A	13	13A	14	14A	47	47A
Capt. Jock McFarley	1	1	1					1	
McFarley Stunt Dbl.	1A							1A	1A
Ens. Holly Rogers	2	2	2					2	2
Lt. Ramirez	3			3					
Misha	4			4				4	4
Misha Stunt Dbl.	4A							4A	4A
Alondra	5			5	5				
Cargo Handler #1	6			6					
Cargo Handler #2	7			7					
Extras:		E:4	E:4	E:11	E:3	E:11	E:11	E:6	E:6
Visual FX:		VFX	VFX	VFX	VFX	VFX	VFX	VFX	VFX
Blue/Green Screens:									
Motion Control:									
(description)		McFarley spots tail of comet in distance	McFarley and Rogers in cockpit looking out GS window	The space freighter crashes into planet	Alondra slides past GS hull opening of ship	Aftermath - ship has crashed on planet	A gaping hole has been ripped into side of ship	Survivors argue: McFarley is angry at Misha	McFarlane sends Misha flying

-- End Of Day 1-- 3/16/2009-- 3 pgs.

-- End Of Day 2-- 3/17/2009-- pgs.

-- End Of Day 3-- 3/18/2009-- 2 3/8 pgs.

-- End Of Day 4-- 3/19/2009-- pgs.

Figure 6.5 This is an example of a vertical stripboard. Vertical strips display more information than horizontal strips. As noted in the text, we can display whether a given shot contains visual effects (VFX), requires a blue or green screen, or motion control. You may choose to create as few or as many special categories as you find useful.

maintain the VFX Producer's scheduling board, and so that task will fall to you. This takes great diligence on the part of the VFX Producer or one of the producer's assistants. As a practical matter you should not count on the ADs to seek you out to inform you about the changes in the shooting schedule. They will publish new schedules whenever necessary, and you need be proactive and stay in touch with the ADs on a daily basis or whenever a change in the 1st Unit's shooting schedule is in the works.

As production gets under way, you will quickly get a feel for how the 1st AD prefers to deal with disseminating schedule changes. Some are quite open to discussing them face to face, while others may prefer having their assistant (2nd AD) deal with this issue. Another common practice is for the revised schedule to be published or posted by the ADs at the end of the day. Whatever the situation, the VFX Producer has to stay on top of the changes and make sure that the visual effects strips are adjusted along with the 1st Unit strips on an ongoing basis.

Scheduling the VFX Unit

While the VFX Producer has only modest influence over when 1st Unit plates are shot, scheduling the visual effects unit's work falls squarely on your shoulders. This responsibility extends to scheduling independent plate shoots (such as aerial and background plates on distant locations), filming of miniatures, and acquisition of miscellaneous visual effects elements intended for compositing (explosions, flames, smoke, and the like).

Quite often, the visual effects unit will start filming elements while the 1st Unit is still in production. In fact, depending on the scope of the project, the visual effects unit may function as a 2nd Unit that works alongside the 1st Unit. When such is the case, the 2nd/VFX Unit may be under the oversight of the VFX Producer. On higher budget productions it may have its own dedicated production team: producer, ADs, DP, and specialized personnel.

The scheduling of principal actors for blue- or greenscreen shots is likely to be of particular concern to the production. Whenever possible, the 1st AD and VFX Producer will try to work these shots into the rest of the schedule to get them out of the way. The blue or green screen can often be set up on a nearby stage, and the actor (who is obviously not otherwise needed on set) can be gotten ready for his or her part. If you are dealing with leading actors who are under contract for the run of the show, there is usually no problem in their being made available for VFX or 2nd Unit photography, subject to their workload and exact contract terms.

Even so, the VFX Producer would be well advised to make sure that, if necessary, a particular actor will be available for blue- or greenscreen work at the end of principal photography. You can't

take this for granted, because contractual terms regarding how many days of work a given actor "owes" for additional work (such as looping of dialogue or pickup shots) at the end of production vary widely. You don't want to get into a situation where a principal actor has to be brought back at great expense for work that could—and should—have been done during principal photography.

Refining the Schedule

When it comes to laying out a schedule for the visual effects unit, the VFX Producer may face some challenges that are absent in principal photography. That's because, when laying out a normal 1st Unit schedule, the 1st AD can draw on more than a century of industry experience to estimate how long it should take to shoot a live-action dialogue scene. Thus, a general rule of thumb is that a 1st Unit on a feature should get roughly two to three pages of script "in the can" during a normal shooting day (the norm is considerably higher for a lower budget feature or a TV show).

Visual effects photography, however, has few rules of thumb to guide the VFX Producer. Shooting situations vary widely, affected as they are by different requirements for such techniques as motion control, miniatures, BS/GS shoots (with or without principal actors), and various visual effects plate shoots such as aerial plates or stage elements.

Scheduling a visual effects unit, therefore, requires a good understanding of the complexities of different visual effects techniques. The VFX Producer needs to consider which elements will take the longest to complete, the order in which miniatures will be ready to be moved on set, what elements can be grouped together to complete a given sequence, and even what shots the marketing department might want to use in its publicity campaign. What's more, the visual effects unit's shooting may be stretched out, off and on, not only over the period of principal photography, but also over much of the postproduction period. It is not unusual for visual effects plates to be going before the cameras only a few weeks before negative cutting begins.

One of the critical aspects of scheduling is correctly estimating how long it will take to complete a setup. This is not as straightforward is it sounds.

During principal photography, the 1st AD sets the schedule and lays out the shooting order. It's the job of the VFX Producer to work hand in hand with the AD and advise him or her how much extra time to allow for filming the visual effects elements you need that are not normally part of the 1st Unit's routine. For example, a scene may require real-time motion control on the set, or you may need to shoot clean plates or reference plates. If you don't make the AD aware of your needs in advance, your plates may not get shot.

The VFX Producer faces similar challenges when she sets out to schedule one or more visual effects units. Estimating how much time is needed to do a given amount of work is as much art as it is science. On the one hand, it's fairly straightforward to schedule the plate shooting for a matte shot. You know how long it takes to get to the location, for example, and about how much time the crew needs to set up, get the shot, and return back to base.

It's a different story when you have to schedule a lengthy miniature shoot that may involve complex motion control photography of a dozen or more miniatures, each requiring several passes of the camera. Such an endeavor may stretch over many weeks or months, not counting the building of the miniatures. An intricate miniature may take several days to set up on stage, another 2 days to light, 2 days for tests, and another week to shoot several time-consuming motion control passes. Striking the set may keep you on the stage for another 2 days. Meanwhile you may be preparing another miniature for a night shoot with five high-speed cameras to film a building exploding.

All of this has to be done with the maximum efficiency possible. Many operations have to be considered and must dovetail into one another so that the workflow can be maintained as smoothly as possible. Rather than guessing, construct your miniature building and shooting schedule in consultation with the miniature facility on how long it will take to complete the work.

Certain items may need to be ready at the time of principal photography. Among them: animatronic creatures and special makeup appliances. These usually take many months to design, approve, and build (e.g., *Planet of the Apes* [2001] or Alien: *Resurrection* [1997]). Depending on the organizational structure of the production and the preference of the producer or studio, one or the other of these types of elements may fall into the realm of the VFX Producer.

Even at this early stage, the VFX Producer will also want to keep the postproduction schedule in mind when planning the filming of various visual effects elements. You should have some rough idea of when certain visual effects elements are going to be needed by a digital facility so that you can make sure the elements will be filmed in time.

Let's say, for example, that in discussing the storyboards for a certain sequence with the director, VFX Supervisor, and perhaps a representative of a digital facility, you have mutually decided that some visual effects shots will be augmented with real fire and smoke plates that will be shot on stage. The collective judgment is that live-action elements will be less expensive to shoot and will look better than if they were created digitally. Armed with this information, you can now lay out your shooting schedule accordingly.

One thing you want to avoid, if at all possible, is delaying a vendor because of missing visual effects elements. You can prevent this

Using multiple cameras

We often use multiple cameras in visual effects when we want to film events that can be repeated only at great expense or not at all, such as a vehicle crashing into a building and setting off an explosion.

This adds to the effects budget in numerous categories: additional crew, additional cameras and accessories, more rawstock, plus greater laboratory costs for processing and printing perhaps thousands of additional feet of film. Make sure you budget accordingly.

by backing into your shooting schedule from when the elements will be needed in postproduction. In other words, you check with the vendor to establish the deadline for delivering the elements, and work backward from there to figure out how long it will take your visual effects team to do whatever tests may be necessary, prepare a stage, do the filming, and wrap out of the stage. Ideally, of course, you're not going to cut it that closely. Instead, you will schedule the shoot as soon as possible amid all the other elements that have to be scheduled.

Reports…and More Reports

A breakdown produced with Movie Magic Scheduling is a treasure trove of information that can be manipulated in various ways to help the VFX Producer stay on top of his or her department's production requirements. We'll briefly touch on two of them, the Day-out-of-Days, and the One-Liner. Both of these types of reports are routinely used by ADs to keep everyone on the production informed of specific production requirements. Similarly—with slight modifications in their design—these reports can also serve the VFX Producer's needs. Depending on how you set up your scheduling database, both these reports can display information that does not show up on your strip board. Together, they are a very useful management tool.

Modified Day-out-of-Days Report

Let's assume that you are on a show that has blue- or greenscreen photography, miniatures, and motion control shoots scheduled over the course of a production. A modified Day-out-of-Days report will show you the shooting days for each of these items at a glance. Figure 6.6 shows what such a report might look like.

		"FALSE HORIZON"				Report created Fri, May 15, 2009					Page 1		
March	Day of Month:	16	17	18	19	Co.							
	Day of Week:	Mon	Tue	Wed	Thu	Travel	Travel	Work	Hold	Holiday	Start	Finish	TOTAL
	Shooting Days:	1	2	3	4								
. 20' X 80' Greenscreen		SW	WF					2			3/16	3/17	2
. 30' X 40' Greenscreen		SW	WF					2			3/16	3/17	2
. Digital Video Assist		SW	WF					2			3/16	3/17	2
. Encoder Head		SW	W	W	WF			4			3/16	3/19	4
. High-Speed Camera		SW	WF					2			3/16	3/17	2
. Motion Control Equipment		SW	WF					2			3/16	3/17	2
. Technocrane													
. Vista Vision Camera Pkg.													
. Zebra Dolly & Track		SW	WF					2			3/16	3/17	2

Figure 6.6 A Day-out-of-Days report for VFX equipment can help you in your budgeting of equipment throughout the show. If you need to rent your equipment for several weeks, be sure to ask for a 2- or 3-day week.

FALSE HORIZON				Page 1
ONELINE SCHEDULE				Sat, May 16, 2009

Begin Production - March 16, 2009

Calvert Studios - Stage 2

Shoot Day #1 - 2 -- Mon, Mar 16, 2009 - Tue, Mar 17, 2009

Scs. 15	INT	**Space Freighter - Cockpit - (Greenscreen)** McFarley spots tail of comet in distance ID:1, 2	**Day**	1 1/8 pgs.
Scs. V15.1	INT	**Space Freighter - Cockpit - (Greenscreen)** McFarley and Rogers in cockpit looking out GS window ID:1, 2	**Day**	pgs.
Scs. 21	INT	**Freight Deck (Breakaway Set)** The space freighter crashes into planet ID:3, 4, 5, 6, 7	**Day**	1 7/8 pgs.
Scs. V21.3	INT	**Freight Deck - (Greenscreen)** Alondra slides past GS hull opening of ship ID:5	**Day**	pgs.
Scs. 23	INT	**Freight Deck - (Greenscreen)** Aftermath - ship has crashed on planet ID:	**Day**	pgs.
Scs. V23.1	INT	**Freight Deck - (Greenscreen)** A gaping hole has been ripped into side of ship ID:	**Day**	pgs.

End Day #1 - 2 -- Total Pages: 3

Shoot Day #3 - 4 -- Wed, Mar 18, 2009 - Thu, Mar 19, 2009

Scs. 89	EXT	**Wrecked Fuselage - Shelter** Survivors argue; McFarley is angry at Misha ID:1, 1A, 2, 4, 4A	**Day**	2 3/8 pgs.
Scs. V89.6	EXT	**Wrecked Fuselage - Shelter** McFarlane sends Misha flying ID:1, 1A, 2, 4, 4A	**Day**	pgs.

End Day #3 - 4 -- Total Pages: 2 3/8

Figure 6.7 A One-Liner showing the visual effects plate schedule.

Modified One-Liner

More accurately, this is called a One-Line Schedule. Provided you have already moved all miniature and separate plate shoots to their own respective parts of your schedule, a One-Liner can be very useful because it shows, in succinct form, the elements that are scheduled for any given day. For example, in Figure 6.7, you will see that on shooting days one and two, you will be shooting three greenscreen elements, V15.1, V21.3, V23.1, and on shoot day three you will be filming one background plate element, V89.6.

The one-liner can also become a useful tool for visual effects equipment scheduling, and you can customize one-line schedules to show specific categories instead of "Cast" that are geared to the VFX Department's needs. So if you entered a moco head in the box that used to say, "Cast or ID" but is now for visual effects equipment, Movie Magic Scheduling will print that out for you just as though it were a cast member, allowing you to schedule that piece of equipment.

A word of caution

The movie industry thrives on paperwork and reports. It would be easy to become overwhelmed with different reports, some of which merely give you the same information in a slightly different form. Not everyone needs to be on the distribution list for all reports. As a VFX Producer, you should be selective in who you give your reports to. Don't overwhelm your colleagues with paperwork that they don't really need.

SUCCESS STORY

Kurt Williams - (*X-Men Origins: Wolverine; X-Men 3: The Last Stand*)

I first began work on corporate image films and commercials in Chicago. This gave me a great variety of experience that wasn't necessarily tied to the set, including editing and postproduction....After helping produce many visual-effects-oriented commercials and special venue projects, I teamed up with Visual Effects Designer John Dykstra to produce the miniatures and additional photography for *Batman Forever*...

I graduated with a degree in Radio, Television and Film...it definitely gave me the basics and a jumping-off point for the beginning of my career. The film business in general, even in the Visual Effects Field, requires quite a varied skill set to succeed.

When I began, the effects world was uncharted territory, unpredictable, intangible at times, exhausting, and the most rewarding thing I have ever done. The ironic part is that it is the very same today.

The budget is the number one obligation and probably the most crucial. Understanding a projected budget and calculating the inevitable and swiftly evolving changes is key. It's important to have an organized approach that everyone who needs to see it understands even if you need to shed some of the detail in order to present to producers who use this information.

One of the most important duties is that of diplomat. We are constantly brokering conversations in order to sync up with a wide variety of other departments in order to be ready to execute the shoot properly but to manage everyone's expectations for what is required to execute the day's work.

In addition to being detail oriented, the Visual Effects Producer needs to be...a driver personality when need be and patiently take the time to explain things technically when the crew is not understanding how you are approaching a sequence or shot.

The Visual Effects Database is literally your backbone that you will live and die by throughout any production. Reports from the database spoke out to reports for all aspects of the process including production requirements, vendor bidding, editorial information, asset control, vendor notes for shots, and shot status, and the database informs your current budget constantly. It is literally your lifeline from start to finish as it evolves from preproduction, through shooting and into post.

BUDGETING THE EFFECTS

The issue of costs will pursue the VFX Producer throughout the course of the film. Therefore, knowing how to budget—and rebudget—the visual effects is arguably a VFX Producer's foremost requirement.

If you are already familiar with film budgets and budgeting software such as Movie Magic Budgeting (as we assume most of our readers are), you will know that costs are divided into two major categories: above-the-line and below-the-line. Above-the-line items mainly cover the film's contractual, fixed costs, such as story rights, salaries of the director, stars, producers, writers, and other fixed and contractual costs. Below-the-line costs include everything else: crew, sets, equipment facilities, travel, and post-production. Every studio, TV network, and many large independent production companies have developed their own budget forms that differ slightly from one another. By and large, however, they will all contain most of the same categories; only the account numbers may be quite different. (See Figure 7.1.)

The Chart of Accounts

Visual effects, as you would expect, is a below-the-line item, one of perhaps 35 or more accounts within the film's overall budget. Use the 1st Unit's chart of accounts, which you can get from the accountant or the studio, and accommodate your general format to theirs (See Figure 7.2). The chart of accounts will establish the overall account number under which you will operate. If your production company's chart of accounts doesn't list a separate visual effects account, you can easily create one, and we suggest that you do so. But before you proceed, please check this out with the producer or production accountant to get the correct account number to use.

Once you know this number, you can then use Movie Magic Budgeting or other budgeting programs to prepare a more

Movie Magic Budgeting
Budget Title: Demonstration VFX Budget

START DATE: March 16, 2009
WRAP DATE: Oct. 9, 2009
LOCATIONS: L.A. + Santa Fe
SHOOT WEEKS: 8.2 Weeks
POST: 22 Weeks
RELEASE: NOVEMBER 2009
SCRIPT DATED: December 2008

PRODUCER:
DIRECTOR:
EXEX. PROD.:
UNIONS: WGA/DGA/SAG/IA/TEAMSTERS
PREPARED BY:
BUDGET DATE: January 19, 2009

Acct No	Category Description	Page	Total
1100	STORY, RIGHTS, CONTINUITY	1	0
1200	PRODUCERS UNIT	1	0
1300	DIRECTOR	1	0
1400	CAST	1	0
1900	FRINGE BENEFITS	2	0
	Total Fringes		0
	Total Above-The-Line		0
2000	PRODUCTION STAFF	2	0
2100	EXTRA TALENT	2	0
2200	SET DESIGN	2	0
2300	SET CONSTRUCTION	3	0
2400	SET STRIKING	3	0
2500	SET OPERATIONS	3	0
2600	SPECIAL EFFECTS	3	0
2700	SET DRESSING	3	0
2800	PROPERTY	4	0
2900	WARDROBE	4	0
3000	PICTURE VEHICLES & ANIMALS	4	0
3100	MAKE-UP & HAIRDRESSING	4	0
3200	LIGHTING	4	0
3300	CAMERA	5	0
3400	PRODUCTION SOUND	5	0
3500	TRANSPORTATION	5	0
3600	LOCATION	5	0
3700	PRODUCTION FILM & LAB	6	0
4000	SECOND UNIT	6	0
4100	TESTS	6	0
4200	STAGE RENTAL	6	0
	Total Fringes		0
	Total Below-The-Line Production		0
5200	VISUAL EFFECTS	6	0
5300	EDITING	6	0
5400	MUSIC	7	0
5500	POST PRODUCTION SOUND	7	0
5600	POST PROD FILM & LAB	7	0
5700	MAIN & END TITLES	7	0
	Total Fringes		0
	Total Below-The-Line Post		0
6500	PUBLICITY	8	0
6700	INSURANCE	8	0
6800	GENERAL EXPENSE	8	0
	Total Fringes		0
	Total Below-The-Line Other		0
	Total Above-The-Line		0
	Total Below-The-Line		0
	Total Above and Below-The-Line		0
	Grand Total		0

Figure 7.1 In this sample chart of accounts of a typical motion picture budget, visual effects falls under account number 5200.[1]

[1] Screen shot created using Movie Magic Budgeting software owned by DISC Intellectual Properties, LLC. For more information, see http://www.entertainmentpartners.com/products_and_services/products/mm_budgeting/support/.

detailed chart of accounts for the visual effects department that breaks out the categories you need. Quite often, you will want more categories than the run-of-the-mill studio chart of accounts lists. It is important that you establish these accounts at the outset, because all future expenditures will have to be posted to one or another of these accounts.[2] Work with your production accountant on this so that he or she understands and approves of how you are setting up your accounts. When that is done, you can go ahead and budget both the physical production support as well as the digital shot costs required for your show.

Computer programs like Movie Magic Budgeting are quite adaptable to the needs of the VFX Producer. They enable you to create specific accounts and categories for your department and integrate them with the overall production budget. It's best to keep the visual effects budget format compatible with the production budget. It will make it that much easier for others to quickly understand your budget. People dislike having to switch mental gears between different layouts.

As with other departments, most budget items in visual effects are pretty standard. That is, you will be using them time and again on various projects. So it makes a lot of sense either to create your own standard visual effects budget layout that you can use over and over again, or use the Demonstration Budget created by the authors (see Appendix A to see the entire budget) and used in our budget discussion that follows. To be sure, you won't use all sub-accounts or specific items on every show, but a good template makes provision for almost every need you're likely to encounter, and you can always modify it to suit your purposes. In a sense, the template is like a menu: a reminder of what you *may* need, but not necessarily what you will need, on every show. Think of it as a list of questions to ask yourself: Do I need this item?

How to Approach a Budget

Keep in mind that a budget is a *roadmap* of where you are going, not a travelogue about where you've been. It is impossible to foresee all the factors that will impinge on your budget in the coming weeks and months. Budgeting is an ongoing process: As the script changes, the budget changes.

Consequently, the VFX Producer is continually revising the budget, especially during preproduction when the challenge is to get the budget down to where the producer or studio will approve it.

[2] Please see Chapter 19 for more information about cost reports.

A major challenge in budgeting visual effects is to fit the work called for by the script into a preconceived budget that seems like it's been pulled out of the air. Usually that figure is too low and the expectations too high. The high cost of visual effects may come as a shock to producers and directors who have had little prior experience dealing with them. It then falls to the VFX Producer and VFX Supervisor to make the case that the visual effects budget needs to be raised, while still working diligently to get the best value possible for the director even when dollars are scarce.

Throughout the budgeting process you will be working in conjunction with the producer, director, and VFX Supervisor. Nothing is locked in permanently, and you must be prepared to make frequent revisions. In fact, in the early stages of a production when everything is in flux, you may find yourself revising your budget several times a day.

Some General Guidelines

Negotiating Who Will Pay for Things

One of the truisms of budgeting is that every department wants its budget to be as large as possible, and no department wants its budget raided by another. Even though people may say, "What difference does it make? We're all working on the same picture," strong rivalries may arise during the course of production about which department has to absorb a certain cost. When it comes to preserving a department's budget, otherwise friendly people can suddenly lose their sense of humor. This is not hard to understand: A department head's reputation in the industry is every bit as dependent on how well he or she manages the department's money as it is on creative ability. Few things are as hard to overcome as the accusation: "He (or she) went over budget."

Most of the time it's pretty clear which department should get charged for any given item. The art director belongs to the art department, drivers to transportation, green screens to visual effects, and Avid rentals to editorial…most of the time.

But there are also plenty of gray areas in budgeting, and sorting them out is best left to the producer and production manager. Take the Avid and other equipment for the VFX Editor as an example. Some producers may want the VFX Editor's equipment and supplies to be part of the 1st Unit's editorial budget. Others will want these items charged to the visual effects budget.

Such gray areas need to be cleared up as early in the budgeting process as possible. It is not simply that every department wants to defend its turf, though that can be a factor. Rather, it is a matter of clarifying the responsibilities each department is to assume, and this applies to visual effects just as much as it does to other departments. At the end of the day, you must know what you are

responsible for. When in doubt, put it on your budget and let the producer tell you otherwise.

It is not much of an overstatement to say that, when a department needs more money during production and the producer has nowhere else to turn, visual effects is often the first pocket to get picked. That is because the visual effects budget is one place where the producer can game the numbers simply by ordering a reduction in the number of effects shots and moving the money "saved" to the department that's in trouble. The thinking goes that, once the picture is in postproduction, it will be obvious that more effects shots are needed to tell the story. And whether it comes out of the producer's contingency or some other pocket, the money will almost always be found somewhere.

Here are a few guidelines to help you through the budgeting process:

- Review everything, and then review it again. It's better to have too many items in a budget than too few.
- Beware of the proverbial "ballpark" estimate, which is usually given in haste and without much reflection. Ballpark figures have a disconcerting way of becoming fixed (see "Getting the Budget into the Ballpark" later in this chapter).
- Add a little padding where possible. The fact of the matter is that if you put too low a cost on an item, only to have to raise it later, you will get a lot of resistance.
- Proofread your numbers carefully; it's easy to inadvertently leave off or add a zero to an item when you're rushing to get a budget done.
- Don't make unwarranted assumptions. Check out everything if you're not sure. It's better, for example, to ask the VFX Supervisor whether he wants to use VistaVision to shoot the background plates than to guess wrong and budget for standard-format cameras.

Even though there will be a production accountant on board, the VFX Producer should keep careful records of everything he or she buys or authorizes to be spent, and make his or her own copies. Documentation is essential, not only because the accountant will demand it, but also because it may be needed later in case of disputes. Keep records of all POs (Purchase Orders) given out to vendors that show when they got paid. The movie business is every bit as litigious (if not more so) as other businesses, and if legal action is taken at some point, such as if a completion guarantor steps into the picture, a clear paper trail will be invaluable.

Constructing a Visual Effects Budget

In the discussion that follows we will refer repeatedly to the account numbers of our Demonstration Budget. As you

Suppressing a budget item

Use the "Suppress" mode in Movie Magic Budgeting to omit items from your calculations without actually deleting them altogether. That way you can reconstruct an earlier budget if circumstances dictate. This situation often arises early on during a project when the producer is still exploring alternate ways of budgeting the movie and may ask the VFX Producer to omit one item or another. By suppressing the line item, you can go back later and show not only that you had actually budgeted the item, but also the amount.

Travel and *per diem* expenses

When location travel is on the agenda, you will have to budget travel, accommodation, and *per diem* expenses in your budget. However, in many cases, the producer will have you give him the numbers so he can add them to his travel budget and will then ask you to suppress that category in your budget. That is why there is no travel allowance in our Demonstration Budget.

look through this budget, you'll see many items that are pretty standard in budgets; we won't spend much time on them. Other items, however, are more specific to visual effects and are worth more than a passing mention.

Setting up the VFX Budget

Let's say that you were hired to produce the visual effects for a modestly budgeted independent movie. After several meetings with the producer and director you have a pretty good handle on the basic parameters under which the movie—and its visual effects—will be produced. You have a start date, know how many weeks of prep, shoot, and post there are going to be, and know when the picture is going to be released. You know that the producer is planning on a 7-week shoot on local sound stages and an additional week on a distant location in the U.S., for a total of 8 weeks.

But when you look at the Demonstration Budget you will notice that the shoot is listed as 8.2 weeks, not 8 weeks. The reason for this is that the production will be on location for 1 week, and location shoot weeks usually consist of 6 days. The fractional 0.2 equals one-fifth of a 5-day week. This demonstration budget assumes that we will require, among other things, 2 weeks worth of greenscreen shooting, some 3D CG character animation, and pyrotechnics with high-speed photography along with all the other standard production requirements.

Given this information, and after breaking down the show along the lines we have been talking about, you can now prepare your budget. We will use Movie Magic Budgeting, one of the most widely used film budgeting programs in the industry, to take you through the steps of constructing this relatively simple visual effects budget. The steps for setting up your visual effects budget are much the same as for preparing a full production budget, though you will obviously be concerned only with budget items that apply to the visual effects department.

One of the first things you should turn your attention to is setting up your globals and fringes (to reiterate, we assume you already have some working knowledge of Movie Magic Budgeting). Dealing with these items now will not only speed up the process later, it also practically forces you to analyze the project's nitty-gritty details early on. It's a great way to become thoroughly familiar with the demands of the show.

Globals: Set Them and Forget Them

We recommend you enter the globals first because they are a kind of shorthand that lets you apply the same values to different

	DEMONSTRATION BUDGET		
Acct No	**Account Description**	**Page**	**Total**
	ABOVE THE LINE TOTAL		0
	PRODUCTION PERIOD TOTAL		0
52-00	VISUAL EFFECTS		
52-01	VISUAL FX SUPERVISORS		248,300
52-02	VISUAL FX PRODUCER		133,700
52-03	VFX PRODUCTION STAFF		98,575
52-04	VFX EDITORS	1	76,500
52-05	REASEARCH AND DEVELOPMENT	1	5,000
52-06	ANIMATICS/STORYBOARDS	1	0
52-07	PRE-VISUALIZATION	1	19,000
52-08	CYBERSCANNING	2	10,000
52-09	SET SURVEYING / LIDAR	2	0
52-10	MOTION CAPTURE	2	0
52-11	MINIATURE BUILD	2	0
52-12	MINIATURE EXPENSES	2	0
52-13	MINIATURE SHOOT	2	0
52-14	MOTION CONTROL - CREW	3	0
52-15	MOTION CONTROL - EQUIPMENT	3	3,950
52-16	PLATE UNIT	5	86,500
52-17	DIGITAL VIDEO ASSIST	5	14,319
52-18	SET CONSTRUCTION	5	0
52-19	GRIP/SET OPERATION	6	5,000
52-20	CAMERA EQUIPMENT	6	0
52-21	BLUESCREEN/GREENSREEN	6	8,365
52-22	PROJECTION	7	0
52-23	MATTE SHOTS	7	0
52-24	DIGITAL EFX/COMPOSITES	8	0
52-25	SCANNING & RECORDING	8	43,100
52-26	VIDEO TEMP COMPOSITES	8	25,100
52-27	FILM & LAB	8	4,058
52-28	RENTALS	9	69,200
52-30	PURCHASES	10	21,500
52-31	STILLS/PUBLICITY	10	0
52-32	BOX RENTALS	10	5,000
52-33	STOCK FOOTAGE	10	0
52-34	TESTS	10	10,000
52-35	TRAVEL & LIVING EXPENSES	10	0
52-36	MILEAGE	11	0
52-97	TRANSPORTATION	11	0
52-98	MISC. EXPENSES	11	0
	LOSS & DAMAGE	11	1,500
	Total Fringes		72,444
	Account Total for 52-00		961,011

Figure 7.2 This is an example of a VFX chart of accounts budget summary. This fictional budget shows the various accounts that you might encounter in putting together a complete VFX budget. Account numbers in the text refer to this sample chart of accounts.

account details scattered throughout your budget very quickly. For example, you can set up a global value representing the number of shoot days that applies equally to every member of the crew. This speeds up the budgeting process immensely.

\multicolumn{7}{c}{**Globals Report**}							
In-Use	D	Name	Description	Calculation	Units	Dec	Value
VFXBookGlobals							
0		OT	Overtime	=0	%		0
0		HOL	Holidays	=1	Day		1
0		LOCW	Location Weeks	=LOCD/6	Week		1
0		DISTEQUIP	Location Equipment	=1	Week		1
0		TVL	Travel Days	=2	Days		2
1		LOCD	Location Days	=6	Days		6
0		SSW	Studio Shoot Weeks	=7	Weeks		7
0		LAEQUIPT	L.A. Equipment	=7	Weeks		7
0		PRW	Prep Weeks	=8	Weeks		8
0		SHOOTW	Shoot Weeks	=SHOOTD/5	Weeks		8.2
0		TSW	Total Shoot Weeks	=8.2	Weeks		8.2
0		EQUIPT	Equipment Weeks	=8.2	Weeks		8.2
0		SW	Shoot Weeks	=SD/5	Weeks		8.2
0		D10	Prep Day = 10 Hrs	=11	Pay/Hrs		11
1		D12	Shoot Day = 12 Hrs	=14	Pay/Hrs		14
0		POST	Post Weeks	=22	Weeks		22
1		SHOOTD	Shoot Days	=41	Days		41
0		TSD	Total Shoot Days	=41	Days		41
1		SD	Shoot Days	=41	Days		41
0		PD	Per Diem	=50			50
0		CO	Camera Operator A	=53.41			53.41
0		SWK	Shoot Week Hours	=D12*5	Pay/Hrs		70
0		HOTEL	Crew Hotel	=125			125
0		CAR	Car Rental	=250			250
0		AIR	Airfare	=358			358

Figure 7.3 The globals in this example chart show the values that were used in the Demonstration Budget. Note that you can use equations in globals. In the preceding illustration, for example, Shoot Week Pay Hours (SWK) is entered as the product of 12-hour Shoot Day Pay Hours multiplied by five, the number of workdays in a week. We omitted crew pay hours since they change according to new union contracts.

To use globals successfully, you need to gather as much information about the project as you reasonably can and then start laying out the globals chart. You would obtain some of the values (such as the number of shooting days) from the 1st AD. Others might come from the production accountant or the producer. Still other values, such as the amount of film the Plate Unit would shoot in a day, you would derive from your own analysis of the project. Don't be concerned if you can't think of all the globals at the outset. You can easily add to them or modify individual values later. Any change that you make in a global will be instantly applied throughout your budget to all items associated with that global. So if, in the example in Figure 7.3, your shooting schedule were to expand by 2 days, you would change that value in the globals table and all calculations based on that value will be adjusted for those 2 additional days.

Reminder

Don't overlook fringes that may apply in foreign countries if you find yourself working on a project that will take you abroad.

Fringes

At this point you should also set up the Fringe Benefits, commonly called Fringes. These are costs the production company is obligated to pay that are over and above an individual's salary or fees and taxes that are imposed by various government entities on goods and services. Some of these charges are mandated by law (e.g., Social Security benefits and Workers Compensation Insurance premiums), others by union or guild contracts (e.g., Motion Picture Health and Welfare Fund contributions), and some can be included at your option (e.g., sales tax on rawstock).

A note of caution: One important distinction between globals and fringes is that globals apply throughout the budget. Fringes, on the other hand, must be applied specifically to an individual or item, even though you have entered the *value* of the fringe benefit in the Fringes table. Thus, one common set of fringes may apply to every International Alliance of Theatrical and Stage Employees (IATSE) crewmember, but that set of fringes will be different for Teamsters. Sales tax may apply to some rentals, but not others. And even after you have set the rate for a specific fringe, you must still make sure that you apply it individually in your budget details.

In the case of fringes that apply to crewmembers, they are usually calculated as a percentage of a person's wages. Less commonly they may be a flat amount. Some have cutoffs (i.e., the fringe is only applied up to a certain dollar amount of salary); others continue for as long as the crewmember is employed on the show.

Just exactly what fringes are applied depends to a large extent on whether you are working on a union or nonunion picture and the size of the crew that is included in the visual effects budget. If it's a union show, all union crewmembers the VFX Producer hires have to be fringed and treated according to their respective IATSE, Teamster, or guild contracts. If the visual effects crew

operates outside of a union contract—as may be the case with visual effects units that operate essentially independently of the 1st Unit—chances are that fewer fringes need to be applied.

That is not to say that many members of the visual effects crew may not also belong to a union. But the reality is that the union's governing body, IATSE, cannot and does not monitor all the non-union work that goes on. So unless an employer flagrantly violates all norms of decent treatment of the crew, both fiscal and physical, the union will often refrain from interfering.

The situation is considerably simpler when you subcontract a body of work to an outside vendor. In that situation, both union and nonunion crew should be lumped together under the subcontractor's payroll. The fringes should be wrapped into the subcontractor's bid, making the subcontractor responsible for collecting and paying them to its own employees.

Among the most universal fringes are contributions the employer (i.e., the producer) must make to the employees' Social Security accounts (FICA), State Unemployment Insurance (Fui/Sui), Medicare, and workers compensation insurance premiums. But beyond these well-known deductions are a host of other employer contributions, such as a dizzying array of motion picture welfare, pension fund, and guild and union benefits that vary considerably among the different unions and guilds. These fringes will also vary quite a bit if the project is a full-fledged union picture versus an independent, low-budget production that may provide fewer fringe benefits to its crew.

Getting the values correct is quite important because even relatively small discrepancies in the fringes can have decidedly negative ramifications for your budget. It is best, therefore, to ask the production accountant for his or her fringe table when you are budgeting the visual effects crew so that both budgets are based on the same figures. The production accountant will have all the latest applicable rates plugged in, something that is particularly important because union contracts may call for periodic changes in benefits, or perhaps because the producer negotiated a separate agreement with certain unions for this particular film. If no production accountant is on payroll, you can get the current fringe rates from either the producer or the payroll company.

Movie Magic Budgeting makes the process of entering fringes relatively easy. All you need to do is type in the applicable percentages and cutoffs, and the program will calculate the fringes automatically.

As an example, look at the *Fringe Summary* in Figure 7.4 from the Demonstration Budget we constructed for this purpose. This summary shows a number of typical fringes a visual effects budget is likely to contain. In the % column you will see the percentages in effect at the time the budget was prepared. The *Cutoffs*

DEMONSTRATION BUDGET	Fringe Breakdown Summary				
Fringe	**Description**	**%**	**Units**	**Cutoff**	**Total**
FUI/SUI	State Unemployement Insurance	7%		7,000	3,430
FICA	Fica	6.2%		102,000	28,153
MEDICARE	Medicare	1.45%		0	9,165
LA W/C-CREW/SAG	Workmans Comp LA	4.5%		0	28,443
W/C Clerical	W/C Clerical	4%		0	0
PAYROLL FEE	Payoll Handling Fee	0.5%		0	3,160
CA Sales Tax	CA Sales Tax	0.09%		0	90
TEAMSTERS	Teamsters	26%		0	0
IA-LA	IA Union - LA	13.35%		0	0
IA-ALL IN	IA Union All in	35%		0	0
SAG	SAG - All in	35%		0	0
DGA H&W	DGA Dir-H&W	8.5%		400,000	0
DGA Vac & Holiday	DGA Vac & Holiday	7.72%		0	0
DGA Pension	DGA Pension	5.5%		200,000	0
ALL FRINGES					**72,442**

Figure 7.4 Here is an example of a fringe table from the Demonstration Budget, created with Movie Magic Budgeting. The percentages and salary cutoffs that apply to various categories may vary from year to year as revised governmental rules or union contract provisions take effect. The top half of the chart shows the applicable payroll taxes, while the bottom half deals with union fringes.

column shows the salary caps that apply to certain categories. The *Total* for each category is automatically extracted from the body of the budget and shown in the last column. The overall total for all your budget categories will appear on both the budget detail page and the top sheet. You should keep in mind that a union picture is likely to contain several other fringes not found in budgets for independent pictures such as the one we are using as an example.

Don't overlook sales tax in states like California where it applies. Sales tax is a very real—and sometimes substantial—cost, but it is easy to overlook when you're budgeting. What's more, the rules vary from state to state as to what is taxable and what is not.[3] You can flag taxable items in the budget in the same way you flag fringes for crewmembers. Although this isn't a "fringe benefit" by any stretch of the imagination (except for state and local governments), it is sometimes included under fringes because it is an additional charge based on taxable items scattered throughout your budget. It is up to you to decide what budget level you want to put sales tax in. You can apply it on the Account level, in which case sales tax gets posted with the other fringes. Alternatively you can enter the sales tax to individual items in the Detail level to make sure it is not forgotten (See Figure 7.5).

[3] Sales taxes change at the whim of state legislatures. Be sure you plug in the current rate in your budget.

If you are budgeting for a project to be shot in a foreign country, you also need to be aware of taxes on items or services that foreign governments may levy. An example of this type of tax is the so-called VAT, or Value-Added Tax, levied in England and other countries. Other types of taxes may include bed (or guest) taxes and energy levies on hotel rooms. These taxes can be substantial, adding as much as 18–20% to a hotel bill, for example. Many countries, aware of the value of motion picture production to their local economies, enable foreign production companies to get at least a partial refund of taxes they paid. But the paperwork can be involved, and it may be many months before the money is refunded. Meanwhile, your budget gets hit with the charge.

Figure 7.5 This illustration shows the fringes that are applied to the VFX Editor's salary in our Demonstration Budget. Note that the amount of the fringes is not displayed on the Budget Detail level. The correct amount is automatically added to the fringes account, no. 5900. We displayed the "Apply Fringes" window below the Account Detail to show the relationship between the two. Normally you would not see the "Apply Fringes" window when you view the account details. Note also that the value for Post is a Global value, as indicated by the dot next to the name in the extreme left column.

So it's best to make allowance for such taxes and add them to your fringes. If you later find that your production will not have to pay them, you can always use Movie Magic's "Suppress" mode to hide this item and keep it from showing up in your budget.

Getting the Budget into the "Ballpark"

One good thing about setting up a budget is that once you have done it, you can use it as a template for future productions. In time, you will have added more categories and details to your own budget form, which essentially acts like a Chinese menu: you pick something from here and something from there, as your needs dictate. With Movie Magic Budgeting, it is a simple matter to omit details and accounts that are empty.

You may have noticed that our Demonstration Budget came to roughly $1,000,000. That is not an accident. Rather, we have found through experience that the visual effects production support for a modestly budgeted movie like the one we use as our model usually ends up costing about that much over and above the digital facility costs. You can use this figure as a "ballpark estimate" but you must do so with CAUTION. It does not include some of the most costly items a budget may need because of the many creative touches a script may call for. We purposely omitted them from our Demonstration Budget because there is so much variance among projects. Some of these "big ticket" items are listed as follows.

A Checklist of Budget Items

When you prepare a budget ask yourself "Do I need this item for this budget?"

- Animatics/Storyboards
- Set survey
- Miniature build and shoot
- Motion control equipment and crew
- Visual effects plate unit(s): How many days do I need?
- Digital video assist: Do I need a Digital Imaging Technician for my unit and for how long?
- Set construction: Do I need special platforms or scaffolding?
- Blue screen or green screen rentals: how big, for how long?
- Blue screen or green screen lighting: how many units for how long? Is this covered under 1st Unit?
- Digital shot costs to cover all 3D CG work and compositing, a potentially huge number that gets added after you get an approved bid

- Miscellaneous expenses: cans of digital blue or green paint (varies with square footage of floor or wall to paint); blue or green tape

These items can add millions of dollars to the budget, even as the core production support costs remain roughly the same.

SUCCESS STORY

Alison Savitch - (*Terminator 2: Judgment Day*; *The Abyss*)

I went to School for Film and Television. Working in news right out of school taught me some of the most important lessons and skills I use to this day on a film set, like prioritizing. It hones your decision making skills and teaches you what is truly important. My background in film started out in traditional production. PA, production Sectretary, POC—My first real VFX film was Honey I Shrunk the Kids. To hear the term "shooting plates" in 1988 people were as likely to think it involved a rifle and an actual plate. So even when we were breaking new ground, I'd been bitten by the CG/VFX bug, and there was no going back.

As a VFX Producer you need to have good organization, be a great communicator and have the ability to prioritize: On a minute by minute basis decisions are made in the production process that can effect as little as one shot, or as much as the entire film... Being innovative enough to think outside the box can be the difference between getting what the production needs and not. You need to be a People Person. You find yourself as a VFX Producer talking people into doing things they really don't want to do.

The VFX bible and database are imperative to have for a VFX Producer. It is what lays the ground work, establishes the rules, creates an understanding of what is trying to be accomplished; without it, you can end up without a common vision, a lack of organization from the onset...this all adds up to a more difficult and costly VFX film.

Discussion of Accounts

We chose to base our Demonstration Budget on a hypothetical, relatively low budget nonunion film using assumptions and a visual effects budget commensurate with that type of production.

Accounts 5201, 5202, and 5203

These three accounts deal with visual effects personnel whose term of employment will run for prolonged periods, if not for most of the project: VFX Supervisor, VFX Producer, and visual effects production staff. Only salaries and wages are included here.

Pay rates vary widely, depending on the experience of the individual and how much in demand his or her services are. The greatest variations from low budget to high budget (from about $3,500 to about $10,000 per week) are found among the ranks of VFX Supervisors, and for VFX Producers the scale ranges from $2,500 to about $5,000 per week. VFX Coordinators range from $1,500 to $1,800 per week. The narrowest pay ranges are among VFX Production assistants (who are usually paid on a scale similar to that of key PAs on a production) and perhaps

VFX Editors, whose wages tend to be in line with those of assistant editors.

When budgeting personnel, you must be aware of applicable labor laws, which distinguish between who is considered supervisory or management personnel (individuals who have actual managerial and decision-making authority and who are not entitled to overtime pay) and hourly workers, who are covered by strict overtime pay laws (though these vary from state to state). Thus, the VFX Supervisor and VFX Producer may get paid a flat weekly rate, no matter how many hours they work, because they are legitimately considered supervisory personnel. PAs or assistant editors, on the other hand, are considered hourly employees and are therefore entitled to overtime pay after 8 hours.

Calculating Overtime Hours

Since the normal workday in film production is considered to be 10 or even 12 hours, the budget should reflect that reality in the case of hourly personnel. Thus, when you set up your globals, your formula for a 12-hour day should reflect the overtime. Also, if there is good reason to suspect that weekend work will be required, you should budget for it at time-and-a-half.

We often make deals with crewmembers for a flat daily rate for a certain number of hours. Converting the flat daily rate into an hourly rate for our budgets is a fairly straightforward process if we remember that every hour over 8 and up through the 12th is equal to 1.5 hours of straight time.

For example, assume we hire an Assistant Cameraperson for a flat $500/day for a 10-hour day. The two overtime hours are worth the equivalent of 3 hours straight time, and so the workday is calculated as 11 hours at straight time. The actual hourly rate is almost exactly $45.46 ($500/11 = $45.46). This is the figure we would put in the "Rate" column of our budget with the correct number of hours (10) in the "Amount" column.

Similarly, a 12-hour workday equals 14 pay hours at straight time. So this person's rate would be the hourly rate of $45.46 × 14 = $636.44/per 12-hr day or $3,182.22 per week.

Account 5204—VFX Editors

VFX Editors are hired by the week, their pay rate generally being on a par with that of a 1st assistant editor. On visual-effects-heavy films, the VFX Editor is often brought on board almost from the beginning of principal photography because visual effects plates begin to pile up very quickly and need to be dealt with once shooting starts. But in our Demonstration Budget, we decided to start the VFX Editor several weeks into production because the shooting schedule had no visual effects plates on tap for the first 3 weeks.

In practice, VFX Editors are good candidates for overtime. Somehow the last few weeks of postproduction always seem to get hectic, and editorial staff ends up putting in long hours. You would be wise to budget what you think is an appropriate figure for Saturdays worked.

Account 5205—Research and Development (R&D)

The type of R&D we would include in this account does not refer to the R&D to develop, say, an animated character, or customized software to perform some exotic function that was never done before. This should be included under the project's digital shot costs. Rather, we would budget here R&D that would go towards developing a unique piece of equipment, or a technique to film a physical phenomenon (the flowing lava effects in *The Lord of the Rings: The Return of the King* come to mind; they required a good deal of experimentation prior to shooting).

Account 5206—Animatics/Storyboards

Storyboards are immensely helpful, if not downright essential, to the VFX Producer when budgeting a project. One reason is that the producer and the VFX Supervisor can discuss the visual effects with the director and get a clear idea of his or her vision. With that information in hand, the VFX Producer can solicit bids from potential vendors who, in turn, will be able to use the storyboards to prepare a reliable bid. Usually the costs of the storyboards should go into the 1st Unit budget, and you should check that this has been done.

Storyboards can also be used to produce animatics, which are storyboards photographed on film or tape that may have pans, tilts, and zooms built in. This process need not be elaborate. It may be done as simply as placing the drawings on a flat surface and recording them with a digital camera or scanning them and importing them into the Avid or other digital editing system. The resulting footage can then be captured by a digital editing system, where the editor can use the animatics to construct a rough cut of a sequence to give the director a sense of how the film will flow.

People in the industry will often use the terms *animatics* and *previs* rather loosely and interchangeably. Strictly speaking, though, animatics are produced from storyboards or still photographs. Previses, on the other hand, are much more elaborate 3D CG animations that closely approximate the visual elements of a given shot, the shot's framing, its timing, and movement of characters or objects.

Account 5207—Previsualization

Previsualization (or previs, as it is commonly called) is the process of generating 3D CG *animated* storyboards. We will discuss previs in greater detail later (see Chapter 8). We usually use previs

during preproduction when the director is still in the process of designing the film. But it can also be useful during production and even postproduction: any time, in other words, when the director needs to design a new series of shots before spending a lot of time and money on them. Depending on the project, you may decide to set up your own in-house previs workstation(s), or you may hire a digital effects facility to do the job. As a general rule of thumb, you should budget about $4,000 to $5,000 per week per artist and equipment, less if you set up (or already have) your own workstations with suitable software.

Account 5208—Cyberscanning

As discussed in Chapter 4, cyberscanning is the process of scanning a person or an object with a laser beam to capture the object's shape and surface features in digital form. When budgeting for this, the VFX Producer needs to ask not only about the direct cost of scanning an object or person, but also about the related cost of cleaning up the data so that it can actually be used by a digital facility.

The time needed to cyberscan an actor or object can vary quite a bit depending on where it is being done. As a general rule, cyberscanning in the U.S. tends to be more readily available than it currently is in European or Asian countries. That situation is likely to change in the future as the technology becomes more widely available.

Account 5209—Set Survey/LIDAR

You need to include the costs of set surveys in this account. Set surveys are not unlike a survey made of your neighborhood to determine property lines except that in visual effects, we survey the exact locations and dimensions—sometimes even the textures—of all significant objects on the set that a digital character will interact with in a shot or that have to be faithfully recreated in the computer. Costs vary according to the production's requirements, ranging up to several thousand dollars a day.

Account 5210—Motion Capture

As we stated in Chapter 4, motion capture has become a major contributor to the effectiveness of contemporary visual effects. It is the process of recording a performer's positions and movements digitally in a computer. It is an extremely useful tool that's used to create digital actors to substitute for human actors when it would be impossible or too dangerous to perform the action for real or to generate fictitious characters that have to be animated realistically, like the entire cast in Robert Zemeckis' film *Beowulf* (2007). Mocap services are still quite costly. You are best off getting bids from potential mocap providers on the basis of your production's specific requirements.

Account 5211—Miniature Build

Unless the production company decides to set up its own miniature/model shop, the VFX Producer would obtain this budget figure from an outside vendor who was awarded the job on the basis of competitive bidding.

We would not recommend a production setting up its own model shop except under rare and extremely favorable circumstances. Model making is a highly specialized skill that calls for expensive tools and dedicated craftspeople with a thorough knowledge of design, art direction, materials, and the highest degree of artisanship. A production company seldom has the time—not to mention the expertise—to set up and staff a model shop in the course of a normal project.

Account 5212—Miniature Expenses

This is a minor account in which you would put miscellaneous expenses associated with building and shooting the miniatures that aren't covered in the contract with the miniature construction company. An example of this might be the cost of storing the miniatures after you have finished photography. It is generally a good idea to keep the miniatures intact until the project is completed and the studio has decided what to do with them. Normally, the miniatures are destroyed when the project is completed. Sometimes, however, there may be some long-term value to the miniatures that would motivate a studio to store them long term, perhaps to rent them out to other production companies in the future, for marketing purposes, or for a possible sequel. Until that decision is made, however, your budget may have to absorb the cost of storage.

Account 5213—Miniature Shoot

It would be extremely difficult—and something of a useless exercise—to try to figure out the exact daily cost of a miniature shoot. There are too many variables. We therefore budget miniature shoot days on the basis of daily averages or ranges, relying on past experience to come up with an appropriate figure. The costs will depend on where you plan to shoot the miniatures, size of the crew, number of elements to be shot, and other considerations that will affect your budget. Unless the VFX Producer has had a good deal of experience in this, he or she would be well advised to work out a budget in consultation with a vendor who specializes in building and filming miniatures.

A good alternative would be to contract the shooting of the miniatures out to the company that is also building them, assuming the company is experienced in providing the full scope of production services. In that case, the potential vendor will supply the budget figure and it is up to the VFX Producer to negotiate the price. Factors that the VFX Producer (in concert with the VFX

Supervisor and Producer) should weigh are whether it is cheaper to shoot the miniatures as part of the production's own visual effects work, or to pay another company's overhead and profit for doing the job. While the latter option may seem more costly at first glance, it eliminates the hassle of setting up and managing a fairly sizable miniature and effects operation, something that carries its own hidden costs with it.

Account 5214—Motion Control Crew

You will find considerable variation in the complexity of motion control systems and number of crewmembers needed for contemporary motion control shoots.

One thing to be watchful of is not to short-change the motion control crew or equipment. Live-action crews often dread the use of motion control on their sets because it tends to slow things down. Even though today's motion control equipment and crews have become quite efficient, the VFX Producer should make sure that all the necessary pieces are in place when the time comes. He or she should resist the pressure to save a few hundred dollars by not hiring an additional technician whom he or she really feels is needed but whom the producer questions, or not having an extra extension of motion control track.

Account 5215—Motion Control Equipment

By the time the VFX Producer gets down to budgeting, she should know from having prepared the shooting schedule in collaboration with the 1st AD and VFX Supervisor what type of motion control equipment will be needed and for how long. It then becomes relatively straightforward to budget the equipment. Motion control gear comes in a wide range of sophistication. Some productions only need (and sometimes can only afford) a computer-controlled camera head to do repeat pans and tilts, while others require the most advanced motion-controlled cameras on cranes or dollies.

Rental houses that carry this type of specialized equipment are few and far between, largely because motion control was never in widespread use to begin with and has become even less so in recent years. This does not mean, however, that the equipment you need is sitting idly in a warehouse, waiting for you to put it to work. It doesn't take many production companies working on effects films at the same time to tie up the equipment for weeks at a time, so you should contact the respective rental houses promptly to inquire about the equipment's availability and try to strike a good bargain well in advance.

Account 5216—Plate Unit

This account would normally cover a variety of visual effects plate photography, anything from an afternoon's shooting of a

few dust elements shot against a black background to full-bore excursions to distant locations to film background plates.

Broadly speaking, we can divide plates into two groups: plates that are shot by the 1st or 2nd Unit, and plates that are shot by the visual effects unit. The VFX Producer is usually only concerned with budgeting and scheduling the second group, which typically consists of such items as traveling mattes (bluescreen or greenscreen plates), miniatures, motion control elements, motion capture, and matte painting plates. (See Chapter 11 for a discussion of visual effects units.)

If you plan on using a Technocrane on a visual effects plate unit shoot, then you will also need to budget for a crane technician and an additional grip. One minor point worth making: Be sure to allow for both set-up and strike days for both crew and stage facilities. They can add significantly to the cost of a shoot.

Our Demonstration Budget shows a provision for 2 days worth of shooting a number of flame, explosion, and smoke elements with a full crew on a stage. The day rate of $45,000 is all-inclusive: crew, facility, equipment, and production services. But we also put in an allowance for pyrotechnic materials (which can be rather expensive), rental of black drapes to black out the stage, and platforms that may be needed to raise the camera or the subject far enough off the ground to isolate the subject cleanly against the black background.

Account 5217—Digital Video Assist

Video assist—the capability to record each camera take and play it back on set—has become standard in the industry. Every 1st Unit will have a video recordist and equipment in its service. Similarly, the visual effects department will often require the same services, though the recordist may have to be hired and the equipment rented separately when the VFX Unit is off shooting on its own. Generally, freelance individuals or companies specializing in this type of service provide video assist. The VFX Producer can put this service out to bid just like any other. Points to be aware of are what labor category the video operator (and assistant, if one is needed) fall under if it is a union shoot, the specific type of equipment being supplied, and the cost of expendables (such as digital tapes, DVDs, etc.). When budgeting this category you should make sure that the digital video assist operator's equipment includes the capability to make simple edits and composites. Also, you may need to budget for additional record decks depending on how many cameras you want to record at the same time.

Account 5218—Set Construction

At first blush you would think that visual effects would not get involved in set construction. That, however, is not necessarily the case. We frequently have to build special platforms for cameras

and actors, construct scaffolding, paint walls or floors blue or green, rent wire rigs, and assemble various other special structures. A good way to figure these expenses is to discuss your needs with the production's construction department. They are experts at this and will be able to estimate the cost fairly accurately.

Speaking of painting, when you have to paint a floor or wall for blue screen photography, you must budget for one coat of white primer and *two* coats of digital blue paint even though this may add several hundred dollars to your budget. But one coat is never sufficient.

Account 5219—Grip/Set Operations

This can be considered as a kind of catch-all account where we provide for such items as man lifts (Condors), special rigging of grip equipment that is a bit out of the ordinary, and other items that we will need on set but that don't readily fit under another account.

Account 5220—Camera Equipment

Rather than breaking down and individually listing all its components, we suggest you estimate the daily or weekly cost of the entire camera package, on the basis of discussions with the VFX Supervisor or VFX DP. Keep in mind that in visual effects work we often need special cameras, such as high-speed Arriflexes, timelapse, or VistaVision cameras.

Once you know the requirements, you can take your shopping list to one or more rental houses and ask them to prepare a bid. All rental houses publish rental catalogs listing their prices for the per-day cost of renting a given piece of equipment. But unless you truly wish to rent equipment for only 1 or 2 days, no one actually pays the list price.

When you are budgeting your production equipment, you should at the very minimum negotiate a 2- or 3-day week. This means that the rental house will charge you two or three times the daily rate for the entire week, including weekends. Rare is the rental house that will not happily agree to this.

Depending on market forces (i.e., how much demand there is for rental equipment at any given time), the type of equipment you need (grip stands, say, versus an expensive camera and lens package), length of the rental (1 week versus 3 months), and other intangible factors, you may be able to negotiate a 2-day or even a 1-day week.

For example, a rental house is more apt to give you a bargain on durable equipment that is in ample supply and not too expensive to begin with (such as grip equipment or traveling matte screens) than on a VistaVision camera package, which is relatively rare, expensive, and delicate.

Another factor that comes into play here is the locality where the equipment is to be rented. You may be able to drive a harder

bargain where competition among rental houses is fierce (such as in Hollywood) than in less well-known production centers where equipment is not as readily available, if at all. So if you are budgeting a shoot on a distant location, it behooves you to weigh various factors in addition to pure dollars: equipment availability, customer service in case of problems, and shipping costs among them.

Be sure to include all the camera equipment you plan to use in the visual effects budget. This seems so obvious a suggestion that you may wonder why we state it at all. But there is good reason for this. When budgets are first being prepared, a studio will demand that costs be kept as low as possible. Every department is asked to sacrifice, and every budget item is subject to close scrutiny and a candidate for being slashed. Visual Effects is no exception, and one of the consequences of this is that a production manager or production executive may expect the visual effects department to share cameras and lenses with the 1st Unit. The thinking is that the 1st Unit generally has redundant camera capability (B and C cameras, as they're often called), and so it should be no problem for the VFX Unit to use one of these extra cameras to shoot its plates when the 1st Unit doesn't need them.

Resist that maneuver if at all possible, because in the real world it's almost impossible to borrow equipment from 1st Unit (assuming that the 1st Unit is not actually shooting the plates itself). Their camera crew will guard its gear jealously and may share it only reluctantly.

Fortunately, experienced producers will seldom cut the visual effects department back on camera gear because they know that you may not be able to get the required plates if you don't have the right camera. Even lower budget productions are best off in honoring the visual effects department's requests for equipment. Still, it is incumbent on the VFX Producer to be as precise about budgeting equipment needs as possible.

The same applies to budgeting grip, lighting, and special equipment for the visual effects. Some productions, in the interest of administrative efficiency, may have the visual effects department channel its equipment requests through the respective 1st Unit departments. For example, the grip department may handle your requests for motion control dollies or green screens. This sort of collaboration between departments can be a great time saver for visual effects but you must not lose sight of the fact that the equipment you order will be coded to the VFX Department's budget, even if the grip best boy orders it. Do not assume that you can put any of these costs off on another department.

You will need to work closely with the VFX Supervisor in putting your equipment list together, particularly when it comes to budgeting "high-ticket" items such as special cameras and dollies. The supervisor needs to analyze each shot to determine how

best to shoot the plates. On the basis of that analysis, the VFX Producer can then budget and schedule the right equipment. This is by no means an insignificant task when you keep in mind that different camera or dolly packages vary greatly in cost.

Account 5221—Blue Screen or Green Screen

Blue- and greenscreen photography is the bread and butter of visual effects, be it in feature films, TV, commercials, or music videos and gaming. As a VFX Producer you will have many occasions to budget and plan these types of shoots throughout your career.

The parameters vary widely depending on the project, and for this reason the VFX Producer, VFX Supervisor, and the DP have to carefully analyze the shots to determine the exact technical requirements, including stage size, screen size and color, and lighting needs. Traveling mattes often involve principal actors, in which case close collaboration with the 1st Unit is a must.

Many productions find it useful to carry a 10×15 or 15×20-ft blue or green screen on their grip or camera truck throughout principal photography. Their rental cost is negligible, but they can be set up at a moment's notice on location when the director wants to grab a shot where a piece of action has to be isolated on blue or green so that a matte can be generated later. In the Demonstration Budget we call it a stand-by blue screen or green screen.

Account 5222—Projection

We use this account to budget rear-screen projection, or RP. In today's production environments RP is accomplished almost exclusively with digital projection. Because it is an in-camera compositing technique (and thus not strictly a visual effect), rear projection is often considered a 1st Unit budget item.

Account 5223—Matte Shots

In this account you would list the matte paintings the show needs and their cost, which you would get from negotiating with your matte artist(s). Cost of matte shots can range from a modest $7,000 for a very simple 2D painting on a locked-off camera setup, to many tens of thousands for a complex 3D painting that includes separately filmed live-action elements, camera moves, and other artistic embellishments. A range for a normal 2D or 2½D matte painting is about $15,000 to 20,000. A more complex 3D matte painting can range from $25,000 to 35,000.

Incidentally, when your project calls for a complex matte shot, you should ask the vendor to supply his or her own visual effects supervisor to oversee the shooting of the plates. Not only is this a form of insurance to make certain the plates are shot correctly, but most experienced matte artists can make a substantial creative contribution to the shots in ways the director, DP, or VFX Supervisor may not have thought of.

The price the artist quotes you for the work should include his or her on-set supervisory fee. However, you will have to budget the cost of transportation, *per diem*, and lodging in your Travel account.

This account can also be used to budget any set extensions the project will need. They are similar to matte paintings, but typically involve more 3D CG work.

Account 5224—Digital EFX/Composites

This account is where you plug in the dollar amount of the digital costs that you have obtained from various vendors. If you look at what else is covered in this account, you'll note that it includes not only the cost of the shots themselves, but also ancillary costs that you may wish to break out separately: CG & Digital Compositing Costs, CG Modeling Costs, R&D Look Development, and On-Set Production Supervision. This last item covers on-set supervision by the digital facility's own plate supervisor to be on set when plates are being shot, in-house production management, and similar items. Whenever you can, you should build in a contingency in this account as well as an allowance for additional shots.

Account 5225—Scanning and Recording

We already discussed how to budget these items in Chapter 5. If you built their cost into your Digital Shot Cost file, it will be part of account 5224 and you won't list it again here. But if for some reason you prefer (or the studio asks you) to show scanning and recording costs as a separate account item, this is where you would enter them. As we stated, scanning and recording are calculated on a per-frame basis. You should also ask about set-up charges a vendor is likely to assess you.

Account 5226—Video Temp Composites

Temps, as they are often called, are preliminary composites of visual effects shots. They are basically tests and composites of works in progress, transferred to disk or film at low-to-moderate resolution. They serve a useful purpose for the director and studio to see how well the shots are working in the film. Include their cost here if it isn't covered in another account.

Digital editing systems such as Avid now enable editors to generate relatively sophisticated composites right in their editing suite, provided the editor has the elements available. This enables them to output their own temps. More commonly, however, the digital effects vendor generates test comps.

When a film has progressed to the point where the studio wants to hold a test screening, you may be asked to output a video temp to film so it can be cut into the print. In those situations, the temp composite is laid off to a digital media that is turned over to another company that will record the shot(s) to

film at the specified resolution. If this step occurs at a relatively early stage of postproduction, the resolution will be fairly low to keep the cost down. Only later, when shots are at or very near their final stage, will it become necessary to request a film output at the final film resolution.

Account 5227—Film and Lab

The consumption of rawstock in visual effects runs the gamut, from very low to extremely high. That's because at one time you may be shooting a motion control element that only requires a few feet of film taken at 1/2-second exposures, to high-speed elements shot at 300 frames per second covered by multiple cameras. Budgeting for rawstock, then, involves a bit of educated guesswork. You will need relatively little rawstock if most elements consist of motion control miniatures; you will need several thousand feet a day if you are shooting flames, explosions, or crashes of miniature vehicles. We typically allow for 3,000 ft of rawstock per day for a visual effects elements shoot.

Whether you will need to budget for rawstock at all in your visual effects budget varies from production to production. Some productions will simply issue rawstock from their own stockpile to the visual effects camera crew as film is needed, having made allowance for it. Others—particularly if there is a lot of high-speed filming anticipated—will want to charge rawstock off to the visual effects budget. Sometimes the DP and VFX Supervisor decide to film the effects elements on a different emulsion than the rest of the production footage. In that case the VFX Producer will have to allow for that expense in his or her budget. If much of the filming of elements is outsourced to a vendor (say, to film all the miniatures under one contract), *rawstock* costs will most likely be included in the miniature vendor's budget.

Be aware, however, that it is customary for lab costs to be charged to the *production's* account at the lab (not the vendor's account), where it is presumed that the negative is covered by the production company's insurance. The VFX Producer should budget for developing all rawstock and for printing 100%. This is different from how the 1st Unit might budget developing and printing. The 1st Unit will customarily print circled takes only (i.e., takes which the director deems to be good).

In visual effects, on the other hand, it's much more likely that virtually all footage will need to be printed and reviewed. To oversimplify the case a bit, when you are shooting motion control elements, the takes are generally short and errors are relatively few since the mechanics of the shot will have been worked out in advance. So there's no point in subjecting the negative to unnecessary handling by a negative cutter to pull selected takes to save a few feet of print. And explosions, crashes, and similar high-speed elements frequently can't be repeated, or they happen so

fast that the director and VFX Supervisor won't know what the camera actually recorded until they see the shot on the screen. Again, a good reason to print it all. You would also include telecines, digital dailies, and similar expenses in this category.

Account 5228—Rentals

This account provides for the VFX Editor's equipment and materials. Unless you are working on an all-digital show (an approach that is becoming more and more common), your editor will need both digital and film editing equipment, plus any special HD monitors and DVD recorders that may be required.

Account 5229—Purchases

We use this account for a variety of general-purpose purchases. You can also include here special purchases for the visual effects department, such as a new software package for the VFX Supervisor that will make him or her more effective. Or perhaps you will be setting up a modest in-house digital capability that will allow you to accomplish a certain amount of digital work at your postproduction offices, in which case you'll be investing some money in both hardware and software (you would budget the artists in the VFX Production Staff chart of account 5203). This account also covers all offices supplies needed.

Account 5230—Stills/Publicity

The production company will have its own still photographer and publicist to immortalize the antics of stars and crew. But unless the VFX Producer makes it a point to invite the unit's still photographer to cover a particularly interesting visual effects shoot, you'll most likely be on your own. Digital photography has made this task fairly easy and inexpensive. Digital cameras have become ubiquitous, and memory cards are relatively inexpensive and can store a wealth of picture data. If the producer or unit publicist wishes to document a particular visual effects shoot because it may have an extraordinary publicity or archival value, then the 1st Unit's publicity department should absorb the cost.

Account 5231—Box Rentals

It's common practice for crewmembers to be paid for the use of their personal equipment and tools that they bring to the job. This is called box (or kit) rental. It applies, for example, to such items as personal computers that a production coordinator may use throughout the run of the project, or the accessories bag (often called a "ditty bag") of an assistant cameraperson. Kit rentals are individually negotiated, but a general rule of thumb is that whatever amount 1st Unit crewmembers are paid for a given item, the people on the visual effects unit should get the same fee. Crewmembers all talk among themselves, and so it will

be common knowledge what the going rental rates are on your project.

Laptop computers, especially, have become commonplace tools on productions. Whereas in the past, kit rentals for laptops ranged quite widely and often exceeded the cost of a new computer on lengthy productions, production companies soon got wise to that and now tend to pay a flat rental for the course of the project. As of the time of this writing, the rate on most productions is $1,000 flat. On lower budget films, this figure is apt to be $500 or less.

When it comes to negotiating kit rentals for a grip or camera assistant's personal tools, the VFX Producer should ask for an inventory of what's in the kit. The producer should look at the kit and see if it contains what he or she thinks it should to do the job the individual has been hired for. Sometimes a kit isn't worth what the person is angling for, so the producer has to negotiate a lower weekly rate. In the case of a visual effects camera assistant, for instance, a kit should contain such items as inclinometers, markers, slate, measuring tapes, and air cans. The producer should take note of what items are expendables (e.g., gaffer's tape, camera tape, Sharpie pens) versus what should be durable tools. The production company will almost always supply the expendables, and so the company should not also be paying for the supplies on top of the kit rental.

Account 5232—Stock Footage

The use of stock footage in visual effects is something of a rarity. Some of the costs the VFX Producer must build into this account are not only the use fees for the footage (which vary according to the actual rights the production is buying), but also such things as per-cut minimums (the minimum footage you will be charged for each shot, no matter how short it is), viewing prints, and the costs of making interpositives or having the shots scanned.

You might also wish to include a modest sum to rent or buy videos or DVDs that the VFX Supervisor and digital artists can use to research the look of a certain environment or how an animal moves. Such references have proved to be extremely useful for artists and directors in coming up with unique creatures.[4]

Account 5233—Tests

Just as the 1st Unit DP may shoot various tests with different lenses and film stocks, so the VFX Supervisor may want to shoot

[4]One of the best-known examples of using documentary footage for artistic inspiration is George Lucas' use of stock shots of aerial dogfights from World War II to inspire the design of the groundbreaking space battles in *Star Wars Episode IV: A New Hope*.

tests that help him or her and the director decide on the look of certain effects. These could include anything from capturing on video how an elephant jogs at the zoo as a guide for animators, to filming a burning mockup of a miniature warehouse at different frame rates to determine the best camera speed for the "hero" take.

Account 5234—Travel and Living Expenses

Any time you and your crew travel to a distant location for a shoot, or even just to scout a location, the production will incur costs for transportation, accommodations, and *per diem* (defined as a daily living allowance). These can be quite substantial. The key question to settle with the producer or UPM is whether travel and living expenses of the visual effects crew will be charged to the visual effects department's budget, or whether the production will absorb those expenses in its overall production budget. If the latter, the VFX Producer merely needs to do a breakdown of the personnel expected to travel to various locations and present the list to the production manager. The visual effects crew then becomes simply another line item in the production budget. More often than not, however, the visual effects crew's travel and living expenses will be charged to Visual Effects, and so the VFX Producer will have to include these costs in the budget. Travel and living expenses for visual effects people should be budgeted at the same rates as the 1st Unit crew (i.e., the same air fares, hotel costs, *per diems*, etc.). The production company will undoubtedly have negotiated the most favorable rates possible with airlines, hotels, and other services. The VFX Producer only needs to get the rates from the UPM or accountant and apply them to his or her crew. As might happen with other budget items, the producer or UPM may ask the VFX Producer to suppress this category and include it in the 1st Unit costs. If so, at least you know that the costs have been dealt with and can be recalled quickly if need be.

Accounts 5235 through 5298—Mileage/ Transportation, Miscellaneous Expenses, Loss and Damage

The remaining accounts are fairly straightforward. We only draw attention to the item of shipping equipment. Depending on the situation, this could become a bottomless pit if the VFX Producer must pay out of his or her budget for shipping a substantial number of (invariably heavy) cases to distant locations or even overseas. Even domestically, equipment is almost always shipped via airfreight, as trucking it may be too slow and even unreliable. If equipment is shipped overseas, customs brokers become involved, and the VFX Producer must allow for their fees.

Fringes

The remaining item in our budget is Fringes. It simply adds up the fringes from all other accounts and shows the total on the bottom line once you fringe by category. Or if you choose you may fringe by production level and have the fringes show up on the top sheet. A final reminder: DO NOT FORGET THE FRINGES! They may amount to tens of thousands of dollars on a high-budget film.

The Contingency: Now You See It, Now You Don't

Every budget should contain a contingency, an extra bit of money that's tucked away and that allows you to deal with unforeseen events that inevitably occur and were not budgeted for. You can be certain that the show's production budget will have a contingency built in. In fact, on most productions it's taken for granted that they will have to dip into the contingency as postproduction progresses. However, this step is never taken lightly, and always only after serious consideration and after special permission has been obtained from the producer, the studio, or the completion guarantor.

Whether the VFX Producer will be allowed to include a contingency in his or her budget depends on the business philosophy of the producer or studio and how close to its budgetary limit the project finds itself. Many productions will only have an overall contingency. If the visual effects need more money in postproduction than was budgeted, the VFX Producer will have to request that money from the producer. How well this goes over will depend on what caused the overage and who is asking for it. You will probably *not* be allowed to show a contingency in the visual effects budget.

But the fact remains that the VFX Producer should have a cushion built into his or her budget, if for no other reason than it is psychologically better to be a bit under budget than to have to go back to the producer to ask for more money. It is simply not possible—nor reasonable to expect—to budget any but the smallest projects without building in some leeway here and there. It is up to you to determine where your budget can be safely padded a bit.

Padding your budget must be done judiciously. It would be a mistake to jack up the budget for any one item so much that an experienced eye will notice that the cost is out of line. That will merely bring suspicion and reproach. Nor is it advisable to bump up the budget for outside contracts, whose total values are subject to review. Instead, you can build a bit of padding into items less likely to be challenged by someone who knows all the ins and outs of visual effects. Experienced VFX Producers do this by spreading the extra money over several budget categories. In any case, the VFX Producer should always be prepared to defend his or her budget as being reasonable.

SUCCESS STORY
Tom Peitzman - (*Alice in Wonderland*; *Mission Impossible III*)

I graduated from San Diego State University with an MS in Telecommunications and Film. I started my career off in 1987 on *The Great Outdoors* as a set/office PA. Worked my way up over the years to assistant POC to POC to production supervisor. On *Forever Young* I got into the Directors Guild of America as an assistant director. Worked for a few years as an AD, then on *Honey, I Blew up the Kid*, started working on visual effects. It was on *Spawn* that I got my first VFX Producer credit. In the last couple of years I have now been working as a co-producer *Spiderwick Chronicles* and currently on *Alice in Wonderland* with Tim Burton. I have worked as a VFX Producer about 12 years.

I feel the most important duty of a VFX Producer is to help put the director's vision up on the screen. People skills are the most valuable asset to a VFX Producer. You have to deal with everyone, the director, producers, crew and the studio executives. I feel that the VFX database is a very important tool to the VFX Producer. I also feel that too many VFX Producers get so caught up in their databases that they forget that they are making a movie. I tend to be the on-set VERY hands-on type of producer. I leave it to my coordinator to update and maintain the database so I can be with the director and actually help make the movie.

8

THE VFX BIBLE AND DATABASE

"Bible: (a) an outstanding or definitive reference
work in any field; (b) a publication regularly
read and regarded as indispensable"
—Webster's Third International Dictionary

You could consider the topics in the foregoing chapters as being more or less preliminary steps in producing the effects because for the most part, breakdowns, schedules, and budgets are basically organizational matters.

We now come to the phase in preproduction where you will need detailed information about each and every visual effects shot on the many lists you've already prepared. We must now concentrate on actually managing the *visuals* that are the whole reason for being behind this whole enterprise. You will have to know exactly what elements are needed to complete the shot, who is doing them, the progress of the work, and many other bits of data.

To do this efficiently, the VFX Producer, in collaboration with the VFX Supervisor, should construct a database that includes all relevant information about every shot in a form that can be manipulated and adapted to different uses, depending on who needs to see it. If the project calls for a relatively small number of shots, you may use a very simple table generated with Excel or other spreadsheet program. More ambitious projects, however, call for a more sophisticated database that we refer to as the VFX Bible.

What Is a VFX Bible?

Simply put, the VFX Bible is a large and extremely versatile database, the ultimate authority on all relevant information about every shot in your film. No visual effects project of even moderate size can be managed efficiently without a VFX Bible. It is not easy or simple to construct one, but as the project goes on you will find that you could not get along without it.

161

It would be best for you to construct the database yourself, delegating only routine functions of data entry to an assistant. The very process of setting it up, entering shot numbers and descriptions, and typing in your plate requirements, digital elements, and the many other bits of data you will need during the course of production, forces you to get to know your show intimately and when you are done, no one will know the project better.

As you are setting up the database, think about ways to keep it simple and as user-friendly as you can. Remember that as the project stretches out over the months, many others on the production will need occasional access to the information on a selective basis.

Perhaps the most widely used database program for this purpose is FileMaker Pro. This is an extremely powerful tool that is readily adaptable to the management of visual effects projects.[1] Its capabilities are limited only by your imagination. All the functions listed here, and more, can be built into the database:

- You can get virtually instant access to every shot and see every element needed.
- You can design different layouts to suit many different purposes.
- You can set up an almost limitless number of categories.
- You can group shots into sequences to prepare bid packages for vendors or for any other reason to break out a specific sequence.
- You can monitor your budget and keep track of shot costs. Depending on how ambitious or skilled you are at using FileMaker Pro, you can devise a variety of layouts to help you monitor your costs.
- You can insert storyboards, previs, and Quicktime movies into the database and change them as newer versions of shots come in.
- You can link up with the VFX Editor's database to keep track of shot delivery.
- You can set up screening reports that provide feedback to the VFX Supervisor, director, producer, and digital facilities.
- You can quickly find out the latest version of a shot that a digital facility delivered.
- You have the information for weekly status reports for the producer or studio at your fingertips.
- You can extract the shots that have been finaled and that can be turned over to the negative cutter or digital intermediate facility.

[1] Readers who prefer to work with off-the-shelf software may consider buying a program called Showrunner, which was specifically designed for managing visual effects projects. Information about this program is available at http://www.vfxshowrunner.com.

- You can import certain data from other programs, such as Microsoft Excel, thus linking your files. For example, if you already have your shot descriptions nailed down in an Excel breakdown or are confident that certain attributes of the effects shots can be named the same in both files, you can import these into the FileMaker Pro database. Be forewarned, though: You must think the procedure through carefully in advance and rigorously follow the rules for this procedure. The information has to be entered in Excel in a certain way in order to import the data into FileMaker Pro.

Using its "Sort" and "Find" commands, FileMaker Pro can look through the entire database and instantly separate out specific groups of shots or data that meet certain criteria that you define. As an example, you may want to pull up all the shots that are still on "Hold," or those that were shot on a blue or green screen. It also allows you to include storyboards or digital photographs in its "Container" field. This lets everyone know at a glance which shot they are dealing with. Your options are almost limitless.

If you are not familiar with FileMaker Pro—admittedly a fairly complex program—you can also construct a somewhat less versatile database using Excel or a similar spreadsheet program that will adequately fill the need for many smaller or lower budget projects. Excel, for example, is not only adept at handling numbers and formulas, but it also allows you to insert storyboard images and to design simple shot tracking and status reports (see Figure 8.1).

As the project moves into the postproduction phase and shots start coming together, you can substitute Quicktime movies (such as an animatic or a temp composite so you can see the shot in motion) for the storyboards.

A key point is that *every visual effects shot must have its own data sheet.* Figure 8.2 shows one such shot detail sheet that includes the kind of information a VFX Producer and supervisor generally need to keep track of and share, on a selected basis, with other members of the production. We sometimes refer to these sheets as Bible Sheets.

As you see in Figure 8.2, shot detail sheets can get pretty dense with information. Not all of it is needed for every project, but a few items are universally useful. At a minimum you will want to include the project's title, some key dates pertaining to the shot (such as when the sheet was created and last modified), and the scene and visual effect number. You will also want to include a storyboard (if available) and a shot description.

Once these essentials are taken care of, you can add other key details about the shot as your situation demands. The most important of these are the elements that will have to be shot (each with its own set of data), and the elements that will have to be created during postproduction. You can determine how to label the details for these entries in a wide variety of ways.

# of shots	VFX Shot #'s	Sec.	SHOT DESCRIPTION	Storyboards/Jpegs	# of Scan Layers	Plate/Production Elements	Digital Elements/CGI	Methodology	Digital Shot Cost
				VFX BREAKDOWN **"FALSE HORIZON"**					
1	V15.1	5	INT. SPACE FREIGHTER - COCKPIT - DAY - McFarley spots tail of comet in distance to Rogers.		1	**Plate** of McFarley and Rogers in cockpit looking out GS window	CG Comet CG Stars CG Sky	Digital Comp w/CGI	
2	V21.3	5	INT. FREIGHT DECK (Breakaway Set) - DAY - MS on Alondra as she goes sliding across the floor, grabbing for a rack or strap. Behind her we see that the hull has cracked open, revealing the planet's surface outside; dust and debris is getting blown in from outside.		2	**Plate** of Alondra sliding across floor past GS hull opening **Clean BG Plate** of Set	Wire Removal CG Sky CG Planet CG Dust CG Debris	Digital Comp w/CGI	
3	V22.1	5	EXT. SPACE FREIGHTER - DAY - Moments after impact. The freighter is starting to break apart, chunks of the ship's steel hull are already flying through the air as the skidding ship's hull is gouging a trench into the planet's surface. Dirt and debris is flying in all directions.		1	**Miniature Plate** of Ship's Hull crashing into CG planet	CG Sky CG Planet CG Dust CG Debris	Digital Comp w/CGI and Miniature	
4	V23.1	5	INT. FREIGHT DECK - DAY - The angle should be such that we can see the gaping hole that has been ripped into the side of the ship.		1	**Plate** of inside of freight deck w/GS	CG Space CG Planet CG Dust CG Debris	Digital Comp w/CGI	

Prepared by
VFX Producer

Figure 8.1 An example of an Excel spreadsheet adapted to serve as a database.

The breakdown sheet (Figure 8.2) provides more details about the elements that make up a shot and provides useful technical information. In addition to the usual shot number and description, the breakdown sheet lists not only all live-action elements, but also the *digital* elements that will be created in postproduction. Each element has been assigned a unique ID number, a brief description, the source of the element (e.g., 1st Unit), and the technique by which the element is to be acquired.

Other relevant information appears toward the bottom of the sheet. In this example, information that will be of interest to the stage crew is that a 30' × 40' green screen will be needed to film one or more of the elements.

FileMaker Pro allows the VFX Producer to devise a nearly unlimited variety of forms to suit different purposes. Figure 8.2 shows some of the most common types of information that the visual effects department might find useful.

The example presented in Figure 8.3 also includes some numerical data and budget figures about each shot. We included these mainly to show the versatility of a good database. The VFX

False Horizon VFX Shots — New — V21.3

Scene: INT. FREIGHT DECK - (GS) - DAY
Sequence Description: SPACESHIP CRASH
Shot Description: Alondra slides across floor past hull opening

Date Shot Modified 3/16/09

ID	Element type	Description	Unit/Vendor	Technique	Slate
V21.3A	Plate	Plate of Alondra sliding past hull opening w/GS	1st Unit	Live Action/GS	
V21.3B	Plate	Clean BG Plate of Set	1st Unit	Live Action	
V21.3C	Plate	GS Plate of Crates falling	VFX Unit	Live Action/GS	
V21.3D	Plate	Smoke on Black	VFX Unit	Live Action	
V21.3E	Digital	CG Crates Rolling and Tumbling	Urania FX	3D CGI	
V21.3F	Digital	CG Dust and CG Flying Debris	Urania FX	3D CGI	
V21.3G	Digital	CG Sparks	Urania FX	3D CGI	
V21.3H	Digital	Matte Painting	Urania FX	3D CGI	
V21.3J	Digital	Wire Removal	Urania FX	Wire Removal	

EncoderHead: ● Yes ○ No **Animatic-Current** ○ Yes ● No
Technique: Digital Comp w/CGI and Wire Removal
Length of shot (Secs): 5.00 (Estimated) **No. Frames:** 120 (Estimated) **Handles:** 8 head & 8 tail
Length of shot (Secs): 5.08 (Final) **No. Frames:** 122 (Final Record Out)
No. of Layers: 4
Final Compositing: 2K 10 BIT

Vendor	Date Due
Urania FX	7/24/09

Notes
30' x 40' Greenscreen needed on set
SFX to rig safety harness on actress
Breakaway Set

Figure 8.2 Example of a VFX Bible Sheet (sometimes called a VFX Database Sheet) created with FileMaker Pro.

Figure 8.3 This FileMaker Pro cost layout shows the adaptability of a FileMaker Pro database to various purposes.

Producer may want to have this information on his or her personal sheets, but may not want to display it on sheets that go to other departments. Everyone concerned with the visual effects, for example, may need to know what elements have to be shot, but it would not be desirable to let everyone know how much the shots cost. By designing different layouts (e.g., a master list with storyboards but no budget figures, or a layout that emphasizes mainly 1st Unit shots that require actors on green screen but omits all reference to digital elements) the VFX Producer can adapt the shot detail sheets to different needs.

The important concept to grasp here is that *all these layouts use the same database*. This means that you have to enter the information only once. That one entry is then available to all the different layouts you may wish to create for various purposes, and each layout shows only the information that you selected to include. And if you change an entry (e.g., a budget figure) on the master, the change will reverberate throughout the other reports that you created.

Examples of Reports from a FileMaker Pro Database

Following is a list of only a few additional types of reports that can be generated from a database:

- Element breakdown list
- Storyboard list
- Summary of vendor bids
- Budget shot costs
- Tasks

V	21		.	3	

Scene Description
INT. FREIGHT DECK - (GS) - DAY

☐ Muse FX
☐ Tantalus FX
☐ Colibri FX
☒ Urania FX

Vendor:

Spaceship Crash
Sequence

Old VFX#

Shot Description
Alondra slides across floor past hull opening

New 3.16.09

Quick List

Status

| Breakdown | Storyboards | Bids | Costs | Tasks | Status | Feedback |

Breakdown

ID		Element type	Description	Unit/Vendor	Technique	Slate	Shoot Date
A	V21.3A	Plate	Plate of Alondra sliding past hull opening w/GS	1st Unit	Live Action/GS		3-16-09
B	V21.3B	Plate	Clean BG Plate of Set	1st Unit	Live Action		3-16-09
C	V21.3C	Plate	GS Plate of Crates falling	VFX Unit	Live Action/GS		6-4-09
D	V21.3D	Plate	Smoke on Black	VFX Unit	Live Action		6-4-09
E	V21.3E	Digital	CG Crates Rolling and Tumbling	Urania FX	3D CGI		
F	V21.3F	Digital	CG Dust and CG Flying Debris	Urania FX	3D CGI		
G	V21.3G	Digital	CG Sparks	Urania FX	3D CGI		
H	V21.3H	Digital	Matte Painting	Urania FX	3D CGI		

Technique:	Digital Comp w/CGI and Wire Removal	Lens	
Length of shot (Secs):	5.00 (Est.)	No. Frames: 120 (Est.	Animatic ○ Yes ⦿ No
Length of shot (Secs):	5.08 (Final)	No. Frames: 122 (Final)	Handles 8 head & 8 tail
No. of Layers:	4	Vendor Due Date	
Pre-Vis	Yes		
Final Compositing:	2K 10 BIT	Urania FX 7/24/09	
Percentage Complete:	%		

☐ GS / BS
☐ Lidar
☐ HDRI
☐ Moco
☐ A/B Switcher
☐ Aerocrane
☐ Underwater Camera

Crane:
☐ Stratacrane
☐ Technocrane

EncoderHead: ⦿ Yes ○ No
Dissolve: ○ Yes ○ No
Dissolve From:
Dissolve Into:
Dissolve ID:

Plate / Production Elements Miniature Notes Digital Elements General Notes

Note: Breakaway Set

30' x 40' Greenscreen needed on set
SFX to rig safety harness on actress
Breakaway Set

| Find All VFX Shots | Sort by VFX # | Duplicate Shot | | Go to Reports |

Figure 8.4 The labeled bars near the top of this element breakdown sheet show that there are several ready-made reports available with a mouse click in the database: Breakdowns, Storyboards, Bids, Costs, Tasks, Status, and Feedback.

- Status report of all shots for studio
- Daily tracking feedback on a shot or sequence
- VFX daily production report
- List of plate elements that need to be shot
- List of equipment that is needed on set
- Screening report
- Approval sheets (to be signed by both editor and VFX Supervisor)

The options are nearly limitless.

Database Maintenance

The database must constantly be maintained and updated, or it quickly becomes a hodge-podge of unreliable data that will cause nothing but confusion and consternation on your team. Therefore,

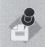

Communicate...

...often and clearly. Do not withhold information in a misguided attempt to make you seem to be the source of all information that others have to come to know what's going on. Let other departments know everything that visual effects does or needs that may affect them. What's more, put it in writing, especially anything that involves money or the schedule. It's called creating a paper trail. Not only will your colleagues thank you for making their jobs easier, it may also resolve disputes that occasionally arise.

you should always designate one individual, such as the VFX Coordinator, whose job it is to maintain the database on a daily basis. You have to be almost fanatical about this housekeeping.

The value of well-designed and maintained shot detail sheets should be self-evident. During production, they are a terrific tool for communicating with the ADs and other departments who will be contributing to the visual effects. The sheets let people know what plates (including lighting references, background plates, element plates and other plates) have to be shot by various units, and the accompanying notes will alert the crew to your department's special needs. Even if you listed them in the One-Liner, it's a good idea to have them published on the shot detail sheets, too, not to mention that they also help both the VFX Supervisor and VFX Producer remember crucial details.

During postproduction, on layouts modified for that purpose, shot detail sheets can help the VFX Producer, VFX Supervisor, VFX Editor, and others on the postproduction team monitor the progress of the visual effects shots as the deadline for completion nears. Postproduction layouts would favor items like digital elements that have to be created, the vendors, due dates, costs, shot approvals, etc.

All in all, then, a FileMaker Pro or similar relational database is not just a tool to create a few pretty-looking forms to tack up on the production office walls. In experienced hands it is a means to create and maintain a complete history of the project, not that everyone on the visual effects team needs access to all that information. Through careful use of passwords, you can make sure that only a few trusted people have access to the database and are authorized to make entries. Just as it is everywhere that computers are used, security is essential. But with those safeguards in place, few things offer a better or more effective means to manage your data.

Visual Aids

Storyboards

Directors are in the business of communicating through images. This process begins quite early during a film's life with *storyboards*. Storyboards are, in a very real sense, a visual script. They should show all significant information about a shot such as live action, greenscreen elements, background plates, and miniatures. Ranging from extremely simple "thumbnails," that is, small sketches that are little more than hastily tossed-off line drawings, to highly elaborate, handsomely drawn little works of art, they are among a director's best tools for communicating his or her ideas to all departments. Storyboards are generally the result of the close collaboration between the storyboard artist and the director who conveys his vision to the artist. The director and VFX Supervisor

can use them to design the shots, and the VFX Producer can base a breakdown on them and use them for bidding.

Some directors will prepare storyboards only of certain sequences and "wing it" for the rest of the shooting. But while storyboards are somewhat optional for live-action filming, they are *essential* in visual effects. In the best of all worlds, visual effects storyboards would be produced jointly by the director, a savvy VFX Supervisor, and an experienced storyboard artist. The director describes what he or she wants, the VFX Supervisor designs the shots, and the artist draws them so that everyone who sees the storyboards immediately understands what is happening in each shot. The storyboards communicate visually what elements will be needed for a given shot: live action, bluescreen or greenscreen elements, background plates, miniatures, matte paintings, digital elements, etc.

It doesn't always work that way. Storyboards get generated under all sorts of circumstances by artists of varying talent working with directors who may or may not be familiar with visual effects. In other words, storyboards run the gamut of quality, and a VFX Producer tasked with doing an effects breakdown of a script may or may not have storyboards for guidance. If she does, all is well. If she does not, the producer should immediately try to persuade the director to get cracking on them.

Their importance is often underestimated, the thinking being that a slap-dash job will be good enough to convey the critical essentials of a shot. That may do in some cases, but in this day and age of high-budget, high-profile films it is advisable to hire a good storyboard artist. He or she, ideally with creative input from both director and VFX Supervisor, can play a significant role in helping the director design the visual effects so that they fit into the flow of the story. In the long run, poorly designed visual effects shots will waste money, time, and energy because they will either have to be fixed at some point or abandoned. An experienced storyboard artist can help avoid those pitfalls.

Storyboards are also a great device for getting a director to talk about his or her expectations for the visual effects. It's a fairly simple matter to set up a video camera, focus it on storyboards placed on a table, music stand, or similar support, and invite the director to talk about what he or she wants to see in each shot. Such informal sessions can yield a treasure trove of helpful information that the VFX Supervisor and VFX Producer can use in planning their work. Plus, it is a great way to avoid misunderstandings when dealing with a bidder.

After the director has approved the storyboards for a visual effects sequence, the VFX Producer can then assign an official V number (visual effects number) to that shot. The producer can do that by simply writing the V number in the margin of a storyboard panel. From this point on, storyboards with their appropriate

Figure 8.5 A storyboard sheet is used as the basis for generating breakdowns. Storyboard layouts vary widely. In visual effects we typically have only one storyboard per shot. Each storyboard with its shot-specific information can then be individually tacked on a wall, posted on set, or kept in a binder.

(Image courtesy of Pete Von Sholly)

effect number attached can be distributed to anyone who needs them without danger of confusion about a given shot number.

Approved storyboards can also be scanned and inserted at the appropriate places not only into your FileMaker Pro database (as in Figure 8.2) but also into your Excel spreadsheet. Keep in mind, however, that images (even line drawings like storyboards) consume prodigious amounts of computer memory. For this reason, you may wish to keep the storyboards in a different FileMaker Pro file than the shot data. You would then write a script (which is basically a separate set of commands; in other programs they might be called macros) that will access and insert the correct storyboard image only when it's actually needed. For example, you may want to include the storyboard in a layout that lists the elements that have to be filmed, but omit it from a budget or scheduling layout.

For the VFX Producer, then, storyboards serve several important functions:

- You can base your own breakdowns on them.
- You can send them to potential vendors to solicit competitive bids.
- You can use them to communicate effectively with other departments or members of the crew as to what the visual effects shots entail.

One more note about storyboards. It may sound odd to think of storyboards as assets, but that is what they are. They are extremely valuable! They and everything else that the visual effects department produces are valuable, from storyboards to previs to dailies to finished shots that are stored on computers. In today's digitally connected world, all assets that reside on a computer or are sent over a network connection are potentially subject to theft. They must be protected from unauthorized use from the moment of their creation (you don't want to have a hacker intercept one of your visual effects shots and post it on the web). You should become involved in that process from the moment you or anyone in the visual effects department begins to accumulate valuable visuals on computers and remain vigilant throughout the entire production and postproduction periods. You also need to make sure that all vendors you work with have a reliable digital rights management protocol in place. Address the issue with the producer of the film and find out how the company wants to protect its intellectual property.

Animatics

Animatics are a slightly more advanced way of presenting storyboards than a printed page. In an animatic the static storyboard is given simple motions: pans, tilts, zooms. If you are working on a tight budget, you may do this by shooting the storyboards with

What's in a name?

The terms *animatic* and *previs* are sometimes applied a bit loosely, almost interchangeably. Be sure you're in tune with everyone around you as to what they have in mind when they talk about these distinctly different applications. Both can be used but an animatic costs much less than previs.

a digital video camera and then importing them into your editing system. More commonly, storyboards can be scanned and transferred into Avid or another digital editing system where the editor can impart simple motions to the static boards.

Used in this fashion, animatics can be very helpful to the director in putting together a story reel, which is a short presentation that encapsulates the story he or she wishes to tell. Additionally, once filmed or digitized, an animatic can be edited into a rough continuity (with or without music or sound effects), thus beginning the process of integrating the visual effects into the movie. Although limited in how much visual information they can convey, animatics are a particularly useful tool early in production or when money is tight and the production can't afford to prepare more elaborate visual aids, such as…

Previs

In recent years a procedure called *previsualization* has become a nearly indispensable tool in the visual effects industry, largely owing to two main factors: the growing complexity of contemporary visual effects and the widespread availability of powerful 3D computer graphics programs. The former demands more detailed preplanning of the visual effects than ever before. The latter has made sophisticated previsualization software affordable for virtually every production company. It is a case of cheaper and more powerful technology serving greater artistic freedom. This is especially the case when a given visual effects shot draws on a mix of different techniques and media, such as live action coupled with greenscreen elements and computer-generated animation.

A previs is a fully animated, three-dimensional storyboard in motion. Previs is about laying out camera angles and moves, blocking out the action, and setting the placement and number of visual elements. As employed by contemporary visual effects supervisors and directors, previs allows filmmakers to design complete visual effects sequences virtually to the frame and experiment with different approaches at very modest cost. Every character, every important action beat, set piece, camera position, and move can be created in simplified form in the computer and played back for the director and everyone else to see, critique, and modify long before the first foot of film runs through a camera. Previs is both a powerful *creative* tool for directors and an invaluable *planning* tool for VFX Supervisors and Producers.

One of the most useful applications of previs is that previs data can now be applied on the live-action stage to control the motion of a dolly and a camera during principal photography, by a miniature or bluescreen or greenscreen unit to repeat the same move, and finally by a digital facility to faithfully track a computer-generated element or elements to complete the shot.

PRE-VIS OF FISHING BOAT SEQUENCE - V205.2

Flash Film Works 1 fb205_02_v03 (20mm)

Figure 8.6 This frame from a previs was generated by Flash Filmworks. Note that the previs figures and settings are drawn to scale, but are realized with simple shapes and shading.
(Image courtesy of William Mesa, Flash Filmworks; © *2006 Touchstone Pictures. All Rights Reserved*)

A Case Study—Previs for *The Guardian*

Previs was an essential tool during the production of the film *The Guardian* (2006). The script—depicting the heroics of U.S. Coast Guard rescue swimmers—called for three hair-raising sequences of sailors and fishermen being rescued from sinking ships during raging storms at sea. The live action with the actors was filmed in a large tank. The live action had to be integrated with enormous amounts of digital water, digital helicopters, and digital ships.

Here is one example of how previs helped the visual effects team and the director plan their shots. In a sequence depicting the sinking of a fishing boat, the VFX Supervisor chose to shoot the boat dry, out of the water, because he knew that he could never create interactive water large enough to simulate the real storms. Most of the interactive water was generated in CG augmented with live footage of real storm-tossed waves.

Each water sequence had to be designed and techniques had to be discussed with the director of photography, production designer, VFX Supervisor, and special effects team to determine the best approach. Getting the previs done prior to photography was a top priority. Schematic layouts were created by the visual effects facility for each of the visual effects shots that showed the start and end for each of the camera crane moves.

From the previs, technical camera data sheets were generated which listed the frame count, lens, maximum camera height, minimum camera height, elevation of the crane at the start of a move, and speed needed. The visual effects team painstakingly planned every shot in advance.

Every day at wrap, the construction and special effects crew were told where to place the equipment for the next day so that no time would be wasted with the crew standing around waiting for a construction crane to move. All this was orchestrated on the basis of production's previs. The importance of planning ahead for each day was invaluable to everyone and saved a great deal of time on the set.

Previs also played a critical role in getting live-action photography of ships to interact believably with digital water. Normally the live-action plates of the boats would be shot first, and the CG water would be added in postproduction. In this case, however,

Figure 8.7 Here is a technical previs data sheet. This type of detailed preplanning is crucial when shooting sequences that involve highly complex moving set pieces and camera moves.

(Image courtesy of William Mesa, Flash Filmworks; © 2006 Touchstone Pictures. All Rights Reserved)

the process had to be reversed because the postproduction schedule was very tight. The CG water had to be developed first, and then technical data was given to the crew on the set to be used for filming the dry boat in the tank. The visual effects crew used this technical data to control the exact pitch and roll of the live action boat so that it would fit into the digital water being created by the visual effects facility.

It should be clear from this example that the advantages of previs are many:

- On occasion, previs can become part of the development process of a project, as when a director uses this tool to help sell the story, perhaps helping to get a project greenlit on the merits of his presentation.
- In the early stages of a project, the director can sit with a digital artist and/or the VFX Supervisor and design the visual effects shots well ahead of time. Even while still working on the script a director can use previs to help him or her see how well a sequence flows. Is it stagnating? Is it captivating enough to hold viewers' interest? Or does a particular sequence need to be perked up with other shots to make the movie more exciting?
- In this respect, previs is a *simulation of the movie*. Individual shots can be simulated in a computer with considerable accuracy long before filming starts. Using relatively simple 3D computer graphics, a digital artist can build models of various objects—sets, cameras, actors, etc.—for a shot and put the models through their paces. He can determine camera angles, lens focal lengths, the movements of a motion control dolly, the height a crane has to reach, and the placement of actors and size of set pieces. The DP can evaluate what is practical to shoot on location with real cameras versus what may have to be shot on a bluescreen stage. This technical previs is especially helpful in figuring out how to achieve difficult camera moves.
- Data from a well-designed previs can now be transferred directly to a real-time motion control dolly on a live-action set or a motion control camera on a greenscreen or bluescreen stage. Thus, we can use the previs first to film the actors using an encoded camera and dolly, and later to match that same camera move on a miniature so that the two can be seamlessly combined in compositing.
- Both the director and VFX Supervisor can—at very modest expense—experiment with different approaches to the effects. They can explore the effect that different interpretations of the storyboards might have on the visual effects, for example by experimenting with different versions of a shot to see if it might be better to use real actors on a green screen or digital doubles.

- In turn, this helps the VFX Producer to plan and budget what facilities and equipment will be needed during visual effects production. It can help answer specific questions, such as how big a set has to be built, how large a blue screen will be needed, or how long a dolly track has to be.
- During the bidding phase of the project, the VFX Producer can send the previs to potential contractors. Not only does this level the playing field for bidders, but it also expresses the intent of each visual effects shot much more clearly than a storyboard.
- During production, reviewing a previs that may have been generated months earlier can help the director, who must be prepared for the day's shoot, recall the details of how he or she wanted to achieve a given shot. For some directors, previs is merely a guide to what they will actually shoot once they get on the set. Others will follow the previs fairly closely.
- Not only is previs a valuable tool for the director, but it also makes it clear to everyone on the set what a specific shot aims to accomplish. This is especially valuable in foreign countries where language differences may make it difficult to get ideas across verbally. In this situation, a previs is worth 1,000 fractured words.
- Lest you think that previs is generated only during the relative calm of preproduction, it can also spring suddenly into being while shooting is already underway. More than one VFX Supervisor has burned the midnight oil in some distant hotel room, working on a laptop to design a new effects sequence—or refine an existing one—to have ready when shooting resumed the next day.
- Finally, previs serves as a placeholder for the editor as he or she begins to edit the picture. As crude as a previs may be, it can be cut into a sequence, thus enabling the editor to judge the pacing of a sequence much more effectively than if he or she had only a storyboard to go by. And test screenings will yield a more favorable response from viewers who get to see a previs cut in instead of that much-derided title card, "Scene Missing."

Generating a Previs

There are several avenues open to us for generating previs. For one, the VFX Producer may want to hire a digital artist to create the previs in-house, setting him or her up at the production office with the requisite workstation and software so the director can work directly with the artist on a daily basis. It can be a creatively liberating experience for a director to have that capability virtually at his or her fingertips as the director works on refining his or her vision.

Alternatively, the VFX Producer may want to engage the services of a company that specializes in generating previs sequences. Such companies are proliferating, and they have artists on their payroll who are experienced at working with directors in designing visual effects. Some of them have written their own software specifically to make previsualization more efficient.

Most reasonably competent digital effects facilities should also be able to tackle previs as long as they have experienced animators and the proper 3D animation tools, and their costs are reasonable.

Previs animators should not only know how to animate, they should also have an understanding of cinematography, camera angles, lenses, and photographic composition; a good sense of timing; and a feel for staging action in terms of choreographing movement both of characters and the camera. In other words, he or she should have the sensibilities of a filmmaker.

The artist (and the director) must also keep in mind that a virtual camera in a computer is free of the laws of physics, but a real camera is not. In the computer, the artist can make a camera move at any speed, have a crane reach any height, invent a lens of any focal length, or have an actor perform any physical feat. To achieve its goal (which is, after all, to help the director understand the whole flow of the action), a previs must be firmly based on what the director can achieve on a real set with real equipment and people.

SUCCESS STORY
Mickey McGovern - (*Speed*; *James and the Giant Peach*)

I've been working in VFX for over 20 years. I was getting a Master's Degree in Film at San Francisco State when I got a dream job, working at Lucasfilm. It was 3 years of a very exciting time for me. I learned a lot about visual effects by sitting in a screening room during dailies every day listening to VFX Supervisors like Ken Ralston and Dennis Muren talk about shots…. I got in on the very beginning stages of digital animation and compositing…I love working in the film industry. I like the people and the creativity. I was inspired to become a VFX Producer by the stage and shooting crews and the other industry people I met while I worked at ILM.

The first thing a VFX Producer does is lay out the plan. Have a close and good relationship with the VFX Supervisor. It's a partnership…a friendship…long lasting and forever. Be able to communicate with the supervisor clearly, frankly, and with humor. Negotiate any problems but solve them together. Commit to a schedule and stick with it. Do your overtime in the middle of the show. Don't cram everything into the last weeks. It'll kill everyone including you.

A good database and bible are imperative. The database works well for the production crew and the editors. Easy access to each shot, what vendor has what and what the status of the shot is. When you have over 500 shots it's good to be able to enter a shot number and see exactly what's going on with it. The VP of VFX for the studio can also access the database and check whatever without pulling someone off of something else. It makes it simple to distribute shots to vendors and to view their work.

PRODUCTION

9

ON-SET OPERATIONS

The care and feeding of the 1st Unit

"Meetings are indispensable when you don't want to do anything."
—John Kenneth Galbraith

More so than just about any other department, we in visual effects must depend on other departments for nearly all our needs, from office space to support crew to camera equipment. For this reason, it's essential to establish and maintain cordial and productive relations with other departments. People skills—diplomacy—are very important in this business. Especially important to the VFX Department's success during production are the DP and his or her crew, and the ADs. We can't emphasize enough how important it is to establish and maintain good communication with these individuals.

The reality is that the visual effects department often has special requirements that are little understood by 1st Unit crews. As a result, our department may be seen as a hindrance that unnecessarily slows down the 1st Unit's pace. Though this is sometimes unavoidable, that is the last thing that we want. Instead, the visual effects crew should strive to keep disruption of the 1st Unit's work to a minimum, even when it is necessary, for example, to bring a motion control setup on stage.

Good relations and collaboration with the 1st Unit begin long before we set foot on the stage. They begin when we have our first significant interactions with the other departments. Frequently, that first significant interaction comes through a general production meeting. Few people really enjoy meetings, but in film production, we hold a lot of them. *Un*fortunately, they

181

are unavoidable. Fortunately, some are useful and will, Professor Galbraith's opinion notwithstanding, lead to action. Some meetings are, in fact, essential.

Production Meetings

Actually, there usually will be two or three of these production meetings during the preproduction phase not long before the start of principal photography. At these meetings the producers, the director, UPM, and the heads of all departments and their key assistants meet and go through the entire script page by page to make sure that there are no loose ends or misunderstandings about what is needed for each scene. Production meetings may last all day and stretch over more than one day. That's how important they are.

Both the VFX Producer and the VFX Supervisor need to be at those meetings. You must be prepared to answer questions, remind everyone about special needs the visual effects department has, and be ready to offer solutions if someone has doubts about whether a scene can be achieved practically or might need an assist from visual effects. But resist the temptation to say "OK" whenever one of the key players on the production says "Let's give it to visual effects." If you do, pretty soon you'll find that you're being overwhelmed with more work than you signed up for without the budget or time to do a good job.

Filmmaking is a complex logistical enterprise, and it is the nature of the business that every department tends to be somewhat myopic. They must look after their own specific needs and responsibilities. And whereas most experienced department heads know a great deal about how other departments work, they may have only limited understanding of the specialized requirements of the visual effects department. The general production meeting may, therefore, be one of the last chances you have to communicate the visual effects department's special concerns that everyone needs to be aware of. Make it count!

The Visual Effects Review

In addition to full-blown production meetings, the VFX Producer also needs to organize one or more meetings that are devoted to the visual effects. The visual effects review meeting should include key individuals of departments that will be involved with the visual effects in one way or another: producer, director (including the 2nd Unit director), AD, DP, production designer, art director, and special effects. This meeting will be devoted to going through the *visual effects storyboards*, one by

one. By concentrating on visual effects issues, this meeting will give the VFX Supervisor and you a chance to focus on the visual effects department's needs and plans in detail without being sidetracked by more general production concerns.

One of the most important decisions that the group should make at this meeting is who is going to do what. Division of labor among the various departments is generally very clearly established by union rules and custom. But when it comes to the visual effects, there is a good opportunity to make some key decisions before production starts that will not only save the production money, but could also greatly enhance the visual impact of the film. We are referring here to the creative collaboration between special effects and visual effects. One of the advantages that special effects has over visual effects is that they deal strictly in natural phenomena, that is, events that occur in the real world and that are subject to all the physical laws of nature. Special effects gets results in real time in-camera on set. There is almost universal agreement in the industry that it's preferable to shoot as many effects in camera as possible because the real thing almost always looks better than anything we can create in a computer, and often costs less.

This opens the way for an in-depth discussion among the director, the special effects coordinator (who is the equivalent of the VFX Supervisor in his department), and the VFX Supervisor as they hash out how best to achieve the visual impact the director has in mind. Quite often the special effects coordinator and his crew can offer solutions that would be costly to do in the computer. Other times, in discussing a shot the director may find that if he makes a minor change in the shot, he would not have to resort to visual effects at all. Still other shots can best be accomplished through collaboration between special effects and visual effects. For example, the special effects coordinator may tell the director that his crew can safely set off dozens of squibs and small explosions on set, while the VFX Supervisor can assure the director that the explosions can be digitally enhanced to make them look more spectacular. Collaborations of this sort can be worked out at one or more visual effects meetings and are virtually certain to pay off in a more efficient production schedule and a better-looking film.

. . . and More Meetings

Aside from these essential meetings there are other, smaller meetings that the VFX Producer should request and organize. Some can be as informal as plopping yourself down in the production designer's office for a few minutes to discuss the size of green screens needed, while others are larger affairs that require

preplanning. The possibilities are endless, and so we will only make some general recommendations:

- Your meetings should be narrowly focused on a few topics that can be resolved in a short time.
- Invite only people who really need to hear what you have to say, but who have the knowledge or authority to do something about your requests.
- If you need to have several people at the meeting, give them reasonable advance notice and let them know what topic you want to cover.
- Have handouts available of storyboards or other reference material.
- Start on time, and try to keep the meeting as short as possible.
- Remember: If you called the meeting, you must set the agenda and keep the participants focused.

Tech Scouts

Tech scouts aren't so much meetings as they are trips or "outings" away from the production offices taken by a number of technical department heads or assistants to check out a location and discuss logistical problems the production may encounter. Tech scouts are usually fairly short affairs lasting from a couple of hours to most of a day. Typically they are organized by the production office and take place a few days before shooting begins at the location. Tech scouts are usually led by the line producer and director, accompanied by the AD and sometimes the UPM. It is important that the VFX Producer and VFX Supervisor go along on tech scouts to any location where visual effects are involved to make sure that the visual effects department's needs are taken into consideration. As the old saying goes, "Out of sight, out of mind." You don't want that to happen to you.

Extended Location Scouts

On occasion a tech scout actually becomes a full-fledged location-scouting trip out of state or even out of the country that may last many days. Trips of that nature typically occur during preproduction, well in advance of the start of production to give everyone time to assess their needs and prepare for them. Because they involve considerable expense, only a few key people will be asked to go along. In these cases, too, it is important for the VFX Supervisor and, if possible, the VFX Producer, to make the trip. These preproduction scouting expeditions will cover all the stages and locations where the production expects to shoot. This reduces (but doesn't entirely eliminate) the chances of

unwelcome surprises when you start shooting. It is also a great opportunity to forge good working relationships with your colleagues on the 1st Unit.

You should be alert to the possibility that such an extended location scouting trip will be needed at some point during pre-production. The AD's shooting schedule is a great "crystal ball" that can cue you to what may be in store. You should get hold of the schedule as soon as it becomes available and analyze it from the standpoint of visual effects. With the schedule as your guide you should budget for the VFX Producer and VFX Supervisor to be included on the location scout. During or after the scout you can then make the UPM aware of your department's needs.

Key to Success: Keep the ADs Informed

Arguably the most important persons to the VFX Producer on the 1st Unit are the 1st and 2nd ADs. The 1st AD runs the set, supported by the 2nd AD. We have already discussed the importance of collaborating closely with the ADs while doing the breakdown and schedule during preproduction (see Chapter 6). This spirit of collaboration must extend all the way through production.

The VFX Producer must advise the AD promptly about what the visual effects department needs on set in terms of time, special personnel, or equipment, such as a high-speed or VistaVision camera. You must alert him if you need to shoot additional takes or passes on any given camera setup, such as empty set plates or lighting, action, and other reference passes (more about these in Chapter 10).

If possible the VFX Producer should let the AD know a day or more in advance about upcoming special situations. Just how much advance notice you give depends on the situation. If the next day you just need a few extra minutes to shoot a lighting reference plate for a certain scene, advising the AD the night before is probably sufficient. But if you know that you will need a 30' × 100' green screen for another scene, you would be better off giving the AD a week or even more advance notice. Don't depend on the AD to be thinking about the visual effects department's needs every day.

We recommend you advise the AD of your requirements through written memos, with copies to other department heads whose jobs will be affected. When it comes to communicating, the motto should be: communicate often and clearly. It is better to give your colleagues on the production too much information than not enough.

Influencing the 1st Unit Shooting Schedule

In an ideal world, every project you work on would have a visual-effects-savvy AD on board. You would sit down with the 1st AD and together lay out a shooting schedule that takes the digital postproduction schedule into account. This ideal 1st AD would honor your request to schedule plate shoots that will eventually require heavy CG work as early in the shooting schedule as possible. The logic behind your request is obvious: You need to turn the live-action plates over to a digital facility promptly because several months of intensive CG work lies ahead of them.

Fortunately for us in visual effects, more and more ADs are getting experience working on projects that require visual effects. When you work with an AD with this type of experience, you should not have any difficulty convincing him or her of the importance of taking visual effects into account in the schedule. But if your AD has had no or only limited experience with visual effects, look upon it as an opportunity to educate him or her. To be sure, an AD may not always be able to accommodate the VFX Department's wishes; there often are other demands on the schedule that have to come first. In that case, try to work with the AD to come up with the best possible alternate schedule. Most ADs will be happy to have you as a thoughtful partner who tries to make the difficult task of scheduling easier.

One of the challenges we have in visual effects is that on many productions, visual effects are the "poor relations." It is sometimes difficult to get the necessary live-action plates shot because the 1st Unit's schedule is so tight. And understandably so: This, after all, is where the big bucks get spent. As a result of the tight schedules—and because even a proficient 1st Unit may encounter delays—what often happens is that either the visual effects plates don't get shot till the very end of the day when the crew is already tired and wants to go home, or the unit wraps for the day and the effects plates get rescheduled for the next morning, if then.

In fairness, this is not always the AD's fault. VFX Producers must understand that the AD's job is to keep the production moving ahead and on schedule. It's what's called "making your day." There are a myriad of factors that can conspire against that, from a slow or indecisive director, to a lead actor who is on the phone to his agent while the company waits, to an unexpected equipment breakdown (yes, they do happen, even on well-prepared 1st Units).

When caught in a situation like this, the best course of action for the VFX Producer is to maintain a positive attitude, keep in close contact with the ADs, and offer alternate suggestions for when the effects plates could be worked into the schedule. Your job is to make sure the visual effects plates get shot as soon as

possible so that your own schedule is protected and to help prevent expensive digital fixes in postproduction.

But What About the Director?

Something that we in the visual effects department must take to heart is that, with rare exceptions, directors don't want to deal with the "technical visual effects stuff," and some are downright antagonistic toward visual effects even when they are needed in the film. We can't always insulate directors from the technical aspects of the visual effects, but we can take steps to ease the process.

The golden rule for getting along with a director is that you never say "No"; never tell him that something can't be done or that he can't have that extra effects shot or two that he just dreamed up. You certainly don't want to get into a discussion on the set on whether he can do it or not. The simple answer is: He can. Of course, the primary responsibility for dealing with the technical aspects of new shots is the VFX Supervisor's, and he will undoubtedly meet the challenge with a "let's see what we can do" spirit. But it is essential that you be part of the discussion because the question of "how are we going to pay for it?" will come up almost immediately. Again, the set is not the place to have that discussion. Here, your best bet is to adopt a "we'll deal with it later" tactic.

If the director's request can be met relatively inexpensively, you can simply tell him that you will absorb the cost in your budget by shifting some money around. However, you will need the producer's permission to move money from one account to another. Hopefully you will have followed our earlier advice: You will have padded your budget here and there. Another approach is to do some "horse trading." By that we mean that there may be visual effects shots that the director doesn't feel strongly about and may be willing to drop so that he can substitute a new one. But these steps will get you only so far before you have to go in search of new funds. That's when you have no other choice than to approach the producer and discuss the situation with him or her. Ultimately it's the producer who has to authorize the money for any additional work that wasn't contemplated earlier and who has to tell the director yes or no.

There are also other ways of supporting the director on set. For example, if during principal photography a difficult and time-consuming sequence is before the camera that has everybody frustrated, perhaps the VFX Supervisor or VFX Producer can legitimately step in and offer the director a solution that will save time in production by shifting part of the work to postproduction. An example of this type of situation is in complex fight scenes, where it may make sense to substitute a digital double for a live actor in

some shots. The VFX Producer and VFX Supervisor can draw on their experience to help the director and producer weigh the pros and cons of such a spur-of-the-moment change in plans. Just be sure you have a good handle on what such a move would cost, not only monetarily, but also in terms of time. You must be confident of having the resources to get the job done if the producer and director say yes.

You can also make a case to the director and producer that some scenes could be given to the visual effects unit to shoot. If the VFX Supervisor is a member of the DGA, he may work as a 2nd Unit director. Under the right circumstances, the director may very well allow the VFX Supervisor to direct traveling matte shots that don't involve principal actors, or to take over the 2nd Unit for a time. If truth be told, most VFX Supervisors are aspiring directors anyway, and will jump at the chance of directing some of the visual effects plates. It becomes a win–win situation for both the production and the VFX Department.

With today's compressed production schedules it is common for productions to be shooting simultaneously with both a 1st and 2nd Unit. When both units shoot at the same time, or when one unit shoots during the day and the other at night, an experienced VFX Supervisor–Producer team can be a great asset to the production. The two of you can each oversee the shooting of visual effects plates of one or the other unit, thereby assuring that the plates are shot properly and that no vital elements are overlooked.[1]

A byproduct of this type of teamwork between VFX Supervisor and VFX Producer is that an experienced team will always be on the lookout for "targets of opportunity" for additional material that isn't on anybody's schedule but could be shot while the 1st Unit is busy. This could be aerial plates, matte painting plates, local "color" if you are on a foreign location, inserts that you and the supervisor think might be useful in postproduction, set documentation, etc. As long as the 1st Unit can spare the equipment and a couple of crew members to help, you should exploit these opportunities. All these efforts will eventually pay dividends when the editor starts hunting for that extra shot that will get him out of a tight spot.

Motion Control: A Special Situation on Set

On many contemporary productions, the VFX Producer is told flatly, "Forget motion control. There's not going to be any." Sometimes, however, motion control is unavoidable, and in

[1] This kind of dual duty is especially common in television series where VFX Supervisors and Producers frequently have to "trade hats" because of the frenetic pace of working on overlapping episodes.

Chapter 4 we discussed some of the situations where that is the case. So when the VFX Producer and VFX Supervisor discuss the need for motion control with the powers-that-be, you must make a sincere effort to reassure them that you will resort to motion control only when absolutely necessary. This is a good opportunity to educate your skeptical colleagues that contemporary motion control equipment is much more production-friendly than it was even a few years ago.

But make no mistake about it: the burden of proof rests on the visual effects department's shoulders. When motion control must be used on a live-action set, the VFX Producer needs to work closely with the AD to plan for the least amount of disruption of the shooting schedule as possible. Here are some points that you need to make the AD aware of:

- How long it will take to set up the motion control system
- How many people it will take to operate it
- Who will furnish the transportation
- What kind of support the 1st Unit will have to provide (such as grips to lay the dolly tracks)
- Extra equipment that may have to be ordered that does not come with the motion control system
- The kind of electrical power needed for reliable operation
- How much time the motion control technician will need to program specific shots
- How long it takes to reset the system for the next take
- Special procedures (such as shooting reference plates) that will have to be followed

You also need to consult behind the scenes with the supplier of the motion control equipment. Take him into your confidence and share all the information you have about the upcoming shoot as early as possible. Discuss the scenes with him, send him story boards and/or previs, and get him to give you a firm bid for services. If you know near the start of a project that a motion control shoot may be in the offing, you might want to arrange for a conference call between the supplier on one side and yourself and the VFX Supervisor, Producer, UPM, or other members of the production staff on the other. Take advantage of the supplier's expertise with this technology and explore alternate ways of capturing the shots with the supplier. By following these simple steps you can help ensure an efficient and relatively painless motion control shoot.

Production Calendars

Most productions regularly issue production calendars. They are another useful tool to help the VFX Producer keep track of what's happening when. Production calendars are usually prepared by

FALSE HORIZON - VFX Shooting Schedule

March 2009

Sunday	Monday	Tuesday	Wednesday	Thursday	Friday	Saturday
1	2	3	4	5	6	7
8	9	10	11	12	13	14
15 DAY OFF	16 INT - Space Freighter Cockpit - (Greenscreen) - Day **V15.1**	17 INT - Freight Deck (Breakaway Set) - Day **V21.3 / V23.1**	18 EXT - Wrecked Fuselage - Shelter - Day **V89.6**	19	20 EXT - Caligari City - Day **V91.1**	21 DAY OFF
22 DAY OFF	23 INT - Space Freighter Cargo Hold - Day **V25.1**	24 **V25.2**	25 EXT - Planet Surface - Day **V77.1 - V77.3**	26	27 EXT - Planet Surface - Space Colony - Day **V103.1**	28 DAY OFF
29 DAY OFF	30 EXT - Planet Surface - Space Colony - Day **V111.1**	31				

Figure 9.1 A production calendar: Note that all that is listed on this calendar are the visual effects shots. Although the 1st AD will list the effects-related scenes on his or her call sheet, the call sheet most likely will not list individual shot numbers. By supplying a calendar such as this one, all departments of the production will be alerted to what's coming up.
(Image courtesy of Reel Logix, Inc.)

the 1st Unit AD and set forth what shoots when and what sets are involved, by the week. Take their calendar (and a copy of their file, if possible) and add your V-numbers to their calendar. You can see right away what's coming up that week. You can color-code the various types of shots, choosing your own colors, and then share your visual effects production calendar with other people and/or department heads. It's a very handy thing to have.

Production Reports

At the end of each shooting day, the AD or one of his assistants reports about the day's happenings on the set to the production department, which prepares a daily production report. This report summarizes the day's essential activities: who, what, when, and where. This report is an important management tool

for the production company because it creates a historical record of how the production proceeded, whether things went smoothly, whether there were accidents, who didn't show up on time, how much film was shot, and other details of the day's happenings.

The visual effects department normally is not too concerned about the production report unless something went awry, say, the motion control computer went down or some similar disaster. Nevertheless, it's a good idea for the VFX Producer to ask that special notes be included if she feels that a question may come up later about some specific detail concerning the visual effects. Increasingly, some studios are requiring the VFX Producer to submit a daily visual effects production report.

When the Schedule Changes

Count on it: No matter how well a schedule has been laid out or how well prepared the director comes to the set, there will be changes. Of the ones that affect the VFX Department, the most significant changes are additional shots that the director conjures up on the spur of the moment or those that radically change the nature of shots that had been previously agreed on.

This is something you simply have to live with. Changes are part of the creative process, and asking for changes is the director's prerogative. Even a highly disciplined director who previses his visual effects carefully may come to the set one day, see something that excites his imagination, and invent new shots or change existing ones on the spot. Besides, even the most carefully laid-out previs can't anticipate all the variables you run into on the set.

Other directors work more spontaneously. They resist the perceived regimentation of previs and storyboards. You may think you have an approved set of storyboards, but they are so much scrap paper once the director starts filming.

This is when the VFX Supervisor's talent and experience may carry the day. Perhaps better than anyone else on the set, the VFX Supervisor can present the director with creative solutions so that production can move forward with little delay. The VFX Producer should also be part of these discussions, because she can advise both the director and the VFX Supervisor about the financial and scheduling impact of their choices. Not only that, but an experienced VFX Producer may also be able to suggest a solution that will cut down on time during production by substituting a digital approach. Sometimes, digital solutions are less expensive than attempting to make a scene work entirely in live action, and who better to take the lead here than the VFX Producer?

Regardless of the reason for changes, you need to be able to adjust quickly to the new situation. Take notes during the

discussions and date them so that you have a record of what was decided. The notes can serve as the basis for revisions you will need to make to your database, your breakdown sheets, and your budget. Advise those who need to know of the changes (such as the UPM, producer, and the studio's production executive) as soon as possible of the implications of the changes.

Physical Support/1st Unit Support

When you prepare a full visual effects budget it's not enough simply to break down the script and figure out how much it will cost to do the digital work. In fact, the digital costs are only a small part of the total line items you need to take into account in preparing a budget. Now it is true that the *dollar amount* of the digital costs may far outstrip all other costs. But the *number* of different budget items you need to consider is actually much greater and much more varied. We refer to them collectively as production support. Here are the principal budget items that come into play during physical production:

- Plate photography
- Camera equipment—encoder equipment, special cameras
- Helicopter
- Technocrane
- Aerocrane and technician
- Digital video assist
- Platforms/Scaffolding/Scissor lifts
- Rentals of green screens or blue screens
- Fluorescent lamps for green screens or blue screens
- Tracking markers
- Blue or green digital tapes
- Blue or green digital fabric
- Blue or green digital paint

Working on Sets

Film production is a quintessentially collaborative enterprise. It takes the efforts of some 20 departments, all supporting one another, to bring it off successfully. Visual effects is only one of them, and on live-action sets, one with the smallest number of people; we can generally get our work done with only two or three people unless some unusually labor-intensive task comes along. The nature of our craft, however, requires us to rely heavily on other departments, especially camera, grip, and electrical, for help and cooperation.

The VFX Producer needs to know long before principal photography starts what production support she will get from the 1st Unit, and whose budget that support will be charged to. This

is not a trivial matter. Your reputation may be made or broken based on your ability to stay within your budget. If your visual effects budget gets hit with a few unexpected charges, no amount of remonstrating that "we're all working on the same movie" is going to help you. Take an example. Let's say that the production rents a helicopter for a few hours to film some air-to-air action of the star's stunt double being lowered to a ship. The action is being filmed from a second chopper. Normally you would consider that a straightforward 2nd Unit shot. But now let's say the director decided on a new shot that requires the camera helicopter to shoot some background plates for a greenscreen composite of close-ups of the star dangling from the helicopter. Who's picking up the extra cost for the additional flight time?

The answer could have significant implications for your visual effects budget. If your UPM were a particularly hard-nosed fellow, he might tell you that half the cost of the helicopter was going to come out of your budget. He might have little sympathy for your plea that this is a totally unforeseen expense. Your budget may simply have to take the hit, and you'll have to use your ingenuity to make up the difference elsewhere in your budget (What? You didn't pad your original budget a little here or there to allow for this sort of thing?)

Laying the Groundwork

As we have said elsewhere, good communication contributes immensely to the successful operation of a visual effects unit. Nowhere is this more apparent than when you are working on a busy set where organized chaos prevails throughout much of a shooting day and your colleagues are depending on you to make sure that every plate needed for every visual effects shot actually gets filmed as scheduled. The VFX Producer can make this task a lot easier by letting the AD and other affected departments know *in advance* exactly what elements must be captured on any given day.

You could do this by talking to the AD a day or two before to let him or her know what's coming up. You could send around a memo to the various departments and hope they read it. But that leaves too many things to chance.

A much better way is to take advantage of your FileMaker Pro database and prepare a layout—let's call it the shot sheet— that lists not only each individual visual effects shot, but also exactly what plates must be filmed for that shot and which unit is responsible for doing so. On the day before the shoot (or even earlier, if a lot of preparation is needed), you distribute copies of each shot sheet to the ADs and all other departments. This will alert them to what they need to have ready and allows them to clear up any questions they may have about your needs. This approach reduces the potential for miscommunications and ultimately makes the VFX Producer's job a bit easier.

Figure 9.2 is an example of such a shot sheet. Notice that the storyboards indicate the focal length of the camera lens that's to be used for each shot. These focal lengths were not chosen arbitrarily, but are based on animatics (or previs, if you prefer that term) that were created to the exact scale of the sets and set pieces. This allowed the director and VFX Supervisor to plan their shots in great detail.

The right side of the shot sheet lists the essentials of each shot: shot description, VFX number, the name of the set, shot length, and the facility responsible for doing the shot. But most importantly for our discussion here, it lists the plates that must be shot and the day they are scheduled.

In addition to distributing the shot sheets of scheduled scenes through the usual production office channels, it may also be helpful to post the shot sheets and detailed shot breakdown sheets on a bulletin board or some other conspicuous place on the set where crewmembers can see the essentials of each shot. This simple step helps the crew to better understand how what they do will eventually contribute to the overall success of the project.

Support from Camera Assistants

If there were a mantra suitable for us in visual effects to intone on the set, it might be "The camera guys are our friends…the camera guys are our friends…" Why? Because perhaps more than any other group of people on the 1st Unit, it is the camera assistants who are in the best position to help us. The 1st AC is practically inseparable from the camera, and therefore knows everything that is going on. He keeps records of lenses, T-stops, frame rates, scene, take, and roll numbers…in other words, all the technical details pertaining to what's being filmed.

This treasure trove of data is available to the visual effects department for the asking. In an ideal situation (meaning on a production that has an adequate budget), we will have our own VFX Data Coordinator on set whose responsibility it is to record all the technical data for each camera setup. But things are not always ideal on set. It is not uncommon for things to move very quickly during production, particularly when the director calls for a new setup. When that happens, pandemonium breaks out as the crew swings into action to break the setup and move to the new position. Under these circumstances, it may happen that whoever in the visual effects department is keeping the shot records may not have time to collect all the data. But when things settle down again (even if it's not till much later), the AC's records will help fill in the blanks.

All this presumes that you have established a good rapport with the DP. Next to the director, he probably has the most pressure-filled job on the set, because along with having the responsibility of making the movie look good, he also has to manage the crew. You should therefore get his permission in advance to work with the camera crew on a noninterference basis.

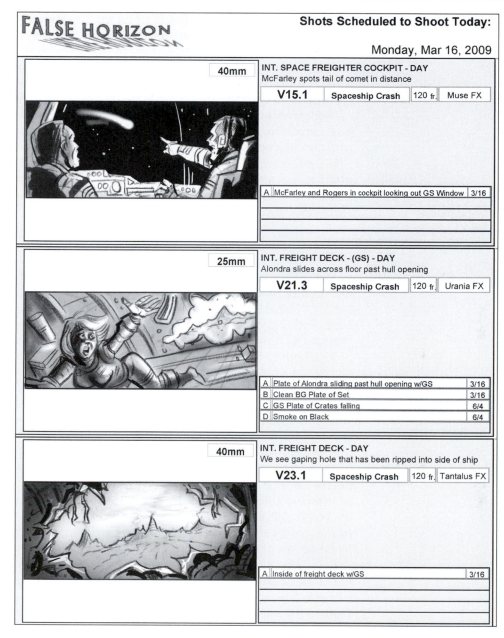

Figure 9.2 Daily shot schedule.

Grips

No production company can function without grips, the people who do most of the heavy lifting and moving of things on a set. For the most part, their labor will not cost your visual effects budget any money as long as they work as part of the 1st or 2nd Unit. Thus, on some productions the best boy grip will order certain grip-related items, such as blue or green screens, for you and arrange to have them delivered. Nevertheless, it is

the VFX Producer's responsibility to let the best boy know what's needed and when; he can't be expected to foresee your needs. But don't think that all grip services will be free. Even if the best boy does assume the responsibility of ordering materials for you, the actual rental cost will most likely be charged to the visual effects account. Your budget must provide for this grip equipment.

More commonly, the VFX Producer will order these specialized items herself because she is likely to have established relationships with vendors and so can get a good price on these rental items.

On set, company grips will lay the dolly track for motion control cameras and set up the dolly, hang blue or green screens, and build platforms and parallels that may be needed for cameras and actors during a blue- or greenscreen shoot.

Electrical

The electrical crew (they're known by various names: gaffers, electricians, lamp operators, sparks) will also be of great help to the VFX Department. Electricians will set up the lights to illuminate blue or green screens. Almost all contemporary productions use special fluorescent lamps to light blue or green screens. As we pointed out in Chapter 6, you will have to estimate the number of fixtures needed and budget them.

Hanging these light fixtures can be a substantial task if the screen is large, and you should therefore allow plenty of time to get the job done before the company gets to those shots. You should also ask the gaffer or his best boy to make sure that the motion control equipment runs off its own electrical circuit, isolated from the set's other electrical systems. If possible, the power supply for all motion control machinery should be an uninterruptible power supply. This is a bit of extra trouble to go to, but it will have been worth it if it keeps you from losing an hour's worth of programming a complex motion control move because of a glitch in the power.

Of course, it is still the VFX Producer's responsibility to advise the gaffer or his best boy of what's coming up in the next few days that will affect their usual routine. It's especially important to let them know if they will need additional electricians to light a blue screen in advance of shooting. Not only is this a matter of courtesy, it's essential to making sure that the 1st Unit can function normally.

Grips and electricians usually work as a team when they are setting up a blue or green screen.

Paint and Construction

The type of support we get from the paint and construction departments goes beyond painting a wall or floor blue or green for a traveling matte shoot. Frequently, when an actor has to be

matted into a virtual environment and he must interact with various shapes, such as a set of steps or a nonexistent rock face, we call on the construction department to build these shapes for us and paint them the appropriate blue or green color we require.

Another situation where we find ourselves asking the construction department for help is when we need a particularly large or wide platform for a blue- or greenscreen shoot. This need arises sometimes because the screen should be at least 15 to 20 feet behind the actors to minimize blue or green spill from the screen. If the actors and the camera were to be positioned on the stage floor (as is normally the case), it would be nearly impossible to isolate the actors against the screen as the camera would almost certainly see the bottom of the screen. By putting the actors on a platform, the screen can hang down below the level of the action, allowing the action to be isolated on blue or green.

Digital Video Assist

Video assist used to be such a simple thing: one man sitting off to the side of the set somewhere with a small black-and-white monitor and a VHS recorder in front of him, capturing the video feed (usually in black-and-white) from the camera recording the action. The video assist technician recorded each take, and the director would often rush to review the take on the monitor. This simple approach has matured into what we now call the video village, which often appears to be the nerve center of the production. The old VHS recorder has been replaced and augmented by extremely sophisticated digital video systems, one of which is known as a Video Perception Recorder, capable of recording the color images from the camera on digital media.[2] Digital video technicians are able to instantly do split screens, edit footage, prepare temporary composites of blue screen plates and any previously prepared background for the director and VFX Supervisor's review, burn DVD disks, call up any take from almost any day's shooting at a moment's notice, and more.

There are times when you may have to hire your own digital video assist technician to work specifically for the VFX Department. The reason for this is that on visual-effects-heavy shows the 1st Unit video technician will be kept busy serving the needs of the 1st Unit and will not have the time, nor necessarily the expertise or equipment, to deal with the special needs of the visual effects unit. This could occur when visual effects plates have been shot previously and the VFX Supervisor needs to preview the fit of a blue- or greenscreen plate that's about to be filmed, or particularly when preliminary digital animation

[2] See Chapter 13, The New Digital Workflow, for more information on this topic.

has already been designed and the director and VFX Supervisor need to see how the animation will play with the live action that's about to be shot. It will take a few moments for your video assist technician to call up the correct shots on his system for the director and VFX Supervisor to view so they will know how to stage the upcoming action. Given this versatility, an experienced digital video assist technician and system are virtually indispensable on today's sets. You should discuss the likelihood of needing your own technician with the UPM and VFX Supervisor well in advance so you can provide in your budget for this individual and equipment.

Transportation

Transportation is one of those anonymous departments that get little recognition, but which no production can do without. Company drivers will pick up and return cameras, lights, screens, motion control equipment, and just about anything else that needs to be moved on wheels. It is our link to outside vendors from whom we buy or rent our equipment and material.

There is also another area where the transportation department helps us get our job done and that is in providing and operating special vehicles. Among these are scissor lifts, forklifts, all manner of hydraulic platforms (which are often generically referred to as Condors), and construction cranes. Most production companies will have several of the more common types of these vehicles on permanent rental during principal photography and they are available to the visual effects department for the asking. As in anything else, thinking ahead pays off. If you foresee a special transportation need (such as needing a scissor lift to hang a green screen), you should let the transportation coordinator know of this well in advance. In addition, you have to budget for any crane drivers needed and their flatbed truck to transport the gear.

SUCCESS STORY

Mike Chambers - (*I Am Legend*; *The Day After Tomorrow*)

Having studied film, theatre, and art in college, I knew I wanted to work in the movies and I was eager to do anything. My first direct experience with VFX was working as a PA on a miniature shoot for one of Roger Corman's sci-fi movies. I later worked for Doug Trumbull at his specialty film company, Showscan, where my first job was as a projectionist. While there, I was introduced to the VFX and production community. There were quite a few companies in the area, including Richard Edlund's Boss Films. I eventually got a job there….I worked my way up to become a VFX Coordinator on several projects…eventually ending up at Apogee Productions, where I got my first shot at producing.

The VFX Producer is responsible for budget, schedule, and delivery, as well enabling effective communication between all participants. It is also the VFX Producer's responsibility to keep the film's producers informed of the status of all work and to report requested or actual changes and the impact these changes will have on the budget, schedule, delivery, or quality of the work.

Keys to Success: A wide-ranging knowledge of the film production process and basic business and legal affairs is essential. Other important traits include integrity, creativity, dedication, responsibility, flexibility, resilience, patience, stamina, energy, a willingness to learn, and the ability to work well with others. As well, a good sense of humor helps.

An accurate and thorough database/bible is essential for the VFX Producer to establish and maintain regularly throughout the production process.

ON-SET REFERENCES

The vast majority of contemporary visual effects are composites. What this implies is that any given shot will consist of two or more separate elements that have to match one another in terms of camera movement (real and virtual), point of view, lighting, color, and all other visual characteristics so that the finished shot looks like everything was photographed together.

If the shot is all CG, no problem: The computer will remember all relevant data. However, the majority of visual effects shots involve one or more live-action elements, and CG elements will have to be matched to the live action in postproduction. To make that process as smooth as possible, we must gather a variety of references about a particular set or even individual setups while we're in production to pass on to our friends in digital. The references we collect take several forms, depending on how a live-action plate will be used.

Reference Photos; Art Department References

At the low-tech end of references are photographs of set pieces, color swatches from the paint department, and texture samples from the set decorator or production designer. Almost anyone on the visual effects team can be delegated to collect these items. One good thing about them is that we don't have to bother the 1st Unit when we're doing this.

Location photographs and pictures of textures from buildings, rocks, and other natural objects can also be very useful to digital artists when they model their virtual objects. Ubiquitous digital cameras make it a snap (pun intended) to collect a large library of pictorial references that your digital artists will be thankful for. In fact, most VFX Supervisors take thousands of stills with their digital still cameras to be used as references and sometimes even as elements in the final shot. The high quality of modern digital cameras

and lenses yields images every bit as good as those obtained with production film or HD digital cameras.

Simply obtaining all these visual references is of little value unless the people who have to use them know what you have gathered and where it is. You can address this issue by setting up a simple reference library in your department. It's the sort of task that might be handled by a capable VFX Coordinator or PA. He or she would devise a database that lists the media (digital stills, video, blueprints, production sketches, etc.), the individual items, and any additional tidbits of information that might be important. For example, it may be important to note the date the visual effects department received the maquette of a creature that will need to be cyberscanned and turned over to a vendor to be digitally animated. If the delivery of the maquette was late, let us say, it may become a bone of contention if your digital facility was unable to begin work on the creature in a timely fashion.

There should be a place set aside in the office where the materials can reside until someone needs to look at them. Most productions will have a DVD player available where someone can pop in a disk to review material that interests him. When someone wishes to remove material from the office, however, we would suggest that you maintain a simple sign-out sheet so that you know who has it. In other words, treat the material like you were a lending library. It would be quite frustrating to have the VFX Supervisor come looking for digital stills he took on location and which he needs to show a digital artist, only to have the desired CD turn up missing.

Element Data Sheets

One step up in complexity is camera and shot data. In addition to scene, take number, and roll number, camera crews routinely make a note of camera data for each setup, recording such information as the lenses being used, T-stops, and camera speed. That information generally becomes part of camera reports as well as the script supervisor's notes. For visual effects elements, however, we also need to take note of details that are not normally of interest to a 1st Unit crew. Normally it is the data coordinator's task to record all technical information.

Let's use the example of a shot in which an actor approaches a CG character that is coming to meet him at the edge of a cliff overlooking a deep river gorge. The camera starts on a medium wide shot to establish the scene, then dollies with the actor a short distance to end up on an over-the-shoulder two-shot of the actor and the still nonexistent CG character. The edge of the cliff and the ground immediately around it are real, but the rest of the location is actually an unspectacular dry wash twenty minutes'

drive from the studio, hardly the spectacular vista the director had in mind. To achieve his vision, the director will call on digital artists not only to create the CG character, but also to extend the set with a 3D CG matte painting.

For a shot like this, the digital facility will need to know a number of things about the live-action element. They'll want to know the standard camera data, but they will also want to know how far the dolly moved, how high above the ground the lens was, whether the camera was pointing up or down, and if so, by how many degrees, how the set was lit, and several other factors that will help digital artists create the CG character, put him into the scene, and create the digital matte painting of the background.

One method of recording the necessary data is by means of shot data sheets. These can take many forms, and every visual effects facility or team may have its own standard format. Look over the example in Figure 10.1 and you'll quickly get the idea of the type of information that may be needed.

You can keep track of the information the old-fashioned way, on paper. Print a sufficient number of blank sheets before the day's shooting starts, and fill in the data as shooting progresses. If the VFX Supervisor or the director invents additional and unplanned shots on the spot, then you have enough forms. You may find it useful to complete in advance certain fields in the data sheets whose specifics aren't going to change during the day. Most obvious of these are the project title, scene numbers, location or name of the set, and other important information. Then it becomes a matter of completing the other fields as you're shooting.

Be forewarned: Getting all this information recorded during principal photography can be a daunting task; a close look at a shot data sheet should convince you of that. No matter how good your relations with the camera crew may be, you should not rely on them to actually gather data for you. Instead, you should have a capable individual on set specifically to perform this task, and the best option by far is for the production to hire a data coordinator whose sole duty it is to gather that data. In most cases, he will be able to get the needed information on his own, but some of it (e.g., lens settings) he has to get from the camera crew even though they may be busy getting ready for the next take or moving on to a new setup under the prodding of the AD. It is a time of controlled chaos, a good time for whoever is charged with collecting the data to be as unobtrusive—and diplomatic—as the situation permits.

Not every production can afford to hire a data coordinator, however. That leaves the VFX Producer with only a couple of options: Either you or the VFX Supervisor must be on set to record the data (an undesirable situation for many reasons) or you have to deputize someone else on the VFX Department's staff to do it. In the real world of film production the VFX Producer may have no choice but to compromise and do it herself.

Prod. Co. **TITLE** **ELEMENT DATA SHEET**

Scene #: [] **Element No.:** [] **FX #:** []

Date Shot: [] Location: [] Ext. [] Int. []

Slate info: [] Camera Roll #: [] Film Stock: [] Aspect Ratio: []

VFX Supervisor: [] DP: []

CAMERA INFO.	LENS INFO.	MISC.

Camera: [] Lens Make: [] Time of Day: []

Frame Rate: [] Focal Length: [] Sun Angle: []

Camera Motion: F Stop: []

[] Lockoff [] Crane Focus (Start) []
[] Pan/Tilt [] Stdy-Cam
[] Dolly [] Hand-held Focus (End) []
[] MoCo [] Cam.Trk.

Camera Tilt: [] Lens Height: []

 Filter: []

Shot status [] Scanning []

ELEM. DESC. []

SET & LIGHTING NOTES

Figure 10.1 This sample VFX Element Data Sheet was created using FileMaker Pro. It has the virtue that you can later find and sort the data according to any number of different criteria. The spaces on this sheet are relatively open to make it easier to jot down notes by hand on a busy set.

VFX - Data Sheets

-- Shot Location Information --

Slate	VO65L	Scene #	65	Unit	1st	Time	14:30	Shoot Date	
VFX#	LF65.3	Storyboard #		Shoot Location	Chinese Village				

Sequence
Chinese Village

Description
ESTABLISHING SHOT OF PPT'S VILLAGE

Set
EXT Chinese Village

-- Camera Information --

Camera	A	Lens	17.5 mm	Lens Height	46'	Lens Focus /Subject Distance	Inf
Camera Roll	A11	SN#	SK17.5–36	Camera Tilt	–4.5 for static		
Film Stock	5277	Stop	T5.6 2/3	Camera Dutch	0	Lens Filters	85,ND3.1/8 Coral Softedge Grad
Film Format	Super 35	FPS	24	Motion Axies	Pan/Tilt		

Camera Body | Pana Platinum Camera Head | Scorpio Camera Mount | BAC

Move Description | Lock or Pan/Tilt

-- Visual Effects Information --

VFX 2D | New Bible shot, possible MP add bldgs left frame.

VFX 3D |

Other Media Information ☐ Photos ☐ Video ☐ Diagrams ☐ HDRI ☐ MOCO Data ☐ Survey ☐ Lidar ☐ Notes

Lens Distortion Calibration ○ Have ◉ Need ○ Possibly Need Additional Elements ○ Need ○ Have ◉ N/A

HDRI Film Rolls |

Camera Notes
Tk1 NG
Tk2 NG
tk4 print
Tk5 tilt down
Tk6 print
Tk7 print

Set Layout Picture

Set Sketches

Figure 10.2 Here is another example of a VFX Element Data Sheet created with FileMaker Pro. It has a space for script notes so that you can note the best take as well as a space to draw a set layout.

There are times when it gets so hectic on a set that it's difficult to keep up with the record keeping. If you find yourself falling behind and are uncertain of the data, your best alternative is to get together with the script supervisor when there is a break and do your best to catch up. Meanwhile, take lots of digital stills to help remind yourself and the VFX Supervisor of who and what was where during shooting.

Once you get past these relatively simple reference tools, you quickly find yourself using increasingly sophisticated methods to gather a variety of references that your digital artists will eventually need to create the CG work for your project. These more sophisticated tools will unavoidably require you to ask for some extra time on the set so you can get your work done. Sometimes the extra time may be no more than a minute or two before the camera is moved elsewhere or the lighting is changed for the next setup. At other times, you will need either to arrive early on the set or stay late to avoid interfering with principal photography. In both cases, you will have to arrange with the AD to get help from the 1st Unit crew to get access to the set and, if necessary, have the actual production lighting turned on.

Reference and Clean Background Plates

This term covers several different kinds of references that you may need. The simplest one is just a shot of the empty set, taken with the normal production camera from exactly the same camera position and under the same conditions as a production take. A few feet of film—a few digital frames—will usually suffice if the camera is locked off. The VFX Supervisor may want this reference for how lighting and color play on that set.

Sometimes we will also have the camera crew fire off a few feet of film of a blue or green screen with the normal set lighting turned on. This can be used by the digital facility to zero in on the best settings to extract as clean a matte as possible from the blue- or greenscreen plates.

We usually ask for a clean reference plate when wire or rig removal will be needed in postproduction. The reason behind this is that a digital artist will later have to fill in the area on the screen where the wire or some other obscuring object blocked the camera from seeing the background. It saves time and money in post if the artist can fill in the blocked area from another, identical take of the empty set. Otherwise the artist has to first paint out the wire(s) or other obscuring object, and then paint in the missing background as best as he can.

This is a very simple and inexpensive solution as long as the camera is locked off during the shot. In this type of situation we really need only one frame because a digital artist can get all the visual information he needs from that one frame. But what to do

when the camera is moving? In this situation the digital artist will need image data from throughout the length of the shot, since each frame is different from the previous one.

Figure 10.3 The wires covering part of actor Tony Curran's head and body will require digital wire removal. In addition, a clean background plate of the set should be shot to allow digital artists to paint back the area in the forest covered by the wires.
(Image courtesy of Screen Gems/Lakeshore Entertainment/Luma Pictures)

Figure 10.4 Here, the wires have been digitally painted out and the areas on the actor's head and body and in the background that were covered by the wires in the original plate were painted back in. Digital wings were also added to the shot.
(Image courtesy of Screen Gems/Lakeshore Entertainment/Luma Pictures)

There are basically three possible solutions. The first one is that we can ask the camera operator to shoot the scene again without the actors and just do the best he can to mimic his earlier camera move. It won't be an exact repeat, but it is better than not having it at all.

Hanging from a wire

Until recently, special effects people went to great lengths to minimize the visibility of wires on set by dulling them down or spray-painting them so they would blend as much as possible with the background. This approach has changed to a large degree. It's now fairly common to make the wires as visible as possible so that a digital artist will see them more easily during wire removal. Either way, shooting a clean plate of the set is still a good move.

The second solution is to use an encoded or motorized head to film the action, and then repeat the exact same move automatically once the director has a take he likes. This pretty much guarantees that the two moves will match. However, we may not have the luxury of having an encoded head on set, especially on lower budget productions. But if one is required by the VFX Supervisor, we must be prepared to order it and make sure that it gets set up on the camera by the crew.

The third solution (and the one most producers seem to favor these days) is to "fix it in post." In other words, shoot the scene, move on, and let the digital artists deal with it later, the thinking being that it's less expensive (not necessarily) and less disruptive (certainly) of the 1st Unit's schedule to push the problem into post.

Performance References

Imagine this scenario: The intrepid hero of our script finds himself on the surface of an alien planet. An alien creature confronts and attacks him. During the fight, the alien strikes at our man, backs off momentarily, leaps on a nearby ledge, and then dives on our hero, knocking him down. This alien will eventually be a CG creation because his design precludes the use of a human suit performer.

This is the sort of situation where a performance reference would be useful. By this we mean that production will film the confrontation between the hero and a stunt performer as a substitute for the CG character. Makers of fantasy and science fiction films have been using performance references for decades. Just think back on many of Ray Harryhausen's films in which an imaginary monster from Greek legends does battle with a hapless hero. Frequently the actor would train for weeks prior to filming with an action coach. At the time of principal photography, the crucial action scenes were sometimes filmed with stunt players taking the place of the fictitious characters. But more often than not, the scene was simply shot without the unseen opponent, who was later inserted into the scene via stop-motion.

The reference plate will establish camera moves, timing, and body language for both the actor and, more importantly, the digital CG character that will later replace the stunt performer. You may want to film a performance reference any time that a stunt performer can double for a digital character. Keep in mind that after the performance reference has been shot, the same shot has to be repeated, only this time without the stunt performer in frame. If a human actor is part of the shot, he or she will have to mimic the action as closely as possible.

It's also a good idea to get performance references for shots where only a CG character will appear. For these types of references,

a stand-in can temporarily take on the role of the CG character and go through the action. The stand-in should be asked to perform the action at different speeds so that the digital artists (and the director) will have a couple of different choices for how fast the CG character should move, something that may not be clear until after the reference plate has been cut into the film as a guide.

Video References

At times you may find it helpful to shoot some sort of video reference. This need could arise occasionally if you want to show how the action progressed during a shot from a different angle than the production camera, or if the digital crew wants to see how the camera actually moved during the take (while on a crane, for example) and there is no other way to record the move. Sometimes it helps to see the spatial relationships between camera and actors from the side or from overhead to get a clearer view of the scene's layout, particularly when a digital character will eventually replace a human stand-in.

It is also quite common to record an actor's facial expressions and body language when he or she is recording the voice track for a digital character that has no human counterpart. These recordings often are a great inspiration for animators and may become the very basis for animating digital characters.

Lighting Reference Tools

A dead giveaway that a digital character or object is a computer creation is when it does not look like it was photographed at the same time as the scene it is supposed to fit into. There may be many reasons for this, but one of the principal ones is that the lighting on the CG object doesn't look right. This is where good lighting references taken on the set come in.

One means of accomplishing this is for a member of the visual effects team to rush on the set with a chrome ball and a dull gray ball, position himself quickly in front of the camera, and ask the camera operator to shoot a few feet of film of the two balls. This short piece of film will now become a *reference plate,* an essential guide to digital artists to help them recreate the lighting on the set in their computers.

The chrome ball, being highly polished and shiny, reflects all the light sources on the set, allowing a digital facility's lighting supervisor to see what types of light sources were used and where they were positioned relative to the action. The matte gray ball will show him the overall quality of the light and its lighting ratio and reveal how shadows were cast by the DP's lighting. Both are essential ingredients in making a CG character or object fit convincingly

into the live action. It takes only a minute to shoot these refer-ences, but they are important.

Figure 10.5 Here is a chromed sphere of the type used during production. The purpose of the shiny sphere is to reflect every light source that illuminates the scene from a given angle as a guide to digital artists in lighting digital elements.
(Image courtesy of Mark Weingartner)

As a practical matter, the visual effects team may initially run into resistance from the 1st Unit when it asks for things to come to a momentary halt on the set while these reference plates are shot. When this happens, a bit of diplomacy will usually overcome that resistance. Once the crew understands how important the refer-ence plates are, they will come to accept the inevitable interrup-tion. At the same time, however, the visual effects team must make every effort to do its job as quickly and unobtrusively as possible.

Tracking Markers

Tracking markers are reference points that are placed somewhere on the set where they will be visible to a *moving* camera during film-ing. The purpose of markers is to visually record a series of refer-ence points by which a computer can later determine exactly where the camera was pointed and where objects and actors were (or will be) located in every frame. This information is essential for adding other visual effects elements, such as miniatures, CG objects, envi-ronments, or animated characters to a live-action scene.

What's important to grasp here is that when a camera moves in any way—be it pan, tilt, dolly, or crane—the camera lens sees the background from a slightly different spot with each progressive

frame.[1] This results in a perspective shift between foreground and background as well as a change in apparent shape of the objects being filmed. The shift may be very small in the case of a pan or quite dramatic when the camera dollies with or past the foreground action.

A visual effects element that is to be composited with a moving live-action plate must not only match the shift in perspective, it must also be solidly locked into the plate so that it doesn't appear to drift in relation to the foreground.

Over time, all sorts of objects have been used as tracking markers: ping-pong or tennis balls, Xs made of camera tape, self-adhesive dots, LEDs (light-emitting diodes)…you name it. We can also use clearly delineated features of the set itself as markers. What the markers are made of is not important. What *is* important is that they stand out against the background and that they be stationary and relatively well in focus so that the computer's software can lock onto them. In other words, the camera may move, but the marker must not. When markers appear in frame and are not actually part of the set, they have to be painted out in postproduction.

Markers are also commonly used on large expanses of blue or green screens. There is no general rule as to their color, but it seems that white is favored on blue screens, and orange on green screens, either of which assures that the markers stand out against the blue or green color. Some VFX Supervisors prefer to space markers an exact distance apart, say, one meter, to give

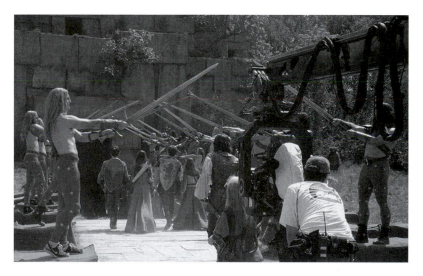

Figure 10.6 Actors with markers on blue tights for tracking of characters to generate CG centaurs.
(Image courtesy of Howard Berger/KNB EFX)

[1] The exception to this is when a pan or tilt is accomplished with the camera on a nodal head.

digital artists a known value to aid them in tracking. Other supervisors are more lenient and merely specify that the spacing be even. Sometimes only a few markers, spaced widely apart, will be needed. So it all depends on the individual situation.

Another type of tracking marker is LEDs, a form of the same electronic lighting devices that are used in hundreds of applications around us every day, from our TV remotes to traffic lights. The types of LEDs used in visual effects filming are small, bright, self-contained, and easily attached to surfaces including cloth screens. Because of their brightness they are well suited to filming situations where there is dust or mist in the air that may obscure more traditional markers such as camera tape.

Tests

Just about every production will set aside a certain amount of money and time for tests prior to the start of principal photography, such as tests of cameras, lenses, rawstock, makeup, hairstyles, wardrobe, etc. Similarly, the VFX Producer should build an allowance into her budget for pertinent visual effects tests. Your test allowance should cover not only shooting, but also digital experimentation that uses the test footage.

Among the items that the VFX Supervisor may want to test are different blue and green screen materials. Different materials yield different results depending on film stock; it would be a good idea to consult with a digital facility to see what produces the best results.

Another type of test that could be important to conduct is speed tests of events that move at other-than-normal speeds and that will need to be integrated with visual effects shots. That can encompass events at either the slow or fast end of normal. Let's say that a setup calls for the rupture of a miniature dam and the release of water and debris down a canyon. What camera speed should be used to make the shot look realistic? You certainly want to have a clear idea of that before you destroy the miniature.

Similarly, you may have a scene that calls for blowing up a miniature city block. Separate buildings, even different floors of the same building, will have to "blow" at different times so it doesn't look like the whole thing just went up in one big ball of flame. In a situation like this, you are dealing with time intervals between separate explosions measured in milliseconds. You know this has to be shot at high speed, but how far apart should the explosions be set to go off? Your pyrotechnician can answer that question by setting off a series of light flashes in sequence and recording the result on film a day or two before you bring in the whole crew to shoot the real thing.

All of this translates into additional crew, equipment, rawstock, and lab costs that you have to budget and schedule. Reluctant as the producer may be to approve the expenditure, it would be penny wise and pound foolish not to provide for necessary tests.

SUCCESS STORY
Robin D'Arcy - (*Alexander*; *Fight Club*)

My base roots grew from being a concert photographer. Years later I parlayed that ability into being a unit still photographer for feature films. My first feature was definitely a comedic beginning, as not many can claim such an auspicious credit as *Voyage of the Rock Aliens*! Ha.

Visual effects was very much on the horizon, but again, coming from photographic roots, I have always been most comfortable as an "in-camera girl"—still am, actually.

Being competitive and trying to excel on all fronts was quickly becoming a mandate for survival, not a bonus…. One needed to wear many hats to exist. Moving into the VFX community was a slow and arduous process for me, but I had many incredible maestros and mentors to help guide me along the way. To be truthful, visual effects was a choice based on retaining a career, and of course, economic survival.

I have been a VFX Producer, technically in practical FX and visual effects since the mid eighties, but officially I began producing VFX in 1996…. I am a third generation film dog…. I have been technically "behind camera" since the ninth grade… it's my love for cinematographers, directors, and writers that keeps me inspired, aroused, challenged and loyal to the craft.

I believe understanding how to navigate through the politics, and weigh out the actual necessities of any given project is an essential attribute…. Additionally….*humor*….a strong and reliable work ethic…. VFX producing is definitely not for the timid or weak-hearted.

OPERATING INDEPENDENTLY: THE VISUAL EFFECTS UNIT ON ITS OWN

A separate visual effects unit may spring into life almost any time during production and even in postproduction. Its life may be like that of a mayfly—here today, gone tomorrow—or it may last for several months. What we are listing here as separate units may, in fact, be composed of some of the same crew members. It's just that they perform different functions at different times and are occasionally supported by specialists in one craft or another. But whether it's just a six-person squad out for a day, or a crew of a couple of dozen craftspeople working for months, it's the VFX Producer's job to budget and schedule their work and often to actually hire them as well. Even though a visual effects unit may have its own crew, it often works closely with the 1st Unit DP who oversees the lighting to make sure it matches what he established during principal photography. Generally the director is not far away, either.

There are several scenarios under which the VFX Producer may find herself overseeing one or more separate visual effects units.

Matte Painting Plate Unit

The size of such a unit may consist of as few as four or five crewmembers, depending on the shot requirements and whether the show is a union or nonunion project. Typically, a matte unit is sent out on a location to capture the plates that will form the basis for the matte work. This doesn't need to be a formally recognized unit. Sometimes a small contingent of crew can be detached from the 1st or 2nd Unit and put under the supervision of the VFX Supervisor or the VFX Producer for a few hours to shoot the plates for a matte shot.

Visual Effects or 2nd Unit?

We should note here that on many productions, the functions of what we refer to generically as the visual effects unit may actually be carried out by the 2nd Unit that's temporarily put under the supervision of the visual effects department. On some productions, the 2nd Unit will actually do double duty as a visual effects unit.

Visual Effects Plate Unit

By this we mean a crew that is assembled to film specific visual effects elements that will be composited into a shot. Examples of these types of elements are smoke, dust, explosions, flames, water, and more exotic items like artificial lava. Most of these elements are shot against a large black background (black cloths) that has to be put up on a stage, or it can be sometimes set up outside. Shooting explosions against a dark night sky avoids your having to black out a stage ceiling and makes fire safety less of a problem. Shooting against a black backdrop gives you the ability to composite these elements into a shot. In addition to the customary camera, grip, and electrical crews, this type of filming often calls for the expertise of a special effects technician or pyrotechnician. It is also the type of shooting that may require high-speed cameras which, depending on how high the frame rate needs to go, may mean hiring a specially trained camera operator. Companies that rent these highly specialized cameras may not allow you to rent their equipment without your hiring one of their technicians, who often is paid a higher daily rate than other camera assistants. You need to be aware of this so that you can budget for both the special equipment and camera technician.

This may be a good time to mention that it's not always necessary to capture all visual effects elements on film. A fast and much less expensive alternative (especially for low- to moderate-budget productions) is to shoot certain elements on digital video. Many elements that will end up small in frame or that are part of the deep background may be of sufficient quality when shot with a high-definition digital camera. Digital video equipment suitable for this purpose can be rented far less expensively than film cameras, and tape stock or memory cards are cheap. What's more, you don't need much of a crew. This "guerilla" approach opens up the possibility of capturing elements on the spur of the moment when the person with the camera happens to spot an image that could be used in a shot.

Miniature Unit

A miniature unit may have a fairly long life and, on really large productions, may have several subunits. Lighting miniatures is a special skill all its own, and for this reason miniature units usually have their own VFX DP who has mastered the art of making miniatures look believable. One of the largest such efforts in recent times occurred during the filming of the *Lord of the Rings* trilogy, which required the filming of dozens of miniatures spread out among several stages over a period of three years.

Traveling Matte (i.e., Blue- or Greenscreen) Unit

This unit would set up and film various traveling matte (i.e., blue or greenscreen) elements. These could be as simple as two

The walk-about

If you're a VFX Producer overseeing a miniature unit, a good habit to get into is to do a "walk-about" first thing in the morning before you settle down to the office work. Go on the stage and see what's going on. It's a good way to find out how things are going, how the morale of the crew is, if there are problems…and to give praise and encouragement.

extras talking to each other who will be composited into a scene to add a bit more life, or as complex as a stunt double in a wire harness running to the edge of a platform as the camera follows him and tilts down with him as he dives off a platform onto a green-covered air bag 40 ft below. It is no longer unusual for a green screen to measure 30' × 100' and encompass three walls of a stage. Setting up and lighting a screen of that size requires an experienced grip and electrical crew and is often supervised by a DP specializing in traveling matte photography. This traveling matte specialist makes sure that the green or blue screen is lit evenly and—more importantly—that the exposure of the screen is correct relative to the lighting of the action being filmed and that his lighting will produce a good, clean matte for the compositors. Lighting of the principal action, however, continues to be under the direction of the project's DP.

Motion Control Unit

This could be an adjunct to the miniature unit, pressed into service to shoot miniatures requiring motion control, or a unit set up to film real-time live-action elements other than those involving principal actors. Not counting other production support that may be needed, the motion control crew will usually consist of a motion control operator who does the programming, a technician, a camera operator, and an assistant. When you budget the motion control unit, be sure you know whether the production support (grips, electricians, transportation, etc.) will be absorbed by the main unit's budget or whether these costs will go on the visual effects budget.

Animatronics Unit

Though relatively rare, occasions do arise when a production has to set up an animatronics unit to film scenes that involve animatronic creatures. This task may end up on the VFX Producer's plate because the visual effects department may be the group best able to handle it, and because animatronics are very likely to be integrated with digital effects.

Lest you think that filming animatronics is child's play, think again. It is often a very complex and arduous undertaking that involves special set construction, rigging, and complex electronics, not to mention specially trained puppeteers that are members of the Screen Actors Guild, with all the requirements that imposes on the production company. For example, in the film *Alien Resurrection*, a sequence involving the Alien Queen and her Newborn required the services of about 40 SAG puppeteers to operate the 20-foot-high animatronic puppets. The puppeteers were located outside the tall set, operating their controls and using monitors to see what was happening inside the set.

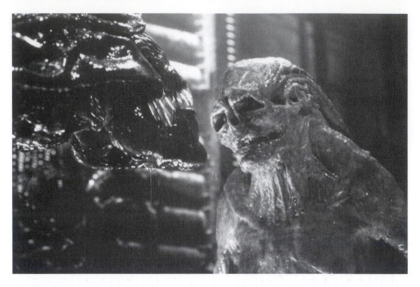

Figure 11.1 Alien Queen and Newborn—Animatronic Puppets.
(Image courtesy of Amalgamated Dynamics, Inc. *Alien Resurrection* © 1997 Twentieth Century Fox.

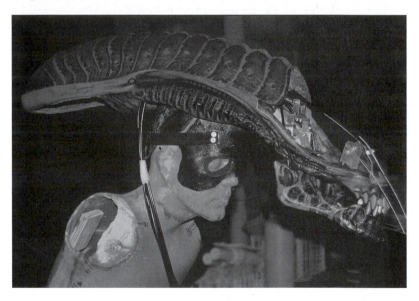

Figure 11.2 Mechanical warrior head puppet showing internal mechanisms exposed.
(Image courtesy of Amalgamated Dynamics, Inc. *Alien Resurrection* © 1997 Twentieth Century Fox.

Motion and Performance Capture Units

The terms *motion capture* and *performance capture* are often used interchangeably, but we should draw a distinction between them. Many people prefer the term motion capture to refer more generally to the recording of *overall* body movements, like those

of a couple of kung fu stunt players. Performance capture refers more generally to an actor's facial expressions; the most spectacular recent example of its use was in *The Curious Case of Benjamin Button* (2008), when Brad Pitt's facial expressions were recorded in a small studio and then used to animate a photorealistic likeness of the actor throughout the stages of his life.

Figure 11.3 Singer Cee-Lo Green wears markers for capturing his facial performance for the animation in the music video *Who's Gonna Save My Soul* (2008). (Image courtesy of Monopoly Management)

Figure 11.4 CG Character based on Cee-Lo Green's performance for the music video *Who's Gonna Save My Soul* (2008). (Image courtesy of Gradient Effects)

Motion capture may be done by a contractor specializing in this service or it may be carried out in-house by some of the larger visual effects facilities that have built their own mocap studios. If a project needs to record only a small number of motion capture performances it would be best to use an established vendor. But if a project is likely to need many mocap sessions and if the performers can be scheduled in one continuous block of time, it may be economical to set up a temporary space for this purpose. It could be a cost-effective alternative to renting time at a motion capture facility and has the added benefit of convenience.

In either case, the VFX Supervisor and VFX Producer should be present when the performances are recorded. Quite often, special rigging, platforms, and apparatus have to be built and tested before the motion capture can be scheduled. Performers to be hired may include dancers, stunt players, or athletes with special capabilities. Managing a motion capture session becomes still more complex when it involves animals or has to be done at a location other than the motion capture studio's facility.

Stage and Visual Effects Photography Procedures

Up to now we've mainly addressed issues that affect the interaction of the visual effects team with the 1st Unit. Let us now turn to some topics that concern us when we operate a separate, freestanding VFX Unit, a fairly common situation on visual effects pictures.

As we indicated in the previous chapter, visual effects units come in all shades and sizes; they can easily shrink, grow, and metamorphose as production wears on. One week, you may have a small crew filming elements for matte shots on location. At another time, you may assemble a crew to shoot a variety of visual effects elements on a stage, all this while you may also have a large miniature unit in operation that may take two or three months to set up, shoot, and wrap.

Each of the above situations may call for not only a different crew, but also a crew with special expertise in one craft or another. You, as the VFX Producer and with help from the VFX Supervisor, will be called on to hire the right people for each job.

VFX Crews

One of the most pleasant experiences a VFX Producer can have is to see good rapport among the members of the visual effects unit. On the other hand, a crew made of up a few superegos or negativists can quickly make everyone miserable, leading to discontent, low

morale, and inefficiency. When it comes to hiring a visual effects crew, therefore, the VFX Producer should strive to assemble a congenial group of craftspeople. Over time, every VFX Producer accumulates a list of favorite crew people who are experienced and reliable and who have the type of personality that meshes with other members of a team.

Often such a group will be composed of individuals who have worked together before, which could be of great advantage to you when assembling a crew for a complex project. Visual effects is a relatively small part of the film industry, and those who regularly work in this field often specialize in one aspect of effects work or another, such as DPs who are experts at miniature or traveling matte photography, motion control technicians, or pyrotechnicians. Just as is the case with any group of professionals who come together for a project, a good visual effects crew is ultimately better than the sum of its parts.

Assembling a Crew

It's not uncommon for a VFX Producer to do the hiring for several subunits: visual effects plate photography, blue or greenscreen plates, visual effects elements, a miniature unit, or an aerial unit. Naturally, you will want to hire the best people you can find. The same basic rules apply to vetting potential crewmembers as do to hiring in standard situations, so we will offer only a few suggestions for this situation.

First, you should consult with the VFX Supervisor and compare notes. He will undoubtedly have his own favorites with whom he has worked in the past, as will you. If you are considering crew people who are new to you, ask around among your friends and colleagues; they can be your best source of leads and information. Beyond your immediate circle of friends, other VFX Supervisors, DPs, and sometimes ADs can give you an evaluation of a technician they have worked with.

When you start interviewing potential crewmembers that are unknown to you, start by asking for a resumé, which should act as little more than an introduction, a quick overview of what the candidate for the position has done. The resumé should tell you whether the applicant merits a personal interview. The interview is your chance to dig more deeply into the person's actual experience, to get an indication of his/her personality, and to ask probing questions about what he/she can contribute to your project.

Get references, and *check them out*. On this score, you may need to exercise a bit of caution. Not everyone you call will be forthcoming about the person you are asking about for fear of a lawsuit if it should come out that negative information may have been the reason the candidate didn't get hired (keep that in mind, too, in case you should be asked to give a reference for someone who has

worked for you in the past). Some companies have strict policies that forbid giving out more information about past employees than verifying past employment, length of service, position, and sometimes their salary.

Demo reels are a relatively rare thing for visual effects crew members to have. They're really useful only when the applicant works at a craft that directly produces visual results, such as a DP. Review demo reels of anyone you are considering for an important creative role: VFX Supervisors, DPs, art directors, motion control technicians, etc. When you evaluate demo reels, be sure to ask the interviewee to state specifically what his or her exact function was on a given project or shot. It frequently happens in this business that the same shots turn up on the reels of several people or different vendors. Usually the reason is that different people or vendors fulfilled different functions. But it could also be that a candidate is pushing the limits a bit on taking credit for work on a spectacular shot when his or her contribution may have been relatively minor.

At a minimum, it is a good idea to verify a crewmember's credits. Two useful sources to consult are

- The Internet Movie Database, one of the most extensive databases of film credits anywhere. It allows anyone with an Internet connection to search for credits by a person's or a film's name. The database can be accessed at www.imdb.com.
- The Margaret Herrick Library of the Academy of Motion Picture Arts and Sciences in Beverly Hills, California. It, too, is a repository of a wealth of film information, including crew credits. The library can be reached at 1-310-247-3020. You can also tap into its resources through its website, www.oscars.org/library/index.html.

You should also ask if your candidate has any special experience that applies specifically to visual effects production. Just as in any other craft, there are specialists in visual effects photography of one kind or another.

Take DPs as an example. Every DP worth his steep salary will know how to light a normal set. But lighting miniatures is a special skill that most 1st Unit DPs do not have. It calls for a different visual sensibility than simply lighting a small, but normal-scaled object. The same goes for lighting blue or green screens. It's one of those tasks that many DPs will dismiss with a wave of the hand and claim that there's nothing to it. If that were truly the case, producers would save untold thousands of dollars having to clean up the damage in postproduction from improperly illuminated blue or green screens.

Another example: Every competent AC is expected to be familiar with a range of production cameras, lenses, and accessories. Still, some equipment is peculiar to visual effects, and not all crew

people will be schooled in its use. Pieces of equipment that fall into this category are VistaVision cameras, certain high-speed cameras, timelapse systems, and motion control cameras. None of this equipment is particularly difficult to learn to operate, but it is to a VFX Producer's advantage to hire someone who already has that experience. Why pay the person to learn on your dollar? If a technician has otherwise good credentials but lacks experience with a specific type of camera, suggest that he or she contact a rental house to ask if they could get checked out on the equipment. Most rental houses will oblige, and some will actually *require* the special training before letting the equipment out of their shop.

On-Set Safety

Safety on movie sets is a major concern. Sets can be hazardous places, what with all the cable strung on the floor, lights, equipment cases, grip stands, and a score of other items creating an obstacle course, even as there are still more lights suspended overhead and people walking around on catwalks. Not only does it make sense to maintain a safe working environment, it is the law, and it applies to productions of all sizes, from student projects to multimillion-dollar extravaganzas. Ultimately, the production company is responsible for providing a safe working environment. In practice, the person primarily responsible for safety on the set is the AD, but it is—or should be—everyone's concern.

As long as the visual effects crew is working on the 1st Unit set, we can leave the overall responsibility for on-set safety to the 1st AD, provided you have made him or her aware of anything unusual that the visual effects unit requires that could present a hazard. However, when the visual effects unit operates on its own, safety becomes the VFX Producer's concern. If there is a VFX 1st AD on your unit, you may want to put him or her in charge of on-set safety, but be aware that the ultimate responsibility is yours. Because of the nature of visual effects, the visual effects unit frequently gets disproportionately involved with stunts, fire, explosions, water, dust, collapsing structures, and other potentially hazardous filming situations. For this reason, every VFX Producer needs to be familiar with basic safety rules and procedures.

First, you should follow applicable state and federal laws relating to on-the-job safety. If you are working in California, state law makes the employer totally responsible for making the set as safe as it is possible to make it. Many states have similar laws on the books. On the federal level, OSHA (Occupational Safety and Health Administration) has had a strong influence on making workplaces safer. There is, of course, no substitute for common sense, which should be liberally applied in any potentially dangerous setting.

Here are some specific pointers:

- Post a *General Code of Safe Practices for Production* on the set. You can obtain a copy from the studio's safety officer.
- Keep a paper trail of all safety meetings, bulletins, advisories, and video documentation that you held, issued, or taped during production.
- When hiring new personnel, make sure that they know how to operate the equipment they will have to use in the course of their employment. If there is any doubt, you must provide adequate training.
- List potentially hazardous activities on the call sheet so everyone is advised of them before arriving on the set.
- Conduct a safety meeting at the start of each workday to take note of conditions that may have changed from day to day, and just to remind people that safety counts.
- Make everyone aware of the exits from the stage or other work area.
- Maintain the work area as uncluttered as possible, not only to minimize banged-up shins and falls, but also to make it easier for people to get out of the area quickly, if need be.
- Provide personal protection equipment (such as masks or fire retardant clothing) if necessary.
- Make sure that anyone working with fire, firearms, or pyrotechnics is properly trained and is licensed by the state in which they (or you) have secured the appropriate permits, and the proper safety personnel and equipment are standing by.
- When stunts, guns, fire, explosions, or some kind of destructive event are involved, hold a special safety meeting and adequate rehearsals till you are confident that everyone knows what is going to happen when, where, and in what order, and document the rehearsals. If anyone is seriously injured, the penalties can be severe.
- Encourage your employees to advise you if they notice any unsafe condition.

For more details about safety on movie sets, we recommend you consult the website of the Contract Services Administration Trust Fund at www.csatf.org/bulletintro.shtml. There you will find a list of numerous safety bulletins that apply to motion pictures, including the very useful *General Code of Safe Practices for Production.*

SUCCESS STORY

Tamara Watts Kent - (*Journey to the Center of the Earth; Chronicles of Narnia: Prince Caspian*)

At 12 years old I attended a TV taping of *Silver Spoons*. It was then that I knew I wanted to work behind the scenes in film or television. As a sophomore in college I landed an internship at Dream Quest Images, a visual effects company that had recently completed work on *The Abyss* and *Total Recall*.... Later, I accepted a job as a visual effects producer at MetroLight Studios, a medium-size company specializing in computer graphics. After 5 years of working as a facility side visual effects producer at MetroLight, Digital Domain, and Manex I moved to the production side working as a visual effects producer directly for the studios.

I majored in Film and Television at Moorpark College, but after receiving my AA degree I passed on film school in order to continue working in the film industry.

Among the duties of a VFX Producer are balancing the creative vision of production with the budget and schedule provided by the studio. Maintaining the organizational integrity of the visual effects department.

Keys to Success: The ability to work well under pressure and to think and react quickly, while things are moving fast around you. Good communication, organizational, and leadership skills. Having a calm demeanor.

It is crucial to have a VFX Database. Not only does it show the big picture of the show (what elements are left to shoot, how many shots left to deliver, etc.), but it also shows the critical details of every shot from camera data to creative notes. With the number of VFX shots continually increasing on films, it is the only way I have found to accurately track the film and make sure all the shots are approved and delivered on time.

MODELS AND MINIATURES

In contemporary filmmaking, miniatures as a visual effects technique are no longer as popular as they once were. Miniatures have had to yield ground to CG models that sometimes are less costly overall and easier to integrate with other elements. Even so, in the right hands and given the right subject, miniatures still bring a cinematic dimension to films that is difficult to match by computer. Witness the flawless miniature work in such films as *The Lord of the Rings* or *Harry Potter* series, *The Aviator* (2004), *King Kong* (2005), *The Dark Knight* (2008), and many others. As a VFX Producer, you are almost certain to have to manage the production of miniatures at some point.

Miniatures come in all shapes and sizes. They may represent just about anything you can imagine in this world or any other that a writer can conjure up. Filming them offers you an almost unlimited range of challenges, from motion control passes that make watching paint dry seem exciting to high-speed events that are over before you can blink, from models no larger than your hand to ones that fill a huge stage. In miniatures, anything goes.

In broad strokes, we use miniatures mainly in four ways:

- as stand-alone entities that, once they are filmed, can be cut into the film without further manipulation. We refer to them as in-camera miniatures
- as elements to be composited into a shot along with other elements, be they live action or CG
- as maquettes, which are detailed sculptures—usually of living creatures—produced to gain approval of what the creature will look like and to serve as an authoritative guide for building a full-sized animatronic puppet or its digital twin
- as models to be cyberscanned, serving as a basis for 3D CG elements that can then be further manipulated almost without limit

This last tactic is a fairly recent development. It consists of building a miniature, taking a series of detailed photographs of it,

and then digitally "projecting" the stills onto an untextured and unpainted CG model of similar shape. At first glance, this sounds counterintuitive: Why on earth would you go to the trouble and expense of building a miniature, only to use it as a prototype for a CG model? Why not build it, film it, and be done with it?

There are at least two reasons why this approach makes sense at times. First, real models often simply *look* better than their digital equivalent. There's a visual quality to a physical model that is subtly different from a digital one, and our brain may subconsciously pick up on that difference. When the maquette is scanned at a resolution that captures every detail necessary for the job, all the subtleties present in the maquette will be transferred to the digital model. Second, once the textures of the *real* model have been applied to its digital twin, we now have a 3D CG model that can be modified at will and—more importantly—can be filmed with a virtual camera that can view the model from any angle, soar over it or enter its internal spaces, or match its moves to any other CG element. No real camera that is subject to the laws of physics can ever approach that limitless freedom.

Miniatures or CG Models?

It is always a challenge for the VFX Supervisor and VFX Producer to choose between building and shooting physical miniatures for a project, building 3D digital models, or using a combination of both techniques. With digital tools being such a dominant factor in contemporary visual effects, many producers simply assume that it is cheaper to create CG models than it is to build and shoot physical ones. For some VFX Supervisors it is not only a matter of economics. They often prefer CG models because once a CG model is built they can have artists working on several shots at the same time, using the digital model at different scales and under any number of varying lighting conditions, whereas with a miniature you can film only one set-up at a time. This can be an important consideration in this age of compressed schedules.

On the other hand, certain subjects lend themselves equally well or even better to being realized through miniatures than by digital means. The fact that many blockbusters of recent years have used both physical and digital models with great success is proof that both approaches are valid.

In practice, the choice whether to use miniatures or digital models depends a great deal on how the director, production designer, and VFX Supervisor envision accomplishing the effects. This should lead to some lively discussions because ultimately it is not only economics, but also creative, technical, and even emotional and personality factors that come into play.

Another factor is the notoriously short postproduction schedules that prevail in contemporary film production. What happens every so often late in postproduction is that the director or studio

Figure 12.1 In-camera miniature of a giant radio antenna built at 1/24th scale. The landscape behind it is a scenic painting that matches an actual location. By definition, in-camera miniatures can be cut into a film "as is."
(Image courtesy of David B. Sharp Productions)

finds that the film needs a few more visual effects shots to clarify the storyline. By then, time is short, and the digital facilities working on the project are probably "maxed out." Miniatures may offer a way out of such a situation because they can often be built fairly quickly and filmed in-camera or with minimal CG enhancement, whereas it may take many weeks to create a CG sequence from scratch.

There is no question that cost is often the ultimate controlling factor. Assuming that the director and VFX Supervisor would be content with either approach, it will be up to the VFX Producer to get bids and prepare a budget that fairly compares one to the other.

Early Estimates

Getting a picture approved for production is an arduous process. With tens or hundreds of millions of dollars at stake, studios will crunch the numbers until they are satisfied that a project has a good chance of making a profit. Only then will a picture be greenlighted. This often leads to a long cycle of budgeting and rebudgeting the project using different assumptions. What if we used Star B instead of Star A? What if we shot it in Beijing instead of Berlin? What if…? What if…?

The visual effects department is not immune from this process, and the VFX Producer (with or without a VFX Supervisor on board) may

find herself weighing the pros and cons of physical vs. digital models even as the studio is still mulling the project over. At this point, the final decision of models vs. CG still lies months in the future. Still, your task is to present the producer with as fair and accurate a comparison as possible. You may or may not have storyboards to guide you; you will almost certainly not have previs available. With luck, you may have had a discussion with the director about the visual effects, but after that you'll be on your own. What to do?

A good approach in this situation is to provide the relevant script pages to both types of facilities (i.e., model shops and digital houses). Along with the script pages, you should supply your VFX breakdown of the sequence you want to get an estimate for and convey any ideas the director may have expressed about the sequence, the approximate budget range of the film, and whether the film is greenlighted or only a glimmer in the director's eye.

You may then want to challenge the prospective vendors to "think like a director." How would they approach the sequence, and how much do they estimate it would cost? Because the information you can provide to potential vendors is likely to lack details at this point, you should not expect them to give you a detailed bid. Rather, you should ask them to give you their best estimate, or even a budget range. Most companies, sensing a potential contract in the future, will be happy to do this.

It's not necessary for you to cast a wide net at this point. It should be sufficient to approach one or two potential vendors to sound them out and get a feel for how much the miniatures are likely to cost. Any more than this, and you would be wasting not only *your* time, but also that of the company you may want to work with later. You should be forthright with vendors in telling them the purpose of asking for the estimate, and what the current status of the project is. After all, right now you're just trying to get a sense of what approach might be less costly so that you can present a reliable visual effects estimate to the producer or studio.

Even as the creative approaches are being discussed, the VFX Producer should already be thinking ahead and considering some practical questions:

- How long would it take to build the miniatures?
- Are they stand-alone miniatures or part of a composite?
- If they are part of a composite, could they be started early enough during production so that they will be available for compositing in a timely fashion?
- Is there so much CG work to be done that it would make sense to have miniatures absorb some of the burden (assuming that there are no creative limitations that would weigh against a miniature approach)?
- And perhaps the most critical question of all: Which approach costs less?

Defining the Task

Before you begin negotiations with a miniature shop you need to have a clear idea of what miniatures you will need.

Here, storyboards and previs will be virtually indispensable in guiding the choice of CG vs. physical miniatures—that and the VFX Supervisor's experience in judging which approach will better serve the film's needs. Shots based on miniatures have to be carefully designed as to camera angles and movement and what actions the miniature must be capable of performing. These considerations will eventually determine such crucial details as the scale at which a miniature has to be built, how many sides have to be detailed and painted, where mounting points must be built into the miniature for motion control rigs, and what materials will have to be used.

As the VFX Producer, you will have to help decide whether the miniature build and shoot should be contracted to outside vendors, or whether it would be better to hire your own crew and set up your own model shop to build and shoot the models. This has to be decided on a case-by-case basis.

There are basically two approaches to getting miniatures done. One approach is to contract the job out to one or more companies that will build and film them. The other is to set up your own in-house miniature operation. Each approach has advantages as well as pitfalls.

Miniatures on Contract

Most of us have, at one time or another, seen films whose miniatures looked so unrealistic that we were momentarily distracted from the story. The thought "Wow, that looks really bad," may have crossed our minds at such times, and with that thought went our willingness to suspend our disbelief. On the other hand, we all have had the pleasure of watching films whose miniatures were undetectable to all but the most sophisticated eye.

Our point here is that building convincing miniatures takes great skill, and the task of selecting a miniature shop to build and perhaps to shoot the models for a film deserves—no, *requires*—the same diligence that you would apply to choosing a digital facility. One factor that makes this task simpler for a VFX Producer is that the choices are quite limited. Whereas digital facilities number in the scores, "A-list" independent miniature shops can be counted on the fingers of two hands, if that.

Independent firms with successful track records in building and filming miniatures are more apt to be found in the Los Angeles area than elsewhere in the U.S. Because so much of the motion picture industry is centered here, Los Angeles still has a pool of skilled

artisans and supervisors with the experience to build convincing miniatures. We stress the word *independent* because the major studios abandoned their in-house visual effects and miniature departments long ago, leaving this specialized niche to a limited number of small companies. In addition to these specialty shops, some set construction companies occasionally apply their skills to miniature construction.

There are also excellent miniature facilities in other major centers of film productions, such as in Northern California, the UK and New Zealand that consistently turn out work of the highest caliber. However, once you are away from the main production centers, getting miniatures built is a bit of a hit-and-miss affair. You may sometimes find a firm that builds architectural models that can adapt its skills, under close guidance of your VFX Supervisor, to your production's needs. You may discover that the production's prop supervisor or construction department can ably fill your needs, as long as these are relatively limited. And while model building is largely the purview of independent shops in Hollywood, you will find that studios in Europe, Mexico, and increasingly in other parts of the globe employ gifted artisans—sculptors, painters, carpenters—in their respective construction and props departments whose services can be engaged by the production. Given the proper guidance from your Production Designer and VFX Supervisor, these artisans can often produce outstanding work.

Away from the main production centers, getting miniatures built is a bit of a hit-and-miss affair. You may sometimes find a firm that builds architectural models that can adapt its skills, under close guidance of your VFX Supervisor, to your production's needs. You may discover that the production's prop supervisor or construction department can ably fill your needs, as long as these are relatively limited. And while model building is largely the purview of independent shops in Hollywood, you will find that studios in Europe, Mexico, and increasingly in other parts of the globe employ gifted artisans—sculptors, painters, and carpenters—in their respective construction and props departments whose services can be engaged by the production. Given the proper guidance from your production designer and VFX Supervisor, these artisans can often produce outstanding work.

The Bidding Package

Let's assume now that the decision has been made to use miniatures in a project that has reached the preproduction stage. You have storyboards and perhaps even a previs that shows what shots will be done using miniatures, and the VFX Supervisor has done his breakdown of the miniatures that will be needed. It's now up to you, the VFX Producer, to solicit the final bids.

Whereas the estimates you obtained during the initial breakdown phase were based largely on the vendors' own interpretations of how the miniatures should be built, it is now up to you to issue the exact specifications the miniatures are expected to meet. To this end, you will need to prepare a bidding package for each vendor from whom you're going to solicit a bid. Here are some of the items the bidding package should contain:

- Appropriate script pages. Model makers like to have an idea of the context in which the miniatures are set.
- Storyboards. These should describe each shot, including desired camera moves.
- Previs, if possible. A previs will be more informative than storyboards alone.
- Photographic references of real objects that the miniatures will have to match.
- Production illustrations or paintings showing design concepts of the miniatures.
- A complete list of miniatures and their scales. When you do this, you must be careful to list all the extra bits and pieces that you think will be needed during miniature photography, including, for example, the tiny pilot puppet that sits inside the cockpit of a model airplane, or pieces of furniture that will go flying in an exploding house.
- Detailed description of what *actions* the miniature must be capable of. If it's a spaceship, does it have to pitch, yaw, and roll? If an airplane, does it have one or more propellers that have to rotate and does it have to roll down a runway? The possibilities are endless.
- An indication of how many sides of the miniature will be seen, and will therefore have to be detailed and painted. Obviously the fewer sides that you see, the lower the cost.
- A description of how the miniature is to be filmed. Will it be set in place and remain there? Will all or part of it be destroyed during photography? If so, you must decide how many duplicates of the miniature you are willing to pay for to film additional takes (the rule of thumb is three).
- If the model is to be filmed with motion control, the number of model mounts (e.g., nose, tail, wing) needed to film the model from different sides.
- A deadline that tells the model shop when you expect the miniatures to be ready for filming.

Be sure to give bidders adequate time to prepare the bid. Bear in mind that no matter how thorough you are in preparing the bid package, you will undoubtedly have to field a number of questions from bidders. Usually the questions merely reflect a bidder's genuine need to clarify certain details, but sometimes they reveal a significant omission on your part, something that neither you nor the VFX Supervisor thought of including in the specifications.

Either way, you should make yourself and the VFX Supervisor available to answer all these inquiries. It's the best and fairest way to obtain a reliable bid.

The above guidelines apply whether you are soliciting competitive bids from several model shops or whether you decided that the miniatures should be built by a vendor's in-house model unit as part of an all-in deal that also includes a significant body of digital work. The guidelines also apply if you split up the miniature work across more than one vendor because the workload is too great or the schedule too compressed for one company to do it all. They all need the same information going into the project.

Monitoring Progress

There's more than a little similarity between building miniatures and building a house. In both cases, you are placing your trust in a contractor to build a physical object according to an agreed-on design by a certain date for a certain amount of money. You may even find, in fact, that a large and complex miniature can cost as much as a house and takes almost as long to build. That being the case, you would no more let the model shop work for weeks without frequently checking on progress than you would a homebuilder.

The basis for your relationship with the model shop will be a contract that clearly spells out what is expected of each party. In this regard, getting miniatures built is no different than engaging the services of a digital effects house. The same basic rules apply: The contract spells out who does what for how much in what period of time, along with other inducements and special conditions that apply to the film industry (see Chapter 19—Legal Matters for more details on contracts).

A miniature contract will normally include one or more exhibits that list the detailed specifications for the task to be performed. Such an exhibit should include a copy of the model shop's bid, a list of the miniatures that are to be built, a description of any actions the miniatures must be capable of performing, copies of storyboards applicable to the miniatures, and any other visual references (such as photographs)[1] that the model shop is to use in the design of the miniatures.

Getting Things to Match

What moviegoer hasn't noticed a mismatch in continuity at one time or another—a door open in one shot and closed in the next, a band-aid on the hero's face now but not a minute later—and taken secret pleasure in having caught the mistake? Mismatches

[1]The production designer will probably have a large library of visual references that you can draw on.

obviously do happen from time to time, and one area where we have to pay particular attention to that possibility is in building and filming miniatures.

Miniatures quite often have to match real sets, locations, or set pieces. The standard approach to this is that, once the sets have been designed, the art department draws up blueprints for the sets and set pieces, and construction builds them. More or less simultaneously, a set of blueprints and a set of the approved designs are turned over to the miniature builder, who then goes ahead and begins his work. The theory is that real sets and miniatures—both of which may take a considerable time to build—can be built in tandem and will match one another.

The fly in this ointment is that, as set construction progresses, small deviations from the designs and blueprints are likely to creep in. There's nothing conspiratorial about this; it's simply a reflection of the fact that blueprints don't necessarily translate exactly into three-dimensional sets. On the construction site, measurements and proportions may end up slightly different than drawn, and final detailing—such as the paint job or the finishing touches a talented plasterer applies to a set—could leave room for interpretation of the drawings.

We in the Visual Effects Department have to be aware that construction is always under pressure to get sets built quickly. It's also common that changes are made to sets even as construction is underway because the director, production designer, or construction supervisor finds that making a change will work better for one reason or another. Under such circumstances it would be rare for construction to remember to let the visual effects department know that a change was made that could affect a miniature build.

The solution? The VFX Producer should make sure that the miniature builders are kept current on design and construction changes. Let the construction supervisor know (or remind him) that you're building miniatures to match certain sets and that you need to be advised of any known changes. Ask your VFX Supervisor and the supervisor of miniatures to periodically look in on the construction sites. Have plenty of pictures taken of the set from all angles, especially close-ups of fine details. If necessary, take measurements as a set nears completion. Get samples of the final paints and finishes that were applied to the actual materials used in construction (not just a glop of paint brushed on any old piece of lumber) so that the miniatures crew knows exactly what they have to match. If all this sounds logical, it's because it is. But experience teaches that mismatches occur often enough to make the effort to prevent them worthwhile.

The risk of mismatches is less when miniatures have to match real locations. No concern about construction changes here. You merely need to thoroughly document the location as it exists, primarily its textures and paint. Once again, photographs are the best means of doing that.

Filming Miniatures

The filming of miniatures is a special art all its own. DPs that excel at it not only have command of the normal skills of cinematography; they also understand the special tricks that will make miniatures look convincing. The primary challenge of miniature photography is to make a smaller-than-normal object look and behave like its full-sized, real-world counterpart. To do that, a director of miniature photography must know how to select lenses and angles that will not betray the fact that we are looking at a miniature, how to match his lighting to the 1st Unit DP's photographic style, how different camera speeds affect the realism of moving objects, and a host of other technical details that most 1st Unit DPs and crews never have to concern themselves with.

With rare exceptions you are best off—and your chosen contractor will undoubtedly propose—to have the filming of the miniatures accomplished by their builder. Most independent model shops, as well as the miniature units that operate within the large visual effects houses, are old hands at dealing with the unique challenges of miniature photography. So asking to film the miniatures is not just a matter of a vendor wanting to make more money (not that there is anything wrong with that), but also a matter of efficiency for both the model shop and the production. Any competent model builder will anticipate challenges that could arise during filming and can either make or suggest changes to the miniatures as they are being built to avoid problems during filming. If the contractor knows he's also going to be responsible for filming the miniatures, he is all the more likely to build the models so that all will go well during the shoot.

There may also be occasions when the production will want to set up its own visual effects unit to film the miniatures. This presents the VFX Producer with the challenge and opportunity of operating a functioning film unit more or less independently of the 1st Unit. The scope of this job will depend on the complexity of the miniatures shots. It could be as simple as hauling a miniature tanker truck out to the desert and blowing it up one fine afternoon or as complex as a full-blown stage operation requiring several months of motion control and visual effects element photography.

If it falls to you to set up and supervise operation of a miniature unit, you will want to consider some of the following points:

- Discuss the scope of the job with the VFX Supervisor well in advance. Together, you can figure out what you will need in terms of equipment, facilities, and crew.
- If you haven't already, do a production breakdown just for the miniatures using Movie Magic Scheduling or another scheduling program; list all miniatures, visual effects elements, and every bit of special equipment that you think you will need. We would include such items as high-speed cameras, blue or green screens, motion control equipment, and video assist with compositing capability in this breakdown.

- Prepare a complete shooting schedule for the miniature shoot.
- Review your budget to see how it holds up in view of current circumstances. Perhaps things have changed since you did your initial breakdown. If you think your allowance was too low, bring it to the attention of the producer immediately regardless of why your earlier figure was too low.
- Get in touch with rental houses you expect to do business with and arrange for a credit account if the production doesn't already have one there. You will probably have to work through the production accountant on this because he or she has the authority to provide credit and banking references and sign the account agreement.
- Start a prompt search for suitable space to do the filming. Engage the services of a real estate agent, if necessary. Finding such a space may not be as quick and easy as you might think. Stage space at a normal movie studio is invariably much too expensive for this type of filming, and so you have to find some kind of industrial space. Here you may have to use your imagination a bit, because there are many different kinds of space that can be adapted for a prolonged miniature shoot. In the past, producers have used abandoned steel mills, decommissioned power plants, shut-down glass factories, aircraft hangars, unused airfields, and a host of other locations that you would not immediately associate with filming.
- When looking for a suitable space, you and the VFX Supervisor need to consider the height from floor to rafters (can we get our lights high enough to simulate the sun?), spacing of support columns (is there enough distance between columns for our miniature?), the availability of power (will we have to rent a generator for three months?), and distance from wherever your production is centered (can we persuade the director to drive out there?). All these factors will affect your schedule and the effectiveness of your operation. One thing you don't have to be concerned about is sound, so you don't really need a sound stage. But *do* check out the floor to see that it is smooth and level. Bumpy floors make moving miniatures and leveling track a problem.
- Check into the availability of special equipment, such as VistaVision cameras (there aren't that many in existence) and motion control cranes (also fairly rare and often booked far in advance). This is especially important if you are working in a foreign country and the equipment has to be imported.
- Get together with the VFX Supervisor and jot down the names of key people you would like to hire (miniature DPs, camera assistants qualified to operate special cameras, ADs with visual effects experience, and wire work specialists). Contact them early so you have an idea of whether they have other jobs lined up for the time you plan to shoot.

- If your situation calls for fires or explosions, check local ordinances to see what restrictions exist before you sign a lease. Also make the owner of the facility aware of what you'll be doing. You don't want either the fire department or the landlord to shut down your operation. Make sure you file for fire permits with the local city agencies several days in advance of the shoot. Most of them will require you to hire a firefighter for any type of shooting involving flames or explosions. And be sure you have budgeted for this.
- Look into local and state laws concerning the use of toxic or hazardous materials if you are setting up a model shop of your own. Environmental and occupational health and safety regulations tend to be fairly strict in the United States. Even so, these laws vary from state to state, and you need to be aware of them. It's different in other countries, where environmental regulations may be more lax and may not be well enforced.

Now go have some fun!

SUCCESS STORY

Terry Clotiaux - (*Spider-Man 3*; *Matrix Revolutions*)

I've been in VFX since 1989 and a VFX Producer since 1991. My direct path to VFX came from working in special venue live-action production with Doug Trumball's SHOWSCAN process. As a fill-in job, I went to help with Showscan's VFX facility, The Chandler Group. What started as a 4–6-week gig resulted in me staying there for 6 years and becoming the executive producer for the facility. Prior to that I had about 10 years' production experience working on network television documentaries, specials, after-school specials, and commercials.

Since I sorta fell into VFX, I'd have to say what's kept me involved is being at the right place at the right time. I saw the advent of digital, the decline of photochemical optical, and the explosion of VFX as a major story element of feature film production. It's just been one helluva exciting ride.

The VFX Producer must be a voice that helps manage the expectations of all the film makers: Director, VFX Supervisor, the film producers, and the studio. Without providing the confidence of leadership, circumstances are too likely to overwhelm the process and threaten delivery. The database is critically important. A big VFX movie is like a huge jigsaw puzzle and data management is crucial to keeping everything on track. Crucial to budget management as well.

POSTPRODUCTION OF VISUAL EFFECTS

THE NEW DIGITAL WORKFLOW

In its newsletter dated January 12, 2009, the Digital Cinema Society published a list of motion picture and television productions that used digital or HD camera systems during 2008. The numbers are revealing:

- Features, approximately 58
- High-profile TV movies and specials, approximately 26
- 3D (stereoscopic) live-action features, 8

This does not include numerous TV pilots, TV series and sitcoms, digital cameras used for visual effects elements and background plates for several features, or shows that used both film and digital cameras. Among them, these projects used at least eight different digital camera systems from different manufacturers.

Digital film production is here to stay.

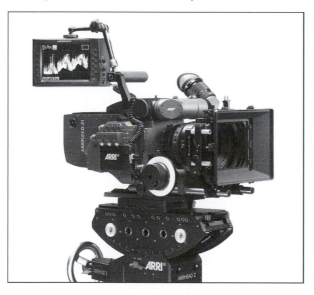

Figure 13.1 The ARRIFLEX D-21 film style digital camera. The Super-35-sized 4:3 sensor accommodates all image formats and exhibits the same depth of field as 35 mm film. (Image courtesy of ARRI, Inc.)

The digital revolution has overtaken our industry like a *T. rex* running down a *Gallimimus*. Up until a few years ago, about the only people using digital imagery were visual effects facilities, who worked their magic on computers. But even these images began life on film, were scanned and converted into digital files, and were eventually recorded out to film again to be cut into the conformed final negative.

Now, entire productions may be shot digitally, never to be transferred to film until the digital intermediate (DI) has been completed and the distributor orders his internegatives, interpositives, digital masters for theater projection, and other mastering materials for distribution of the film to a multitude of markets, both foreign and domestic.

This digital revolution has brought with it a whole set of new technologies and these in turn have affected the workflow of how we acquire the images, transfer them to different media, and treat them during various phases of postproduction. While the majority of technological innovations have had—and continue to have—their greatest impact on 1st and 2nd Unit production, we in the visual effects department need to be acquainted with the new technologies because there are times when they affect us directly.

Digital Workflow on the Set

Digital production begins with filming the action on the set. The word often being used now is image *capture*. Depending on the producer's choice, this is accomplished either with an HD (High Definition) or digital camera. Digital image capture and successive workflow can be done by means of two systems that are currently popular and are intensely competitive as both offer many of the same capabilities.

S.two System

This versatile technology integrates the digital workflow from image capture (the camera) to recorder to editorial to final delivery of the film. In normal studio operations, the camera is connected via cable to a digital field recorder. The captured images are recorded on a solid-state media called a D.MAG. This is the same type of memory that is used on USB drives and digital cameras, among other applications.

In another configuration a recording device called OB-1 can be mounted on some digital cameras. Images are captured on a FlashMag, which is basically a compact and portable version of the D.MAG that is loaded into the recorder. You can think of it as a digital film magazine. Because the OB-1 frees the camera from external cable connections, this configuration is suitable for hand-held camera operations. The S.two system captures raw DPX files.

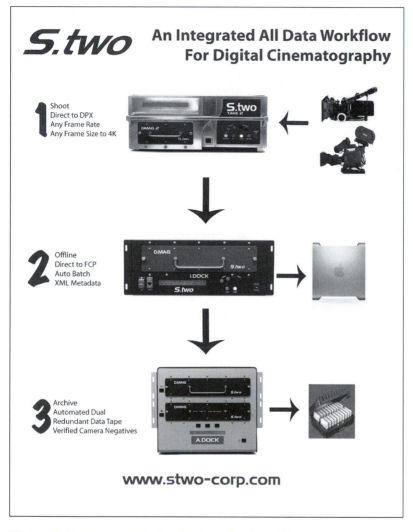

Figure 13.2 A diagram of a typical digital workflow for the S.two system.

Two other pieces of equipment round out the system. One is the docking station, which is used to create digital dailies. Docking stations are at heart an editorial tool found primarily in post-production facilities. However, some productions will bring a docking station on set so that a digital imaging technician can create digital dailies instantly even while principal photography continues uninterrupted. This can be very helpful when shooting on distant locations.

The other piece of equipment that completes the system is an archiving station. Its purpose is to store—or archive—the recorded footage for protection and to create what amounts to a digital master negative that will be used in the final stages of postproduction.

Codex Digital System

The Codex Digital system also works with most professional high-definition digital cameras. It is a self-contained location recording system that is based on a high-resolution digital media recorder that records images to a Disk Pack. As in the S.two system, in normal set operation the camera is connected to the recorder via cable.[1] It records in a variety of formats and can be used in location and studio environments as well as in postproduction houses. This system is bulkier than the S.two, but it can store twice as much data.

As a general rule, camera-mounted flash systems are lighter, consume less power, are more reliable, and cost less to operate than disk-based systems. They are likely to supplant the cable-connected disk systems in the not-too-distant future.

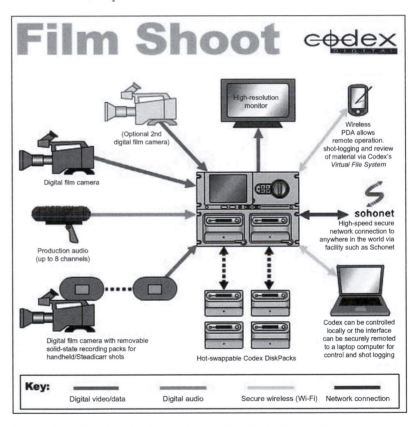

Figure 13.3 Flowchart showing a typical workflow for the Codex system.

In either system, the captured images are usually stored as *uncompressed* data in the form of full-resolution 10-bit DPX (Digital Picture Exchange) files, meaning that what you get are raw data as they were recorded by the camera. Along with the

[1] Both systems offer portable versions where the magazines are attached to the camera.

images, vast quantities of data related to each shot, the *metadata*, are recorded simultaneously. Both systems are tapeless.

Digital Workflow in Post

If you are shooting film, the next step in the process would be to send the film to the lab to get it developed and either make workprint dailies or convert it to digital dailies. These days digital dailies are becoming the norm even when a production originates on film.

However, generating dailies is a bit more complex and offers more choices when you are shooting in HD or digital. Once shooting is completed, the digital recording media (whether tape, hard disk, or solid-state memory) now enters the workflow that eventually produces digital dailies in various formats, depending on what is needed by the people who will be working with them. The S.two and Digital Codex systems approach the task somewhat differently but ultimately yield pretty much the same result.

In the S.two system, the raw footage (either on D.Mag or FlashMAG) is taken to a docking station, a fancy term for what is basically a highly sophisticated duplicating deck. The Codex system uses disk packs instead of the solid-state media favored by the S.two. Both systems are capable of transferring the raw camera data to almost any other format that production, editorial, or the visual effects department may need. Among these are DNxHD Avid files[2] that can be loaded directly into the Avid editing system, HD Quicktime movies, HD dailies and DVDs, or TIFF files that can be used by visual effects facilities as references for visual effects shots.

Both systems can make DVDs dailies while on set. The S.two system requires that you rent a docking station to make dailies. This also requires the addition of a digital image technician (DIT) to your crew and another computer to convert the images captured by the system into one of several formats for later viewing. With the Codex system, the DIT who does the recording can also create the dailies, as well as final deliverables on the same machine. The system has the advantage that it has all necessary file formats built into it.

Generating your dailies on set will save the cost of making DVD dailies at the lab or a postproduction facility. In the case of HD dailies it makes the footage available almost immediately for review on an HD monitor on set. DVDs can be handed out at the end of the day to the director, DP, and others for viewing at night.

One thing that should NOT be done on set, however, is to play back the original digital files captured by the digital camera, treating them as though they were video assist dailies. There is always the risk that something might go wrong during the playback that

[2]A high-definition format pioneered by Avid that maintains high image quality at much reduced file sizes

could damage the file, thereby destroying your original material. It is highly advisable to have a video assist technician on the crew who can record the data directly from the camera into his digital video assist system. You can then use that for playback on the set without risk to your original files.

Uncompressed Data for VFX

It is important that visual effects facilities be given only uncompressed 10-bit DPX files that are full resolution and full frame to work with. There are several reasons for this. The most important is that the raw camera data captured all the visual information of the original scene without any image degradation or manipulation. Color, contrast, density, dynamic range…all the critical characteristics of an image are captured and become the common foundation for all future visual manipulations. Another reason is that the original image is *full frame* (meaning full 2K resolution).

The full frame allows the visual effects facility considerable freedom to manipulate the shot in postproduction. The shot can be reframed up or down or left or right; unwanted objects along the edge of the frame can be cropped out; and it is possible to enlarge portions of the frame within limits. The normal aspect ratio of 4:3 of the full frame also enables a facility to work in any wide-screen format that the production requires, be it anamorphic 2.4:1, 1.85:1, or 16×9 HD, and still retain the image proportion that will eventually be needed for standard television broadcast.

In sum, anything less than uncompressed data will impair the ability of a digital facility to get the most out of the captured images and may make it difficult to seamlessly match the visual effects to the rest of the film at the final stage, the making of the DI.

Equipment Needed for a Digital Capture System on Set

(Note: These prices—like all others mentioned in this book—are subject to change. Please confirm them with your vendor before you finalize your budget.)

Assuming that you have a DIT in your employ, here are some typical costs involved in working in digital. You would budget according to your exact needs.

DIT needed for either of the following systems: $850/10-hr day

S.TWO SYSTEM PACKAGE

Digital Field Recorder:	$400/day
D.Mags (1 D.Mag):	$100/day
S.two I (Ingest) Docking Station:	$350/day
S.two A (Archival) Docking Station (needed if making dailies on set):	$400/day
Subtotal Equipment:	$1,250/day equipment

OR

CODEX SYSTEM PACKAGE

Codex Capture Station (includes Digital Field Recorder):	$1,450/day
Disk Packs (1-Disk Pack):	$225/day
(You may need six Disk Packs if shipping footage back to lab and not making dailies on the set)	
Subtotal Equipment:	$1,675/day equipment

With either package above:

Optional OB-1 Recorder with three FlashMags:	$1,000/day
Additional Magazines:	$180/day

The preceding rental items are usually available on a three-day rental week basis.

LTO 3 tape stock, 1 roll = 33 minutes for D.Mag:	$75/tape
LTO 4 tape stock, 1 roll = 66 minutes for Disk Pack:	$90/tape
Daily Avid DNxHD files to Firewire Drive for Editorial:	$35/day
DVD Dailies (Per Disk or Per D.Mag):	$12/day

If you want to make a HD tape on set from your digital files, you will have to rent an additional HD deck at the rate of $300/day. These tapes can then be used for your screening purposes. Most of the time a hard drive (like a Firewire drive) with Quicktime movies transferred to it or a set of DVDs is sufficient for viewing dailies and temp composites. Hard drives can be sent back and forth from location to studio or lab with new material being added every day. DVDs can be burned on an inexpensive DVD burner that the production can buy or rent.

The visual effects department needs this digital daily capability only when there is heavy visual effects work going on during the shooting day, as when your VFX Supervisor needs to make temporary composites and it is urgent that the director, editor, and VFX Supervisor have the visual effects dailies available to take with them at the end of the day. Short of that, it is still less costly to make your digital dailies at the lab or postproduction facility.

A Note about Digital Video Assist Costs

As a VFX Producer it would be pretty rare that you would need to set up a separate full-blown digital video assist system just for visual effects. Video assist is primarily a 1st Unit function. But it pays to have some basic understanding of the costs involved. And they can be considerable.

Keep in mind that this technology is in constant flux. New cameras, new data storage systems, more powerful and hitherto undreamed-of technical capabilities are coming online in a steady stream. It is hard to keep up with all the changes, so a novice in digital production should be cautious when first venturing into this arena.

There are several systems competing with one another, and no one system is clearly superior to another; all have advantages and disadvantages. Be sure to get the advice of reputable people who have had experience working in digital production, from camera experts to video assist technicians. You will find that every on-set digital production system has different requirements in terms of both additional equipment and manpower. Add a certain piece of hardware, for example, and you may unexpectedly find that it also requires an additional video assist technician who will cost you several hundred dollars a day.

A valuable feature—especially useful when you are shooting on a distant location—of new digital video assist technologies is that they make it possible for you to generate digital dailies on set. However, this capability comes at a price. As we noted in Chapter 9, you would either have to rely on the 1st Unit's video assist technician to make them for you at the end of the day or you would have to have your own digital video technician who has the equipment and time to perform this function at a convenient time during the course of the day.

SUCCESS STORY
Debbie Denise - (*Forrest Gump; The Polar Express*)

I was living in the San Francisco area in the pioneer days of interactive entertainment…trying to design interactive videos. One weekend, I saw *Who Framed Roger Rabbit* and from then on, I was hooked on visual effects. I drove up to Industrial Light & Magic and applied for every position I could—for a year and a half…. Finally I was hired as a temp coordinator. The project lasted for a few months…. After some management changes, Patty Blau was promoted to Head of Production, and suddenly they needed a producer for *Death Becomes Her*. I interviewed for the job and have been working with Ken Ralston as a visual effects producer ever since.

I majored in Broadcasting and Film…. Our department was part of the music school, so we were able to attract great talent for our student films.

As Patty Blau (my VFX Guru) once told me, "one third of your job is to support your VFX Supervisor, one third is to support your client, and the other third is to support your crew." That pretty much sums it up….You have to be a multitasker and have good people/communication skills. The other traits that you need are the ability to work with numbers, technical aptitude, and macro to micro vision…

Without the VFX database, you have no historical data and no ability to forecast—the lack of either is deadly.

GETTING A HANDLE ON VFX EDITORIAL

The VFX Producer's Role During Post

Contemporary visual effects–driven movies routinely contain hundreds of visual effects shots. Is it any surprise, then, that the postproduction period may last much longer than principal photography? And just sit through the end credits of any recent VFX-heavy film, and you will see the names of several hundred people who contributed their talents to the visual effects. On many such projects, the VFX Producer will just be hitting full stride when postproduction starts.

It's in the nature of the human species to want to classify and categorize things. We love order, and so we take comfort in compartmentalizing a complex undertaking like making a film into distinct phases in which one phase neatly follows another, from development to preproduction, production, and postproduction. There's only one problem with this: In the real world, events don't always occur in such a neat progression; they happen out of order, or blend with others.

It certainly is that way with production and postproduction. To be sure, each of these represents a distinct phase in the making of a film, involving a set of specific tasks and responsibilities with little physical overlap between them. But don't let that fool you. In spite of its name, postproduction does not so much *follow* production as it almost always occurs *in tandem* with production; the two phases overlap a great deal in time as postproduction activities get underway even as principal photography is still in progress. Conversely, just because principal photography is done doesn't mean that all visual effects plates have been shot; this may continue well into postproduction as miniatures and various visual effects elements such as water, fire, and smoke elements continue to be filmed. So

Speaking of credits

Ask your vendors to give you their list of credits well before you have to turn them in to the producer for the preparation of the film's credits. That way there will not be delays at the end while each vendor goes through this sometimes long and drawn-out process.

rather than thinking in terms of *when* certain phases occur, you may be better off to think in terms of *what* occurs.

When you think of it like that, you will quickly realize that as a VFX Producer, it is a near-certainty that you will be dealing with production *and* postproduction issues simultaneously even before the first visual effects plate is shot. For example, you will have to budget editorial and other postproduction functions for the visual effects department almost from the time you do your first breakdown. Once the picture is greenlit, you will have to line up editorial facilities, interview visual effects companies, solicit bids, and negotiate postproduction contracts, all activities that are technically part of postproduction. Meanwhile you are also dealing with previs, miniatures, effects elements, blue- or green-screen shoots… well, you get the picture.

The most important function—Job One, as a high-profile car advertising campaign once put it—of the VFX Producer in post-production is to oversee the timely completion of the visual effects. Chances are you will already be deeply engaged in deal-ing with digital facilities, getting new bids, and distributing visual effects shots to digital facilities that the VFX Supervisor and you have chosen long before principal photography is done. Together, these sets of challenges will keep the VFX Producer busy for many more weeks or even months.

Visual Effects Editorial

One of the most important relationships in the visual effects department is the one between the VFX Producer and visual effects editorial. The men and women of the visual effects edito-rial department may well be the unsung heroes of our craft. When postproduction is under full steam and dozens or even hundreds of visual effects shots, each made up of several layers, have to be kept organized, it is the VFX Editors that we turn to. They, and their databases, keep us on track.

To be sure, not every film requires a VFX Editor. On smaller productions where there are relatively few visual effects shots to be dealt with, the 1st Unit's assistant editor may be responsible for wrangling the visual effects shots throughout the postproduc-tion process. But on shows with, say, fifty or more visual effects, neither the editor nor his assistant will have time to pay much attention to the visual effects shots. With some high-profile fea-tures now boasting *several hundred* visual effects shots, having a VFX Editor on staff is no longer a luxury, but a necessity. On high-profile shows, not only will the production have a VFX Editor on staff, but so will most vendors.

The VFX Editor's role in contemporary feature film production can be quite challenging and personally satisfying. With the 1st Unit editor and his assistant concentrating on getting the picture

edited and keeping the cutting room going, the VFX Editor may have an opportunity to develop a creative working relationship with the director. Though his influence will be much less than the VFX Supervisor's, he nevertheless may be able to offer alternate ideas for a visual effects sequence that others may not have thought of.

The VFX Editor thus becomes a valuable asset to the production and can forge an important link between the 1st Unit editor and director on the one hand, and the visual effects department and vendors on the other. He is a curious hybrid, at once a member of the editorial staff and accountable to the VFX Department.

One area where he can make his influence felt is in the selection of takes. Quite often, the VFX Supervisor will make notes while shooting plates about which take he likes best for the visual effects. The VFX Editor will normally defer to the VFX Supervisor's judgment. But if they have a close working relationship, and the VFX Editor sees that another take would work better in terms of timing and performance in relation to other elements, he can play an advisory role in choosing the optimal plate (though this rarely applies to shots with principal actors where the director must make the final decision).

The VFX Editor's Tasks

Although by no means exhaustive, the following list will give you an overview of the VFX Editor's duties. The VFX Editor

- is responsible for having all visual effects shot dailies transferred to DVD or other media for distribution to those who need to review the dailies, such as the director, editor, executives, and visual effects facilities who need them to understand the context of their shots so they can be integrated with the sequence
- as the film is being shot and edited, works with the editor on identifying new visual effects shots that may come up and have to be sent out for bids
- makes DVDs periodically from cut sequences as they are updated by the editor for distribution as needed
- after they are approved by the DP or director, gets match clips as a reference for vendors for them to match color and density of visual effects shots to principal photography (for more on this topic, see the section on match clips)
- works with digital facilities to assure that elements get back and forth and that corrections are made to shots per director's instructions
- when necessary, obtains the negatives of reference plates to make them available to digital facilities
- attends screening of visual effects dailies and reviews them with the VFX Supervisor and director, noting comments for changes or approvals

- marks workprints (or identifies frames on a digital edit list) and prepares count sheets to indicate where specific events (e.g., laser hits) are supposed to happen in the shot. This information is critical for animators and sound effects people
- cuts in new shots into the color workprint or into the Avid cut as they arrive at editorial, from temp comps to final approved shots as they are approved by the director or (in the case of temps) by the editor, thus keeping the cut picture up to date; he does this in collaboration with the 1st Unit editor
- when working on a nonlinear system, usually has the responsibility of inserting new visual effects shots into the existing cut
- when working with film, keeps track of all shots and elements, sets up dailies, keeps the workprint clean, and checks all shots for correct color and length
- assembles all 1st Unit shots with the matching visual effects shots on a reel to show at screenings to the director and VFX Supervisor. For efficiency's sake, he will try to assemble several shots at a time for review and approval.

Attributes of a Good VFX Editor

As a VFX Producer, you may be called upon to hire, or at least participate in the selection of, the VFX Editor for your show, so a few comments about what to look for in this individual may be useful.

Certainly one of the most important qualities of a VFX Editor is that he or she has to be able to work well with the director and editor of the picture. He has to be mindful that he—like the other members of the production team—is there to support the director. As a sort of middleman between the director and a visual effects facility, the VFX Editor must be able to discern what the director's vision for a shot is and get the visual effects facility to deliver that look.

He should have a well-rounded background in film and a basic understanding of the entire postproduction process even if he is not an expert in, say, sound effects, ADR (automated dialog replacement), or music production. Artistically, he should have a good visual sense and a good sense of pacing and timing.

It's especially important for the VFX Editor to have a keen eye that is attuned to fine details. He is usually the first person in a position to spot flaws in incoming shots, and so can draw attention to them or even reject shots before the editor or director see them. Experience in the cutting room is a must, all the more so today when he must be knowledgeable about both film and digital editing technologies and must be able to work efficiently in both.

He should have his own well-developed record-keeping system and database programs tailored to visual effects to help keep track of shots and their status and progress. This goes beyond simply using software that's commonly available in editing rooms and used by the assistants. Ideally, the VFX Editor should have access to the same FileMaker Pro database being used by the VFX Producer and coordinator. The visual effects team should all share the same layouts for count sheets, etc., and should try to link their databases.

Budgeting for Editorial Staff and Equipment

Budgeting for the VFX editorial functions is generally a pretty straightforward affair, because there are not too many unknown factors involved. You only need to get some basic information from the producer or postproduction supervisor:

- How long is the postproduction schedule? This is the schedule that will ultimately drive all others. It lists the critical dates that everyone in postproduction has to adhere to. For the visual effects department, the most critical date is the date that negative cutting begins on the picture. That's the date by which all visual effects should be finaled, and the ultimate deadline that your vendors have to abide by.

 However, if you are shooting in HD or digital format you can continue finessing visual effects shots right up until you need to deliver the finaled shots to the DI facility. The rule of thumb is to try and complete delivery one week prior to the start of the DI process. This gives you a one-week pad to fix certain troublesome visual effects shots prior to the "drop dead" delivery date. It is helpful to have this extra time because the editor and director will still need to review the final shots and approve them prior to your delivering the shots to the DI facility. It's better not to disrupt the DI process by having to cut in visual effects shots while the director and/or the director of photography are trying to color correct the film with the colorist.

- Will you be shooting visual effects plates apart from 1st or 2nd Units? If so, you will definitely need to budget raw-stock, processing, and printing in the appropriate visual effects accounts. This can quickly add up to a significant sum if a lot of live-action elements, miniatures, or high-speed photography are part of your production.

- When will the VFX Editor start work? You should establish that date in consultation with the producer and/or editor. This can vary quite a lot, but as a general rule, we like to have the VFX Editor start when principal photography begins, allowing a week of prep to set up his equipment, become familiar with the visual effects database, and study

the storyboards. We don't want to bring him or her on after a large number of visual effects plates have already piled up. It makes it just that much harder to catch up and get the visual effects organized. Perhaps more importantly, on shows that require a lot of complex 3D CG work, vendors have to get their hands on the effects plates as quickly as possible. It's the production's responsibility to make that happen.

- Is the show big enough to require an Assistant VFX Editor? If so, he or she will have to be budgeted, though in normal production, Assistant VFX Editors are fairly rare as the VFX Editor himself is already perceived as an assistant to the main editor.

- Where will the VFX Editor be set up? With 1st Unit editorial or at a separate location while visual effects plates are being shot? It is fairly rare that the VFX Editor's facility is located separately from 1st Unit editorial, but if it is, you will have to allow for office space rental. Whereas the rent for editing rooms is usually included under the editorial department's budget, it is likely that the producer will require the rent for a separate room for the VFX Editor to be added to the visual effects budget.

- Whose budget does the VFX Editor's equipment go on? The answer is not as obvious as it may seem. Production companies and studios may have their own reasons why they want certain expenses charged to the film whose visual effects budget alone approaches the stratosphere. The producer may decide that it would be better to show a lower budget for the visual effects, so he may tell you that he will put certain of your editorial costs into his postproduction budget, thereby making the visual effects budget appear lower. Even so, he still needs to know what those costs are going to be. We therefore take the view that the VFX Producer should always include editorial equipment in her visual effects budget. You don't want to be shocked by an unexpected $64,000 charge when you're checking your cost report (assuming a 10-week shoot and a 22-week post @ $2,000/week). The item can always be deleted or suppressed later at the producer or UPM's request.

- Will the VFX Editor need any special equipment that's not normally part of an editing suite? Avid or Final Cut Pro systems are pretty standard, but will there be a need to make DVDs of dailies for which you will need to rent or buy a DVD recording package?

- Will the VFX Editor accompany 1st Unit editorial to a distant location, even overseas? If so, you should budget for travel, accommodations, and *per diem* in your visual effects budget. Again, the producer may want all travel and

accommodation expenses consolidated in one account, but you still need to crunch the numbers and tell him how much your VFX editorial crew will cost.

- If the production is shooting on film, will they make color workprint of all dailies or just print a few takes as an overall quality check while supplying their key people with dailies on DVDs? In either case, the visual effects department should have a set of film dailies of all visual effects plates, shots, and composites. So include an appropriate amount for visual effects dailies, telecine, and DVDs for the visual effects department in your budget.
- If, on the other hand, production photography is in HD or digital, you will not be making film dailies, thus saving a major cost item. Instead, you will have to budget for other items associated with high-definition or digital production.

Budget Guidelines for VFX Editorial

Here are some general guidelines for budgeting staff and equipment for VFX Editorial. Just keep in mind that both personnel and equipment rates change all the time as union contracts are renegotiated or rental prices fluctuate.

- VFX Editors: weekly rates range from about $2,500 to $3,500/wk.
- Assistant editors: weekly rates go up to about $1,500 to $1,800/wk.
- Avid systems are now available from about $1,500/wk and up, depending on the system's configuration, amount of disk storage, and accessories.
- Final Cut Pro systems rent for about $1,200/wk, depending on configuration, disk storage, and download needs. Final Cut Pro is becoming almost as common in editing rooms as Avid as editors gain more experience with it.
- Partly as a result of the ongoing digital revolution, the rental costs of traditional film editing accessories have come down in price. For conventional film handling rentals, including flatbed editing machine, benches, racks, splicers, tape dispensers, rewinds, etc., figure on about $1,500/mo.
- A special HD monitor and HD editing system might be needed for the VFX Editor, especially if he or she has to make temporary composites for previews. Then you might have to budget for an Avid DS Nitris or similar system that can be used to make temporary composites. Overall, it is much easier working in high definition than in standard definition.

As with all rentals, it behooves the VFX Producer to shop around for the best deal on equipment. Many editors own equipment that they may be willing to rent out at lower rates than an established rental house if they are not using it.

It has become common practice in the industry to telecine dailies directly to digital form and to skip the color workprint stage. Fewer and fewer directors have the luxury of seeing their work projected on a large screen. Admittedly, this saves the production money. However, we consider it essential that visual effects elements should be printed and viewed on film on a large screen as soon as possible.

The VFX Producer should therefore include a budget item for color workprint of visual effects shots from the outset and urge a reluctant producer to approve the additional cost. It will be money well spent.

Additionally, we recommend that the editorial budget provide for at least *two* prints of each visual effects shot. Why? Because several groups of people will need to see—and sign off on—the work. One print is needed for editorial (which basically includes the director, editor, and VFX Supervisor), the other for the vendor working on the shot. Both these groups need to see the same images so that they can evaluate the work and have common ground on which they can base their comments and corrections.

Pros and Cons of Digital Dailies

One of the cherished rituals of filmmaking is the screening of dailies, sometimes called rushes, the footage that was filmed the previous day. In this traditional film workflow, dailies consisted of 35-mm color workprints accompanied by the appropriate sound and were projected in a screening room. This worked well when a production was filming at a studio or a more or less stable base of operations where a projection room could be set up.

This traditional process has largely been replaced by digital dailies. In digital dailies, instead of being printed onto film, the previous day's footage is telecined, digitized, and transferred to one of several digital media. These could be HD tapes, DVDs, or hard drives.

Though very convenient because they can be so easily adapted to suit different purposes, digital dailies also have some pitfalls associated with the variation in technical standards among facilities, different viewing formats, and the different perceptions that the people who time and judge the dailies in different places and on different systems bring to the table. These can vary from viewing DVD dailies on a laptop on set to screening them from a hard drive on a theater-quality digital projector.

Advantages of Digital Dailies

- Once your dailies are digitized, they can be shown on many systems: laptops, DVD players, TVs, and digital projectors.

- They can be encrypted and password-protected, something that is not possible with videotape.
- You can create play lists and group selected takes together (e.g., all of 1st Unit's footage separate from 2nd Unit).
- You can easily and quickly pull up specific shots for anyone who needs to see only a selection of shots.
- You can send them with relative ease anywhere in the world via a variety of means.
- The quality of digital dailies remains pristine; there's no risk of damaging film, no projector wear-and-tear, and no scratches or dirt on the images.

Drawbacks of Digital Dailies

- Unless you are screening them on a high-end digital projector, the best you will get is HD-quality images; as good as they may be, it isn't film quality.
- You must have a "buy-in" from all the participants (i.e., everyone concerned with viewing the dailies must agree to this method of viewing them, whether it is HD or DVD).
- When you are on location and away from a major city, digital projection may not be readily available. However, what with 12–14-hour shooting days being almost the norm, finding time (not to mention the energy) to screen dailies can be a challenge for directors, DPs, and other members of the crew. No wonder directors and producers often prefer just to have a DVD of the dailies that they can view in their hotel rooms instead of going to a projection room at the end of a long day.

That said, we should note that the whole field of digital cinema is a rapidly evolving technology on both the production and postproduction ends. Some DPs now feel that digital image capture yields every bit as much fine detail as does film, and in postproduction it is now possible to distribute dailies via the Internet with the help of companies such as PIX.com Technologies or DAX Technologies that can upload digital dailies to almost anywhere in the world.

High-Definition Digital Dailies from Film

High-definition digital dailies from film are made at a laboratory or well-equipped postproduction house. The first step in this process is encoding. The original film negative is scanned in a conventional telecine suite and converted directly into the HDCam format and is then encoded. The cost for this is about $250–$350/hour in a telecine facility. The entire batch of dailies is then encoded on a workstation. This process takes the digital files and encodes or encrypts them so that the dailies can only be viewed by authorized people. Security, as always, must be 100%.

At this stage, a great deal of ancillary data can be embedded along with the images, such as slate and roll numbers and other camera data (this is often referred to as *metadata*). This makes it possible when someone wants to screen the dailies to decide instantly what shots he wants to pull up. Sorting through the footage thus becomes a snap.

Currently there are two common methods for preparing digital dailies. One is to make HD or DVCam tapes, and the other is to make DVD dubs.

HD dailies have high resolution,[1] very near to what would be a "best-light" color workprint, allowing the director and DP to evaluate the dailies with a good deal of confidence. In fact, it is this high resolution that has been a major reason why producers often skip making film workprints altogether.

DVDs are, by nature, a compressed media, so their viewing quality will not be as great as HD tape, but they make up for that shortcoming in convenience. They are inexpensive and easy to ship, and when they are produced at a lab or postproduction facility, individual shots or sections can easily be randomly accessed. So even if there are two hours of material on the DVD, a director, DP, or VFX Supervisor can quickly skip to the shots they are interested in.

Lab Transfer Costs from Film to HD

Below are some cost guidelines:

Telecine 35-mm negative to HDCam:	$250 to $350/hr
Standard Definition (SD) Transfer to DVCam:	$165/hr
Create DVD with chapter menu:	$125 each
Additional DVDs:	$12 each
Digitize dailies to hard drive (for Editorial):	$150/tape
HDCam tape stock (120 min.):	$100–120/tape
DVCam tape stock:	$25/tape

The digitized HDCam dailies are given to editorial on a hard drive, and from this copies of the dailies can be made on DVD to give to visual effects facilities for reference. If a production is shooting all-digital, a set of HD dailies is often made for editorial and a separate set of only the visual effects shots is made for visual effects facilities.

[1]The highest HD resolution is 1920 × 1080 pixels, which is a screen aspect ratio of 16:9. This comes close to the most common resolution used in digitizing film, 2K (actually 2048 × 1536 pixels).

SUCCESS STORY

Joyce Cox - (*Avatar; The Dark Knight*)

I started in business doing everything from typing pool at Miami University to accounting clerk for manufacturing companies to personal assistant to mortgage bankers…and became involved in advertising in Chicago in the 70s representing illustrators, photographers, and music composers…. The exposure sparked an interest in commercial production and film in general. I moved to L.A. in 1980 where I worked as a freelance producer for live-action commercials and short films. In the late 80s I became executive producer for a commercial production company with multiple directors working for agencies…worldwide producing traditional live-action commercials as well as projects requiring the emerging art of digital visual effects. In the mid 90s I returned to freelance which led to opportunities in live action as well as visual effects for features, one of the first being a portion of *Titanic*….

We're ultimately drawn to things we have an aptitude for. Mine is organizing and managing large complicated endeavors. I was not seeking visual effects but opportunities to produce. Visual effects is ever changing, each project loaded with new challenges. That keeps me interested.

A VFX Producer needs to maintain enough perspective to guide the complicated collaboration of art, science, psychology, sociology, and commerce that is visual effects and film production in general.

15

INTEGRATING VFX SHOTS WITH THE POSTPRODUCTION SCHEDULE

Visual effects editing doesn't take place in a vacuum. The process has to smoothly integrate and be coordinated with the editing of the movie which, in turn, must fit into the overall postproduction schedule. On most productions, the whole postproduction phase will be under the guidance of a postproduction supervisor. This individual will prepare a schedule that lays out a timeline for when certain milestones have to be reached for the picture to be completed on time. On the production end, some of these milestones include completion of the rough cut, the director's cut, music recording sessions, preview screenings, start of negative cutting, and many other steps in this complex process.

The visual effects are just one piece in this puzzle. The VFX Producer must get a copy of the postproduction schedule as soon as possible, because one of her main tasks will be to coordinate completion of the effects with the postproduction supervisor as well as the editor. The post supervisor needs to be kept abreast of when various effects shots are expected to be available to cut into the film and of the changes in delivery that inevitably happen. This becomes especially important in the later stages of postproduction. This is the time when the director still wants to make changes, the marketing department wants a new trailer, visual effects vendors find that the work is backing up for any one of a number of reasons, and everyone else is generally on edge.

Even on well-managed productions you can expect some slippage of interim dates. That is not necessarily a bad thing as long as everyone involved understands what is happening and is able to make appropriate adjustments. What you *don't* want is unexpected surprises.

261

Parceling Out the Work

As we pointed out in an earlier chapter, on major visual-effects-driven movies the choice of who will do the lion's share of the effects will probably be made by the studio early on during preproduction. Both the VFX Supervisor and the VFX Producer are likely to be involved in that decision, with the studio sometimes directing the VFX Producer to solicit bids from specific facilities. Their role in those situations is basically to generate an effects breakdown, soliciting bids from potential vendors and making recommendations to the producer as to which ultimately is the best facility for the job. Such high-profile movies, often involving several hundred effects shots, can only be handled by major effects facilities that have the man- and computing power to deal with such huge projects.

On the other hand, on independent films or on projects with a more modest shot count the, VFX Producer could be very influential in choosing which digital facilities should get the work. In those situations, we draw on our own experience with facilities that we have worked with before, or go on recommendations of trusted colleagues. In any case, a VFX Producer should interview and check on the references of any facility she hasn't worked with before to ascertain their ability to do the job.

How Many Eggs in One Basket?

Few are the films these days that don't have visual effects in them. The film may only need a couple of greenscreen composites here, a matte painting there, or a split screen to pick the best performance of two actors from two different takes. Projects whose visual effects are limited in scope and number don't usually present much of a challenge as to whom to hire for the job: The VFX Producer solicits three or four bids from potential vendors, and after consultation with the VFX Supervisor selects a facility and awards it the digital work.

At the other end of the spectrum are the visual effects extravaganzas involving hundreds of state-of-the-art effects shots and hundreds of artists. The common practice today is that work on projects of this magnitude is invariably broken up over a number of visual effects facilities.[1] No VFX Producer would seriously consider doing otherwise because only a few visual effects facilities have the capability of tackling such projects and completing them within a reasonable time frame without help from other

[1] If you would like to see convincing proof of this assertion, look through a few recent issues of *Cinefex* magazine and review the list of facility credits for the films featured in the publication.

facilities. Even they will occasionally have to be supported by a facility with a unique specialty.

But the majority of projects falls between these extremes, and it is here that the question "Should we give all the work to one full-service facility or split it up among several smaller effects boutiques?" arises almost immediately. The answer depends as much on personal preferences as it does on factual matters, such as the number and types of shots, and it is here where the VFX Producer may be most influential in deciding how the effects load is shared. There are pros and cons to either approach.

Among the advantages of awarding all the work to one large facility are:

- Presumed economies of scale. You are paying the overhead for only one company, and therefore this overhead can be amortized over a large number of shots.
- Having all the work under one roof makes it easier for the VFX Supervisor and VFX Producer to keep track of progress.
- The artistic style of the visual effects is likely to be more consistent. The artists derive inspiration and support from one another, tend to work with the same software, and are kept creatively on track by the in-house VFX Supervisor.
- A large facility is more likely to have its own computer engineers on staff to write custom software, a great advantage when an unusual challenge crops up that off-the-shelf software has not quite solved.

On the other hand, proponents of splitting up the work among several digital facilities also point to some advantages:

- Splitting up the work allows you to hire specialists with different skills.
- It allows you to hire "solo" artists, gifted individuals who literally work by themselves on a few selected shots. Smaller facilities often cost less, not because their artists are less talented, but because (a) overhead tends to be lower and (b) in smaller boutiques, the owner–partners often do much of the hands-on creative work themselves and therefore don't have to hire so many high-salaried digital artists (it's always about the money, isn't it?).
- Your work may get more personal attention because you are, in effect, the big fish in the little pond.
- Splitting up the work may give producers more control over the workflow because more shots can be worked on at the same time at different facilities, possibly shortening the schedule.
- It cuts down on but doesn't entirely eliminate the risk of having shots coming in late.
- It's a form of insurance because it makes it easier to pull a group of shots from one facility to award to another in case of a major failure to deliver.

There are also some downsides to spreading out the work over several facilities:

- It is more problematic for the VFX Supervisor to maintain a consistent artistic look to the effects.
- It adds more levels of management to the whole project. Instead of dealing with the management of one facility, the VFX Producer must now cope with the management of several facilities.
- The VFX Producer, VFX Supervisor, and sometimes the director must make more trips to visit the various facilities, or—if they are reviewing the work remotely—it means more disruption of the workday, having to get up and running with several facilities instead of just one.
- For the VFX Producer there are also more billings to scrutinize and approve, and more delivery dates and progress to keep track of.

Many people would argue that the best way out of this dilemma is to place the lion's share of critical 3D CG work with the best facility you can afford, and split up the less demanding work among other qualified but less costly vendors.

All these pros and cons notwithstanding, there is no getting around one other fact that may trump all others: Postproduction schedules these days have become so short that the VFX Producer on a show with a substantial number of visual effects shots has no other choice than to farm the work out to several facilities. Unless you are fortunate enough to have a megafacility like ILM working on your project, an 18- to 20-week postproduction schedule is simply not long enough for one vendor to complete the work on hundreds of shots satisfactorily. Therefore, even megafacilities frequently have to share the load with others. This has, in fact, been common practice for years.

Getting Facilities to Talk to Each Other

With visual effects production becoming more widely dispersed even as the work grows more complex and deadlines shorter, collaboration among different effects facilities has become standard practice. By collaboration we don't just mean that Facility A will be doing one complete sequence while Facility B will do another. Sometimes, two or more facilities may be working on different aspects of the *same sequence*. That means that they will be sharing data with one another and that they are dependent on one another to meet deadlines not necessarily of their own making. Managing this type of collaboration presents its own set of challenges for the VFX Producer.

Here are some guidelines that will help you deal with this type of project:

- Schedule a meeting among the principal parties (i.e., the production and the digital facilities) as soon as you know

that this situation will arise. Such a meeting will be useful even before you know the specifics of the shots or sequences that different vendors will have to work together on. If the facilities are far apart, consider holding the meeting via conferencing that allows participants to see one another's work and discuss the shots.

- Remember that the vendors you've invited to work together would normally be competitors. They will need to develop a certain amount of trust among themselves.
- Once the initial relationships have been established, it's critical that your vendors talk to one another directly so that they can plan how they will share digital files. Make sure that the software they will use is compatible all across the board and that they agree on file sizes they will be exchanging with one another. Address the issue of proprietary software with your vendors.
- Determine who will do what on the sequences or shots that the facilities will collaborate on. You don't want two vendors doing a previs for the same sequence, for example.
- Work with the vendors on the schedule. Each vendor has his own pipeline that will affect the order in which they will need to get elements from their collaborators. Inevitably there will be some scheduling conflicts, so it is important that the vendors sort out the due dates for each phase of the project.
- Stress the importance of frequent communications. The VFX Producer can't—and shouldn't—control all the technical details, but you *can* make sure that the facilities are clear on the creative approach and that each lets the other(s) know the specifications of the elements they are going to work with.
- Set up a system by which various facilities, the director, and studio brass can all view the material with relative ease. Use Internet communication tools such as iChat and cineSync, which allow viewers in widely separated places to view dailies and comment on them in real time.
- Establish a central database through which all the bits and pieces of the work can be tracked. When dozens of elements may be transferring back and forth between facilities, it's critical that every key person working on shared shots be able to see where things stand. This really only works for sharing certain character animation shots or 3D models like helicopters. These are elements that you do not want to duplicate work on, and it is more cost effective to share them.
- Work with the VFX Supervisors at the various facilities (and your DP, if possible) to establish a common color standard that they will all be held to. A good way to do this is to have each vendor take the same piece of film, digitize it, and

output it back to film. If the project is digital all the way through, have the facilities work with the same digital files. This can then serve as the basis on which each vendor can tweak his internal color settings.

- Insist on a series of tests to shake down the system. You and your VFX Supervisor must be satisfied that every pixel touched by the different vendors will eventually fall in the right place when a shot gets filmed out or is delivered to a facility for integration into a digital intermediate.

- Decide as early as possible who will be responsible for the final compositing and film-out of a final shot. This is a huge responsibility, the step where all the work of perhaps dozens of artists from two or more facilities comes together. Whoever is chosen for this step is likely to be under great pressure, especially if one or another facility has missed a deadline in delivering elements. For this reason, it would be wise to build some extra time into the schedule and set aside an allowance in the budget to pay this vendor for overtime.

Monitoring Vendor Performance

The foundation of any business relationship has to be trust among the parties. You would not have entered into a contract with Company X if you did not trust the company to do the work for the agreed-upon price and time schedule. Conversely, Company X would not have taken the job if they didn't think that you were forthright with them in establishing the specifications for the work and would pay them according to the payment schedule both of you agreed to. Even so, you are not going to walk away and turn the vendor loose without checking up on him regularly.

You will constantly be following up on (in other words, tracking) shots and checking their status and the vendors' schedules and deliveries. Keeping track of shots is a painstaking and time-consuming task that, ideally, should be delegated in large part to the VFX Coordinator. He or she must update records frequently and review them carefully so that no shot gets accidentally overlooked. For this purpose you will need to have all shots entered in a database or spreadsheet (such as Excel) that lists the due dates for the completion of various steps.

Actual verification of a vendor's progress must ultimately be done *visually*. That's where the VFX Supervisor must take the lead. He can expect to put a lot of mileage on his car because he needs to visit the various vendors' offices regularly. If vendors are located in distant cities or even overseas, the VFX Producer should set up a schedule for reviewing the work over the Internet using the aforementioned cineSync or iChat services, an FTP

site, or other remote viewing systems. As the director's partner and surrogate, the VFX Supervisor must judge the artistic details of all shots before they're shown to the director. It's not necessary for the supervisor to be skilled at using the various computer programs that digital artists employ, but he must be able to analyze the results of their work, issue directions, state his opinions clearly, provide inspiration…and occasionally express displeasure without insulting an artist.

The VFX Producer should always be present when the VFX Supervisor reviews work being done by your various effects facilities. Not only does that keep you informed about the status of things, but it also allows you to make sure that the supervisor's instructions get followed up on. Reviewing the work can be as simple as sitting next to an artist to offer a few suggestions, or more formal, as when the vendor screens two or three days' worth of dailies for you. If the latter, someone on the vendor's staff will undoubtedly have prepared a screening list of all the tests, temps, and composites that are to be screened. The vendor's artists and in-house producer(s) will most likely attend the screening so that everyone can take part in the evaluation of the work.

If the amount of work to be reviewed is substantial or involves mostly elements in progress that the VFX Supervisor must comment on, it may be useful to call for a meeting at the vendor's facility where a group of artists can jointly present their work in progress. Whenever you get together with a vendor to review his work, you or someone you trust (preferably your VFX Coordinator) should be there to take notes about what shots were discussed and the instructions the supervisor or director gave the vendor about what to do next on any given shot. Do not rely on the VFX Supervisor or the vendor to take notes. The VFX Supervisor needs to focus on the creative work, while the vendor may interpret comments more in his favor than might have been intended. Thus, the notes really serve a dual purpose. First, they're an effective reminder for artists of what they need to do on a shot. Second, they serve as a paper trail that allows you to go back to review past decisions in case of misunderstandings or disputes. Taking accurate notes is a good habit to get into.

Shot review notes can take any one of a number of forms. You may simply want to type them up as a text document, like the minutes of a meeting. This works quite well when there are few shots involved in a project. If, on the other hand, you are working on a show with a substantial number of effects shots, you'd be better off constructing a spreadsheet or database layout that lists all the shots and from which you can quickly use a "Find" function to extract the shots you reviewed with the vendor on any given date. That will save the drudgery of repeatedly having to type in shot numbers, descriptions, and status updates, while letting you modify your comments on a daily basis (see Figure 15.1).

Surprise visits

Drop in on your vendors unannounced once in a while. It's only human nature, but if a vendor knows you're coming, you can be pretty sure that every artist will have your shots up on his monitor. An unannounced visit, on the other hand, may give you a truer picture of how diligently the vendor is working toward meeting his deadline.

After a facility review of shots, your notes should be typed up as soon as possible and distributed to the VFX Supervisor and to the vendor, who is expected to follow through with his artists. Depending on your situation, you may also want to give copies to the director, editor, and producer. Some people like to be copied on everything; others don't want to be troubled by the details and prefer to let the VFX Supervisor move things along until a shot gets to a point where the director's input is needed.

In sum, an uninterrupted record of shot notes is a useful management tool that goes beyond the statistics of shot numbers and completion dates but provides an anecdotal history of the progress of your project.

FALSE HORIZON			SHOT REVIEW NOTES		
FX #	**Description**	**Review Date**	**Meeting Notes**	**Status Details**	
V15.1	INT. SPACE FREIGHTER COCKPIT - DAY - McFarley spots tail of the comet in the distance.	07/15/2009	Make comet tail more wispy and fanned out. Extend about 10% longer across frame. Star field OK	See reference pix of Comet West on file in Art Dept.	
V21.3	INT. FREIGHT DECK - DAY - The Space Freighter's hull breaks open.	07/15/2009	More camera shake. Add CG debris and dust flying off when hull breaks open. Add sparks.	Revisions due by 7/29.	
V77.1	EXT. PLANET SURFACE - SPACE FREIGHTER WRECK - DAY - McFarley scans the horizon with binoculars as Kinney extends solar panel on rover. The dust cloud looms.	07/15/2009	Make dust cloud larger, more active. Set extension lacks detail; needs more dents, add another hole in side by engine pod. Planet surface looks good.	Have ready for review by 7/22. OK for temp render for action.	
V77.2	EXT. PLANET SURFACE - SPACE FREIGHTER WRECK - DAY - The dense dust cloud rolls in. McFarley and Kinney scramble to put a tarp in place over the rover.	07/15/2009	Looks great. No changes.	Approved 7/15. Deliver to D.I.	
V89.6	EXT. WRECKED FUSELAGE - SHELTER - DAY - McFarley sends Mischa flying.	06/24/2009	Approved 6/24/09 by director	Editorial has approved it in the cut. OK to go out to film 6/25/09	

Figure 15.1 Example of shot review notes form.

SUCCESS STORY

Joel Mendias - (*Superman Returns*; *Nim's Island*)

I began as an assistant to the Senior VP of production at Boss Film Studios. After a very short stint as a VFX Coordinator in their commercials division I began work at Digital Domain…. After 5 years I joined Rhythm and Hues as a production executive, focusing specifically on bidding and new business/client relations. That led directly to my first job as a VFX Producer; after bidding *Around the World in 80 Days*, I moved onto that project as VFX Producer.

As a vendor VFX Producer, your primary responsibilities are two-fold: You have to be responsible to the client, to deliver work that meets their standards of timeliness and quality. At the same time, you must be responsible to your company, ensuring that you operate within the limits of the budget and that you juggle money and bid days from one area to another, as needed, in a way that is ultimately in line with the target bottom line.

As a VFX Producer…it's key to be detail-oriented, but you should never lose sight of the big picture, global milestones, and deliveries. You need to follow up and keep tabs on the details enough that things don't get off track and take you by surprise later.

A good VFX Producer is a constant and clear communicator of where you and your team stand at any given moment. A functional, robust database is absolutely essential to production…at any given moment, I need to be able to find and sort shots based on a variety of criteria—VFX elements within shots, shot status, etc. Having that information readily available is key to monitoring the progress of the show.

POSTPRODUCTION SCHEDULING ISSUES

"I love deadlines. I love the whooshing sound they make as they fly by."
—Douglas Adams

Postproduction schedules in contemporary feature film production have become brutally condensed. This is mostly because of economics. The longer it takes a film to be completed, the more it costs, not only in terms of crew and facilities, but also in interest payments on the tens of millions of dollars of production costs until the studio or production company starts to see a return on its money. In addition, studios are constantly juggling their release schedules to beat out their opposition at the box office.

Another factor driving these condensed postproduction schedules—one not usually admitted to by producers—is the simple fact that it *can* be done. Studios simply expect everyone to work that much harder or longer. "All-nighters" don't just happen in college dorms before exams. They are endemic to visual effects production in the latter phases of postproduction. In earlier times, the two or three weeks before a picture's release were a time of relative calm for VFX Supervisors and Producers. Most of the visual effects would have been approved and cut into the film, and only a few stragglers or particularly difficult composites might be left to be shepherded to completion. But in this digital age, visual effects shots may be added or changed quite literally up to a day or two before the final digital and film masters have to be made. Why? Because digital technology, in the form of digital intermediates, makes it possible.

This production environment makes it all the more important for the VFX Producer to work out as reliable a postproduction

271

schedule as possible at the outset. Several steps can help make this task easier for the VFX Producer.

Practical Steps in Devising a Postproduction Schedule

The official postproduction period is the period (weeks or months) immediately following the last day of principal photography. For a major feature, postproduction typically runs between 20 and 24 weeks, but as we observed above, these schedules are getting more and more compressed. It is sure to be a stressful time for the VFX Producer and supervisor because of the pressures of completing the work. One of the first questions the VFX Producer should ask when she first joins the project, therefore, is "How long is postproduction?" The answer will influence everything you do until the last visual effect is delivered.

For practical purposes, postproduction ends only when the cut negative has been turned over to the laboratory for the manufacture of preprint materials. Alternatively, if your film is slated to finish as a digital intermediate (which has become standard for the majority of studio films), you may still be delivering digital files of visual effects shots until the very last day that the digital intermediate is being worked on.

To say that postproduction is limited to the period that follows principal photography is therefore a bit misleading. In actuality, certain activities of postproduction will have been ongoing for many weeks, the editor working on the first cut of the film being the most obvious example. And digital work—which strictly speaking falls under post-production—will have been underway long before the last foot of film is shot. Your schedule has to take this overlap into consideration.

Handing Off Shots to VFX Facilities

As we previously observed, editing begins almost the first day of principal photography; the film starts taking shape even as the director is still spending twelve hours on the set every day, then perhaps going to see dailies and preparing for the next day. Periodically he also must work with the editor to review the cut and provide guidance.

Because so many steps are involved in getting complex visual effects shots finished, each step along the way has to happen in a timely fashion. Vendors doing the digital work need to be given elements and count sheets to work with as soon after they are shot as possible. For this reason we often ask the director and editor to give priority to rough-cutting visual effects sequences. This doesn't mean that shots have to be cut to their exact length; it's

a given that the picture is still taking shape and many revisions lie ahead. But it *is* reasonable to expect the director and editor to choose the takes they prefer and to determine the part of the shot they want to use.

The issue of turning visual effects shots and counts over to digital facilities has, in fact, become sufficiently important that most contracts now specify that frame counts and filmed elements must be turned over to the digital facility within a certain number of weeks after a scene is filmed. This is an important milestone because a digital facility can't do much until the VFX Producer has given the vendor the visual effects shots along with the count sheets.

A widely used rule of thumb is that this should happen about five to six weeks after the sequence has been shot. In other words, that's how long the director and editor have from the time a scene is shot to make up their mind how they are going to cut the scene, which takes they are going to select, and how long each cut is going to be. The interval could be less if the shots involved are fairly simple, such as wire removals. It's very likely that the editor will add a handle ranging from 8 to 16 frames at the head and tail of each shot, depending on how tight the cut is that he wants to turn over. Adding handles to the shots allows the director and editor some flexibility to fine-cut a sequence later.

To help everyone stay on track, the VFX Producer has to work out a turnover schedule with editorial that the editor can meet. Some VFX Producers find that a simple editorial calendar (see Figure 16.1) is useful for this purpose. This calendar has its roots in the production calendar that we discussed in Chapter 9 (see Figure 9.1). If you compare the two, you will see that that there is an approximate five-week interval between the time a visual effects plate is shot and the date the editor is expected to turn over rough cuts with count sheets of the visual effects sequences.

When updated frequently the editorial calendar can serve as a useful scheduling tool for the VFX Producer. Why? Because it allows you to look weeks ahead even while you are still in principal photography to the time when your digital vendor needs count sheets and effects elements so he can work on the visual effects shots. With an updated calendar in hand you can go to a visual effects vendor and ask, "Can you finish your work in time based on these turnover dates?" (See Figure 16.2.) Sometimes a vendor will tell you no, he needs the plates sooner. If his reasoning is sound, you may then have to go back to the 1st AD to see if the live-action plates can be scheduled earlier. This is a common situation when you need to shoot greenscreen plates that will have complex 3D CG added in post.

Scheduling and keeping track of the digital work becomes all the more important as you get deeper into postproduction. Not only must editorial turn over shots and counts on time so that you

Day one

Day One for purposes of establishing turnover dates is the day *after* the plate was shot. We do not count the day that a plate is shot or weekend days or holidays.

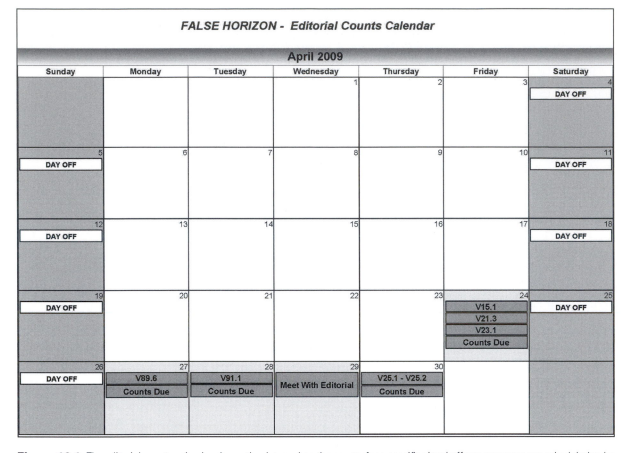

Figure 16.1 The editorial counts calendar shows the dates when the counts for a specific visual effects sequence are scheduled to be turned over to a visual effects facility. This calendar is intended primarily for internal use.
(Image courtesy of Reel Logix, Inc.)

can keep shots moving along, but at the same time you must also be diligent about meeting contractual obligations to your vendors. To help in this task, many VFX Producers issue a turnover schedule (such as the one in Figure 16.2) that lays out when the editorial department must turn over the counts and elements for each shot to a vendor. These schedules are primarily for the production's internal use. They are considerably more detailed than the simple editorial calendar and should be maintained conscientiously.

Whenever possible, the VFX Producer should try to get the director and editor to first deal with the main or 1st Unit plate that drives everything else in the scene. In other words, the live-action element that all others depend on for length and timing of the shot should be turned over first.

For example, let's say you have a scene of a martial arts fight between two adversaries, one a human, the other an alien, set

VFX SHOTS TURNOVER SCHEDULE									
SET DESCRIPTION	VFX Shot	Planned Shoot Date	Actual Date Shot	Unit	Counts Due	Weeks	Counts Received	NOTES	VENDORS
INT. SPACE FREIGHTER - Cockpit									
	V15.1	3/16/09	03/16/09	1st	04/24/09	5.6 wks		GS Composite	Vendor #1
	V21.3	3/17/09	03/17/09	1st	04/24/09	5.4 wks		GS Composite	Vendor #1
	V23.1	3/17/09	03/17/09	1st	04/24/09	5.4 wks		GS Composite	Vendor #1
EXT. WRECKED FUSELAGE - Shelter									
	V89.6	3/18/09	03/19/09	1st	04/27/09	5.2 wks		Wire Removal	Vendor #2
EXT. CALIGARI CITY									
	V91.1	3/20/09	03/20/09	1st	04/28/09	5.2 wks		Matte Painting Set Extension	Vendor #3
INT. SPACE FREIGHTER - Cargo HOld									
	V25.1	3/23/09	3/23/09	1st	04/29/09	5.4 wks		GS Composite	Vendor #1
	V25.2	3/24/09	3/24/09	1st	04/30/09	5.4 wks		GS Composite	Vendor #1
EXT. PLANET SURFACE									
	V77.1	3/25/09	03/25/09	1st	05/01/09	5 wks		CG Matte Paintng of Planet	Vendor #3
	V77.2	3/25/09	03/26/09	1st	05/01/09	5 wks		CG Enhancement	Vendor #3
	V77.3	3/25/09	03/26/09	1st	05/01/09	5 wks		CG Enhancement	Vendor #3
EXT. PLANET SURFACE - Space Colony									
	V103.1	3/27/09	03/27/09	1st	05/04/09	5.2 wks		CG Enhancement	Vendor #3

Figure 16.2 An example of a typical shots turnover schedule for counts due to digital facilities. It lists not only when counts *should* be turned over, but—more importantly—when they were *actually* turned over.

against a fortress. The fight element of the principal actor and the stunt double who will be replaced by a CG alien is shot on a greenscreen stage and the fortress is a miniature. Quite logically, you would urge the editor to give you the greenscreen plate within the allotted 5–6 weeks from principal photography so the counts and negative or digital files can be turned over to the vendor who will create the alien. Not only that, but as we suggested in an earlier chapter, you should encourage the AD to schedule the greenscreen shoot as early as possible. You'll not be as concerned with the miniature plate, which can be added later.

For efficiency's sake—and also to help maintain a uniform creative look to any given sequence of shots—it is best to hand off shots to a facility when a whole sequence can be turned over at the same time. Both the director and the VFX Supervisor should take the time to review the sequence before it's handed off to the digital facility so that they're in agreement on what they want the sequence to look like. Having achieved this kind of understanding will make it easier to communicate clearly with a vendor who relies on the VFX Supervisor for creative guidance.

The VFX Producer can take a hand in this by asking her colleagues to get a block of shots ready to go, even though other sequences are still under discussion and, indeed, may not have been edited at that point. The VFX Producer should also make sure that all elements for the shots being handed off are available to be turned over. It is counterproductive for a vendor to put work into his pipeline, only to find that elements are missing.

When you are actually ready to hand shots off, you should give the vendor at least four items for every shot:

- a match clip if you are working in film, or a digital file whose color timing has been approved by the DP
- a rough cut of the sequence for context; a DVD should be sufficient for this purpose
- the editor's count sheet or EDL
- if your project was shot on film, either the negative itself (if the vendor is responsible for the scanning), or the selected scenes already scanned on a hard drive or a tape medium that the vendor can work with (if production is having the negative scanned)
- alternatively, if your project was shot in HD or digitally, a hard disk or firewire drive with the digital files of the selected scenes

The Shot Delivery Schedule

Many a VFX Producer must have wished for a crystal ball at one time or another, hoping to see into the future so she could avoid some pitfalls when she constructed a postproduction schedule. Alas, too many unpredictable factors can derail even the most efficient of schedules, like unexpected difficulty of shots, other commitments that a vendor may have to honor, later-than-promised delivery of effects elements to the vendor, or a changed release schedule. Even so, a schedule is essential. With it, everyone involved can see, in broad terms, the task that lies ahead. Without it, you have a good chance of losing track of the status of the shots and—even worse—you may not realize that things are going off-course.

Setting up a digital shot delivery schedule has to be a collaborative effort between the VFX Producer, the VFX Supervisor, and the digital facility. We on the production side know the broad outlines that cannot be violated that dictate when the work must be completed. On the other hand, the vendor is in the best position to decide how to deploy his resources to meet the ultimate deadline. Our basic goal is to determine how many shots a given facility will complete in any given month of postproduction.

A good way to construct a digital shot delivery schedule is to work backward. That is, we will consult our postproduction schedule, take the ultimate completion date, which is usually dictated by the film's release date, and then calculate backward to establish various interim milestones. At this point it is helpful to have a sequence breakdown that shows how many visual effects shots each sequence calls for. This, in turn, lets you figure out how many shots must be completed each month and week *on average* to complete the show on time. Such a breakdown can also give you and the VFX Supervisor a better picture of whether the digital work should be distributed over more than one vendor.

Admittedly there is a good bit of educated guesswork involved in this procedure. You have to take into consideration the total number of shots, the length of the postproduction schedule, the number of shots a given vendor is contracted to do, and the difficulty of digital work required. Other factors that may affect the delivery schedule are the needs of the trailer department, studio preview screenings, and other special requests that the marketing people may have.

Here is a hypothetical delivery schedule for a film which lists all the essential information you need to make tracking the work reasonably efficient:

- Shot ID (VFX) numbers
- Facilities doing the work
- Number of shots assigned to each facility
- Monthly targets
- Overall shot totals
- Each shot's status
- When a shot is FINAL

While we have been emphasizing the obligations of the vendor to deliver work to us at a certain pace, we must not overlook that we on the production end also have certain obligations to the vendor. Prime among them is the obligation to deliver effects elements to

#	Planned Shoot Date	Actual Date Shot	VFX Shot	Unit	Counts Due	Counts Received	NOTES	MARCH	APRIL	MAY	JUNE	JULY	AUGUST	SEPT
							VFX SHOTS DELIVERY SCHEDULE (286 VFX SHOTS)							
							VENDOR #1	7	22	16	55	39	44	6
							VENDOR #2	*	*	*	*	*	11	
							VENDOR #3	*	*	*	*	30	18	5
							VENDOR #4	*	*	*	*	*	*	16
							VENDOR #5	*	*	*	*	*	*	17
							TOTAL	7	22	16	55	69	73	44
	INT. XRAY ROOM:													
1	1/30	1/30	V100.1	1st	2/27	2/27	Animate Blue Target Lts						F	
2	1/30	1/30	V102.1	1st	2/27	3/1	CG Muzzle Flash	F	*	*	*	*	*	
3	1/31	1/31	V103.1	1st	2/28	3/1	"Bulletcam" Shot		F	*	*	*	*	
4	2/1	2/1	V111.1	1st	3/1	2/15	DF/Wire Removal		CBB	*	*	*	*	
5	2/1	2/1	V111.2	1st	3/1	2/15	Moco Split Screen		F	*	*	*	*	
6	2/1	4/20	V111.3	1st	3/1	6/20	Wire Removal					F	*	
7	2/1	2/1	V111.4	1st	3/1	3/1	Wire Removal	F	*	*	*	*	*	
8	2/1	2/1	V111.5	1st	3/1	3/1	Wire Removal	F	*	*	*	*	*	
9	2/2	2/5	V116.1	1st	3/2	3/1	Wire Removal	F	*	*	*	*	*	
10	2/2	2/5	V116.2	1st	3/2	3/1	Wire Removal	F	*	*	*	*	*	
	INT. HOSPITAL :													
11	2/8	2/8	V131.4	1st	3/14	3/9	Wire Removal/Comp	F	*	*	*	*	*	
12	2/14	2/14	V131.3	1st	3/14	3/7	Wire Removal	F	*	*	*	*	*	
	INT/ EXT CHUCK'S HOUSE:													
13	2/20	2/20	V207.1	1st	3/20	3/20	Wire Removal/Roto Debris		F	*	*	*	*	
14	2/20	2/20	V207.2	1st	3/20	3/20	Wire Removal		F	*	*	*	*	
15	2/20	2/20	V207.4	1st	3/20	3/20	Wire Removal		F	*	*	*	*	
	EXT. BEVERLY HILLS HOUSE:													
16	2/23	2/27	V37.1	1st	3/30	3/29	Palm Top/Graphics						F	
17	2/23	2/27	V37.2	1st	3/30	6/7	Palm Top/Graphics						F	
18	2/26	2/26	V30.1	1st	3/30	3/29	Wire Removal		F	*	*	*	*	
19	2/27	2/27	V30.2	1st	3/30	3/29	Wire Removal				F	*	*	
20	2/27	2/27	V30.3	1st	3/30	3/29	CG Muzzle Flash		F	*	*	*	*	
21	2/27	2/27	V30.4	1st	3/30	3/29	CG Muzzle Flash		F	*	*	*	*	

Figure 16.3 An excerpt from a typical VFX shot delivery schedule. This schedule assumes that the project has 286 VFX shots spread among five vendors over seven months.

Help for your budget

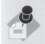 We mentioned previously that the marketing people sometimes ask the VFX Producer to speed up delivery of one or more VFX shots to use in their marketing campaign. When they do, it is quite likely that Marketing would be willing to help pay for the extra work involved in getting the VFX shots finished sooner. If no one else brings this up, the VFX Producer certainly should.

him in a timely manner. The VFX delivery schedule shown in Figure 16.3 takes note of this obligation by including a column for the due dates for counts from Editorial (see column 6 in Figure 16.3).

In the hardball world of feature film production, failure on production's part to live up to these terms could have undesirable consequences. That's because by delivering elements late, you may cause a digital facility to be unable to meet its deadlines on a normal work schedule that their bid was based on. Under these circumstances, the facility's management may feel justified to renegotiate its contract for more money, more time, or both. As you can imagine, producers seldom look favorably on such requests, which could result in a cooling off of—if not an out-and-out rift in—the relationship between producer and vendor.

Another duty we on the production side have is to give the digital facility a prompt response when it submits work for the director's approval. The director has to review and approve interim stages of the visual effects work within a 48- to 72-hour window so that a vendor can proceed to the next stage. With schedule in hand, the VFX Producer can advise the director and editor when they can expect to see shots start arriving at the editing room for review. It may seem like a small thing, but having the assurance that progress is being made on the visual effects in a predictable fashion may help ease the pressures that often take hold during postproduction.

Visual Effects by the Reel

Generally, the negative cutter will want to cut negative in complete reels. By this we mean that after the picture is locked, the negative cutter will confirm the negative only when he or she can complete an entire reel, preferably beginning with reel 1 and working his or her way to the last reel. Though it happens from time to time that a correction or addition has to be made in the middle of an already-cut reel, negative cutters positively loathe having to do that. It is fraught with additional risk of damaging the negative every time they have to handle it, no matter how careful they are.

Most DI facilities also prefer to work on the film a reel at a time, but visual effects shots can be delivered at any time and stored in the facility's I/O (input–output) department. They will then be called up to the DI suite when the reel is being worked on. Just be aware that some DI facilities may charge a storage fee if you deliver a large number of digital files long before they are needed.

As the effects get closer and closer to being finished, we will start paying increasing attention to the reel breakdown, that is, noting which reel any given effects shot falls in. This information allows the VFX Producer to coordinate with a digital facility which shots to push to completion in preference to others. For example, let's say there are 10 visual effects shots in reel 8, and 35 in reel 3. Which ones would you crack the whip on first?

Milestones

Milestones are targets, points during the course of postproduction when an important juncture is reached where the director must approve the work that has been done up to that point before a facility can go on to the next step. We use milestones mainly as checkpoints to make sure that vendors have achieved certain goals by a certain date. They allow the director and VFX Supervisor to check creative progress at specific points, and they help the VFX Producer monitor the budget.

Milestones must be carefully thought through and clearly defined in the contract with vendors. Within broad limits, the milestones will be influenced by the overall postproduction and delivery schedule. There is not much the VFX Producer can do change those, and so everything you do has to fit within that time frame. But given those constraints, it is a good idea to develop the specifics in close cooperation and consultation with the respective vendors because ultimately, every vendor is responsible for meeting the milestones he has agreed to. Each facility will operate under its own unique set of conditions—size of the task, delivery deadline, budget, etc.—that apply specifically to that company, and so the milestones you establish must be tailored to the situation.

Completion of almost any specific and clearly definable task on the part of a vendor can be designated a milestone. For a miniature builder, it could be when he presents a preliminary model made of foamcore of a city street and buildings that he will later build and paint in great detail. For a digital facility, it may be when it has completed a detailed 3D model of an alien character, or when it shows an acceptable animation test, or when the company has received approval of 25% of the shots it was contracted to do.

Two things should be clear. First, milestones are the lifeblood of a project's schedule. Start missing milestones and the project may be facing serious trouble, especially as the final delivery date approaches. Second, milestones are usually closely tied to progress payments spelled out in the contract. If a vendor misses a milestone, he may not get paid until he delivers. In fact, when trouble looms, producers may be tempted to withhold progress payments.

But withholding payments is a double-edged sword, to be wielded only as a last resort and when the vendor's failure to perform is beyond question. If the vendor is firm in his conviction that he has performed according to the terms of the contract, not only in terms of time, but also in terms of quality of the work, he may retaliate and decide to slow down or stop working on the project until he's been paid or may refuse to turn over the negative or digital files of completed shots. Then where does that leave you? So both the production and the vendor have an interest in meeting the deadlines.

This is not to suggest that milestones should be immovable objects. Ours is a business with too many uncertainties and variables. You should make sure that a vendor hits his weekly targets

on average. This does not necessarily mean that each vendor must deliver the *exact* shots that you and he initially scheduled to be finished in any given week. You have to maintain some flexibility. There is nothing wrong with substituting one piece of work for another as long as substitutions don't get to be the rule rather than the exception, and as long as the substituted work fills in other gaps and the vendor keeps "hitting the numbers."

As the VFX Producer you will want to keep close watch on the progress of all shots at the various vendors. If you see a problem on the horizon, such as an unrealistic deadline for the delivery of finals, you need to address the problem as quickly as possible and devise a solution.

When confronted with such a situation, you should determine immediately what the *real* "drop dead" date is for the shots that have fallen behind. You may quickly find that, the postproduction schedule notwithstanding, drop dead dates may actually mean different things to different people. For example, although we're not normally concerned with sound in the visual effects department, we do need to be aware that the sound effects editor may need certain visual effects shots with their exact timing to finalize the sound effects tracks. The shots don't necessarily need to be in their final form as long as the action beats, animation, and exact length have been locked. The VFX Producer should keep in touch with the sound (sometimes even the music) department because changes in the *visual* effects may affect *sound* effects.

SUCCESS STORY
Karin Joy - (I, Robot; The Forbidden Kingdom)

When I started working in the visual effects business, it was pretty much just starting. I had actually no experience in visual effects at all; my background was in advertising, public relations and marketing. I was hired to be Richard Edlund's assistant and help out with marketing at Boss Film Studio. After 6 months there, they felt I would be more valuable...to be trained to be a VFX Producer. Of course I jumped at the chance...it was a fantastic opportunity for me to learn so much about the visual effects industry because Boss Film did it all.

Later I went to Cinesite where I was the Head of Bid Dept. for 3 years. It was a different job, and I was responsible for tracking all of the potential shows, meeting with the teams. This gave me a lot of insight into how long each type of task takes and how much each type of shot should cost and what kind of mark ups are charged, etc. Invaluable information.

I went freelance many years ago to work on the production side. I've worked on I, Robot which we shot in Vancouver; Charlotte's Web which we shot in Melbourne, Australia and most recently The Forbidden Kingdom which took me to Seoul, Korea for post.

I think the most important duties of a VFX Producer are: to keep good relationships with all the companies throughout the world and maintain tabs on which artists are where and who is good at what… having a low key manner and the ability to maintain calm under pressure is key. Having a strong team to support you is really important as it really is a team effort and working with people you trust is important.

Interaction with 1st Unit Editorial

Matching the VFX to the Live Action

Principal photography may go on for weeks, and digital elements may be in the works for many months, but at some point all elements have to come together to produce the final shot. The design of the entire shot or sequence of shots must leave the viewer with the illusion that every element within the shot—live action, backgrounds, creatures, etc.—were all created at the same time on the same piece of film. This requirement gives rise to one of the most critical issues for a visual effects facility: matching the look of various effects elements of a shot to the live action and to one another. We achieve this through the process variously called grading, timing, or color correcting.

Grading in the Digital Age

For decades, grading was a relatively straightforward task that was accomplished mainly with the help of short clips of color workprint, called timing clips or match clips. It was a generally simple and reliable methodology.

The same can't be said of color timing using digital means. More than one VFX Supervisor has told us, "It's a mess." In large part, this is because there are no commonly agreed-on standards when we are dealing with digital files as there were when film clips were the norm. As a result, difficulties abound.

In *theory*, digital grading should be fairly straightforward. After all, the desired end product of the grading process is simply an approved, color-corrected digital file that can be as short as one frame that gets turned over to the visual effects facility as a reference. The steps to get there are also pretty simple. They vary a bit in their details, depending on the original material, but in broad strokes they follow a similar path.

In the case of a project that originates on film, the negative is first telecined, or transferred to tape. At this stage, a colorist at the lab or post-production house—sometimes in consultation with the DP—will give the scenes an overall color correction. This is analogous to a one-light color workprint in film. The footage is then given to Editorial so that it can be ingested into the Avid or other editing system. A copy of the telecined footage should also be given to the VFX facility as a general reference or to enable it to look for alternate takes of a shot, if needed.

Scenes intended for visual effects compositing also go through a separate step, though not necessarily at the same time: they are scanned, digitized, and converted to DPX (Digital Picture Exchange) files. This format is especially well suited for dealing with high-quality digital moving images. Scanning is a more exacting process than telecine. The DPX files are what a digital facility will use to actually

create the visual effects, and as a consequence scanning has to take into account certain technical factors, primarily what film stock was used in principal photography. Because film stocks have widely varying grain and color characteristics, scanners must be set specifically to match different emulsions. The color-corrected DPX files are recorded on a hard drive (firewire drive) or on solid-state memory and are delivered to the visual effects facility.

When starting with HD,[1] the desired visual effects shots are transferred from tape and converted to 10-bit digital DPX files, whereas when starting with *digital* image capture (raw data), there is no need to digitize the footage. The desired takes are simply laid off to a hard drive (firewire drive) that can be given to editorial or the digital facility. Figure 16.4 shows the steps just described in simplified form.

It may also happen that the DP (or sometimes the VFX Supervisor) may independently review the footage and create his own digital files with the color corrections he wants applied to a specific visual effects sequence or shots. He may do this on his laptop, at a laboratory, or at a postproduction facility. Once he is satisfied with the result, he saves the file and turns it over to the visual effects facility to use as a reference. The media on which the files are stored could be as simple as a data DVD or a USB flash drive.

The difficulties with digital grading arise from several causes. On the technology side, there are numerous digital formats, from standard definition to high definition to full-on 24 fps 2K digital capture. The pixel count per frame varies dramatically among formats, and each format has its own characteristics in how it handles digital color space. Each film emulsion has a different grain structure and varies in its ability to capture details in the shadows or retain them in the highlights of the scene. And digitally captured images have no grain at all. Monitors are notorious for varying all over the place, so what the DP sees on his laptop on set will almost certainly differ significantly from what the VFX Supervisor will see on a facility's high-resolution monitor.

On the human side, each DP has his own technique for timing his shots and even these may vary within a film depending on what raw-stock was used during production. Since DPs are ultimately responsible for the look of a show, they are asked to come up with the visual references—in other words, the color timing—that the visual effects are to match. Additional difficulties may arise for the visual effects department when a DP who is shooting in digital, with the best of intentions, alters the *original* digital files in a way that may limit the ability of a visual effects facility to take full advantage of the dynamic range of the original, uncompressed material. Once those files are altered, there is no getting back to the original raw data.

[1] HD (high definition) comes in many formats. We are only concerned here with 24 fps production for feature film projects, in which the standard is 2048 × 1080 pixels of resolution.

Figure 16.4 Simplified workflow for digital grading.

Another factor that contributes to the challenges of color timing visual effects in the digital age is that more and more productions are shooting on digital media, thus bypassing film altogether. Even those being shot on film are now commonly finished as digital intermediates.[2] A consequence of this is that it has become very easy (though costly) to continually tweak the color and density of the digital images until the very last day when the project absolutely, positively has to be delivered.

This is where human nature enters the equation. Many times producers, directors and DPs have vastly different tastes and opinions about how a film should look. But typically it is not until the project enters the digital intermediate suite that they can get a chance to see the finished film in continuity with the color timings the show's colorist has applied.

Two for the Price of One?

The discrepancies in how digital images are viewed by different people in different places have also added to the challenges faced by VFX Supervisors and VFX Producers who must help steer a course that will ultimately result in visual effects graded so that the facility making the digital intermediate can successfully integrate the visual effects shots with the rest of the movie. Remember the color-corrected telecined digital dailies we mentioned a moment ago? Once they get to editorial, they will from then on be viewed as the "standard." People working with that material week after week will get used to that look. So when visual effects shots begin showing up at editorial, the editor and director will expect the shots to match the rest of the footage, even though they may not be the correct color. But if the shots don't match, they will stand out from the rest of the cut sequence in the Avid, and the visual effects facility might have a difficult time getting approval on their shots.

But that is rarely the way the movie will eventually be color timed in the digital intermediate suite where radical changes in the look of a film can be made. This has added a new wrinkle to completing the visual effects: the need to produce two versions, one set of finals for editorial and the studio that matches the telecined dailies and a second version has not been color corrected for use in the DI Suite. Many productions now instruct the digital effects facility to aim for a "neutral grade," that is, a look that maintains good neutral color and density that will give the DI facility maximum flexibility when they work to achieve the artistic vision of a director or DP. Even so, the digital effects house still has to provide a second set of shots to editorial.

For the VFX Producer this dual approach often means having to budget for two deliverable versions of every shot, one neutral and

[2] See Chapter 18 for a discussion of the digital intermediate process.

one color corrected. It also makes the job of tracking shots and the budget more difficult, sometimes to the point where an additional coordinator may have to be hired. Although these issues arise only in postproduction, you must be aware of them from the time you prepare your visual effects budget at the outset.

Negative Scanning; Handling Negative

The VFX Editor is normally in charge of ordering negative needed for visual effects shots to be moved back and forth between the negative cutter and a scanning facility. In the interest of efficiency, a good VFX Editor will see to it that, whenever possible, all the negative pertaining to a given sequence is pulled and sent to be scanned at the same time. This will include not only live-action plates, but also clean background plates and reference plates that may be needed by a digital facility to match the lighting of its computer-generated elements to the live action.

The VFX Editor will also make sure that the negative gets returned to the negative cutter promptly. It is not a good idea to leave negative stored away from the negative cutter's vault any longer than necessary. Losing track of negative is one of the greatest sins a VFX Editor (or anyone in the editorial department, for that matter) can commit. For this reason negative cutters and virtually all facilities are near-fanatical about getting signed receipts every time a can of negative changes hands.

Count Sheets

When the time comes to scan a shot, the VFX Editor has to give the scanning facility a precise count of the frames that he wants scanned. Normally, the 1st Unit editor will turn an approved visual effects sequence over to the VFX Editor, who will take the exact counts of live-action elements from the cut sequence. The VFX Editor will also include the counts for clean background and reference plates on the count sheet. The count sheet (Figure 16.5) should list all of the different layers that need to be scanned, the correct number of frames plus the length of the handles for the head and tail of each shot, and the length of the shot (in frames).

Scanning Sheets

After the count sheets are done, the VFX Editor (or sometimes the VFX Coordinator) will prepare a *scanning sheet* (see Figure 16.6), which indicates the exact key or time code numbers for the "in" and "out" frames of the selected takes. He will also give a list of the selected takes to the negative cutter, who will actually pull the negative to send to the scanning facility. The main difference between a count sheet and a scanning sheet is that the count sheet describes the scope of the visual effects work that has to be done, whereas the scanning sheet is basically a work order for the lab that tells it what shots to scan.

> **Length of handles**
>
> The length of handles may vary from production to production, but the most widely preferred length is 8 frames at both head and tail for a total of 16 frames (1 foot).

VFX EDITORIAL COUNT SHEET

VFX SHOT

FACILITY

DATE

ELEMENT

1 OF 1

SHOT DESCRIPTION

SLATE

CAM ROLL

LAB ROLL

DATE SHOT

PRINTER LIGHTS

CUT KEY NOS

FROM

+

TO

+

CUT LENGTH

96

COMP HANDLES

4

4

HD

TL

COMP LENGTH INC. HANDLES

FRAMES NEEDING WORK

104

SELECT AREA FOR SCANNING

KEY NOS

+

TO

+

HEAD HANDLE

TAIL HANDLE

TOTAL SCAN LENGTH

LINEUP /VFX NOTES

ID NUMBER

Figure 16.5 Simplified editorial count sheet.

Film Scanning Order Sheet

Ticket No. _____

Producer _____

Status _____

Creation Date _____

Title _____

Client Information

Contact _____

Company _____

Address _____

City _____

State / Zip _____

Telephone _____

Cell Phone _____

Fax _____

Email _____

Billing Information

Attn: _____

Bill to _____

Address _____

City _____

State/Zip _____

Telephone _____

Cell _____

Fax _____

Email _____

Shipping Information

Attn: _____

Ship to _____

Address _____

City _____

State / Zip _____

Telephone _____

Cell _____

Fax _____

Email _____

Production Report

Film Stock	Aperature Format	Scan Resolution	Color Correction	Notes
		2K=2048x1556	None	

Output Bit Depth Gamma Tar Style

File Format Total Frame Count

Editorial Report

Editorial Prep _____ hrs.

Add head handle _____ Add tail handle _____

Scanner _____

Emulsion _____

Bar Code _____

No.	Roll No.	Frame Start	Frame Stop	Length	Keycode Start	Keycode Stop	Description	Filename Prefix

Figure 16.6 This scanning request sheet specifies the exact in and out frames of every shot that has to be scanned. The information will then be used by a line-up person at the scanning facility to assemble the negative for scanning.

A Word about Counts and Time Codes

Not so many years ago, dealing with film footage and frame counts was relatively straightforward. Motion picture negative film has key numbers along one edge that you can actually *see* when holding the film to the light. When you make a workprint, these key numbers are copied onto the print. In the days when visual effects were composited on optical printers, a new dupe negative of the composited shot was produced. Although the dupe negative carried a different set of key numbers from the original shots, still, it was a visible number.

In today's digital world, key numbers are converted during the telecine process into time code that can be read electronically and can also be displayed visually on viewing materials, such as DVDs of your dailies. This is referred to as visible time code.

Scan Request

VFX SCAN BATCH # ORDER DATE:

Batch	Scan #	Lab Roll	CamRoll	Slate	File Name	Scan Format	Res	3 perf Key Codes (includes handle)	Length
053	1461	199631	RB77	R94AD_1B	da003_0550_fg1_29_v001	Cin_10bit FULL AP	2k	EB 39 8429-9647+16-3 / 9650+19-3	68
Vendor:	Framestore			Scan Notes:	Reshoots scanned w/24f handle				

Batch	Scan #	Lab Roll	CamRoll	Slate	File Name	Scan Format	Res	3 perf Key Codes (includes handle)	Length
053	1462	199631	RB77	R94AC_1B	da003_0560_fg1_29_v001	Cin_10bit FULL AP	2k	EB 39 8429-9276+02-1 / 9279+04-1	67
Vendor:	Framestore			Scan Notes:	Reshoots scanned w/24f handle				

Batch	Scan #	Lab Roll	CamRoll	Slate	File Name	Scan Format	Res	3 perf Key Codes (includes handle)	Length
053	1463	199628	RA96	R94AK_2A	da003_0570_bg1_29_v001	Cin_10bit FULL AP	2k	EB 11 9669-7822+16-2 / 7826+02-3	72
Vendor:	Framestore			Scan Notes:	Reshoots scanned w/24f handle				

Batch	Scan #	Lab Roll	CamRoll	Slate	File Name	Scan Format	Res	3 perf Key Codes (includes handle)	Length
053	1464	199634	RB81	R94AL_2B	da003_0580_bg1_29_v001	Cin_10bit FULL AP	2k	EB 11 9670-8439+01-2 / 8444+14-1	121
Vendor:	Framestore			Scan Notes:	Reshoots scanned w/24f handle				

Batch	Scan #	Lab Roll	CamRoll	Slate	File Name	Scan Format	Res	3 perf Key Codes (includes handle)	Length
053	1465	199628	RA97	R94AN_2A	da003_0590_bg1_29_v001	Cin_10bit FULL AP	2k	EB 11 9670-7793+00-3 / 7796+10-3	75
Vendor:	Framestore			Scan Notes:	Reshoots scanned w/24f handle				

Batch	Scan #	Tape #	CamRoll	Slate	File Name	Scan Format	Res	Timecodes (includes handle)	Length
054	1466	1698	B501	94A_AG_2B	da001_0010_fg1_29_v001	HD_RGB_444_LOG	HD	18:09:28:13 / 18:09:31:17	77
Vendor:	Framestore			Scan Notes:					

Batch	Scan #	Tape #	CamRoll	Slate	File Name	Scan Format	Res	Timecodes (includes handle)	Length
054	1467	1696	A474	94A_AG_3A	da001_0020_fg1_29_v001	HD_RGB_444_LOG	HD	16:08:14:15 / 16:08:17:12	70
Vendor:	Framestore			Scan Notes:					

Figure 16.7 Scanning sheet for both film and digital images. Note: The first 5 shots list standard film key code and the last 2 shots list time code. (Image courtesy of Ed Marsh, VFX Editor)

Instead of feet and frames, time code keeps track of your filmed material by counting hours, minutes, seconds, and frames.

When the VFX Editor goes to prepare a count sheet for the negative cutter, he or she will normally use key numbers to make sure that the negative clips pulled will match the key numbers given for scanning on the scanning sheet.

We have to deal with counts whenever there are film elements involved, whether they come from the 1st or 2nd Unit or one of our visual effects units. A digital element doesn't have key numbers until it is output on film, though we always have to deal with frame numbers so we know how long a shot has to be.

In 3D CG, you have to specify how many frames of handle the vendor is obliged to animate. For some directors, you'll want the whole eight; some vendors will balk at that and only animate one or two frames beyond the actual cut because it can be quite costly to animate additional frames. It has to be clear from the outset so vendors know how many frames to bid on.

Scanning the Negative

Scanning (or inputting) is the process by which the visible analog image (that is, what we think of as a traditional image composed of continuous tones of gray and infinitely varying colors) that you see on film is converted into a digital file of zeros and ones. Every filmed element must first be scanned and converted to a digital format before it can be worked on in a computer.

Scanning is done with a light-sensitive chip called a charge coupled device (CCD) that looks at almost two and a half million points on a standard Academy 35-mm frame, senses the color and brightness of the light at each point, and converts that into a packet of digital data.

Scanning can be done at various resolutions, but 2K is currently the most common. By this we mean that the CCD "reads" the color and density of approximately 2,000 points horizontally across the width of a full 35-mm frame and approximately 1,500 points vertically (see Appendix C for the exact numbers). This resolution has been found to be satisfactory for standard film projection in movie theaters.

As the technology continues to improve, however, 4K resolution will surely become more common in 35-mm film work.[3] This

[3]We emphasize 35-mm film work here because 4K and even higher resolutions have been common in large-format films. It's easy to understand why: If you double the width of an image, but want to keep the sharpness the same, you have to double the number of points, or pixels, that the viewer sees. Otherwise you are simply enlarging the pixels. It's like making a 4 × 6-inch photographic print from your vacation snapshot, and then liking it so well that you decide to enlarge it to 8 × 10 inches to hang on the wall. Suddenly, the photographic grain that wasn't a problem on the 4 × 6-inch print looks huge.

represents not just a doubling, but effectively a *quadrupling* of the resolution over 2K. It takes a fairly sharp eye to tell the difference, but many leaders in the industry feel that even average viewers may be subliminally sensitive to the difference between 2K and 4K resolution. Normally today when shooting film or digitals formats you would give to the vendors 10-bit DPX files on a firewire drive.

Recording the Final Image

Recording (or outputting) is the final step in the process of creating a visual effects shot. This is where the digital file that represents each frame of an effects shot is converted from a digital to an analog medium. In other words, it goes from a computer (which "thinks" in zeros and ones) back out to film (which shows you an actual image you can see). Normally, the digital files are output to a new negative, which is then cut into the negative of the completed show.

Film outputs today are done with CRT or laser film recorders. In brief, what happens is that the digital information represents the final rendered image of your shots which is read by a computer in the laser recorder. In turn, the recorder's software directs a laser beam to expose a certain point on a piece of film at a specific color and density, repeating the process for about two and a half million points…per frame.[4]

Keeping up with Editorial Changes

If you are familiar with nonlinear editing systems like Avid, Final Cut Pro, or Adobe Premier, you will know how easy it is to make changes in the cut of a film. The ease with which such changes can be made on modern editing systems can pose a major challenge to VFX Editors and, indeed, to the VFX Supervisor and VFX Producer as well. In the heat of foreshortened postproduction schedules (as most of them are) it is easy for the 1st Unit editor to become so involved in his work that he may forget to advise the VFX Editor when he or the director have made a change in a visual effects shot.

Perhaps the editor shortened the shot by three frames. Well, that's not a big deal, because that's within the section of negative that was scanned. But what if he *lengthened* the shot by 19 frames? Or what if the director decided that he now likes the performance of Take 4 better than Take 2? Any of these actions can happen—and be reversed again later—with a few keystrokes. The VFX Editor therefore has to keep close tabs on 1st Unit editorial. He should not rely on the editor or assistant editor to keep him informed of changes. Instead, he needs to ask frequently whether

[4]The number given applies to the 35-mm Academy aperture format. Numbers are proportionately higher for full aperture, Super-35, and larger formats.

changes were made to any visual effects shots, or sit in with the editor when he or she is working on a visual effects sequence. Alternatively the VFX Editor can review the cut on his own and note the places where changes have been made by the 1st Unit editor.

First Line of Defense

In common practice, the VFX Editor is the one who first receives shots from a visual effects facility. As such, he is often the first person to see the work when it is submitted by the facility, and is therefore in an excellent position to alert the VFX Supervisor or VFX Producer to problems in a shot before it's turned over to the editor or director for review. This gives the supervisor a chance to make corrections and send it back to the vendor for further work before he deems it good enough to show to the director (or he may decide to show the shot, problems and all, to the director and editor anyway to get their feedback before sending the shot back to the effects facility for further work).

Another—very practical—reason for paying close attention to shots when they come in is that a shot may occasionally come up short. It can happen even with the best of facilities. Maybe they didn't add handles to the shot, or perhaps an artist got the count wrong and didn't animate the last frame or two. In any case, the VFX Editor must always check for correct length. You don't want to send the editor a shot that's too short only to have him (or worse, the director) catch the mistake. It makes the visual effects department look careless at best or downright incompetent at worst.

Temps

Temps (an abbreviation for temporary) are preliminary composites of visual effects shots that are produced periodically throughout the postproduction period. They are a useful, even essential, tool for the key creative people on the project to check the progress of shots. The director can check animation, timing, composition, and other attributes of shots and use this information to give feedback to the VFX Supervisor and digital artists. The editor finds temps useful as placeholders, replacing the "Scene Missing" card and allowing him and the director to see how shots fit into a sequence. And the sound effects designer will get inspiration for his sound track.

Temps can take several forms. Even while principal photography is still ongoing, the editor may put together temps on the Avid or other editing system from elements that have been shot and digitized. As CG elements start to take shape, we may ask a digital facility to start providing temps in the form of HD Quicktime movies that can then be imported into the Avid.

Digital previews of films before a recruited audience have become fairly common in recent years. The projection format is usually HD (1920 × 1080 resolution). Sometimes an Avid Nitris system can be brought into editorial so that the visual effects shots can be downloaded from an FTP site, temps can be made and then cut into the film, and a new HD Master can be created. Making temps in the editorial department has the advantage of allowing facilities to continue working on your visual effects shots, instead of interrupting work to make temps. Since temps are the responsibility of the visual effects department, rental costs for the Nitris system come out of your budget.

When a shot is judged to be in near-final form, it may be recorded, or output, to film for the first time, still at lower-than-final resolution, usually in what is referred to as 1K resolution. This merely indicates that the film image will consist of approximately 1,014 pixels across and 778 pixels down for a full aperture frame. The main reason for delaying outputting a shot to film is that this is a more costly step than recording it to the standard video format. Though still considered a temp, it has the virtue of being on film which, when projected, allows the creative team to judge the work in near-final form.

In current practice, composites that are intended to be final are recorded at 2K resolution, which yields roughly double the number of vertical lines per image. It's very likely that resolution of the final image will increase to 3K or 4K in coming years.

What the VFX Producer needs to keep in mind is that you need to budget for a certain number of temps. At the very least, we would recommend that your budget should provide for one or two video temps (for editorial) and one film temp at 1K resolution, in addition to the two final film record-outs at the full 2K resolution. We should also note that most digital facilities will produce temporary test composites on their own as shots gets closer and closer to their final form.

VFX and the Marketing Department

One department that is sometimes overlooked in the heat of getting the visual effects done is marketing, the people whose job it is to promote the film. But experienced VFX Producers and VFX Supervisors are aware of the needs of marketing and will offer their help in promoting the project through the use of temps. Studios will happily use temps (as long as they are of acceptable quality) for previews, promotions, focus groups, or conventions, or to show to visiting journalists who will hopefully write nice things about the project. Depending on the anticipated prestige of the film, marketing (through the producer or the studio) may also ask the visual effects department to put a few especially spectacular shots on a fast track to completion. You may

even want to take the initiative here and approach the producer to discuss the idea. It not only helps the production all around; it also may prevent a last-minute request for visual effects shots from the marketing people who suddenly want to put some of your shots in the trailer. Though this may affect the shot delivery schedule to a degree, it is well worth doing. And by the way, try to get marketing to help pay for the work.

Status Reports

As work on the visual effects progresses, the VFX Producer will be asked to provide status reports to various individuals. They are one of the quickest and most effective ways to communicate to everyone who needs to know how the effects are coming along. There are two types of status reports, external and internal. Each type has its own readership and serves a specific function.

External Status Reports

This type of status report is usually required by the studio and by the completion bond company. In part, the *external* status report serves as a bit of a public relations document while also keeping the brass informed about how the effects are coming along. *It must always be factual.* The status report is not the place to "game the numbers" or offer opinions.

We should acknowledge here that many upper-level executives, producers, directors, and anyone else with real responsibility in completing a picture on time and on budget may get very nervous about visual effects. This happens not just because visual effects are expensive or the fate of the movie may depend on them, but also because many executives don't really understand what it takes to accomplish them.

One big factor that contributes to these fears is that in effects work, nothing seems to happen for a long time, and that makes people edgy. It's not like principal photography where you go to dailies and see the previous day's work. The outward appearance often is that principal photography ends, the director and editor are progressing from assembly to rough cut to director's cut in admirable fashion…but where are the effects? To those who have not been through the process, every week that passes while the ominous "Scene Missing" slug or previs remains in the cut is cause for alarm.

Unfortunately, visual effects disasters—where the effects look awful, or fall behind schedule, or go way over budget—do happen from time to time. Their infamy spreads throughout the industry, sensitizing everyone to the problem. Fortunately, they are rare. The reality is that it often does take many weeks or even months to reach the point where effects shots can be composited and cut into the film. But the creative work is going on behind the scenes

PROJECT NAME HERE

WEEKLY SHOT SUMMARY STATUS REPORT
W/E6/5/2009

VENDOR	TOTAL SHOTS	FINALS	PENDING APPROVAL	CBB	REMAINING SHOTS
Vendor #1	175	116	12	1	46
Vendor #2	137	62	16	2	57
Vendor #3	56	25	5	1	25
Vendor #4	32	16	4	0	12
Totals	**400**	**219**	**37**	**4**	**140**

400	Total number of shots
219	Finals
37	Internal Finals, pending approval
4	CBB's
140	Total remaining shots

Figure 16.8 This is the type of external status report that might be distributed to a studio, to production executives, or a film guarantor company.

as the effects elements make their way through a facility's pipeline and eventually come together in compositing.

In practice, the VFX Producer or the VFX Coordinator can pull the data together for the status reports. When submitting the report, the VFX Producer should also flesh it out with a memo that summarizes the overall situation but sticks to the facts.

The external status report should summarize the main items, though you don't necessarily have to list all of these:

- Total VFX shots
- Shots in progress
- Shots ready to be screened for the director
- Shots on hold
- Shots added this week
- Shots omitted this week
- Shots completed this week

- Shots still to be delivered
- A budget summary (sometimes included, though budget reviews are best left to separate reports)

A typical memo to accompany a weekly external status report might look something like Figure 16.8.

Internal Status Reports

Whereas the external status report communicates information about the effects from the visual effects department *outward*, internal reports are more of a management tool for the visual effects department's and producer's own use. As such, the internal status report gets more into the nitty-gritty of daily and weekly operational issues, pulling together information from outside vendors as well as from the department's own operations.

To be useful, the data for the internal status report should be faithfully maintained and updated several times a week. This is where a good VFX Coordinator will prove to be invaluable. It takes great diligence to stay on top of the information, especially on larger shows where several vendors may be working on scores or hundreds of shots, and where new shots in various stages of completion are coming into editorial daily, ready to be cut into the picture.

Reliable information from all vendors is crucial. For this reason, each vendor should be contractually required to submit weekly status reports of its own. The reports should let the VFX Producer know where the vendors stand at any given time. The vendors' reports should provide such details as

- due dates for certain milestones for each shot (e.g., due dates for previs, video temp, first 1K film output, and the final 2K film output); the milestones will have been set during contract negotiations with each vendor
- actual dates when a given milestone was reached
- a summary of the number of shots at any given stage of work; this can be as simple as a checkmark or X in the appropriate box on a chart and a count of the totals
- budget status, the vendor's assessment on where it stands relative to the budget (i.e., how much the vendor has been paid to date, and how much is still owed by the production)

The VFX Producer will also need to know what was actually done with work that vendors submitted after the editorial department received it. How many shots did the VFX Editor get that week? How many got cut into the picture? Did the director see them? Approve them? Reject them? All these items of information go toward maintaining good management controls over the project.

As you can surmise, there is a lot of data to be digested and understood, and to do this effectively a VFX Producer can use a database, spreadsheet, or some other display format so that the data can be evaluated quickly. Some production offices use large

wallboards that list all visual effects shots and display their status on a grid. Others pin up storyboards and use color-coded self-adhesive dots to designate every shot's progress. Whatever system you use, make sure it is clear, simple, and KEPT CURRENT.

SUCCESS STORY

Kerry Shea - *(Sid the Science Kid; Madagascar)*

I started my career working in traditional live-action low-budget films in Salt Lake City, Utah as a production coordinator and production supervisor. I moved to Los Angeles, and one day received a call asking if I would come interview for a position as a VFX Coordinator for 20th Century Fox. I had never worked in visual effects before that, but I knew production, so with an open mind and an excellent mentor I began my career in visual effects. I learned everything on the job and continued learning by working at VFX facilities and directly with artists.

The most important duties are laying out the big picture in terms of schedule and budget. You have to be in tune with the director and the VFX Supervisor in order to help determine how and where to spend the money and how to inspire creativity.

A VFX Producer should have the ability to remain calm… the ability to focus… the ability to listen…the ability to laugh.

You CANNOT do a project without a VFX Database and Bible. The show I am presently working on already has over 1000 assets and without a way to break down and track the work—it is impossible to quantify the budget.

CHANGES AND APPROVALS

"The three scariest words in visual effects: 'Can't you just…'"
—Charles Finance

You don't have to be a cynic to recognize that, in spite of everyone's best-declared intentions, changes are inevitable in the visual effects line up as postproduction progresses. Everyone secretly understands that from the very beginning, although it is the rare producer who will acknowledge it at the outset. In fact, it's not unusual for the number of visual effects shots to double or triple.[1]

The most common reason for this is that, as the film takes shape, directors and editors realize that they need additional shots—or have to revise existing ones—to tell the story properly, to make it more exciting, or to clarify a story point that might otherwise get lost. But it would be misleading to lay the blame mainly on directors or editors. Requests for changes may also come from the producer or studio executives when they see the director's cut or for any number of other reasons.

Changes have the potential of severely disrupting the shot delivery schedule as well as blasting a huge hole in the visual effects budget. Because changes frequently come at a time when the pressure to get the film finished is huge while most of the money has been spent, this can turn into a very contentious time for the participants. Just picture this very credible scenario: It's one month before the film has to be delivered. The director wants ten more 3D CG shots, the digital facilities you are working with are already maxed out, and the studio is digging in its heels about paying for the extra work.

One of the VFX Producer's critical tasks in postproduction, therefore, is to manage and keep track of the changes. It can be a delicate position for the VFX Producer to be in because of the competing interests. You have to contend with at least three

[1] In the 2006 hit *Casino Royale,* the VFX count is reported to have increased from about 80 digital shots to about 570 (page 54, Cinefex no. 108, January 2007).

297

major players: the director (who will insist that the changes will make the picture a blockbuster), the studio (which will plead poverty), and the visual effects facility (which will complain about overages). In actuality, most changes are handled calmly and professionally in the normal course of everyday business.

Changes and Approvals

Perhaps the most delicate part of managing changes is in knowing how to deal with the director. This is where what might be called "foresight of experience" can come to the VFX Producer's aid. The first rule is that you never say "No" when the director wants additional shots, regardless of whether the budget is already under stress or not. Better to acknowledge the request, get the details of what the director wants, and then diplomatically raise the question of how the extra work is going to be paid for. Also, as we advocated elsewhere, you should have built a modest contingency into your Movie Magic Budget when you first prepared the visual effects budget, which may help you to accommodate the director's additions or changes up to a point.

However, when you have burned through your contingency and when there is basically no money left in the budget, the VFX Producer can approach the overage issue by exploring with the director whether there is another shot that can be eliminated or simplified, thereby saving some money. You may also find that you didn't use money in another account that you can now apply here. Obviously this requires you to maintain good budgetary controls and records that are updated regularly.

If neither of the above alternatives works out, the next step is for the VFX Producer to go to the producer and lay the situation before him. Armed with the status reports that you have supplied him regularly, the producer will know how things stand with the effects and will be able to give you direction on how to proceed. The producer almost always has a contingency in *his* budget that allows for overages during postproduction, though the producer may not be authorized to dip into the contingency until he has consulted with executives at the studio or, in the case of independent films, with the investors or bond company. Ultimately it is his responsibility to approve the director's requests.

Changes come in all shapes and sizes, from minor ones that involve a few hundred dollars, to wholesale revisions of a significant body of work. And this is where one of the curious traits of human nature may intrude: Producers always seem to expect that vendors will do the additional work for free (don't laugh; it happens all the time). What's more, if the change order calls for eliminating a shot, producers routinely assume that they will get credit for the entire cost of that shot that was earlier agreed on.

The VFX Producer will have to make the producer aware that this is not always true.

Here's why. If a portion of the original work you contracted for is simplified or eliminated, the vendor *should* give the producer a credit for the uncompleted work. Generally, there will be no argument about that. The question is, how much? The factor that's often ignored is that a vendor will already have incurred some costs, even if he hasn't touched the shot at all. There are several possible reasons for this. For one, every vendor has facility overhead that must be amortized over a body of work. For another, the vendor may have spent many thousands of dollars building a 3D model of a creature or a digital environment that appears in many shots. Or perhaps he hired a software engineer to develop an important bit of computer code that will control a certain characteristic of a digital character that appears throughout a sequence. Whatever the reason, the production will almost never get a 100% credit for a canceled shot unless no work was done.

Typically, most smaller digital facilities will bend over backward to accommodate the producer at this stage of postproduction, even to the point where they may take a financial hit. That's simply the reality of the economic power of a studio or production company at work. Producers may cajole, wheedle, or even argue with a vendor to get them to agree to their terms, and so vendors, being reluctant to offend their clients by playing hardball on changes, often reluctantly agree to do what's necessary to keep a producer or director happy. Large visual effects companies, though not entirely immune to such tactics on the part of producers, have a better chance of at least recovering their costs.

Change Orders

We deal with changes through change orders. Change orders are an important management tool for the VFX Producer. They are the essential paper trail through which the VFX Producer lets the key players know what they are getting and how much it is going to cost (the schedule is a whole different issue), and they serve as a means for the VFX Producer to manage the process internally.

You can easily design your own change order form, depending on the needs of your project and the software you are most comfortable with. The form we present in Figure 17.1 (designed to work with Microsoft Excel) touches on all the basic bits of information you will need to keep track of. The most important information is:

- The person who asked for the change
- A description of the change(s) in sufficient detail to let people know what's expected
- All the salient budget figures listed in such a way that subtotals and totals are automatically calculated by the program you are using

- The original price of the shot
- The new (renegotiated) price
- The difference (could be up or down), which becomes the amount of the change order
- Optionally, a new overall budget total
- The signatures of individuals authorized to sign for the parties

In a real work situation, you will sometimes find that change orders start out as hastily arranged verbal agreements because they tend to happen when everyone is under time pressure. Your colleagues on the production feel that you can ill afford to wait a day or two till you get permission from everyone who has to approve the expenditure. This is a slippery slope. Any verbal agreement between the VFX Producer and the vendor's management should be followed up by a written change order as soon as possible. If you are working for one of the larger studios, in fact, the studio will not allow you to go ahead with any additional work until the studio representative has signed the change order.

Once the VFX Producer has a handle on what needs to be done, she negotiates with the appropriate vendor to settle on a price for the work and a revised schedule.

When the change orders are duly signed, make sure that everyone concerned gets copies. That would include the producer, the visual effects facility/vendor, the production accountant, the studio, and (when applicable) the completion bond company.

You will also want to keep your own budget up to date. At least once a week, consolidate all change orders for the week, enter them in your budget file, and recalculate the budget changes. It is best not to fall behind in your record keeping.

Approvals

> *"Visual effects are never finished; they're abandoned."*
> —Anonymous

Whether you subscribe to this quote or not, it's a certainty that every shot must be approved or omitted sooner or later. Those which are approved will make it into the film.

We have chosen to address the topic of approvals in the context of postproduction. Approvals, of course, are necessary throughout production, from storyboards to previs to miniature design till the last composite is finished. But the basic principles remain the same: Whenever you work with an outside vendor you must establish milestones, get the director to review the work in a timely fashion, and get his approval in writing.

Who Does the Approving?

On a feature film it is mainly the director who has the final say. That fact notwithstanding, final approval is something of

CHANGE ORDER NO.15 – VENDOR TBD

Production:	***False Horizon***
	Date: **7/22/09**

Shot Number:	**See Below**
Requested By:	**Chuck Finance**
Type of Change:	**See Attached VFX Bible Sheets**

Description of Change:

V15.1 - Omit Shot

V89.6 - Post speed change, additional wire removal

V103.1 – New Shot: 3D Matte painting (space colony enhancement)

V111.1 - Additional wire removal, plus scanning of clean plate

OVERAGE:

V89.6 -	$ 6,500
V103.1 -	$ 20,500
V111.1 -	$ 3,500

SAVINGS:

V15.1 -	($4,750)

Total Overage	**$30,500**
Total	($ 4,750)
Total Savings (Overage)	**($25,750)**
Original Agreement	$3,000,000
Previous Overages	$35,000
Previous Savings	$ 5,000
Amount of this Change Order	**$25,750**
Revised Total	**$3,055,750**

APPROVED BY:

Studio Representative: Signature: _____ Date:_____

Picture Representative: Signature: _____ Date:_____

Vendor Representative: Signature: _____ Date:_____

Figure 17.1 A typical change order.

a collaborative act: Not only the director, but also the producer, editor, and VFX Supervisor may influence the decision. Much depends on the mix of personalities and their relationships.

Even before the director gets to say yea or nay, several other people will have reviewed a shot before it reaches him. This serves as an effective screening system so that the work is in sufficiently good shape to present to the director. Generally the VFX Supervisor should be the one to decide whether a shot or an element should be shown to the director. This is not always an easy decision. If the VFX Supervisor shows work that is still in pretty rough shape, the director may not be able to judge it fairly and may focus instead on flaws that are obvious to everyone. This tends to waste time, may cause annoyance, and may reduce the effectiveness of any feedback the visual effects team is hoping to get.

Yet if the supervisor allows the work to progress too far before getting the director's reaction, a shot may have gone off in the wrong direction. Bringing it back on course will take precious time that would be better spent making real progress on other shots. It will also raise the potentially touchy issue of who will pay for the mid-course correction. The VFX Producer shouldn't hesitate to step in and urge the VFX Supervisor and director to review progress of a vendor's work when she judges it to be appropriate.

It's one thing to review a shot at a digital workstation, and quite another to see it cut into the picture. For this reason, most directors will give final approvals only after a shot has been cut into the sequence. Only then can everyone judge whether the shot "feels right" in terms of action, texture, color, and density.

Turn-Around Time

Approvals often go hand in hand with milestones. As we pointed out, a vendor's contract will obligate him to deliver work in stages—the milestones—by a certain date. Conversely, the contract will obligate the *production* (normally the director) to promptly respond to and approve the vendor's work. This response, or turn-around, time must also be established in the vendor's contract, and it is usually fairly tight. The most commonly stipulated turn-around time in effects contracts is either 48 or 72 hours after the work is submitted for approval. The reason for imposing strict limits should be self-evident: If the director delays reviewing work submitted to him, he slows down progress and may jeopardize the vendor's delivery schedule.

In practice, most digital facilities will cut the director some slack as long as they don't fall behind because of his tardiness on the rest of their work. But we should not count on it. If a vendor takes a particularly hard-nosed stance on deadlines, it can lead to a deteriorating relationship between the parties. So it is always a good idea for the VFX Producer (who is usually the one who has

to keep track of the submissions) to see to it that the spirit—if not the letter—of the contract is honored.

Clarifying the Term "Submitted"

To keep misunderstandings about response times to a minimum, the definition of the term "submitted" must be very clear; different people can easily interpret it differently. Let's take the example of a shot that's been in the works for many weeks. The delivery deadline is fast approaching, and the digital facility needs approval from the director of the animation of a 3D CG character. Complicating things is that the director is editing in a different country so he must get someone else to download the visual effects shots from an FTP site for him to review. Then notes can be emailed to the VFX Supervisor and VFX Producer unless a video conferencing exchange can be set up and feedback can then be given directly.

Logic might dictate that the approval period begins when the director is actually in a position to review the work and that should be when the vendor has delivered the work, be it via FTP site or DVD. Then the director has 48 to 72 hours to respond. But unless such contingencies are covered in the contract, disagreements and serious financial repercussions can arise, as indeed they have in the past.

It's really a two-sided coin for vendors: They *can't* move forward until they get approval to do so, and they (usually) *won't* move forward until they get paid. So it's in the interest of both the production and the vendor for the director to review any work that is submitted to him as soon as possible. .

The Importance of Written Approvals

Why should we be so concerned with getting a director to sign off on work as it goes along? Mainly for two reasons. First, visual effects is a *creative* process: subjective, dynamic, and sometimes fleeting. What looks good to you one day may not look so good a week later. Let's face it: People change their minds. Second, it is also an *economic* process: costly, time-consuming, and sometimes contentious. If something goes awry, someone will have to pay to set it right. Typically, the longer we wait to have things approved, the more expensive it becomes to change them.

To put this in more concrete terms, let's say your director reviewed the primary animation two weeks ago of a 3D CG dragon swooping out of the sky and flapping its wings as it launches a fiery blast at the parapet of a castle occupied by archers launching arrows at the beast. The arrows bounce off its tough hide. The director liked what he saw and approved the animation. Following the approval, the digital facility's artists continued working on the shot, incorporating a couple of small changes the director asked for in the dragon's flight path.

To show that he approved the animation of the shot, the director signed an approval form, such as the one shown in Figure 17.2, or allowed the VFX Supervisor to sign for him once they both agreed that the shot was final. These approval forms are an essential paper trail that allows the VFX Producer to maintain a history of a body of work, be it individual shots as in our example, or the design of an airplane hangar miniature. Approval forms should be fairly simple; you can easily design your own to fit your project.

It's now two weeks and $15,000 later. The vendor submits the same shot again, having incorporated the changes the director asked for and having refined the secondary animation. Everything looks great…except the director now thinks the dragon's wings flap too fast. "I want them to flap about 20% slower," he says. Well, you can imagine the worried look from the vendors.

There are a couple of possible outcomes to this dilemma. You can politely remind the director that he signed off on the animation two weeks prior. He may remember having done so and relent, in which case the digital facility can move on with the work. Or he may insist that the animation be changed anyway, and chances are that his wish will be fulfilled. If that happens, the VFX Producer has little choice but to discuss the situation with the producer. If he supports the director's demand, the approval form the director signed earlier becomes the basis for negotiating any adjustments in price with the digital facility.

The VFX Supervisor also needs to remain intimately involved in this process. He, along with the director, should approve the work as it progresses. As we stated earlier, the VFX Supervisor should act as the gatekeeper who decides when a shot is ready to show the director. He will review a particular shot many more times than the director, tweaking it until it is ready to be shown. If further changes are to be made, he will work intimately with the director to accomplish this as effectively as possible.

Approval Forms

Approval forms need not be complicated nor long. You can easily construct your own to suit your project. Figure 17.2 contains pretty much all the information you will need to get the job done. Aside from the standard information identifying the show and the shot, the most important items are the date (so everyone will know when the director looked at the work), and the disposition of the shot (whether it was approved or, if not, what exactly needed to be changed). Including a storyboard or low-resolution still picture of the shot for reference is helpful, but not necessary.

When the Job Goes South

Successful, timely delivery of all shots comes down to accurately tracking the progress of shots and taking action when

Figure 17.2 An example of an approval sheet for multiple shots that the Editor and VFX Supervisor can approve.

things start to go off-course. Unfortunately, despite everyone's best efforts, sometimes things can start to go wrong with a project. A vendor falls behind in delivering shots, or—even more serious—the work is simply not acceptable. What do you do then?

First, the VFX Producer has to identify the problem with the vendor. She has to get to the bottom of why shots are late. Does the vendor have too much work to do? Is there other work in house that is consuming precious resources? Or is the director demanding too many changes?

Among the remedies might be to devise a new delivery schedule with the vendor. Perhaps shots can be moved around on the schedule, some being moved up, while other, more difficult ones might be pushed back. The VFX Producer may also have to apply pressure to get the vendor to hire additional artists or insist that the existing staff work longer hours. In general, it's best to give the vendor every opportunity to finish the work he was hired to do.

But release dates are rarely movable. The effects have to be finished by a certain date. End of story. If a vendor claims that he does not have the money to complete the work, this can lead to a serious conflict that must be resolved quickly. The studio or production company could opt to agree to pay the vendor more money, or could choose to take a portion of the work and move it elsewhere, an unpleasant prospect at best.

The situation is even stickier when the vendor's work is subpar. Now the issues are not just time and money, but also intangibles such as creativity, taste, and judgment…not to mention egos. When faced with this situation, the VFX Producer—with the help of the VFX Supervisor and director—needs to find another vendor, fast.[2]

These are likely to be stressful times for everyone involved. The director sees his vision going awry and will be pushing the producer to change vendors. The vendor does not want to lose the work and will be trying hard to convince the director that he is capable of an artistic mid-course correction. And both the VFX Supervisor and VFX Producer will be under the gun, partly because they had a hand in choosing or at least approving the now-deficient vendor, and partly because they must now scramble to get the work done elsewhere.

When this happens, the VFX Producer must take decisive action. The first priority is to secure the services of another digital facility. This is not likely to be easy because, in a way, it's like starting the selection process all over again. But now that it's several months after the project got underway, the mix of potential candidates will be different. A facility that might have been a good prospect in September is maxed out with work in March. And since the parting of the ways came over "creative differences," the director will need to take the time to vet several facilities before settling on the one that everyone thinks can rescue the project. Once you have decided on a facility, it will take time for it to get up to speed with what the director wants. All in all, it's a risky proposition that no one likes to face.

The VFX Producer must also deal with the economic aspects of the change in vendors. No one involved in this situation will be happy about it, and so negotiations for a financial settlement may be somewhat tense. At times like these, it is important for the VFX Producer to remain calm and fair-minded. If your legal department has done its job properly, there will be provisions in your contract with the vendor that allow for this eventuality. In other words, there should be a mechanism to help the vendor and you determine how much of a rebate you will receive for work the vendor will not be doing.

Even assuming that the vendor had not begun work on all shots he was contracted to do, your production will not get 100% credit for those shots. The vendor will have certain development and overhead costs that he was amortizing across the entire slate of shots, and he will expect to charge those to your budget. He will also argue forcefully that he did the work in good faith, and that he is not at fault (in breach of contract, in legalese) for a difference in judgment about the quality of the work.

[2]See Chapter 19 for a discussion of legal remedies.

The upshot is that arriving at a satisfactory settlement is not an exact science. Both you and the vendor will have to negotiate in good faith to achieve that goal. Fortunately, it is only in rare cases that a mutually satisfactory compromise can't be reached, resulting in legal action. By then it will be the attorneys, not the VFX Producer, who'll be doing the talking.

SUCCESS STORY
Josh Jaggars - (*2012*; *Hancock*)

I…started freelancing as a production assistant on commercials and TV movies. I was lucky enough to start my film career working as a PA on *The Usual Suspects*…. In 1996 I was given the opportunity to produce my first dozen shots for *From Dusk till Dawn* while at VIFX. Over the next few years, I served as a facility producer, before moving to the production side as a digital producer. By 2004, I moved on to VFX produce an entire feature.

I believe one of the most overlooked job aspects in producing visual effects is managing expectations. Being able to manage the studio's expectations as well as those of your VFX Supervisors and filmmakers is key. Being honest with delivery dates and the quality of works-in-progress is important. Keeping people apprised of the continuing changing landscape (both during shooting and postproduction) is critical. Having a clear line of communication with the filmmakers during the shoot will prevent (or at least diminish!) any surprises from happening down the road.

There are constant changes and surprises in this job (both on the set and in postproduction), and being able to roll with the punches has gotten me a lot farther than shouting or screaming. Since a significant portion of our job as VFX Producers involves dealing with "creatives," it's important to steer them in the right direction, without limiting their vision or preventing them from doing their jobs.

I think the database is critical. It needs to be flexible enough to generate a myriad of reports, able to track all versions of shots, every note, financial editorial data, etc. Having a functional database/Bible is beyond important. It's vital.

18

CROSSING THE FINISH LINE

It has now been many weeks or months since the digital facility began work on your shots. At last all the approvals are in and the shots are ready to be delivered to you. What happens now?

Well, here we have to be mindful that the ultimate goal of the months or even years of toil is to distribute the film to theaters where, the producer hopes, multitudes of people will flock to see it. At present, there are two distinct paths by which a film can be completed and released: the traditional, photochemical path, and the new kid on the block, digital intermediates. The path the studio or producer chooses will affect how you deliver the visual effects.

Finishing on Film

The traditional method of completing a film has been with us since the earliest days of motion pictures. That method was to perform every step—from workprint to release print—on film. This method is referred to as *photochemical*, or analog, because the images are captured on light-sensitive film that is developed in various chemical solutions.

If your producer follows this traditional approach, a negative cutter conforms the original negative to the final cut of the film. Most likely, the film will have been edited on an Avid or other digital editing system, and instead of getting a cut workprint, the negative cutter will get an edit decision list (EDL) to go by to cut the negative. The conformed negative is then turned over to a film laboratory for the final steps to make prints for release.

The visual effects shots—which up to now have existed only as digital files in an effects facility's computers—are converted back into an *analog* signal and output (i.e., recorded) to film. This is accomplished at a recording facility where the zeros and ones that define our effects shots are converted into light beams that

Film recording/output

There are two technologically distinct approaches for recording digital files to film. Without going into details, in one method the final images are photographed off a high-quality cathode ray tube (not unlike the picture tube in a TV set, but far superior in resolution), and in the other, a laser beam is used to expose the film. Both methods result in a new piece of negative that is then treated like any other shot.

are recorded on film. From now on, the effects shots become a part of the completed picture, to be color corrected, squeezed, duplicated, or otherwise manipulated along with the rest of the film.

Now just to back up a moment, when you or your vendor orders a film-out, you must choose the resolution at which the output will be done. Your choice of resolution will depend on whether the film-out is a final, or whether it's a temp. If it's the latter, a low-resolution (meaning 1K) film output should suffice to see whether the shots are satisfactory or whether there are problems like color and density mismatches or subtle problems with action. 1K outputs are less expensive than 2K because they take less time per frame to record. Alternatively, your effects shots may be projected digitally if the production company has access to a digital screening room.

The final film-out will normally be done at the full 2K resolution unless some special circumstances come into play. There may be occasions, for example, where a producer or director may decide to output the shots at 3K or 4K resolution because the film was photographed in Super-35 or IMAX and he wants to preserve the highest degree of detail in the visual effects shots. This is increasingly common with so-called "tent pole" films, those megabudget special effects extravaganzas we've become accustomed to seeing during the summer or just around the year-end holidays. Though not a widespread custom as yet, the trend toward 3K or 4K record-outs is almost certain to grow because of their higher quality and because the recording process is getting faster and (relatively) more affordable.

After the conformed negative has been turned over to the laboratory, a colorist at the lab times, or color corrects, the negative scene by scene to produce the final result. A film laboratory has basically only two ways of making corrections. It can either change the amount of light that exposes the film (affecting density), or it can add or subtract various filters in the light path (affecting color). Note that the laboratory can only change the *overall* density and color of any given scene and then only at a cut from one scene to the next.

After the negative is timed, the laboratory makes several answer, or trial, prints of the film for approval. Once the members of the creative team (including the producer, director, DP, editor, VFX Supervisor, and color timer) are happy with the answer print, the machinery of cranking out release prints swings into action. Interpositives (IPs) and internegatives (INs) are struck, and release prints are made by the hundreds or thousands for shipment to theaters.

This traditional photochemical process has always had three major disadvantages. One, color corrections can be made only

from scene to scene and the ability to manipulate the look of a film chemically is severely limited. Two, every step in the duplicating process entails repeated handling of film, be it the original negative, the IP, or the dupe negative. No matter how carefully a laboratory proceeds, film picks up dust, dirt, scratches, and other flaws along the way. Three, it is costly in both manufacturing and shipping.

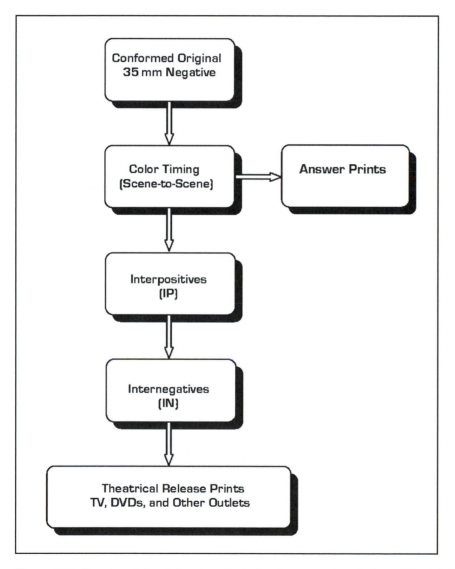

Figure 18.1 The principal steps in bringing a film to the release print stage via the traditional photochemical method.

Finishing on Digital Intermediate

In recent years a new method has been developed that removed those shackles. It is the Digital Intermediate (DI) process, a technology that has almost completely replaced the traditional photochemical process because it offers colorists, directors, and DPs a set of wonderfully diverse digital tools. Going the DI route is now the method of choice for completing most studio films and many independents.

When making a DI, the entire film is scanned and digitized (unless it was shot digitally in the first place). A production that plans to use the digital intermediate process may or may not physically cut the original negative. If the producer chooses to cut negative, the negative is conformed in the traditional manner and the cut negative will then be scanned and stored on computer disks basically as one huge digital file. But he may also choose *not* to cut negative, in which case the facility making the digital intermediate extracts the correct scenes directly from the *uncut* negative, using an EDL to match the DI to the final cut of the picture. In effect, the DI facility acts as the negative cutter, scanning only the exact frames of a scene specified on the EDL and laying them off to disk, all in the correct order and accurate down to the frame. The original negative remains uncut, possibly to be used again in the future in a different version of the film.

Similarly, we can deal with the visual effects shots in two ways. One is to proceed in the traditional manner; that is, the effects are recorded out to film and cut into the final negative to be scanned along with the rest of the negative. The other way is to deliver the shots in digital form (2K files, not color corrected) on a hard disk (firewire drive) to the facility doing the intermediate, where they will be integrated into the digital intermediate without first having been recorded to film.

At this point, then, the entire film exists in digital form. This means that the images can be manipulated in an almost limitless number of ways, to the great delight of directors and DPs (and the DI facility that gets to charge substantial amounts of money while the creative people play with the look of the film).

Digital intermediates are created in sophisticated suites equipped with state-of-the-art digital gadgetry and first-class projection systems on which the visual quality of the images is judged. The colorist, working in collaboration with the DP, director, and sometimes the VFX Supervisor, can use the digital tools of his DI suite to make color and density changes not only from scene to scene, but also from frame to frame and even in selected areas *within* the frame. This far outstrips the color and density corrections that a traditional motion picture laboratory can achieve. For example, the DI colorist can create a matte around the eyes of an actress that were slightly shadowed and brighten

them up, and animate the matte so that it follows the movement of the actress's head. In a manner of speaking, the entire film can be thought of as one continuous visual effect as tools that were once reserved for visual effects work can now be applied to a whole film.

Digital intermediates also have the advantage of being...well, digital. After the original negative has been scanned, any signs of dust, dirt, or scratches are removed once and for all in a process called "dust busting." Dust busting is very labor-intensive, but once it's done the digital master will remain pristine no matter how many other masters or media are struck from it in the future.

The process is not cheap, however. In fact, at the outset it is more costly to produce a digital intermediate than it is to finish a film via the photochemical path. Even though costs have moderated since the process was first introduced around 2000, it may still cost between $150,000 and $250,000 to produce a DI and other deliverables.

Nevertheless, digital intermediates sing a seductive siren song: It is the promise of long-term monetary savings and distribution flexibility that is enticing both studios and independent production companies to choose this path. Once a digital master exists, it can then be used with relatively little additional expense to produce all the different media in which a film may eventually be released: film prints, TV in its multitude of formats, satellite delivery, DVDs, foreign versions, in-flight movies, etc. Not only can the studio release the film conventionally (i.e., on release prints projected by conventional film projectors), but it can also release it in digital form in theaters that feature digital projection. Being in digital form, the film will not suffer any degradation in image quality. It is this versatility that makes this an economically viable option in the long run.

The consequences of this application of digital imaging technology are both immediate and unforeseeable. Immediate, in that it gives filmmakers unprecedented control over how their images ultimately look when they are presented to viewers. Unforeseeable, in that we are only in the infancy of digital technology as it is applied to motion pictures. It holds great promise, but at present—and probably for a number of years to come—release prints on film are by far the most common method for distributing films. Digital distribution comes in a distant second.[1]

[1] Of the roughly 40,000 movie theaters in the U.S., only about 5,000 are equipped for digital projection.

SUCCESS STORY
Crystal Dowd - *(2 Fast 2 Furious; Titanic)*

I have a Bachelor of Arts: Communication Studies, Film Production, and Theater Arts, from the University of Iowa. My first job in the film business was as an office PA on a feature in Tucson in the mid 80s. The head gasket blew on my car and I was fired after four weeks of work. This was a valuable lesson for my future Hollywood endeavors: Don't cry, producers' and directors' head gaskets blow, and everybody gets fired sometime. I later became an assistant to a producer who on my first day sent me to Elizabeth Taylor's trailer and told me to take care of her and get her whatever she wanted…. Later I became a set PA and assistant production office coordinator. On *Terminator 2* I started out as an assistant coordinator and later became the 2nd Unit coordinator and eventually the postproduction coordinator. Watching the progression of the visual effects on that film was truly awe-inspiring…I knew then that I had found a new passion.

The VFX Producer's duties include bridging the gap between production and postproduction to find cost-effective and innovative solutions to the challenges of motion picture production.

Keys to success: Flexibility—keep an open mind; maintain a sense of humor; stay organized.

BUSINESS AFFAIRS— OPERATING THE VISUAL EFFECTS DEPARTMENT

LEGAL MATTERS

"A verbal contract isn't worth the paper it's written on."
—Sam Goldwyn

As the business and administrative head of the visual effects department, the VFX Producer frequently has to deal with matters that have a legal component to them. Most of the time the legal component is quite simple and innocent, and we don't need to give it a second thought. At other times, however, the VFX Producer may be deeply involved in quasi-legal dealings. It is helpful, therefore, to understand a few basic ideas about legal matters that affect how she does her job.

What Sam Goldwyn was saying in his inimitable way was, *get it in writing.* Most of our dealings with crew people, rental houses, vendors, and others who provide services are conducted verbally or in a few exchanges of e-mails or memos. There is always a lot of give and take involved. The VFX Producer wants the weekly rental fee on a camera package to be charged at two times the daily rate; the rental house offers three. The 1st assistant cameraman wants a weekly box rental fee of $250, the producer counteroffers with $150. The digital effects house budgets the shots at $1.5 million; the show can afford only $1.25 million. And so it goes, back and forth until you arrive at mutually satisfactory terms...or walk away from the deal. In any case, please get it in writing.

> **Disclaimer**
>
> What we offer in this section is some thoughts about legal matters that may come up during the course of visual effects production. It should not be construed as legal advice, which may only be given by licensed attorneys.

Contracts

In visual effects we deal with agreements of various complexities. Contracts are usually written to cover a major body of work by a facility. They can become quite complex, but all contracts have certain features in common. Basically a contract states who does what (the task) for whom (the parties) for how much (the consideration) by when (the time frame) and under what artistic

guidelines (the specifications). Contract law is quite complex, and it's beyond the scope of this book to do more than provide a few guidelines.

The fundamental assumption in all dealings, be it for a multi-million-dollar digital extravaganza or the rental of a $30-per-day tripod, is that all parties are negotiating in good faith. Without that assumption, business would come to a grinding halt. Generations ago, a handshake often sealed a deal. Unfortunately, the complexity of modern business—not to mention the larceny that lurks in many a heart—has pretty much put an end to that tradition.

The visual effects business is no exception. Large visual-effects-driven movies involve contracts worth tens of millions of dollars. The visual effects budget may, in fact, be the single biggest item in the below-the-line section of a budget. People on all sides will watch those dollars very carefully and therefore the studio or the production company's attorneys must ultimately approve a contract with the visual effects facility for the scope of the work for the film.

However, relatively few attorneys will have had any experience in dealing with the intricacies of visual effects. Sometimes even the producer of the movie doesn't get involved in the negotiations until late in the game. For this reason the VFX Producer is often at the forefront of negotiating the technical terms of the contract. It is she who will have prepared the specifications for the work to be done, the budget, delivery and payment schedules, milestones the vendor is to meet, and other particulars. She is therefore in the best position to supply the relevant details to the attorney who ultimately writes the formal contract.

Letter of Engagement

Partly because contracts are intricate documents that take a long time to finalize, we often arrange with a vendor to begin work on the basis of a relatively simple Letter of Engagement (sometimes called a Letter of Agreement) that binds or obligates the parties to one another. It precedes a formal contract because the full contract often doesn't get signed until the project is well underway or, indeed, nearly finished.

A Letter of Engagement is a legally binding document that allows vendors to start work and gives them seed money even though you don't know the final price yet. It's like a good faith deposit. This letter generally sums up only the main points of the agreement you reached with a vendor, leaving many details unstated—but hopefully mutually understood—by the parties. At minimum, the letter needs to state the who, what, when, and how much of the agreement.

Contract Details

Full-fledged contracts are usually reserved for items that are costly and complex and whose production stretches out over a considerable period of time. In contrast, purchases of materials, equipment rentals, and services of short duration involving relatively small sums are usually handled with purchase orders, and crewmembers are hired on the basis of deal memos.

Among the items that a contract needs to address are:

The Scope of the Work

Every vendor needs to have a clear idea of what he is to do, so one of the first things a contract states is the scope of the work. In the case of a model shop, the contract should name the miniatures that are to be built as well as photographed. In the case of a digital facility, it should give a complete list of the shots the vendor is to produce. In each case, production designs, storyboards, and—where available—previs details should be supplied to the vendor. These details are often attached to contracts in the form of "Exhibits."

Quality Assurance

Possibly the most elusive item to pin down contractually is the quality of work that's expected of the vendor. Because visual effects are a creative medium, artistic criteria are very difficult to spell out in writing (directors often talk about making the effects "look cool," but try defining that term contractually). Still, you may want to make a stab at establishing some kind of quality standard, by including something like "work shall be performed in a professional, competent, and consistent manner pursuant to the highest quality standards of the motion picture industry." Your consulting attorney should be able to come up with some appropriate wording.

Shot Breakdowns

Shot breakdowns essentially list the nitty-gritty details of what goes into each shot. These details will have been worked out between the director and the VFX Supervisor and incorporated in the VFX Producer's database. A portion of the database pertaining to the visual effects shots a vendor is being asked to produce might be made part of a contract.

Budget

Quite often, you and a vendor will agree on a budget only after lengthy discussions in which both parties will have examined

the factors influencing the budget over and over. Once you have agreed in principle, the vendor should provide—and the VFX Producer will put in the contract—a detailed listing of costs, not only of the individual shots, but also of any associated items that went into making up the final bid. This will include items such as research and development, visual effects design, building and texturing models (if digital models are called for), fees for on-set supervision, etc. The contract should lock the vendor into the budget. In other words, he shouldn't come to you halfway through the project and claim that he needs more money to finish the job (though that, too, happens every so often). The only valid exception to that should be if the production asks for changes, either creatively or in terms of the schedule, or if an event happens that is beyond the vendor's control.

Delivery Schedules and Interim Milestones

Along with the budget, you and the vendor will also develop a schedule specifying when certain phases of the project will be completed. This, too, is subject to give and take, but ultimately the delivery schedule must satisfy the production's schedule. This gives rise to one of the standard terms we see in many contracts: "time is of the essence." It means that if a vendor misses his deadlines, he is in breach of contract. Just keep in mind that the requirement for on-time performance also applies to you and the production. Though it is not a foregone conclusion, breach of contract because of missed deadlines can have serious repercussions for both the vendor and the production company.

Payment Schedules

Vendors may be paid according to several payment schemes. One common method is for a vendor to be paid one third of the contract amount up front, another third when a specific milestone is reached, and the final third upon completion and approval of all the work. Sometimes it is four payments of 25% each. Another scheme is to tie payments to several specific performance milestones that the VFX Producer and the vendor mutually agree on, such as having submitted a certain number of shots as temps; alternatively, the payment can be a percentage of the work completed. You use the method that makes the most sense for the vendor you are dealing with. It is all negotiable.

Key Personnel Guarantee

You may have chosen a vendor, in part, on the strength of the vendor's demo reel. If so, you should insist on a contractual guarantee that one or more key creative people on the vendor's staff will, in fact, be attached to your project. Along the same lines, you

should also limit or forbid a vendor from subcontracting critical work to another vendor (except for service bureaus like scanning/recording facilities) without prior written consent.

Exclusivity of Vendor's Services

This addresses the issue of whether the vendor guarantees to work on your production exclusively for a certain length of time, or whether his services are limited in some way, such as on a "first priority" or "nonexclusive" basis. It is an important point to bring up when you are dealing with a vendor who has numerous clients. If the vendor has other projects in the works, you can be sure that each of them will also be competing for the vendor's artistic staff.

Vendor Reporting Requirement

How often will the vendor's production office submit progress reports to you, and what will it be required to include? On small projects, it may work quite well for the VFX Producer to call a facility or have the VFX Supervisor pay a visit every few days to get an informal report on how the work is coming along. But on large productions—and especially when your vendor is in another country—you need a more formal reporting procedure that gives details about the status of all shots. Without this type of weekly status report, the VFX Producer will not know where things stand and may be unable to report to her producer or studio.

Right of Approval

Who is authorized to approve a vendor's work on the production's behalf? When it comes to evaluating creative work, many voices will want to speak but only one should be heard. That voice is usually the director's, although under certain circumstances it could be the VFX Supervisor's, the producer's, or even the editor's. In any case, the contract should name one—and only one—person who can sign off on the work. Normally the director signs off on all creative issues and the producer signs off on all production and cost issues.

Revisions and Change Orders

Changes are a given in the visual effects business. Shots get added, dropped, and redesigned. As the VFX Producer, you need to have a procedure in place that states how a vendor will get authorization to make changes in or add new shots. Again, it is usually the director who will ask for changes, often supported by the editor who is trying the make the cut work. Ultimately, though, it is the producer or the studio that has to give the OK to spend the money. The contract should name the person(s) whose

signature must be on the change order before the vendor may proceed (see Chapter 17 for a discussion of change orders).

Rights of Cancellation and Rebates for Cancelled Work

This can be a sticking point in negotiations. A vendor will often set aside a block of time to work on your visual effects. He may have to rent additional space, guarantee a freelance artist employment for a certain length of time, or make other commitments that lock him into certain fixed expenditures. If the production company now wishes to eliminate a portion of the work, the vendor may be stuck with those overhead costs. The contract therefore needs to spell out how much the vendor is entitled to charge for partially completed work, how the production company will be credited for work not yet done but partially paid for, and the basis for negotiating for additional work.

Technical Considerations

Creative considerations aside, the production of visual effects is also a highly technical affair. To avoid misunderstandings a contract should cover such particulars as the resolution and color space digital images will be generated in, how many film outputs or final renders of the DI a vendor will be required to provide of each shot, whether he will provide one or more color workprints of the shots, and similar technical details.

Screen Credits

The trend in recent years has been toward ever-expanding end credits. Everyone likes to see his or her name on the screen as a reward for work well done, and you may be sure that every name you see in the end credits was put there because of a contractual agreement. Credits are normally awarded to a facility based on the number of shots in the contract. Though they are a nonmonetary issue, screen credits should be clearly spelled out in the employment contract or deal memo because, when not handled properly, they can lead to a lawsuit.

The VFX Producer rarely has the authority to grant or withhold screen credits. It is a function reserved to the production company or studio and you will have to follow those guidelines. Generally, the company's standard deal memo will state its policy regarding screen credits for the crew. When the situation is not entirely clear, and you are asked about screen credit when you are negotiating with a crewmember, the best approach usually is to tentatively say yes, subject to the producer's approval. Most deal memos will include a clause reading something like "size

and placement at producer's discretion." Unless the crewmember occupies a position of considerable responsibility, he or she will have to settle for a listing along with the rest of the crew.

Screen credits for a vendor's employees should be spelled out in the vendor's contract. You may be sure that the vendor will ask for everyone who worked on the show to be credited, but achieving that goal isn't a foregone conclusion. The longer the end credits, the more costly it becomes for the producer. Consequently, producers will often seek to limit the credits to a few key people on the vendor's staff. As with so many other items, end credits are negotiable.

"What If" Clauses

Then come the various provisions intended to protect the parties: How do you get out of a contract when things go awry, such as when it becomes clear that a vendor will be unable to meet the schedule or his work is artistically unsatisfactory? A contract should define, insofar as it's possible to do in a creatively driven field, what constitutes a material breach (i.e., a significant failure on the vendor's part to live up to his contract). Under what circumstances is the producer entitled to take work elsewhere? What penalties will be assessed against the vendor? What will it cost the producer to get out of the contract? How will any credit for uncompleted or unsatisfactory work be calculated?

These are all very real concerns to attorneys, whose job it is to prepare for the worst. As you might imagine, a breach of contract may have profound consequences for both vendor and studio. Quite often, large sums of money are at stake, not to mention release dates that may have been cast in concrete many months earlier. All the more reason to have a thoughtful, well-crafted contract that is fair to both parties in place. The fewer the items that are left to chance, the smoother the sailing.

Force Majeure

This is everybody's escape hatch. The expression refers to any event or set of circumstances that could not reasonably have been anticipated, controlled, or prevented by the parties. It's often referred to in insurance policies as an "Act of God." This legal principle may be invoked by either party when something so unexpected and damaging happens that is *beyond their control* that whoever suffers the damage cannot continue work on the project. Let your imagination run wild: a hurricane destroys the production company's sets, a leading actor dies, the vendor's building burns down....

Though such incidents are fairly rare, your contract must include a provision to cover the possibility. And if it should come to pass, there is little alternative than to settle your accounts with the vendor in good faith.

Purchase Orders

Purchase orders are used for any number of relatively minor purchases or well-defined tasks of relatively limited scope throughout production. They are usually very straightforward and simple, but you should be aware that—just like a contract—purchase orders are legal documents and should be respected as such.

Whether the VFX Producer will be given the authority to issue purchase orders may vary from production to production. Some productions will allow you to do so, subject to certain limits or with authorization from the UPM or producer. Other companies will require you to submit all purchase orders for approval. Normally if the VFX Producer has money in the account she is writing the purchase order for, it just has to be signed by the accountant and producer. However, if there is not enough money to cover the cost of the purchase order in the account, then she has to ask the production for the money.

If you do get the OK to issue purchase orders directly, you will want to maintain tight control over them. It is generally best not to allow anyone on your staff to actually issue a purchase without your signature. But if you do wish to allow a trusted subordinate to do so, you should set strict limits as to the maximum value of purchases this person may make on his or her own authority. You are ultimately responsible for the actions of your staff. It is best each week to check the cost report of the visual effects accounts to see where you are and how much money you have left in each account to complete the show.

Contractor Status

One of the recurring questions in our business is the matter of the legal status of contractors. Let's assume you have received several bids, and you are set to award the job to a company or individual who works on his own. This vendor is legally designated an independent contractor, an important distinction from an employee whom you hire and put on your payroll for a time.

The definition of what constitutes an independent contractor has been fiercely argued in many courts because having true independent contractor status can convey huge tax advantages to an individual. But *claiming* independent contractor status and not actually *having* it under the law can land a worker in a heap of trouble. We can't go into the details of those issues here, but suffice it to say that an independent contractor must meet *all* the following requirements:

- He is a person or business who performs a service for you under an expressed or implied agreement or contract. There is usually a time limit set on the relationship.

- He operates under his own control. You generally do not have the right to control the manner and means by which he performs the work or to set his work hours. You only have the right of approval of his work.
- He has the right to control and supervise his own employees.
- He is responsible for paying his own expenses, income taxes, social security contributions, workers' compensation premiums, and employee benefits.
- He may maintain his own workplace and supplies his own tools and equipment.
- He has the opportunity to make a profit (or take a loss) on his work.
- You are not liable to him for any acts or omissions on his part.

And finally, the status of independent contractor is defined by law, *not* by how you or he defines it. For example, you cannot make an agreement with an artist to come to your postproduction offices to create computer animation, using your equipment during your office hours and under your supervisor's guidance, and call him an independent contractor just because he wants to invoice you for his services (something that is actually fairly common in the movie business). Such an individual must be treated as an employee, with all the deductions and benefits that status conveys. So keep the relationship between yourself and the contractor clearly defined and separated.

Deal Memos

The VFX Producer frequently negotiates with and hires the visual effects crew. In this task she will work closely with the VFX Supervisor in interviewing and selecting the right people. Once they have decided whom to hire and the terms of employment have been verbally agreed on with the crewmember, she will fill out a deal memo and have the crewmember sign it.

The deal memo states the terms of crewmember's engagement: start date, salary, length of engagement, screen credit to be given (if any), box rental, who owns the rights to the work the crewmember creates (this could be an important issue if he/she is an artist), and other terms of service. On most productions, the UPM must also approve the deal memo on behalf of the production company.

Work for Hire

An important work classification that a VFX Producer who has to hire freelance artists should understand is "Work for Hire." This term refers to virtually all crew members and it means that they do not retain any rights to the work they do or create. Thus, a digital artist who is employed by a digital facility and creates a matte

painting for the company does not retain any residual rights to his work because the work is done in the course of employment.

But if you hire an artist as a freelancer to create a matte painting, generate a previs at home, or draw a set of storyboards, you must include a clause in the work agreement stating that it is a Work for Hire, that the production owns the copyright, and that the artist has no further rights to the work other than, say, for personal use on his demo reel or portfolio or to show it in a class he may teach.

Insurance

Every production company carries several types of insurance: on the cast, on equipment, workers' compensation, etc. As VFX Producers we don't usually get heavily involved in this field. One exception, however, is when we have to rent equipment specifically for the visual effects unit. At these times it is important to have a complete list of equipment that is being rented and present it to the UPM or production accountant so that the proper coverage can be obtained. This is a task that can be turned over to the VFX Coordinator. He or she will see to it that whoever picks up the equipment completes the paperwork and issues a Certificate of Insurance for the equipment.

When you are the one negotiating the rental, be sure to ask about what type of insurance coverage—if any—is available from the rental house. Chances are that the rental house will not cover its equipment once you sign for it. You will have to insure it through your production company's insurance carrier.

Though it is usually pretty straightforward, it's worth noting that coverage should be "all risk," including what may be called "mysterious disappearance" in the policy. For example, it's pretty clear when a production truck gets broken into and some cameras are stolen. But "mysterious disappearance" comes into play when no one seems to be able to figure out just what happened. Did the equipment fall off a truck? Did it get left behind somewhere? Might it have been shipped accidentally to the wrong destination and no one knows about it? Unless you have "all risk" coverage, your insurer may refuse to pay off on the claim.

Cash Flow

Productions are often set up so that the cash needed to operate them is given out incrementally, usually on a weekly or biweekly basis. That is, the studio or other financier will not deposit the entire amount for a film in the production's bank account, but will disburse the money according to a cash flow projection. Cash

flow is critical to the production. Interrupt it, and a lot of things—all bad—can happen.

One of the tasks of the production manager or production accountant will be to prepare a cash flow projection for the entire course of the project. The VFX Producer, in turn, may be asked to prepare a cash flow projection for her department. She does this by analyzing her schedule on a week-by-week basis and listing all expenditures that are expected in any given week.

Cash needs will bounce around quite a bit during the course of production. They will be relatively modest during prep and pre-production. Staffing will still be minimal, and the costs of setting up the visual effects production office will be modest. But expenditures are likely to jump very quickly once preproduction swings into gear, such as when a project requires extensive previs or miniatures need to be built so that they are ready to go before the camera even while the 1st Unit is doing principal photography. This may also be the time when digital facilities have to start work on the show's computer graphics, requiring substantial advance payments that were negotiated with vendors.

In planning her cash flow, the VFX Producer will determine the size of the visual effects crew for any given week, what equipment needs to be rented and what facilities leased, and what purchases have to be made. Whereas the cash flow for the 1st Unit will be heaviest during principal photography, cash needs in the visual effects department may be heaviest during postproduction. This is a time when one or more visual effects units may still be shooting element plates, aerial photography, or miniatures, and when huge payments to digital facilities may come due every month.

Cost Reports

Cost reports are critical to the financial health of a production. They are prepared by the production accountant and his staff. The accountants track all expenditures on a daily basis and can generally print out a cost report for the producer or studio at a moment's notice. The visual effects department's expenditures become part of these reports, and it is imperative for the VFX Producer to ask for, and to carefully go over, the cost reports for her department. She should do this at least once a week, if not more often (this is sometimes referred to as the Bible Run) so that she knows where her budget stands.

Here's why. The production accountant or one of his assistants will post every expenditure to a specific account. As long as the accountant knows the correct account number, all is well. But if, for whatever reason, some of your expenditures get posted to the wrong account, you could quickly find yourself overdrawn in that account. Few things will bring more unwanted attention from a

studio than an overdrawn account. It's best to avoid that situation by verifying that all expenditures were posted correctly, and if they were not, to bring this to the accountant's attention immediately. The cost report will prove very useful because it will allow you and the accountant to easily shift the money out of the wrong account into the correct one.

The actual form of a cost report will vary, but generally they all have some items in common. All reports will tell you the accumulated costs of what has been spent to date, plus what is still ahead. They will tell you the cost to complete, which tallies all expected expenses yet to come. Finally (and this is the scary part) the report will give an over/under figure, the difference between what it will actually cost to complete the effects and the actual budget. This is also called the variance. Variances show up in several types of forms and reports.

Variance is a measure of the financial health of the visual effects department, and the VFX Producer must watch it very closely. For one thing, it tells her whether she has budgeted the show correctly. If the over/under figures and the budget are fairly close to each other, she can heave a sigh of relief. But if the cost report shows a substantial deviation (over *or* under), immediate action is needed because any major deviation is cause for concern.

If the visual effects are currently running under budget, things are not so bad. About all this shows is that the VFX Producer may have overestimated one or more categories, and she needs to review her assumptions. Overestimating by a substantial margin doesn't happen very often, and if it does, the VFX Producer may have done so because of information she got from the director, VFX Supervisor, or others who had a hand in setting up the show. The show's producer is not likely to issue a pink slip for this infraction.

But if the effects have gone significantly *over* budget, it is a sign that there was a serious miscalculation—or substantial deviations from what was earlier agreed upon—somewhere along the line. The VFX Producer must immediately track down the causes and try to correct them. She must advise the show's producer and discuss the situation with him. Quite often the causes are beyond the VFX Producer's control. Perhaps the visual effects crew incurred unexpected overtime due to malfunctioning equipment, or a miniature shoot was more time-consuming than expected. Perhaps the director added more shots in post, a digital character had to be redesigned, or a vendor demanded more money to finish the work. Or perhaps the budget was unrealistic to begin with. Whatever the reason, the issue has to be faced and resolved.

Controlling the Budget

Partly over concern of the possibility of going over budget, the VFX Producer should exercise tight budget controls all along the

way, even on small items. She will frequently be asked to approve expenditures for various extra items. It is always easier to say yes to an apparently legitimate request than to be a Scrooge and say no. But even so, the person asking for the extra item or service should make a convincing case that it is needed. It is then up to the VFX Producer to exercise her judgment and common sense so that she makes decisions that are not penny wise and pound foolish.

One thing is certain: Undue generosity in any given category may come back to haunt you. For example, the camera crew should be tight with film stock as every foot of film that is exposed must not only be processed and printed, but must also be handled numerous times in editorial. The VFX Editor needs to be sparing in ordering extra prints and dubs. Services such as outside messengers should be kept to a minimum. A minor item? Certainly. But to shamelessly misquote a famous U.S. Senator, "a thousand here, a thousand there, and pretty soon you're talking real money."[1]

It's customary for the VFX Producer to go over all bills and invoices for items tagged with a visual effects account number. Generally, the production office will send her the relevant invoices, at which time they are matched up with a contract or purchase order. This is a task that the VFX Producer may wish to delegate to the VFX Coordinator. However, final approval of an invoice should come from the VFX Producer. Her initials on the bill show that the service has been rendered or the articles received.

"Big ticket items" (such as progress payments on major computer graphics contracts) may first be sent to the production accountant, who will be familiar with—and can check on—the terms of the contract. But before he or she approves a large payment, the accountant will normally ask the VFX Producer to verify that a vendor has actually achieved a given milestone and is, in fact, entitled to the payment.

Though relatively rare, differences of opinion do arise as to whether a given expenditure should be charged to visual effects or some other department. These situations call for a bit of diplomatic negotiating, because there may not always be a clear-cut answer.

Monitoring Payrolls

Maintaining a tight rein on the visual effects budget is particularly important when monitoring payrolls. As the VFX Producer you may be in charge of several units whose size may range from a three-person camera crew and driver out for a day's worth of plate shooting to a crew of more than fifty people building and shooting a series of miniatures over a period of several months.

[1] Sen. Everett Dirksen (R-IL.) "A billion here, a billion there, and pretty soon you're talking about real money."

When such large crews are involved, you may want to hire a 1st AD or UPM specifically for the visual effects unit. There's an enormous amount of paperwork involved in keeping track of the comings and goings of crewmembers. The visual effects department must maintain accurate records of all their comings and goings, which is commonly done through weekly time cards that crewmembers have to fill out and sign, attesting to their accuracy. Accurate time records are important because (a) The production's payroll service issues payroll checks based on a crewmember's signed timecards, and (b) timecards are essential in settling pay disputes that crop up from time to time.

The Virtual Production Office

The business end of our industry runs on data and documents. Production offices are inundated by them, and as producers and studios are requiring ever more daily reports and film production has spread to the far corners of the world, managing this Mount Everest of data efficiently and securely has become a major challenge.

Enter a software-based service called the Virtual Production Office (VPO), developed by Entertainment Partners. VPO is a sophisticated, but easy to use, tool that allows a practically unlimited amount of data pertaining to a production to be stored in a central location (the server) where anyone authorized to do so can view and work on the files.

VPO offers two major benefits to a production company. One is that it can store all the production's files in one location and does so with total security. Every user's files are protected by passwords, and only an authorized user can access any given file. Thus, every department and even specific individuals can lock away their data with complete confidence that it will remain confidential.

The other major benefit is that anyone with the proper clearance can instantly access the files directly from anywhere in the world and can share them with whomever he chooses. All he needs is a computer, an Internet connection…and the right password. File sizes can be very large, unhindered by the limits often imposed on e-mail.

When a production company subscribes to this service, the VFX Producer should take full advantage of it. It is particularly valuable when you are working on a distant location from which you need to constantly exchange information and update files. For the visual effects department this could include breakdowns, budgets, storyboards, call sheets, production reports, data sheets, daily and weekly status reports, previs Quicktime movies, temp shots from vendors, and so on.

Figure 19.1 A sample screen from Virtual Production Office.
(Image courtesy Entertainment Partners[2])

The most important part of the operation is updating and maintaining the information. This must be done religiously, or you will find yourself back to doing things the old-fashioned way: pushing paper. Every key person on your team must understand what advantages this tool brings to the table, and agree to use it.

The key to a successful operation of the VPO is identifying the people who should have access to various files. On the production level, it is usually the production office coordinator who sets up the authorizations that will allow only certain individuals to access specific files. In the visual effects department, it is the VFX Producer who should specify who should be permitted into visual-effects-related files. You would be well advised to be very selective in deciding who should be on that select list. Tight security (as well as a large measure of trust) is essential. Internet piracy is rampant these days, and you don't want your visual effects shots-in-progress suddenly popping up all over the Internet.

[2]Screen shot created using Virtual Production Office software owned by DISC Intellectual Properties, LLC. For more information, see http://www.entertainmentpartners.com/products_and_services/products/ep_vpo/support/

Visual Effects and Film Guarantor Companies

Unless a film is being made by a major studio, chances are that a film guarantor company, also called a bond company, is insuring the film's completion. For a fee (usually 2 to 2.5% of the total budget), not counting the contingency and bank charges, a film guarantor will guarantee to the investors that the film will actually be completed according to the script and other terms that were agreed on at the outset.

The relationship between the producer and the film guarantor can be a very touchy one, because the guarantor has the right—indeed the legal obligation—to step in and take over a production that is in imminent danger of collapse. Such a collapse can happen for any number of reasons and at almost any stage of production or postproduction. Film guarantors don't relish the prospect of taking over a project, but it happens.

Visual effects are a particular source of anxiety among film guarantors for a couple of reasons. For one, it's difficult to predict how the effects are going to look in advance. Much is left to the imagination of the director and his visual effects team. If the visual effects look "hokey" or "cheesy," large sums will have been wasted and more money will have to be found to fix them. Cost overruns in the visual effects arena are common, and they don't usually announce themselves until the work is well underway and it becomes apparent that things are not working out.

For this reason it behooves the VFX Producer to keep the producer and the film guarantor apprised of the work's progress. The guarantor will most likely have a provision in its contract with the production company that the production company must submit a weekly report similar to the external status report discussed in Chapter 16 that details the effects being worked on that week, what elements were shot, and what has been added or deleted.

Negotiating and Bidding

As VFX Producer you are entrusted with the budget for your department. That means, among other things, that you have to stretch the production's dollars as far as possible. In turn, that gets you involved in negotiating with vendors.

Many books have been written about the art of negotiating, and no wonder. It is a difficult task for most people to learn, let alone to feel comfortable with. How well you do it depends a great deal on the personalities involved (are you timid or aggressive?), the relative strength of the parties (which one can afford to walk away from the deal?), and a host of other factors.

One of the basic tenets of bidding is that you should obtain bids from at least three vendors, sometimes more, depending

on the project. Ultimately you want the best deal for your production, and that means pitting vendor against vendor. This is common business practice and you should pursue it without hesitation, even when bidders are friends. Just the same, you should follow some basic rules of conduct.

The Bidding Dance

First and foremost, competitive bidding requires you to be fair to all parties you're soliciting bids from. They all should get the same information from you so they have an equal chance at the job. Not only is this fair to them, but it also allows you to compare "apples to apples." One way to do this is to prepare a set of detailed specifications for the job at hand. Each bidder should get a copy of your shot breakdown. If your needs are fairly routine, such as the compositing of a number of two-element bluescreen shots with a minimum of blue spill clean-up, a simple listing of the shots may suffice.

But if you are soliciting bids for a number of miniatures or for creation of digital characters to be integrated into live action, you should provide detailed storyboards or a previs of the scenes so a vendor can come up with an accurate bid. You and the VFX Supervisor, perhaps even the director, should be prepared to sit down with vendors to discuss the visual effects in detail. When appropriate, you will want to visit the vendor's facilities to check them out and assure yourself that he is capable of accomplishing the effects your project calls for.

Inevitably, one of the first questions vendors will ask you is "What's your budget?" Conventional business wisdom has it that you should hedge your answer. That's not to say that you should give them misleading information. Rather, you should tailor your answer to the situation. Competing bidders will get a good sense of the magnitude of your project from storyboards, previs, and other information you provide, and from there on it's up to them to come up with a bid.

If the job is of more modest proportions, you may wish to indicate a budget range, or describe your project in terms of low, medium, or high budget. You may even set the upper limit for the job, and then let competition do the rest. It's all part of the bidding dance.

It's common for vendors to angle for any advantage they can get to win a desirable job. They may ask how much a competitor bid or how he is planning to approach the creative aspects of the work. When faced with that question, you owe it to other bidders to remain discreet. You may wish to give a wide price range, or you may choose to cut off the speculation with a polite "Sorry, I can't tell you anything more." It pushes ethical boundaries when, for example, one vendor comes up with a terrific idea and you

pass it on to another one who can give you a better price. Proceed carefully, lest you gain a reputation for double-dealing and ripping off other people's good ideas.

"May I Cut In?"—The Uninvited Bidder

Once word gets out (and it will!) that you are soliciting bids for a project, you will get calls from potential vendors who want your business but were not invited to bid on the project. Perhaps some of them are unknown to you. They will offer to send you demo reels and will invite you to their facilities. How do you deal with them?

As a matter of general business etiquette, you should at the very least give them the courtesy of viewing their work with the VFX Supervisor. After having seen it you may not care for their work very much, but this is the time to remember that all of us started out somewhere below the pinnacle of our careers. And even if the work is less than stellar, keep in mind that the artists who produced it did their best under the circumstances. They probably put just as much effort into their work as a company that has artists with greater talent, or whose work is more in line with your needs. Besides, you may not know the restrictions—budget, time, the client's artistic taste—under which the work might have been produced.

So when the vendor's rep makes his or her follow-up call to you, treat that person with respect. Try to find something positive to say about his work. You might ask how they did a certain shot, or what software they used to do their animation, or whether the artist who did the compositing is still with the company. You get the idea. This shows that you saw their work and gave it some thought. Then, when they ask you about working for you, it makes it more pleasant for them to hear "We'll keep you in mind."

Cutting Your Losses

Let's assume you are two–three months along in working with a vendor out of a five-month schedule. The initial design is done, modeling work on a major 3D character is looking good, and initial animation tests with a shaded model were approved. But now that the real push on animating and compositing is underway, it has become evident that the work is not living up to the director's expectations. The director and VFX Supervisor have repeatedly met with the vendor to discuss their creative concerns, but the vendor just "doesn't get it." Plainly, something has to be done, and fast.

You basically have two options, neither of them very appealing. You could grit your teeth, and with the reluctant agreement of the director and the VFX Supervisor you could continue to work with

the vendor. Everyone realizes that it's going to be something of a battle from now on. The VFX Supervisor will be spending more time at the vendor's facility grappling with artists, hoping that through his direct input every step along the way the pixels will somehow get pushed into a semblance of quality. The director, at best, will not be in a good mood every time he looks at one of the vendor's shots and will unfailingly criticize the work. About the only redeeming feature of this approach is that it's probably not going to cost the production any more money.

Or you could start making discreet inquiries to see if another vendor might ride to the rescue. That approach, too, is fraught with pitfalls. There is, first of all, the matter of finding a vendor who is qualified, willing, and—most importantly—*available*. Realize that any vendor meeting all three of these qualifications may be reluctant to take over the job. Chances are that the two vendors know each other professionally if not personally, and vendors generally don't like to be brought onto a project under these circumstances. If they succeed in their assignment, praise from the studio and the producer will be muted. If they fail, everyone will know about it, their reputation will suffer, and no one will remember a year later that they were brought in to save the project.

What's more, the successor vendor will face a steep learning curve. He will have very little time to get up to speed, both creatively and technically, if he has to make any adjustments to his internal organization to handle the work.

To top it off, the VFX Producer will now have to negotiate with two vendors: a very unhappy one who is losing work (and "face" vis-à-vis his colleagues), and a second one who will be in a very strong bargaining position. While this successor vendor may be a totally ethical businessman, he will nevertheless expect to be well rewarded for pulling your bacon out of the fire and will justifiably ask for an extension of the completion schedule…or lots of overtime pay.

Couldn't You Just…?

The foregoing is but an extreme example of what can occur when there are major "creative differences." Far more common are disagreements that arise when a vendor refuses to do additional work on a shot without additional payment. In fact, it is a classic situation in the visual effects business: You and the vendor have agreed on certain parameters for a shot and how much it will cost. The vendor does his work in a satisfactory manner, but the director continues to "noodle" the shots, wanting a little more of this here, a little less of that there. How far is it legitimate to cajole the vendor into absorbing the cost of making these changes, and where should the vendor be entitled to additional payment?

There is no clear answer to this question. The common practice in the industry seems to be to push a vendor as far as possible. It's generally left to the vendor to cry "Enough!" and to raise the issue of additional pay. At that point, it is incumbent on the VFX Producer to negotiate in good faith with the vendor to arrive at a fair settlement.

How an organization handles such situations very much depends on the mix of personalities. Is the director difficult to work with or cannot make a decision on the shot? Is the producer a strong, fair-minded leader? Can the VFX Supervisor calmly guide the artists to do their creative best amid the turmoil? Do you, the VFX Producer, have the temperament and diplomatic skills to negotiate a fair settlement with the aggrieved vendor… and get it approved by the producer?

Ultimately, everyone in business relies on that intangible attribute called good faith. And for the most part it actually works.

SUCCESS STORY
Nancy St. John - *(I, Robot; Gladiator)*

In 1980 I started a small film production company with a DP/cinematographer friend and we did mostly commercials and documentaries…. It was the early days but…we tried to take advantage of every new technique as it became available. In 1984 I moved to L.A. to work at Digital Productions in L.A. They had a 17-million-dollar computer and we did groundbreaking work in both features and commercials.

I got my BA in Journalism. Before that I had gone to theater school. Learning how to put a theater production together was a perfect first step toward film.

The VFX Producer's work begins in preproduction and ends when the movie is delivered….We manage companies all over the world. We manage budgets of 30 million+ dollars. We hire and contract everyone who contributes VFX services to the film. We are technologists, accountants, lawyers, contract negotiators, and team leaders.

A great producer supports their team while helping them grow. They mentor, they offer advice, their door is always open…. It's the VFX Producer's job to keep the team working together in a healthy and happy way.

Producing VFX is all about the details. Every day in postproduction you go back to details on the day of shooting. As you move forward in postproduction, keeping detailed records of all comments by the director is imperative. I'm a firm believer of keeping detailed records as directors, producers, and studios all have selective memory…. If a VFX Producer doesn't have a good database I don't think they can really do their job well.

20

WORKING OVERSEAS

The Challenges of Operating on Distant Locations

Runaway production—that bugaboo of the Hollywood entertainment industry—has had at least one positive effect on visual effects: It has taught us to exploit the vast resources of the Internet to share images among widely scattered locations. Sooner or later, these far-flung operations will need to be linked to exchange not just mundane data like tomorrow's call sheet but *visuals* such as dailies and shots in progress.

There are a number of efficient electronic and digital tools that facilitate long-distance communications, and the vocabulary of these tools has become part of the digital age: broadband, file sharing, FTP sites, satellite communications, teleconferencing.

One of the more useful technologies for the visual effects unit is an FTP site. FTP (which stands for file transfer protocol) is a simple technology that allows a user to exchange files between his computer and the Internet. Setting up an FTP site is relatively simple. All you need is a fast Internet connection, a decent computer, and someone with a bit of technical expertise to design the site and establish the procedures for who may share various files.[1] Once the initial setup is done, any files posted to the site can be shared by anyone in the world who has permission (via a user name and password) to access the site. As with other Internet-related file exchanges, you must maintain security and make sure files are regularly updated, logged, and backed up.

The most important benefit of an FTP site for the visual effects department is that your visual effects facilities can post shots

[1] Instructions for and help setting up and operating an FTP site may be found in abundance on the Internet, including through the website http://www.windowsnetworking.com (or download software for free from Core FTP Lite).

to the site, and then you can download them for review and get comments from the director, whether he's across town or across the ocean. Further, it is a useful tool to have if the production does not subscribe to VPO or has shut it down at the end of principal photography while visual effects work continues for several more months. You can also upload any on-set references that the VFX Supervisor captured that day or week to keep the visual effects facility in the loop.

Aside from FTP sites, there are other types of services that can be hired to enable a production unit at a distant location to collaborate with its home base or, for that matter, anyone else anywhere that has been granted access to the site. Among these services are iChat, CineSync (previously mentioned in Chapter 15), and Wiredrive, which is an application that consolidates all production communications on one site. It is a service that needs no special technical knowledge or equipment to operate; a computer with a fast Internet connection is all that's required. Wiredrive and similar, competing enterprises allow the production to share virtually any type of data, including visuals, among workstations anywhere and to review work instantly. This makes such a service a handy tool that allows a VFX Supervisor or a director still filming on distant locations—whether in another state or overseas—to interact with digital facilities doing the work.

On larger budget productions, a good way of communicating with the director is to set up a weekly videoconferencing hookup between the director and editorial, the visual effects team, and the digital facility. Videoconferencing provides instant feedback because the various parties can both see and hear one another as well as the work being discussed in real time. This is a huge benefit in these days of accelerated postproduction schedules.

On medium- to low-budget productions, one means of effectively communicating between a widely separated vendor and director is to videotape the director (consumer digital cameras are pretty inexpensive) while he is watching the shots submitted by a vendor on a monitor. You can then burn a DVD not only of the director's comments, but also of what he was viewing at the time on the monitor, and either courier it to the digital facility or upload the material on the FTP site.

Lastly, if your budget is severely restricted or you find yourself in a location where more sophisticated hook-ups are not available, you may find the inexpensive Internet telephone and teleconferencing service Skype to be a viable way of keeping the director in touch with your digital facility. Though Skype lacks some of the bells and whistles of more sophisticated teleconferencing systems, it does the job.

The Lure of Working Overseas

American filmmakers have been making films abroad for at least a century. Countless producers sought out foreign locations and brought their footage back to Hollywood where they completed their works of fantasy. For decades, the work of creating the special photographic effects for virtually all American films was securely in the hands of a relatively small fraternity of skilled Hollywood artists. They had a virtual monopoly on that part of the business.

Not anymore. The digital revolution swept this monopoly away with the click of a mouse. Today, visual effects—in all their many variants—are being produced all over the world, and American production companies are flocking to overseas digital facilities like sinners to a revival tent.

The principal reason? Money. By going overseas, productions can save huge sums in two ways: one, through tax rebates, and two, through lower prevailing wages elsewhere in the world. When you consider that visual effects budgets alone can be in the millions, even a modest tax rebate may spell the difference between a film getting a green light or being axed.

Lower wages of film technicians, both in production and post-production alike, provide the other strong incentive for producers to take their work overseas. This is especially true when it comes to the wages of digital artists. Digital work often goes on for weeks, even months, and frequently requires a large staff of artists. While it is not unusual for the weekly rate of an American digital artist, including company overhead and profit, to bill out at $5,000 to $6,000 per week, rates in developing countries like India and China are in the range of $1,250 per week. That's a huge incentive to outsource the digital work.

Encountering Cultural Differences

When you go abroad to work on a film, you may encounter significant cultural differences that can affect how you perform your job. You should be prepared to adapt your ways to how things are done in the host country.

Try to remember that here *you* are the foreigner. Crews in other countries may not be as experienced as ours are, may not speak English very well, and probably have different work habits than we do. But they take pride in their work and generally try hard to do their jobs well. The authors (both of whom have worked overseas) have found from personal experience that, with rare exceptions, foreign crewmembers will work hard and conscientiously to do a good job. Show them that you appreciate their work, and

you will earn their respect. Not only will that make your job easier, but you will also create a reservoir of goodwill for the next American production that comes calling.

On a more practical side, you will need to learn something about the social and work cultures of the host country. If you can, look into that even before you go overseas by asking friends and acquaintances in the industry about their experiences in a particular region. You could also consult travel guides for tips on another country's business etiquette. Once you get to your destination, be observant and solicit the advice of some of the local people on your production.

For example, what is the management style? Is it generally open and interactive, or does it tend to be authoritarian? In the U.S., we are used to a certain amount of give-and-take between those in charge and the people in the ranks, but in some countries that would be tantamount to showing disrespect to the authority figure. Especially important is the etiquette of working with foreign directors, who may be more sensitive to being questioned or being given unsolicited advice than would be the case in our free-wheeling film culture.

Another cultural difference may show up in how a given country's workers view work. In some countries people value their time off more so than we seem to here and crew people may not tolerate the hideously long hours that have become the hallmark of digital postproduction of many an American feature. You need to make allowance for that in your scheduling and budgeting, and you can do that only if you do some research in advance.

Speaking of time, be alert to a culture's attitude toward time, more specifically the significance they attach to punctuality. If someone assures you that he will do something for you right away, does he really have the same understanding of "right away" as you do? Or is he simply nodding his head to be agreeable, perhaps not even quite understanding what you are asking? Given that schedules are of great importance in our business, it's up to you to make sure to communicate your needs clearly.

The Language Challenge

You would think that when you go to work in a country where everyone speaks English, there shouldn't be any problems with people understanding one another. But as George Bernard Shaw famously said, "England and America are two countries separated by a common language." Add places like Australia, New Zealand, and India to the mix and you may be in for an illuminating lesson in English dialects.

Language challenges are magnified ten-fold when you work in a non-English-speaking land. A competent interpreter is a must. This goes beyond simply helping you with mundane requests (*"Would you please send our runner into town to get us a widget?*

Tell him we need it right away!"). In our craft we constantly use technical terms and give creative directions to artists whose sensibilities need to be brought in line with what the director and VFX Supervisor are asking for.

When production hires an interpreter for you, don't hesitate to speak up when the assigned person comes up short. Try to look beyond the foreign (to you) accent the interviewee may have. Instead, get him to talk about artistic or technical matters related to film or digital effects and focus on discovering whether he actually understands what you are saying. Also, try to make sure that this person will be assigned exclusively to your department. Having to share interpreters with other departments may well lead to a temporary halt in your operation.

Physical Production

One thing to be aware of is that the talent pool of experienced crew people in some countries may be pretty shallow. Let's say that there are two or three top crews in a country but they're tied up on other features. This could put you at a disadvantage if you need to go out and shoot plates for your effects. It isn't always possible to schedule your plate shoot for a day when you can borrow personnel from your 1st or 2nd Unit. As often as not you may have to work alongside the 1st Unit, in which case you and the VFX Supervisor need to take a bit of extra care to make sure the plate crew performs well. That said, almost everywhere we go these days film crews are getting better.

Working with Digital Facilities Overseas

The digital effects industry is already quite mature in several countries whose facilities employ hundreds of gifted artists. As we observed in Chapter 17, it is now common to have digital facilities on different continents work not only on the same film, but on the same *sequence or shots*. Now, smaller digital facilities are proliferating all over the world and are competing for work. The easy access to broadband connectivity makes them serious competitors on the international scene.

Ambitious companies in Guatemala, India, China, Vietnam, Eastern Europe, and elsewhere are tracing a similar arc of progress to that traced by companies in the United States when they were first learning how to create digital effects. It was barely two decades ago that Jim Cameron's *The Abyss* (1989) broke ground with some 20 digital shots of a watery pseudopod, and even the film many people think of as *the* breakthrough film for digital creatures, *Jurassic Park* (1993), had fewer than 60 CG shots. It took facilities in the U.S. years to develop the talent, management

tools, software, and digital pipelines that now make films with more than a thousand effects shots seem routine.

The fledgling digital facilities in emerging countries have one thing in their favor: Their learning curves are much shorter than ever before, thanks to the steady improvements in both software and hardware and to their eagerness to prove they can do the job. Given the ever-present pressure to produce effects for less money, a VFX Producer may find herself getting bids from and working with some of these lesser-known—and less tested—companies.

This is not without its risks, and the VFX Producer must carefully manage the body of work that's assigned to a foreign facility with only a limited track record. Management issues aside, the most important issue is that you and the VFX Supervisor must see to it that the work is matched to the facility's capabilities. It's one thing to give a group of wire removal shots to a relatively untested company. It's quite another to entrust the development and execution of a 3D CG animated character to such a facility.

Along these lines, you and the VFX Supervisor must keep in mind that artistic sensibilities may be quite different across two cultures. For this reason alone you must have a creative supervisor at the other end who understands what your project requires. In the absence of such an individual, you need to either put a trusted supervisor of your own in place or be prepared to have him or her make frequent trips back and forth. But when everything works out, there will be tremendous satisfaction in knowing that artists from other parts of the world worked with you toward a common goal.

The Foreign Factor

Working in foreign countries challenges the VFX Producer in a couple of ways. First, in budgeting: When the production is considering shooting overseas, you may be asked to get bids from vendors in foreign countries and compare them to similar services in the U.S. The bids may be submitted to you in a foreign currency, and you will have to convert them to U.S. dollars. This is actually a relatively simple task with Movie Magic Budgeting, Excel, and other programs that have built-in formulas to make currency conversions with relative ease.

A second way in which you may have to deal with production in foreign lands is preparing paperwork for materials and equipment that you will need to send overseas. Although all production companies will have production coordinators and customs agents taking care of most of the paperwork, you may be asked to submit the information about the equipment the visual effects department is having shipped.

Completing such paperwork is tedious but absolutely necessary. Many countries have very strict import, customs, and even

censorship laws that have to be obeyed. Officials want to make sure that equipment that enters their country will leave again and not enter the black market to be sold to one of its citizens or in some other way circumvent the country's trade laws. Thus, shipping a camera package will require a complete listing of every item contained in the various cases, including serial numbers. Even a duffel bag containing a single blue screen must be strictly accounted for.

Doing the nitty-gritty paperwork can be turned over to any trusted person on your staff, but you need to verify that the information is complete and correct before turning the matter over to the customs agent.

There is also the practical challenge of getting supplies. In the U.S. we are used to being able to ask for almost anything and get it, usually fairly quickly. It's different abroad, where even finding a sheet of posterboard may turn into a daylong undertaking. We in the visual effects department occasionally need special materials that may have to be imported or shipped from a supplier in another city, especially if we require large quantities or unusual materials not available in the host country. For this reason, you need to plan ahead so that you allow extra time to obtain supplies that are not routinely used by the production company.

Effect on Your Personal Affairs

Let's say you had a successful interview with a producer who now wants to hire you for a project that will require you to work overseas for a considerable length of time, maybe even in a developing or third world country. Suddenly, you're thrust into a situation where you must negotiate terms of employment for yourself, not for a crew that you're hiring. Here are some of the issues you should be mindful of.

Taxes

Under certain circumstances, working overseas might affect your tax status both here and abroad. Normally, taxes are not an issue as long as you are employed by an American production company that pays you in U.S. dollars drawn on a domestic bank. Personal income taxes may become an issue only if you are away from the U.S. for several months during any given year.

It is possible that you may have to pay taxes in the country where you are working, particularly if you work abroad for an extended period. If you end up having to pay taxes in a foreign country, consult with your accountant on how to offset the foreign taxes paid.

A more likely scenario would be one in which you agree to be paid in a foreign currency (e.g., Canadian dollars). Production companies will sometimes offer employment to Americans on

Tax Advice

Tax laws are very complex, and it is outside the scope of this book to do more than alert you to the importance of the topic. Please consult your tax adviser to discuss your individual situation.

condition that they become a "local hire," which means that they'll hire you only if you basically go to live in the foreign land and agree to work for the production as though you were a resident. You would pay your own expenses every step of the way; the production is relieved of having to pay your rent, *per diem*, and other personal expenses.

There is nothing illegal about this arrangement as long as (1) you have a work permit to work in that country (which the production company should be able to secure for you), (2) you really want the job, and (3) you can negotiate a deal that's to your satisfaction. Just remember that most of the tax deductions that you may be entitled to in the U.S. probably won't be available to you elsewhere.

Travel

There are several issues you need to keep in mind concerning travel. For one, extended travel is disruptive of family life. That may not be a problem for a single person, but it is a major factor for someone who is married and has a family. If you expect to be abroad for an extended period, you will want to address the matter of how many trips home the producer is willing to pay for over and above those required to manage your project, especially around the holidays.

There is also the question of method of travel. It is an unfortunate fact of life in the film industry that visual effects is still often regarded by studio people as a "poor relation." Given that mindset, it is common that the VFX Producer and even the VFX Supervisor are pressured to travel by coach and given as little time as possible between the time of arrival and beginning work. Try to negotiate for at least a business-class ticket for both the VFX Supervisor and VFX Producer, especially for long-distance travel overseas.

There are a couple of good reasons for this. First, as a matter of principle visual effects needs to be acknowledged by producers as a legitimate department, just like the camera, art, or any other department. You may be in charge of a budget in the tens of millions of dollars, and as such you and the VFX Supervisor are due the same respect and treatment (perks, if you like) as the heads of other departments. The fact that visual effects is not currently represented by a crafts union does not make your role any less important.

Second, there is a very practical reason why you should be accorded first-class (or at minimum business-class) travel status. It is that there is a good chance that you will have to "hit the ground running" upon arrival. By that we mean that you and the supervisor may be expected to start attending meetings immediately, or even go to set the very next day to supervise. You will be able to perform your duties much better if you had a comfortable

trip and a reasonable amount of rest. A smart producer will recognize this and should see the value of allowing an extra day or two for you to adjust to the new time zone and to get settled.

Health Issues

Be aware that your personal health insurance may not cover you if you fall ill or have an accident overseas. Even the production's policy may not fully cover you. It is therefore important to make sure there is adequate health insurance in place that will cover you 24 hours a day, even during your free time. If it does not, be sure to get your own and try to negotiate the premium as part of your employment agreement.

Some countries pose serious health risks, from inadequate medical facilities to endemic diseases. Malaria in tropical climes is one of the most serious of these. There are other diseases as well, and you and your companions may need to take a series of vaccinations before you leave. It should go without saying that these predeparture expenses must be paid for by the production company.

Health issues don't stop there. You may be required to take medications the entire time you are on location. Certain medications have unpleasant side effects that affect a crew's ability to function after a time. So before you sign on for a job at an exotic location, find out first what health issues you might encounter, and whether you think you are up to them.

In Sum

Working abroad definitely has its challenges and frustrations, ever more so as you move away from English-speaking and into more exotic lands. But on balance, it can be a rewarding experience. You'll have a chance to learn how people in other countries go about making movies, just as you hope they will learn from you. This can be not only deeply satisfying on the personal level, but also be very beneficial on the professional one. Many opportunities for both short- and long-term overseas employment exist for experienced VFX Producers. So if you are offered an opportunity to do a film in another country, take it.

SUCCESS STORY
Kim Lavery - *(Enchanted; Bridge to Terabithia)*

My two biggest passions in life are photography and piloting: traditional art and technology. Both of these interests have strongly influenced my path in life.... After attending Rhode Island School of Photography... I landed an intern position as a news videographer with an NBC affiliate....

After three great and challenging years at WPTZ. I was keen to hear what Hollywood might have to offer. I landed an interview with Universal Studios/Studio Operations, which led to a job.... I interfaced with the "best of the best" in film making. On *The Shadow* I was exposed to stage shoots with this funny blue backing (bluescreen) and on the backlot, to a funny-looking camera (VistaVision) and to a camera track on the ground (motion control)...visual effects!... The VFX Supervisor from *The Shadow* and I became friends.... I left Universal to work independently with that supervisor, on my first full VFX film, *Mortal Kombat.*

VFX producing is a combination of many skills: top organizer, money manager, politician, researcher, teacher, social worker, chameleon, challenge seeker, master hoop jumper. The Visual Effects Industry is ever evolving with new technology, new business models, new art forms, new mediums, and new global markets.

ACKNOWLEDGMENTS

Making movies is a collaborative enterprise that relies on the efforts of many individuals to succeed. So it was with this book: The authors benefited from the help and advice of many who are more expert than we are on a number of topics. We wish to express our sincere appreciation to them.

THANK YOU

Margaret Adamic (Disney Publishing Worldwide, Inc.)
Steve Addleman (Cyberware, Inc.)
Candice Alger (President, Giant Studios, Inc.)
Jeff Antebi (Waxploitation) - (Agent for Cee-Lo Green)
Howard Berger (KNB EFX Group, Inc.)
Emil Besirevic (Student)
Jonathan Betuel (Luma Pictures)
Chuck Binder (Agent for Daryl Hannah)
Scot Byrd (Director of PR for Rhythm & Hues)
Stephen & Edward Chiodo (Chiodo Bros)
Ilram Choi (Solo Mocap Actor Giant Studios)
Denny Clairmont (Clairmont Camera)
JoAnne Colonna (Manager for Elijah Wood – Brillstein Entertainment Partners)
Tony Curran (Actor)
Trinh Dang (Fox Clips Clearance Department)
Kevin Dorman (2nd Mocap Actor – Giant Studios)
Rose Duignan (Kerner Optical)
Syd Dutton (Illusion Arts)
Toby Gallo (President of OPS – Codex Digital)
Shannon Blake Gans (New Deal Studios)
Alec Gillis (Amalgamated Dynamics, Inc)
Daryl Hannah (Actress)
Mark Hansson (Ist AD)
Julie Heath (Warner Bros. Licensing)
Pam Hogarth (Gnomon School of Visual Effects)
James John Kerigan (Lawyer for HBO)
Rob Legato (VFX Supervisor)
Matt Madden (Giant Studios, Inc.)
Ed Marsh (VFX Editor)

Paul Maurice (Lidar VFX)
Randy McGowan (Reel Logix, Inc.)
James McQuaide (SVP, Production, Lakeshore Entertainment)
William Mesa (VFX Supervisor – Flash Filmworks)
Marlo Pabon (VFX Supervisor)
Miles Perkins (ILM)
Greg Philyaw (Giant Studios, Inc.)
Christopher L. Romine (president, S.two Corporation)
Tammy Rosen (agent for Tony Curran)
David Sharp (David B. Sharp Productions)
Payam Shohadai (Luma Pictures)
Tiffany Smith (Binder & Associates)
Derek Spears (Rhythm & Hues Studios)
Brian Sunderlin (Gentle Giant Studios)
Thomas Tannenberger (Gradient Effects)
Bill Taylor (Illusion Arts)
An Tran (PR Manager, Arri Inc.)
Mark Weingartner (VFX Supervisor)
Elijah Wood (Actor-Lord of the Rings – The Fellowship of the Ring)
Tom Woodruff, Jr. (Amalgamated Dynamics, Inc.)
Hoyt Yeatman (Director/VFX Supervisor)

SPECIAL THANKS

Ron Cogan (Entertainment Partners)
Kelly Crawford (VFX Editor)
Daniel Flannery (cover Design)
Jenny Fulle (The Creative Cartel)
Jeb Johenning (Ocean Video – Brainstorm Video Assist System)
Amy Jupiter (Animation Producer)
Gene Kozicki (Rhythm & Hues)
Joe Lewis (General Lift)
Ray McIntyre, Jr. (Pixel Magic)
Craig Mumma (digital Imaging Technician)
Jeffrey A. Okun (VFX Supervisor)
David Sanger (Miniature Producer – New Deal Studios)
Chuck Schuman (DP)
Robert Stromberg (Digital Backlot)
David Stump (DP/VFX Supervisor)
Nick Tesi (Eyetronics)
Tom Vice (FotoKem)
Pete Von Sholly (storyboards)
Ted White (S. two Corporation)

A SPECIAL NOD OF THANKS to our colleagues who agreed to answer our questionnaire about their personal road to becoming Visual Effects Producers.

VFX PRODUCERS

Tom Boland
Mike Chambers
Terry Clotiaux
Joyce Cox
Robin D'Arcy
Debbie Denise
Crystal Dowd
Jenny Fulle
Josh Jaggers
Karin Joy
Amy Jupiter
Tamara Kent
Kim Lavery
Mickey McGovern
Joel Mendias
Janet Muswell
Lori Nelson
Alison O'Brien
Tom Peitzman
Alison Savitch
Kerry Shea
Nancy St. John
Lynda Thompson
Kurt Williams

MOVIE MAGIC VFX BUDGET

This is the complete Demonstration Movie Magic 7.0 visual effects budget that our budget assumptions are based on in Chapter 7. You can select which accounts to add or delete as you go through the visual effects budget. Keep in mind that this budget is only an *example* that you can use as a template. Not every project will need all items listed, which is why many line items in this sample budget are purposely left blank. Also, be aware that the labor accounts give salary *ranges* which depend on whether it is a low or high budget film.

DEMONSTRATION VFX BUDGET

START DATE: March 16, 2009
WRAP DATE: Oct. 9, 2009
LOCATIONS: L.A. + Santa Fe
SHOOT: 8.2 Weeks
RELEASE: November 2009
SCRIPT DATE: December 2008

PRODUCER:
DIRECTOR:
EXEC. PROD.
WRITER:
UNIONS: WGA/DGA/SAG/IA/TEAMSTERS
BUDGET PREPARED BY:
BUDGET DATE: January 19, 2009

Acct No	Category Description	Page		Total
	ABOVE THE LINE TOTAL			0
	PRODUCTION PERIOD TOTAL			0
52-00	VISUAL EFFECTS	1		888,567
	TOTAL POST PRODUCTION			888,567
	TOTAL OTHER			0
	TOTAL ABOVE-THE-LINE			0
	TOTAL BELOVE-THE-LINE			888,567
	TOTAL ABOVE & BELOW-THE LINE			888,567
	TOTAL FRINGERS			72,444
	GRAND TOTAL			961,011

Acct No	Account Description	Page	Total
	ABOVE THE LINE TOTAL		0
	PRODUCTION PERIOD TOTAL		0
52-00	**VISUAL EFFECTS**	1	
52-01	VISUAL FX SUPERVISORS	1	248,300
52-02	VISUAL FX PRODUCER	1	133,700
52-03	VFX PRODUCTION STAFF	1	98,575
52-04	VFX EDITORS	2	76,500
52-05	RESEARCH AND DEVELOPMENT	2	5,000
52-06	ANIMATICS/STORYBOARDS	2	0
52-07	PRE-VISUALIZATION	2	19,000
52-08	CYBERSCANNING	2	10,000
52-09	SET SURVEYING / LIDAR	3	0
52-10	MOTION CAPTURE	3	0
52-11	MINIATURE BUILD	3	0
52-12	MINIATURE EXPENSES	3	0
52-13	MINIATURE SHOOT	3	0
52-14	MOTION CONTROL - CREW	3	0
52-15	MOTION CONTROL - EQUIPMENT	4	3,950
52-16	PLATE UNIT	5	86,500
52-17	DIGITAL VIDEO ASSIST	5	14,319
52-18	SET CONSTRUCTION	6	0
52-19	GRIP/SET OPERATIONS	6	5,000
52-20	CAMERA EQUIPMENT	6	0
52-21	BLUESCREEN/GREENSCREEN	7	8,365
52-22	PROJECTION	8	0
52-23	MATTE SHOTS	8	0
52-24	DIGITAL EFX/COMPOSITES	8	0
52-25	SCANNING & RECORDING	8	43,100
52-26	VIDEO TEMP COMPOSITES	9	25,000
52-27	FILM & LAB	9	4,058
52-28	RENTALS	9	69,200
52-29	PURCHASES	10	21,500
52-30	STILLS/PUBLICITY	10	0
52-31	BOX RENTALS	10	5,000
52-32	STOCK FOOTAGE	10	0
52-33	TESTS	10	10,000
52-34	TRAVEL & LIVING EXPENSES	10	0
52-35	MILEAGE	11	0
52-36	TRANSPORTATION	11	0
52-97	MISC. EXPENSES	11	0
52-98	LOSS & DAMAGE	11	1,500
	Account Total for 52-00		888,567
	TOTAL POST PRODUCTION		888,567

Acct No	Account Description	Page	Total
	TOTAL OTHER		0
	TOTAL ABOVE-THE-LINE		0
	TOTAL BELOW-THE-LINE		888,567
	TOTAL ABOVE & BELOW - THE LINE		888,567
	TOTAL FRINGES		72,444
	GRAND TOTAL		961,011

DEMONSTRATION BUDGET  Page 1

Acct No	Description	Amount	Units	X	Rate	Subtotal	Total
	ABOVE THE LINE TOTAL						0
	PRODUCTION PERIOD TOTAL						0
52-00 VISUAL EFFECTS							
52-01	VISUAL FX SUPERVISORS						
	(01) VFX SUPERVISOR						
	Rate: $5,000 - $7,500/week						
	Name:						
	Prep	8	Weeks	1	6,500	52,000	
	Shoot - LA	7.2	Weeks	1	6,500	46,800	
	Shoot - New Mexico	1	Weeks	1	6,500	6,500	
	Wrap/Post	22	Weeks	1	6,500	143,000	
	Holiday						
	Saturdays O.T. Shoot						
						248,300	
	Total						248,300
52-02	VISUAL FX PRODUCER						
	(01) VFX PRODUCER						
	Rate: $2,500 - $4,000/week						
	Name:						
	Prep	8	Weeks	1	3,500	28,000	
	Shoot - LA	7.2	Weeks	1	3,500	25,200	
	Shoot - New Mexico	1	Weeks	1	3,500	3,500	
	Wrap/Post	22	Weeks	1	3,500	77,000	
	Holiday						
	Saturdays O.T. Shoot						
						133,700	
	Total						133,700
52-03	VFX PRODUCTION STAFF						
	(01) VFX Prod. Coordinator						
	Rate: $1,500 - $1,800/week						
	Name:						
	Prep	6	Weeks	1	1,500	9,000	
	Shoot - LA	7.2	Weeks	1	1,500	10,800	
	Shoot - New Mexico	1	Weeks	1	1,500	1,500	
	Wrap/Post	22	Weeks	1	1,500	33,000	
	Holiday						
	Saturdays O.T. Shoot						
						54,300	
	(02) VFX Assist. Prod. Coord.						
	Rate: $750 - $1,000/week						
	Name:						
	Prep	2	Weeks	1	750	1,500	
	Shoot - LA	7.2	Weeks	1	750	5,400	
	Shoot - New Mexico	1	Weeks	1	750	750	
	Wrap/Post	22	Weeks	1	750	16,500	
	Holiday						
	Saturdays O.T. Shoot						
						24,150	
	(03) VFX Prod. Asst.						
	Rate: $125/day						
	Name:						
	Prep	2	Weeks	1	625	1,250	

Continuation of Account 52-03

Acct No	Description	Amount	Units	X	Rate	Subtotal	Total
	Shoot - LA	7.2	Weeks	1	625	4,500	
	Shoot - New Mexico	1	Weeks	1	625	625	
	Wrap/Post	22	Weeks	1	625	13,750	
	Holiday						
	Saturdays O.T. Shoot						
						20,125	
	Total						98,575
52-04	VFX EDITORS						
	(01) VFX Editor						
	Range $2,500 - $3,500/week						
	Name:						
	Prep	0.4	Weeks	1	2,500	1,000	
	Shoot - LA	7.2	Weeks	1	2,500	18,000	
	Shoot - New Mexico	1	Weeks	1	2,500	2,500	
	Post	22	Weeks	1	2,500	55,000	
	Holiday						
	Saturdays O.T. Shoot						
						76,500	
	Total						76,500
52-05	RESEARCH AND DEVELOPMENT						
	(01) Research & Development	1	Allow	1	5,000	5,000	
						5,000	
	Total						5,000
52-06	ANIMATICS/STORYBOARDS						
	(01) Animatic Reel Production						
	(02) Editing Animatic Reel						
	(03) Storyboard Artist						
						0	
	Total						0
52-07	PRE-VISUALIZATION						
	Labor:						
	(01) Lead Animator #1	1	Week	1	2,500	2,500	
	(02) Secondary Animator #2	1	Week	1	2,500	2,500	
						5,000	
	Equipment:						
	(03) Equipment #1 - 1st Animator	1	Week	1	2,000	2,000	
	(04) Equipment #2 - 2nd Animator	1	Week	1	2,000	2,000	
						4,000	
	(05) Animatic Expenses						
						0	
	(06) Outside Pre-Vis Vendor	2	Weeks	1	5,000	10,000	
						10,000	
	Total						19,000
52-08	CYBERSCANNING						
	Eyetronics (1 cast member)						
	High Res Scan of Full Body with Head	1	Day	1	4,000	4,000	
	plus wardrobe						
	Cleanup of Scan for 3D Ready	1	Allow	1	2,000	2,000	
	(1 actor)						
	Cyberscan Day - $1000/dy per tech	2	Techs	1	1,000	2,000	
	Travel Day $500/dy per tech	2	Days	2	500	2,000	

DEMONSTRATION BUDGET Page 3

Continuation of Account 52-08

Acct No	Description	Amount	Units	X	Rate	Subtotal	Total
						10,000	
	Total						10,000
52-09	SET SURVEYING / LIDAR						0
52-10	MOTION CAPTURE						
	(01) Facility Charges						
	(02) Motion Capture Performers						
						0	
	Total						0
52-11	MINIATURE BUILD						
	Miniature Contract:						
	(01) Buidling/Construction Bid						
	List of Miniatures and Scale						
	1. (See Miniature Breakdown for costs)						
						0	
	(02) Stage/Warehouse Rentals						
						0	
	(03) Other Costs						
						0	
	Total						0
52-12	MINIATURE EXPENSES						
	(01) Transportation, Gas, & Oil						
	(02) Per Diem						
	(03) Hotels						
	(04) Misc. Expenses						
						0	
	Total						0
52-13	MINIATURE SHOOT						
	(01) Miniatures Shooting Costs						
	(See Miniature Detail Budget)						
	Prep/Test Days						
	($25,000 - 35,000 per day)						
	Shoot Days						
	($40,000 - 45,000 per day)						
	Wrap/Strike Days						
	($25,000 per day)						
						0	
	(02) Stage (Included)						
						0	
	(03) Special Rigs/Support Etc.						
						0	
	(04) Equipment Costs						
						0	
	Total						0
52-14	MOTION CONTROL - CREW						
	(01) VFX DP/Cameraman						
	Prep - $1500/10 Hr Day - $136.36						
	Shoot - $1909/10 Hr Day						
						0	
	(02) VFX 1st A.C.						
	Prep - $500/10 Hr Day - $45.45						
	Shoot $636 /12 Hr Day						

Continuation of Account 52-14

Acct No	Description	Amount	Units	X	Rate	Subtotal	Total
	Strike - $500/10 Hr Day						
	Kit Rental $50/day or $250/wk						
	(02) Moco Operator						
	Prep - $950/10 Hr Day - 86.36/hr						
	Shoot - $1209/12 Hr Day						
						0	
	(03) VFX 2nd A.C.						
	Prep - $400/10 Hr Day - $36.36						
	Shoot $509 /12 Hr Day						
	Strike - $400/10 Hr Day - $36.36						
						0	
	(04) Moco Technician						
	Prep - $605/10 Hr Day - $55/hr						
	Shoot $770/12 Hr Day						
	Strike - $605/10 Hr Day - $55/hr						
	Kit Rental $50/day or $150/wk						
						0	
	(06) EncodaCam Operator						
	Prep - $850/10 Hr Day - $77.27						
	Shoot $1082/12 Hr Day						
						0	
	(07) EncodamCam Enginner						
	Prep - $850/10 Hr Day - $77.27						
	Shoot $1082/12 Hr Day						
						0	
	(08) EncodamCam Technician						
	Prep - $850/10 Hr Day - $77.27						
	Shoot $1082/12 Hr Day						
						0	
	Total						0
52-15	MOTION CONTROL - EQUIPMENT						
	(01) EncodaCam Visualization System						
	Includes: Encodacam/Brainstorm Workstation/Ult						
	& Video gear to generate Blue/Green real time						
	composites - 3 day week						
	Rate: 3 Day Week @$600/day						
						0	
	(02) Fisher or Chapman Dolly						
	Encoder Kit						
	Rate: 3 Day Week @$150/day						
						0	
	(03) Technocrane Encoder Kit						
	Rate: 3 Day Week @$150/day						
						0	
	(04) Lenny Arm II Plus Encoder Kit						
	Rate: 3 Day Week @$150/day						
						0	
	(05) Tripod, O'Connor Head, Blue I						
	Camera Tracker						
	Rate: 3 Day Week @$500/day						
						0	

Continuation of Account 52-15

Acct No	Description	Amount	Units	X	Rate	Subtotal	Total
	(06) AeroJib w/O'Connor 2575, Magnum Dolly						
	Rate: 3 Day Week @$1000/day						
						0	
	(07) Weaver-Steadman 3 Axis Encoded Head						
	Rate: 3 Day Week @$300/day						
						0	
	(08) Genuflex Mark III - (Quiet Servo System)						
	and Jet Rail Motion Control Dolly						
	Rate: 3 Day Week @$3,000/day						
						0	
	(09) Technocrane Encoder Kit with						
	Libra Head Kit - Kuper System						
	Rate: 3 Day Week @$600/day						
						0	
	(10) RotoFlex Field Unit						
	Includes: RotoFlex Head, Focus + Zoom Motor						
	Brackets, Kuper System Rack Mounted Computer,						
	4 Channel Stepper Drivers, Pan/Tilt						
	Encoder Wheels, all necessary						
	Kuper and Camera Sync accessories & cables						
	Rate: 3 Day Week @$1,000/day						
						0	
	(11) Arri 435 Camera						
	with Video Tap						
	Arri Ultra Zeiss Prime Lens Set						
	1 Hyrbrid II Dolly w/Ubangi						
	2575 O'Connor Head for Pan/Tilt System						
						0	
	(12) Zebra Dolly & Track:						
	1-Zebra Motion Control Dolly w/Track (36')	1	Week	1	2,500	2,500	
	1-Focus and Zoom Motor Package						
	1-Pan/Tilt Encoder Wheels Package w/Focus/Zoom						
						2,500	
	(13) Track - 60' Feet	1	Week	1	950	950	
						950	
	(14) Truck RT w/Driver	1	R T	2	250	500	
						500	
	Total						3,950
52-16	PLATE UNIT						
	(01) Flame/Smoke/Pyro/Dust/Water/Bullet Hits						
	Range: $25,000 - $35,000 for Prep/Strike						
	Prep Crew	1	Day	1	30,000	30,000	
	Range: $40,000 - $45,000 for Shoot						
	Shoot Crew	1	Day	1	45,000	45,000	
	Strike (no strike)						
	(02) Pyro Rigs, Materials	1	Allow	1	10,000	10,000	
	(03) Rental of Blacks 40 X100	1	Week	1	1,500	1,500	
						86,500	
	Total						86,500
52-17	DIGITAL VIDEO ASSIST						
	(01) Video Perception Recorder (Labor)						

Continuation of Account 52-17

Acct No	Description	Amount	Units	X	Rate	Subtotal	Total
	Y1 - $46.15/Hr (12 W/Hrs)						
	Prep	1	Day	1	507.65	508	
	Shoot	2	Weeks	1	3,230.5	6,461	
						6,969	
	(02) Digital Video Assist Equip.						
	Digital Compositing Station $450/dy	2	Weeks	1	2,250	4,500	
	A&B Mixer which allows overlays +	2	Weeks	1	1,000	2,000	
	live green screen keying between sources						
	(Sales tax included in fringes)						
						6,500	
	(03) Expendables:						
	Black + White Printer - 200-300 pictues	1	Allow	1	50	50	
	Color Printer - 200-300 pictures	1	Allow	1	200	200	
	Velcro, tape + cable repair parts	1	Allow	1	200	200	
	DVD Backup Discs	1	Allow	1	200	200	
	(200-300 discs w/cases)						
	Labels + Ink	1	Allow	1	200	200	
	(Sales tax included in fringes)						
						850	
	Total						14,319
52-18	SET CONSTRUCTION						
	(01) Platforms/Scallfolding						
	(02) Construction Expenses						
	(03) Painting Labor						
	(04) Painting Expenses						
	(05) Masonite Sheets - 4 x 8 Sheets						
						0	
	Total						0
52-19	GRIP/SET OPERATIONS						
	(01) Cranes	1	Allow	1	5,000	5,000	
	(02) On Set Special Rigging						
						5,000	
	Total						5,000
52-20	CAMERA EQUIPMENT						
	Vista Vision Camera with Accessories:						
	(01) Mini-Vistavision (light weight) Camera						
	(specify ground glass)						
	CEI Flickerfree Color V Video Camera						
	3 Pin Registration/ 1-72 FPS Crystal Speed Control						
	1 Set of Leica Lenses						
	3 x 3 Arri Matte Box						
	Arri Type Riser Plate with 2 Rods						
	4 Camera Power Cables / 2 Video Power Cable						
	3 - 400´ Magazines						
	1-remote on/off cable						
	1-Arriflex MB 18 Matte Box						
	2 - Block Batteries						
	1 - Arriflex Manual Follow Focus/2 Rods						
	Rate: $2500/per week						
						0	
	(02) Cameras and Lenses						
						0	

Continuation of Account 52-20

Acct No	Description	Amount	Units	X	Rate	Subtotal	Total
	(03) Camera Accessories						
						0	
	(04) Set Survey Labor/Equipment - Lidar or Laser E						
	($1500 - $5,000/day)						
						0	
	(05) Digital Still Camera Equipment						
	(for on set lighting + reference photos)						
	35mm camera, with lens, + bracket converter						
	about $1100 to purchase						
						0	
	Total						0
52-21	BLUESCREEN/GREENSCREEN						
	(01) Blue/Greenscreen Stage:						
	Pre-Rig/Shoot Days						
	List of GS Sets and Sizes of GS						
	Stage - 20' x 80' GS	2	Weeks	1	800	1,600	
	(Sales tax included in fringes)						
						1,600	
	(02)Grip Labor						
	Prep/Shoot/Strike per Set						
	(Included in 1st Unit Budget)						
						0	
	(03)Electric Labor						
	Prep/Shoot/Strike per Set						
	(Included in 1st Unit Budget)						
						0	
	(04) GS Location						
	10' x 15' GS	8.2	Weeks	1	75	615	
	15' x 20' GS	8.2	Weeks	1	150	1,230	
	30' x 40' GS	8.2	Weeks	1	600	4,920	
	(Sales tax included in fringes)						
						6,765	
	(05) Kinos For GS Stage						
	4 Lamps/$65 each = $130/wk						
	(Sales tax included in fringes)						
	(Included in 1st Unit Budget)						
						0	
	(06)) Kinos For Location GS						
	(Sales tax included in fringes)						
	(Included in 1st Unit Budget)						
						0	
	(07) Image 80 Lamps						
	(Sales tax included in fringes)						
	(Included in 1st Unit Budget)						
						0	
	(08) Misc. Expenses:						
	Mirrorplex for Flooring ($125/sheet)						
	Drop Cloths 9 X 12 ($15/Cloth)						
	Mylar Tapes 2" wide ($25/Roll)						
	Digital Green Tape 2" wide($25/Roll)						
	Digital Green Paint ($60/Gallon)						

Continuation of Account 52-21

Acct No	Description	Amount	Units	X	Rate	Subtotal	Total
	Digital Green Fabric ($100/Yard)						
	(Sales tax included in fringes)						
						0	
	Total						8,365
52-22	PROJECTION						
	(01) Rear Screen Projection						
	(includes labor & equipment setup						
	charges, and platforms needed)						
	Stage Costs:						
	(Range: $25,000 - $30,000/day)						
	Prep						
	Shoot						
	Wrap						
						0	
	Total						0
52-23	MATTE SHOTS						
	(01) Matte Painting Bid						
	(02) MP Set Extensions						
						0	
	Total						0
52-24	DIGITAL EFX/COMPOSITES						
	(01) VFX Facility #1 BID:						
	(See Detailed Excel Breakdown)						
	CG & Digital Compositing Costs						
	CG Model Costs						
	R & D Look Developement						
	On Set Production Digital VFX Supervisor						
	(Range if $1,000 - $1,500 per day)						
						0	
	(02) Add'l Shots/ Wire/Rod Removals						
						0	
	(03) VFX Facility #2 BID						
						0	
	(04) Digital Tape Stock						
						0	
	Total						0
52-25	SCANNING & RECORDING						
	Based on 100 Shots:						
	(01) Scanning	27,200	Frames	1	0.5	13,600	
	(8 frame handles at head + tail =						
	136 frames per layer x 100 shots x 2 layers)						
						13,600	
	(02) Record Out	36,000	Frames	1	0.75	27,000	
	(no handles - 120 frames per 5 sec. shot)						
	(1 Temp + 2 Finals)						
	(120 frames x 3 x 100)						
						27,000	
	(03) Setup Charges	20	Allow	1	125	2,500	
						2,500	
	(04) Film/Dev/Print for VFX Shots						
						0	

Continuation of Account 52-25

Acct No	Description	Amount	Units	X	Rate	Subtotal	Total
	(05) Stock Charges						
						0	
	Total						43,100
52-26	VIDEO TEMP COMPOSITES						
	(01) Previews	1	Allow	1	25,000	25,000	
						25,000	
	Total						25,000
52-27	FILM & LAB						
	(01) Purchase Rawstock						
	Rawstock (Plate Element Unit)						
	(Element Shoot 3,000 feet per day)	3,000	Feet	1	0.6	1,800	
	(1 shoot day = 3,000 feet)						
	Rawstock (GS Unit)						
	(Sales tax included in fringes)						
						1,800	
	(02) Develop (100%)						
	Rawstock (Plate Element Unit)	3,000	Feet	1	0.12	345	
	Rawstock (GS Unit)						
	(Sales tax included in fringes)						
						345	
	(03) Printing (100%)	3,000	Feet	1	0.28	838	
	(Sales tax included in fringes)						
						838	
	(04) Telecine/Transfer for Dailies						
	VFX Unit						
	HDCam SR - 60 minute load	3,000	Feet	1	0.35	1,050	
	(Sales tax included in fringes)						
						1,050	
	(05) Stock $20-$25/ per Disk						
	DVD's	1	Allow	1	25	25	
	(Sales tax included in fringes)						
						25	
	(06) Reprints						
	(Sales tax included in fringes)						
						0	
	(07) Screening Room Charges						
	(08) Outside Lab Service						
						0	
	Total						4,058
52-28	RENTALS						
	(01) Avid Media Composer 4000,	30.6	Weeks	1	1,500	45,900	
	+ Beta SP Player/Recorder &						
	9 GB Drives.						
	(Sales tax included in fringes)						
						45,900	
	(02) Avid Editing System Rental	30.6	Weeks	1	450	13,770	
	(Includes Benches, Tables, etc.)						
	(Sales tax included in fringes)						
						13,770	
	(03) Misc. Equip. Rents	30.6	Weeks	1	0	0	
	(Sales tax included in fringes)						

Continuation of Account 52-28

Acct No	Description	Amount	Units	X	Rate	Subtotal	Total
						0	
	(04) VCR's / Monitors	30.6	Weeks	1	50	1,530	
	Hi Def Monitor	8	Months	1	1,000	8,000	
	(Sales tax included in fringes)						
						9,530	
	(05) Misc. Allowance						
						0	
	Total						69,200
52-29	PURCHASES						
	(01) Supplies/Office Expenses	1	Allow	1	10,000	10,000	
	(02) Stills/Photos	1	Allow	1	500	500	
	(03) Computer System Repair	1	Allow	1	1,000	1,000	
	(04) Software Programs						
	(05) Editorial Purchases/Supplies	1	Allow	1	2,500	2,500	
	(06) G4 Workstation w/Final Cut Pro	1	Allow	1	7,500	7,500	
	(07) Beta Deck/Cables						
	(08) Craft Service/Meals						
	(09) Setup for T-1 Line						
						21,500	
	Total						21,500
52-30	STILLS/PUBLICITY						
	(01) Stills - Film & Dev.						
						0	
	Total						0
52-31	BOX RENTALS						
	Range between $500 - $1,000						
	(01) VFX Supervisor Computer	1	Allow	1	1,000	1,000	
	(02) VFX Producer Computer	1	Allow	1	1,000	1,000	
	(03) VFX Editor Computer	1	Allow	1	1,000	1,000	
	(04) VFX Coord Computer	1	Allow	1	1,000	1,000	
	(05) VFX Asst. Computer	1	Allow	1	1,000	1,000	
						5,000	
	Total						5,000
52-32	STOCK FOOTAGE						
	(01) Stock Footage Library						
						0	
	Total						0
52-33	TESTS						
		1	Allow	1	10,000	10,000	
						10,000	
	Total						10,000
52-34	TRAVEL & LIVING EXPENSES						
	(01) VFX Supervisor						
	Hotel						
	Per Diem						
	Airfares						
	Car Rental						
	(included in 1st Unit budget)						
						0	
	(02) VFX Producer						
	Hotel						

Continuation of Account 52-34

Acct No	Description	Amount	Units	X	Rate	Subtotal	Total
	Per Diem						
	Airfares						
	Car Rental						
	(included in 1st Unit budget)						
						0	
	(03) VFX Crew						
	Hotel						
	Per Diem						
	Airfares						
	Car Rental						
	(included in 1st Unit budget)						
						0	
	(04) Cars/Vans						
	(included in 1st Unit budget)						
						0	
	(05) Airport Taxes						
	(included in 1st Unit budget)						
						0	
	(06) Shipping Equipment						
	(included in 1st Unit budget)						
						0	
	Total						0
52-35	MILEAGE						
	(01) Runner/P.A. Mileage						
						0	
	Total						0
52-36	TRANSPORTATION						
	(01) Trucking/Delivery - M/C Cameras						
	(02) Scissorlifts/Condors						
	(03) Transportation of Miniatures						
	(04) Stakebeds/Vans						
						0	
	Total						0
52-97	MISC. EXPENSES						0
52-98	LOSS & DAMAGE						
	(01) Loss & Damage	1	Allow	1	1,500	1,500	
						1,500	
	Total						1,500
Account Total for 52-00							888,567

TOTAL POST PRODUCTION		888,567
TOTAL OTHER		0
TOTAL ABOVE-THE-LINE		0
TOTAL BELOW-THE-LINE		888,567
TOTAL ABOVE & BELOW - THE LINE		888,567
TOTAL FRINGES		72,444
GRAND TOTAL		961,011

CREW DEAL MEMO

Daily / Weekly Employees

Name: _____ Position: _____

Address: _____ SSN: _____

_____ Loanout: _____

_____ Fed ID#:: _____

_____ Phone _____

Type of Assignment: Daily: _____ Weekly: _____ Start Date: _____

Base Hourly Rate: _____ (NONEXEMPT POSITIONS)

Weekly Rate: _____ (EXEMPT POSITIONS ONLY)

(PARTIAL WEEKS PAID PRO-RATA)

Daily Rate: _____

Car Allowance: _____ (PARTIAL WEEKS PAID PRO-RATA)

Box / Kit: _____ (PAID FOR PRODUCTION WEEKS ONLY
ONLY PARTIAL WEEKS PAID PRO-RATA)

Rentals: _____

Other Conditions: _____

IN ACCORDANCE WITH THE IMMIGRATION REFORM AND CONTROL ACT OF 1986, ANY OFFER OF EMPLOYMENT IS CONDITIONED UPON SATISFACTORY PROOF OF APPLICANT'S IDENTITY AND LEGAL ABILITY TO WORK IN THE UNITED STATES.

EMPLOYEE ACCEPTS ALL CONDITIONS OF EMPLOYMENT AS DESCRIBED ON THE REVERSE.

EMPLOYEE SIGNATURE: UNIT PRODUCTION MANAGER SIGNATURE:

_____ _____

DATE: _____ DATE: _____

NO IN-TOWN 6TH DAY, DISTANT LOCATION 7TH DAY, OR HOLIDAY WORK WILL BE PAID UNLESS AUTHORIZED IN ADVANCE BY PRODUCTION MANAGER. NO FORCED CALLS WITHOUT PRIOR APPROVAL OF PRODUCTION MANAGER.

1. Before hire, Employee must provide Company with all documents required by governmental agencies, etc. for Employee to render services, including INS Form I-9 and submission of original documents establishing Employee's employment eligibility.
2. All purchases / rentals MUST be approved by the Production Manager before being ordered.
3. Petty cash expenses not accompanied by original receipt will NOT be reimbursed. Petty cash must be cleared PRIOR to completion of assignment to ensure timely payment.
4. Employee hereby expressly authorizes the Employer to deduct unsettled incidentals and / or petty cash advances incurred by Employee from the Employee's paycheck.
5. Petty cash expenses incurred prior to or after employment periods will not be reimbursed unless approved by UPM.
6. Employee is responsible for all recoverable items purchased by Employee, to be collected and reconciled with accounting during wrap.
7. Holidays will not be worked and will not be paid.
8. Time cards must reflect hours worked, not hours guaranteed.
9. Time cards must be turned in Saturday in order to ensure timely payment.
10. Kit / car rentals will be prorated for any partial week worked, and are to be paid for shoot days only.
11. Employee must provide Company with a legitimate itemized list of items being rented in kit or box. It is the responsibility of the Employee to insure all personal property rented by the Company. The Company assumes no liability for loss or damage to such property.
12. Employees who are driving their own vehicles for production-related work are NOT covered under the Company's auto insurance. If a car allowance is given, this payment includes mileage, wear and tear, gas, and auto insurance. Fines and penalties imposed for the violation of parking and traffic laws are to be paid by Employee and are not reimbursable.
13. There is no reimbursement for cellular phone calls unless authorized IN ADVANCE by production manager. If agreed to, reimbursement will be for actual calls only at a reimbursement rate of no more than $0.45 per minute.
14. Employee is responsible for all hotel incidentals. Company is responsible for room and tax only.
15. Employees hired on a daily / hourly basis are guaranteed compensation for one day; Employees hired on a weekly

basis are guaranteed compensation for one week, prorated thereafter.

16. Car allowance, box or kit rentals and living allowances in excess of IRS guidelines will be reported as income on the W-2 form and appropriate taxes will be withheld.

17. Employee shall comply with all rules and regulations of Company and shall be subject to the direction and control of Company.

18. Company is under no obligation to commence principal photography as scheduled and may advance or delay Employee's start date at its sole discretion.

19. This is NOT a "Pay or Play" deal. Company reserves the right to suspend work without compensation during all periods when Employee is unable to perform services by reason of physical or mental disability, when Employee is in default (i.e., fails, refuses, or neglects to comply with obligations thereunder), or if an act of God, accident, failure of facilities or other "force majure" event not within the Company's control occurs. Company may terminate Employee's engagement at any time for the foregoing reasons. Company's only obligation is to pay the unpaid balance of any compensation accrued by Employee prior to such termination.

20. Employee shall not engage in activities that might result in conflict of interest. With the exception of kit rentals and car allowances Employees may not rent or sell any personal items to the Company without prior approval from the production manager. Employee represents and warrants that Employee is not subject to any obligation or disability which would interfere with or prevent the Employee from performing the functions of the job, with or without reasonable accommodations.

21. Company is the sole, exclusive, and perpetual owner for use in any manner of all rights, title and interest in Employee's engagement and services, and to the results and proceeds of Employee's engagement and services, which is deemed a "work made for hire" for Company under U.S. copyright laws.

22. Screen credit is at Company's sole discretion. If granted, name to read as listed on deal memo.

TECHNICAL INFORMATION

NTSC Format
The standard television/video format in the United States, which delivers images at a resolution of 525 vertical lines at 29.97 frames per second.

High-Definition (HD) Format
A newer television/video system than NTSC that almost completely replaced NTSC in broadcasting in 2009. The HD standard for television is 1920×1080 pixels.

Resolution
Resolution refers to the number of pixels the digital image is composed of. Pixels (a contraction of the words "picture element") are the smallest, microscopic building blocks of digital images. The more pixels an image is composed of per unit area, the higher the resolution—and therefore the perceived clarity – of the image.

Leaving aside large format films (such as IMAX and other special venue formats) and 16mm, contemporary feature filmmakers have a number of common 35mm formats to choose from.[1] When a VFX Editor writes up an order for negative to be scanned, he or she must specify the format to be used for the scan, since each uses a slightly different area of the film. Among the most common formats we encounter in visual effects are Academy Aperture, Super-35, 1:1.85, and VistaVision.

[1] Scores of film formats have been invented and used since motion pictures were invented. Thankfully, only a few have survived.

Common formats and their pixel counts[2]

Full Aperture (Super-35)

2K Resolution	2,028 × 1,556 pixels
4K Resolution	4,056 × 3,112 pixels

Academy Aperture

2K Resolution	1,828 × 1,332 pixels
4K Resolution	3,656 × 2,664 pixels

A single frame of Academy format is made up of almost 2-½ million pixels, each of which has a numeric value describing its color, brightness, and position in space.

[2]For more detailed information about film formats, please refer to sources like *American Cinematographer Manual*, published by the American Society of Cinematographers.

GLOSSARY

2D ANIMATION—A flat, digital image that is defined only by height and width, not depth.

3D CG—Digital imagery created with software capable of producing virtual objects having height, width, and depth. 3D CG objects can be fully moved and rotated inside the computer.

ACADEMY APERTURE—The standard camera aperture used in 35-mm film. It is slightly smaller than full aperture to allow an area along the edge of the film for the sound track.

AD (ASSISTANT DIRECTOR)—During preproduction he or she does the script breakdown and schedules the shooting; during production the AD (with the help of one or more 2nd ADs) is in charge of running the set in all its complexities.

ANIMATIC—A rough approximation of a scene achieved by photographing storyboards to indicate critical action and timing.

ANIMATRONIC—Generally refers to puppets of humans, animals, or imaginary creatures that are made to move through the use of mechanical, electronic, or radio control devices.

ASPECT RATIO—The proportion—or ratio—of the width of a frame to its height. Common ratios in film are 1.85:1 and 2.33:1.

BACKGROUND PLATE—The image to be used in the background of a composite scene. Frequently, they are referred to simply as "plates" in the context of their filming.

BEAM SPLITTER—A mirror that is semi-transparent so that part of the light hitting it is reflected, and part of it passes through it. Most beam splitters are 50–50, meaning that they will allow half the light to pass through them.

BLACKSCREEN—A technique used to film visual effects elements such as smoke, water, dust, and flames against a black background so that they can be composited with other elements.

BLUE/GREEN COMPOSITES—This is a technique where a piece of foreground live action or miniatures is filmed against a pure blue or green backing. The blue or green color is replaced during compositing with another element that can be another piece of live action, a miniature, or a digital element. The technique is more generally called traveling matte photography.

BREAKDOWN SHEETS—Sheets that list all essential requirements needed to film a scene; they are usually generated by the 1st AD.

CBB (COULD BE BETTER)—A term sometimes used to indicate that a shot is almost final and may be revisited if there is time and money to improve it, once the other shots have been finalized.

CGI—Commonly called CG, an abbreviation of computer-generated imagery; any image created by computer.

CLEAN (EMPTY) BACKGROUND PLATE—A plate of just the background of a shot without actors or other moving objects that obscure the background in the live-action plate. Used mainly to fill in the background in wire removal shots.

COMPOSITING—The process of combining all elements of a visual effects shot into one final shot so that it looks like everything was filmed together.

CONFORMING—The process of cutting a film's negative to match the key numbers on the final cut of the work print or of extracting digital files to match the final Edit Decision List when assembling the Digital Intermediate.

CYBERSCANNING—The process of using a laser to scan people, props, or wardrobe for the purpose of creating digital doubles of the scanned object, so a 3D model can be made which can then be manipulated in a computer.

DIGITAL BACKLOT—The practice of using digitally created sets in place of real ones, sometimes adapting existing digital sets to future projects.

DP (DIRECTOR OF PHOTOGRAPHY)—Next to the director the second most important member of the creative team on the production. The DP is responsible for the visual interpretation of the script; he is also the person in charge of the set crew.

DPX (DIGIAL PICTURE EXCHANGE)—The best digital format for capturing the complete range of colors and contrast of the moving images of an original scene and for accurately exchanging this and other critical information between different facilities and formats without loss of data.

ELEMENT—Any live-action or digitally created image that becomes part of a composited visual effects shot.

FILM SCANNER—A scanning device that converts the analog images of film into digital data that can be read by a computer for subsequent image manipulation.

FINAL—A composite that has everyone's approval to be cut into the picture.

FIREWIRE—A means to connect different pieces of high-end digital equipment so that they can easily and rapidly transmit digital data back and forth between them.

FORCED PERSPECTIVE W/LIVE ACTION—Forced perspective is a technique meant to fool the eye into believing that an object is much farther away from camera than it is in reality, or to make it look like an object is much bigger than it really is. Forced perspective can be done in-camera or as a composite.

FOREGROUND ELEMENT—Any piece of action that appears closer to the camera than all others. It usually implies that this element will be matted in over one or more background elements.

FORMAT—The aspect ratio of an image, that is, the proportion of the width of the image to its height. May also refer to film gauge, such as 35-mm, 16-mm, or 70-mm film.

FOUR-PERF—Refers to the four perforations, or sprocket holes, of a standard 35-mm frame.

FPS—Frames per second.

FRAME RATE—The rate at which film or video is exposed in the camera, measured in frames per second. In film, the standard frame rate is 24 frames per second

FULL APERTURE—The largest image area available in any given format of image capture system. Most often used in reference to 35-mm film.

GLOBAL—In Movie Magic Budgeting, globals are values that apply equally throughout a budget. They are generally short equations and are designated by an abbreviation that is easy to remember and to type. An example of a global might be SW (meaning shoot weeks) as the abbreviation, and SD/5 as the equation, where SD equals the number of shoot days in a five-day work week.

GRADING—Also known as color timing. The procedure of determining the correct color, density, and contrast to a shot so that it matches the surrounding scenes.

HANDLE—A few extra frames of film at the head and tail of a shot added as protection to allow for changes in length of an edited shot. Used primarily when ordering negative to be scanned for visual effects shots. Standard handles are eight frames long, but any length can be designated.

HANGING MINIATURES/FOREGROUND MINIATURES—An in-camera technique where we place a miniature close to the camera and line it up and paint it so that it blends perfectly into a live-action background that usually is much farther away.

HIGH-DEFINITION (HD)—Generally refers to any video system of higher resolution than standard definition (SD) video. It is commonly used in TV production, usually at display resolutions of 1280×720 (720p) pixels or 1920×1080 (1080i or 1080p) pixels where 'p' indicates a progressive scan, and 'i' indicates an interlaced scan. 1080p is the current format for highest resolution TV production.

IN-CAMERA—A term meaning that the action is filmed as it occurs in real time on the set (see below) in one or multiple passes so that no image manipulation is needed in postproduction

IN-CAMERA MINIATURES—These are stand-alone miniatures that are shot all in-camera and can be cut into the film as is without further manipulation in postproduction.

INTERNEGATIVE (IN)—A duplicate negative made from an interpositive, most commonly used in the manufacture of release prints of a film.

INTERPOSITIVE (IP)—A duplicate made from an original film negative that results in a positive image. IPs are most commonly used to produce internegatives from which large numbers of release prints can be struck.

KEY NUMBERS (also called edge numbers)—Visible numbers embedded along the edge of motion picture film that are used to identify any given frame of film. Key numbers change every 16 frames (one foot) in 35-mm film.

KEY-FRAME ANIMATION—Animation in which the animator draws a character's poses manually instead of generating the action from motion capture data. "Key frame" refers to the fact that the animator may draw the character's poses a few frames apart (the "key frames")

and an artist called an in-betweener fills in the poses between the key frames.

LASER SCANNER—A scanner that uses a laser beam to read the color and brightness of thousands of points in a single frame of motion picture film.

LIDAR (Light Detection and Ranging)—A technique by which very large areas are scanned by a laser, resulting in highly detailed views of the surface of the objects being scanned. The data can then be used by a digital artist to build a photorealistic model of the scanned object to use as an element in a visual effects shot.

MATCH MOVE—The procedure of exactly repeating a camera move during photography of foreground and background elements, or of duplicating the move of a real camera in the computer to match the movement of digital elements to live action.

MATTE—An opaque image that conforms to the shape of an object to prevent exposure of the film or to keep that area of the image blank when working in digital so that another object may be put in the area covered by the matte.

MATTE PAINTINGS—Paintings that augment or replace part of a live-action image. Matte paintings are used to create fantasy environments or add scope or complexity to a shot that would otherwise be too expensive or impossible to film for real. Now usually created as digital 2D, 2.5D or 3D CG paintings.

MODELING—The process of building a model in the computer and then painting and texturing it to create the final 3D model that can be animated.

MOTION CONTROL—The technique of using a computer to repeat the exact same movement of a camera, a model, or any number of other objects as many times as necessary when the movement of the camera or other object must be repeated in different passes or camera takes. Motion control was made famous by the movie *Star Wars*, but more primitive forms of motion control have been around for a long time.

NEGATIVE—A piece of film onto which the original scene is photographed. The light values of the scene are reversed (i.e., dark areas are light, and vice versa) and the colors are the complement of the real colors.

NODAL HEAD—A camera head that allows a camera to be placed so that the nodal point of a lens can be positioned at one or more of its rotational axes of pan, tilt, or roll.

NODAL POINT—The exact optical center of a lens through which all light rays pass on their way to the film plane.

NTSC FORMAT—The standard television/video format in the United States, which delivers images at a resolution of 525 vertical lines at 29.97 frames per second.

PASS—A single run through the camera of a piece of film while it is exposed. Several passes may be needed to capture a number of elements for a shot. Examples of passes might be: beauty pass, fill light pass, smoke pass, etc.

PER DIEM—A fixed amount of cash given to each crew member on a distant location for his or her daily personal expenses.

PIPELINE—Normally this is the digital workflow within a facility that has to be set up for every show.

PIXEL—Short for picture element. The smallest point of an image that contains the color and density information at that point in the frame. The number of pixels in an image determines its resolution. The larger the number of pixels per frame, the higher the resolution and therefore the greater the detail of the image.

PLATE—Any piece of filmed live action, usually involving actors filmed during 1st or 2nd Unit photography, that becomes part of a visual effects shot. A plate is always an element in a shot, but an element is not always a plate.

PRECOMP—An abbreviation for preliminary composite, in which a certain number of a similar-type visual effects elements (e.g., stormy waves) are composited into one element prior to being composited in turn with the final shot. The main purpose of this preliminary step is to simplify the final compositing.

PREVIS (PREVISUALIZATION)—Essentially a sophisticated method of creating moving storyboards in 3D CG that portray the essentials of a shot in detail. All visual elements of a shot are shown and animated in their correct screen proportions, sizes, timing, and speed of movement. Previs can be cut into a rough cut as placeholders, and the director and VFX Supervisor can use them as reference on the set when complicated visual effects scenes are being filmed.

PUPPETS/ANIMATRONICS—Generally refers to any creature or puppet likeness of a human or animal whose movements are controlled through the use of electronic, mechanical, or radio control devices. Includes hand and rod puppets.

PYROTECHNICIAN—A trained and licensed craftsman authorized to use explosives on sets.

QUICKTIME—A multimedia moving video format capable of handling various kinds of digital video, still photos, animation, movie clips, and other media. Particularly useful for sending visual effects shots and elements back and forth between editorial and a visual effects facility.

REAL-TIME MOTION CONTROL—A motion control system that can record live action in real time on sets and locations.

REAR-PROJECTION—An in-camera compositing technique in which a previously filmed background plate is projected from the rear onto a translucent screen while the action plays out in front of the screen.

REFERENCE PLATE—A shot usually taken immediately following a satisfactory take of a piece of live action, intended as a reference for digital artists in the creation of CG characters that have to interact with the action on the set. Sometimes a stunt player may perform opposite a lead actor so that artists can match the CG animation more precisely to the live performance.

RENDER FARM—A facility's sum total computing power available to render digital images; in large facilities this may amount to hundreds of processing units.

RENDERING—The computer process of assembling all elements of a computer-generated shot to create the final image that can be viewed and recorded.

RESOLUTION—Refers to the degree of detail visible in an image. In a computer, resolution is measured by the number of pixels in a horizontal line (e.g., a 2K image actually has 2048 pixels per horizontal line).

SHOT BREAKDOWN—A list of all visual effects shots called for by a script. A breakdown will list all essential people and items that will be needed to accomplish the shot. There are many different types of breakdowns, depending on who prepares the breakdown and for what purpose.

SPECIAL EFFECTS—Effects that are performed during photography on set in real time. Also variously called mechanical effects or floor effects.

SPECIAL VISUAL EFFECTS—A now seldom-used term to distinguish what are now simply called visual effects from special (mechanical) effects.

STEPPER MOTOR—A special type of electrical motor used in motion control photography. Instead of turning continuously when the power is on, a stepper motor turns in small increments—steps—one step at a time when triggered by an electrical pulse from a computer.

STOP-MOTION ANIMATION—Stop-motion animation is a technique in which an animator moves a three-dimensional model in small increments from one frame to the next so that the motion of the model looks smooth and continuous when the film is projected. Also known as dimensional animation.

STRIP BOARD—A film's shooting schedule represented by narrow strips containing a summary of essential requirements needed to film a scene. Strip boards are abstracted from the information contained in breakdown sheets. Until the advent of computers, strip boards were made of actual cardboard strips about 3/8 to 1/2 inches wide. Today, strips exist mainly as graphics in a computer.

SUIT PERFORMERS—Actors wearing elaborate suits that disguise their human shape, like the apes in *Gorillas in the Mist* or Chewbacca in the *Star Wars* saga. They are usually SAG actors.

TECH SCOUT—Sometimes called *reckies*. A trip by technical crew to reconnoiter a location prior to photography.

TELECINE—The process of transferring film negative to digital files.

TEMP—Also known as a temporary composite. A preliminary version of a composite that contains all the elements of a shot but may still have flaws.

TIME CODE—A sequential series of numbers counted in hours, minutes, seconds, and frames that positively identifies every frame in a digital or video image.

TRAVELING MATTE—A matte that fits perfectly over its subject, creating a silhouette that moves with the subject from frame to frame. Most commonly used in blue or green screen photography.

VIDEO RESOLUTION—The resolution of a video image as measured by the number of horizontal scan lines. Standard definition (SD) video in the United States is 525 lines. High definition (HD) displays 720 lines.

VISTAVISION—A high-resolution widescreen format developed by Paramount Studios in 1954. VistaVision images are about twice the size of a normal 35-mm frame and therefore hold considerably more detail. Each VistaVision frame extends over eight perforations of 35-mm film instead of the usual four, hence the term 8-perf. Many visual effects facilities used this format to shoot visual effects elements to preserve as much detail as possible when the elements were duplicated to 35-mm film during optical compositing.

WIRE REMOVAL—The process of digitally removing visible wires from a shot. This involves replacing the area occupied by the wire with the background, often by digitally painting in the background frame by frame.

BIBLIOGRAPHY/REFERENCES

Books

Archer, Steve. *Willis O'Brien: Special Effects Genius*. McFarland Co., 1998.

Bacon, Matt. *No Strings Attached: The Inside Story of Jim Henson's Creature Shop*. MacMillan General Reference, 1997.

Block, Bruce. *The Visual Story: Seeing the Structure of Film, TV and New Media*. Focal Press, 2001.

Brinkmann, Ron. *The Art and Science of Digital Compositing*. 2nd ed. Morgan Kaufmann Publishing, 2008.

Cotta Vaz, Mark, and Patricia Rose Duignan. *Industrial Light + Magic: Into the Digital Realm*. New York: Del Rey/Ballantine, 1996.

Cotta Vaz, Mark, and Craig Barron. *The Invisible Art: The Legends of Movie Matte Painting*. San Francisco: Chronicle Books, 2002.

Culhane, John. *Special Effects in the Movies*, Ballantine Books, 1981.

The ASC Treasury of Visual Effects. Edited by Dunn, Linwood G., ASC, and Edward E. Turner: ASC Holding Co. Hollywood, 1983.

Fielding, Raymond. *The Technique of Special Effects Cinematography*. 2nd ed. Focal Press, 1985.

Finch, Christopher. *Special Effects: Creating Movie Magic*. New York: Abbeville Press, 1984.

Fry, Ron, and Pamela Fourzon. *The Saga of Special Effects*. Prentice-Hall, Inc., 1977.

Goulekas, Karen. *Visual Effects in a Digital World: A Comprehensive Glossary of Over 7,000 Visual Effects Terms*, Academic Press, 2001.

Harryhausen, Ray, *Film Fantasy Scrapbook*, A. S. Barnes, 1972.

Harryhausen, Ray, and Tony Dalton. *Ray Harryhausen: An Animated Life*. Billboard Books, 2004.

Koster, Robert J. *The Budget Book for Film and Television*. Focal Press, 2004.

Lee, John J. Jr. *The Producer's Business Handbook*. Focal Press, 2000.

Litwak, Mark. *Contracts for the Film and Television Industry*. 2nd ed. Silman-James Press, 1998.

Masson, Terence. *CG 101: A Computer Graphics Industry Reference*. Thousand Oaks: New Riders Publishing, 1999.

McAlister, Michael J. *The Language of Visual Effects*. Los Angeles: Lone Eagle Publishing Co., 1993.

McKenzie, Alan, and Derek Ware. *Hollywood Tricks of the Trade: Special Effects, Stunts, Makeup*. Gallery Books, 1986.

Millar, Dan, *Cinema Secrets: Special Effects*. London: Quintet Publishing, Ltd., 1990.

Miller, Philip. *Media Law for Producers*. Knowledge Industry Publications, 1993.

Perisic, Zoran. *Visual Effects Cinematography*. Focal Press, 2000.

Pettigrew, Neil. *The Stop Motion Filmography: A Critical Guide to Over 325 Features Using Puppet Animation*. McFarland Co., 1998.

Pierson, Michele. *Special Effects: Still in Search of Wonder*. Columbia University Press, 2002.

Pinteau, Pascal. *Special Effects: An Oral History*, translated from the French by Laurel Hirsch. Harry N. Abrams, Inc., 2004.

Poole, Curtis, and Ellen Feldman. *The Digital Producer*. Focal Press, 2000.

Rae, Donald W. *A Critical Historical Account of the Planning, Production, and Release of* Citizen Kane. University of Southern California Cinema thesis.

Rickitt, Richard. *Special Effects: The History and Technique*. Watson-Guptill Publications, Inc., 2000.

Rovin, Jeff. *Movie Special Effects*. A.S. Barnes and Co., 1977.

Sawicki, Mark. *Filming the Fantastic*. Focal Press, 2007.

Singleton, Ralph. *Film Budgeting*. Lone Eagle Publishing Company, 1996.

Singleton, Ralph. *Film Scheduling: Or, How Long Will It Take to Shoot Your Movie?*. Lone Eagle Publishing Company, 1991.

Smith, Thomas G., (1986). ILM: The Art of Special Effects

Winder, Catherine, Dowlatabadi, Zarah. *Producing Animation*. Focal Press, 2001.

Periodicals

American Cinematographer
Animation World
Cinefex
Millimeter

Selected Websites

There are literally hundreds of websites devoted to the movie business covering every topic from the most obscure 19th century attempts at capturing motion on a recording medium to the most arcane details of contemporary imaging technology. The list below merely scratches the surface.

www.awn.org
www.cgsociety.org
www.cgunderground.com
www.cgw.com
www.cinema-sites.com
www.csatf.org
www.entertainmentpartners.com
www.etcenter.org
www.fxguide.com
www.imdb.com

www.millimeter.com
www.moviemagicproducer.com
www.movieweb.com
www.starcomp.net
www.studiodaily.com
www.vfxblog.com
www.vfxworld.com
www.visualeffectssociety.com

In addition to the websites listed above, most of which have general appeal (some with links to other websites), virtually all visual effects facilities, software and hardware manufacturers, and other companies with an interest in serving the visual effects community have websites of their own. Most of them use their company name in their website address. Use your intuition, and more than likely you'll find the company's website by either typing their name into your browser or doing a search on Google.

INDEX